Art History

22—

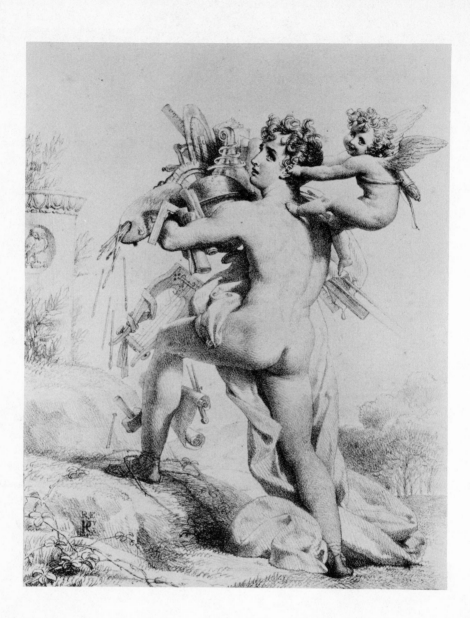

Qui trop embrasse, mal étreint: Lithograph (I/II) by Pierre-Narcisse Guérin
1816. Coll. Anne et Arsène Bonafous-Murat, Paris

ART HISTORY:

Its Use and Abuse

W. McALLISTER JOHNSON

La destinée des connoissances,
est de se perdre par degrés,
comme elles se sont acquises,
& par les mêmes causes
qui les ont portées à leur perfection.

WATELET & LEVESQUE,
Encyclopédie méthodique. Beaux-Arts, 1789

UNIVERSITY OF TORONTO PRESS

Toronto Buffalo London

© University of Toronto Press 1988
Toronto Buffalo London
Printed in Canada

Paperback edition 1990

ISBN 0-8020-6841-3

∞

Printed on acid-free paper

Canadian Cataloguing in Publication Data

Johnson, W. McAllister (William McAllister), 1939–
Art history: its use and abuse

Bibliographies.
Includes index.
ISBN 0-8020-6841-3
1. Art – Historiography. I. Titles.
N380.J64 1988 707'.2 c88-093918-4

This book has been published with the help of a grant from the Canadian
Federation for the Humanities, using funds provided by the Social Sciences
and Humanities Research Council of Canada.

To Homer L. Thomas and the late Jean Adhémar,
to whom so much is owed

Contents

Preface

In reading these pages it may be felt that I have unnecessarily magnified simple matters while nuancing complex ones beyond reason. My intent was well-meaning and the results, if imperfect, have at least achieved the aim of sensitizing the reader to more than he or she sees; that is, more to *why* than *how* things are done. After all, a glove pulled on and off assumes the basic form of the hand while retaining all the additional forms incidental to its use but which may simply be regarded as the signs of wear and tear.

Rather than the manual this might seem to be (an expectation that should be firmly undercut by the table of contents and index), the essays contained herein try for a delicate balance, inhaling an enormous amount of conceptual material relieved somewhat by discussions of *causality*. Despite its considerable density of framing, the text breathes on its own rather than through the respirator of erudition. Its title (*Art History: Its Use and Abuse*) describes the field as it was, is, and could be; a field where power can be had on the basis of affiliations and memberships, and reputations may be based on exhibitions – the modern equivalent of the 'historically invalid source.' This latter phenomenon is a kind of 'Nabokov Effect' of butterflies flitting from catalogue to catalogue – the result of ad hoc or opportunistic research, where fewer and fewer distinctions are being made between *descriptive*, *comparative*, and *intellectual* analysis – a phenomenon whose limitations carry the field with it.

Some readers may find irritating the number of words and passages italicized throughout. While agreeing with them in principle, this is my way of sparing them the distasteful effort (distasteful, that is, for any reader thereafter) of whipping out a yellow felt marker to deface pages. If emphases are to be made, it follows that *I* should make them! The exposition has, I am told, a 'conversational' character about it; in which case *intonation and accent* can be all important in understanding a passage that has been ruth-

lessly compacted to retain its force of expression. Whether as introduction, conclusion, or some pivotal thought along the way, I have sought to retain that conversational nature by the liberal introduction of quotation marks and italics. The thoughtful reader will find that they do work *within the whole* and provide their own justification.

Similarly, no quarter has been given in respect of the epigraphs that introduce different sections. They have been selected as commentary or counterpoint to their text and, like the texts, they are found precisely where one would least expect to find them. If they cannot be read, one may be led to do something about it. They further 'illustrate' the sections more surely than illustration that, when it appears, has been selected for its suggestive values.

Fully a third of the exposition deals with queries and problems arising from catalogues of one kind or another. However surprising this may seem, it will appear so only to those who have not 'kept up' with the spectacular development of this type of literature, now the most current, most practised form of art-historical writing. Also, the most *unthinking*, for how many who write, edit, or use catalogues really have some idea of how they function, or *could be made* to function with a bit more thought?

I may be faulted for a seeming overemphasis on French and American catalogues at the expense of the Germans (who are producing some of the most interesting ones) or other language groups. I can only reply with a *nolo contendere*. The catalographic tradition here proposed as a parallel to the historiographic tradition we all know and ignore is longest and most highly developed in France. In America it has of late become highly sophisticated and even more highly visible as a form of 'marketing' that slowly pervades the field. It is in Germany and America that institutions, individuals, and foundations (public and private) have supported an activity manifested through an astonishing number of experiments in format and presentation, reflecting national traditions or solutions of the moment. Art History is like a merry-go-round; you get on and off where you can, but the field goes on. This book may make mounting and dismounting easier.

W.McA.J.

Introduction

Art historians fall into 'occasional' and 'regular' categories. These correspond to people who know what research is about and how to do it well, but have no time, and those who have all the time in the world and no idea of what *they* are really about. In either case, they all are supposed to have grasped the essence of their topic and to have come to know its 'ins' and 'outs.' They must 'work through the detail' in order to get back to the larger issues.

Something often dies along the way, mainly spontaneity. The larger the problem addressed and the longer the research time, the more difficult it is to regain one's initial directness of observation in some *documented* way. Much art-historical writing is dull, tedious, for it has more or less consciously exchanged literary values for historical weight. This defect is to some degree inherent in the range and variety of sources that everyone must use before knowing what they are and sensing how they should – or can – be used. If used once and within limited context (which is to say for immediate purposes only), all sources are used *literally*; they may be seen and used in very different lights with time and greater familiarity. This is an argument for specialization within at least broad areas of competence.

Yet research *into* a subject can be done by anyone. The level of results obtained, however, invariably proves the aptitude of the researcher and his preparation, not just for the topic at hand but for the field as a whole. Research is a form of communicable disease against which the only potent antibody is a prudent, thoughtful reserve. Research is also a matter of timing. Some topics can be 'worked up' immediately by individuals, while others may require a collaborative effort stretching over one or many generations. Research is never done, never perfected. Recognizing the scope of a problem and determining what one can legitimately hope to do is the sign of the sensible, accomplished art historian. The vocation requires time,

travel, money, and formation, not necessarily in that order. While all these givens may somehow be finessed, none can entirely be escaped.

In all this, much depends upon the perceptions one has of the field through its literature and traditions. While productive scholars may put out several articles 'between books,' these may represent to them simple modulations from one bit of research or field to another. Students might, however, decide that these present the substance of the latest book, just as they may (quite erroneously) conclude that anything that *can* be put together can also form the *substance* of an article. Experience yawns at such opportunities; all sorts of morsels are thrown out in conversation to the schools of carp – and sometime sharks – with readied maws. Experience knows that it is only by having pursued attractive but unworthwhile topics that one learns what never to do again. Without regularly engaging the intellectual processes, the art historian is not likely to learn much if anything.

Once a topic is settled, there are hard decisions as to whether to communicate one's findings, and what form they should take. Most of the researcher's work should be incorporated into memory and never proceed beyond the verbal aside that may or may not represent insight. When, however, the decision is to 'go for print,' questions of form and presentation arise that must affect all that has been or can be done. It is at this moment when all the invisible scholarly apparatus is brought to bear through experience, logic, and discernment. This is when others discover the degree to which you can think and speak outside your immediate knowledge and social, even cultural, context. This is the historian's basic work, for what 'passes' in a restricted milieu with uniformity of means and attitudes will likely be much less impressive when seen in any larger perspective. The aim of this book is to measure the gulf existing between fine intentions and research results, to suggest various means of gauging the danger signs, and to examine not only research method but also the assumptions governing it well before the situation becomes expensive and demoralizing.

Research being what it is – assorted oddments revolving around facts and ideas – the independent scholar cannot usually rely on institutional support staff and research assistants; if the staging is not right, if simple transactions are not met, he has only himself to blame. A sound practical sense (which can never be taught) must be developed as he goes from project to project. If this is not the case, the full implications of his casually repeated transgressions come when he goes *further than he intended* and finds himself facing questions whose existence he never dreamt of. Rather than only the most immediate things (the prerogative and the bane of in-

stitutional affiliation where one is an agent of larger forces), the scholar's problem is what to do with his time and free choice. There is, perhaps, some point of convergence between those who couldn't be bothered about anything and those who, perhaps obsessively, can. The vast middle ground between these two attitudes, which are only too real, is the object of our present consideration.

The history of art and its catalogues may be compared to the circumstance of the musicologist who deals with the scores that are necessary to the furtherance of the discipline. She proceeds from what is currently available and works back to the original notations and all their problems and inconsistencies. Along the way she becomes conscious of historiographical processes that examine how the scores were produced and how they were received; how, as well, opinion has changed as a result of greater or more precise knowledge on given points. At the same time, she must keep abreast of the scores, old and new, that are being produced, revised, and rediscovered by as yet unrecognized authors and commentators. How she comes to know and work with these variables is also the subject of these essays.

Should the would-be art historian consult existing manuals, he finds that the field itself is nowhere addressed for its larger implications. He is treated to bibliographies of overlapping and essentially repetitive nature, treatises on essay and thesis writing, and, worse yet, research methods that ought to have been mastered in the lower schools.

This is symptomatic of the field as it has become – a society of ants without, however, having the purpose or direction that such colonies innately possess. Yet few of us have any innate sense for historical research and method in general, and certainly not as it pertains to art. The 'normal books of reference' offer precious little in the way of information on the notational problems that are legion in the field. Nowhere will one find much of substance on the research process *as it really is* once one leaves the protected and highly structured classroom environment.

Nor will one realize that the exhibition catalogue, a highly problematic form of art literature, has become the single most characteristic statement of the artefact. Thus it is that the present essays on art history have been written not to an outline but to the issues. Nowhere will one find all the information pertaining to one subject under one chapter heading. After all, intellectual work 'migrates' from one level or application to another, if it does not operate simultaneously at all levels. The result is intended to resemble Fowler's *English Usage* with a dash of Turabian's *A Manual for Writers*, but with a difference.

No claims are made that reading this book will generally remedy an al-

ready difficult situation within the university and the art institutions. Some respondents have wondered about the density and detail of the argument – its texture and a complexity that seemed to them fully manageable only by an audience that operated on a very high level of sophistication – and asked: 'Have your graduate students changed? Or have mine?' My reply is that it is for anyone who has a chance of *doing* something in the field. To that end, the bibliographical sections make no pretense at completeness of coverage and no concession on linguistic matters necessary for their use. I feel no special obligation to write for publication what I would not write or speak in practice. If a historian is willing to understand only what is stated in his language or terms, seeking information rather than examining for-mulations that condition it, he may as well turn to genealogy or statistics. In research as in no other realm, one's sense of humour equals one's sense of proportion.

In addressing these problems, I find I owe much to eight years of edit-ing *RACAR* (*Revue d'art canadienne / Canadian Art Review*). From it I gained many practical insights beyond those of my own teaching and research. Foremost among these was that most people find it difficult to 'compose' a text, while virtually all of them are ignorant of the editing process that gives better form to even the most accomplished texts. There is nothing like editing someone else's work to learn how *not* to proceed – until the mo-ment one loses one's own spelling, grammar, and syntax as a result of what flows over one's desk. What most struck me was the general incompre-hension as to what was to be done and how to proceed; its corollary was a characterized inability to relate visual matters to facts and documentation in any meaningful way. What has resulted is an attempt to remedy defects that are somehow inherent in the field by the provision of a *vade-mecum* that does not pretend to have the answers, only the problems.

I have divided the text by clusters: research, writing, and cataloguing, with an unavoidable detour into the study of history of art at the university level. It has been written section by section, sometimes page by page in sev-eral different sections simultaneously. The chapter on computers and art history must await a revised edition. The inadvertent 'cross-referencing' that has resulted is, I think, more beneficial than not, for no one works in ideal circumstances and has more than a fleeting measure of control over his work beyond that inherent in the proper functioning of his mental faculties.

The intent is that the reader be provoked to immediate or delayed reac-tions or qualifications based upon what is *not* said, or upon his or her own experience. The essays (for they are only that) may be read objectively or subjectively, and I am told they give rise to laughter as much as cold chills

down the spine. I am even happier, as an admirer of Flaubert, that the high generality I intended has often been construed rather ruefully as *ad personam* comments; at least, that one recognized something about oneself in reading about other things.

I have profited more than individual acknowledgment could indicate from what I have seen, observed, or read – and from the litanies of woe that researchers seem to think concern only themselves rather than the genus. The best and most optimistic among them have unfailingly been able to reduce these problems to a single pregnant sentence or aside that I have shamelessly used to my own purpose. On a regular basis, however, few people seem willing or able to discuss these with the insight and requisite detachment. Among the notable exceptions have been the librarians of the Art Gallery of Ontario and the Robarts Library of the University of Toronto, at the Bibliothèque Nationale, Paris, and the Zentralinstitut für Kunstgeschichte, Munich. I fear my own formulations have none of their rhetorical structure or elegance. One is never quite free of one's temperament, and mine is reflected in a lapidary style.

I am particularly indebted to the following for allowing me to reprint, in slightly revised form, material that was originally published by them: The Agnes Etherington Art Centre for the section 'Cataloguing and Some Unrelated Matters,' from their catalogue *French Lithography: The Restoration Salons, 1817–1824* (1977), pp. 1–6; the editors of RACAR, for the 'Half-a-Dozen Heresies Mainly Regarding Collections, Exhibitions, and Catalogues' (VIII [1981], pp. 137–52); and the Museum of Modern Art for permission to reprint the passage from Rewald's *The History of Impressionism* (on pp. 222–3). I should at the same time like to express my thanks to those institutions and publishers that allowed me to reproduce photographically pages from their catalogues: Wallraf-Richartz-Museum, Royal Academy of Arts, London, Rijksmuseum, Musée du Louvre, Uffizi; and most particularly to the Musée du Louvre and the Bibliothèque Nationale, Paris, for permission to reproduce works in their possession.

The one thing that is missing from the present volume is an understanding of what the practice of the history of art has meant over the years in constantly changing conditions and expectations. Present circumstances are much more sophisticated in appearance, but I am not convinced that they have necessarily improved despite all the activity around us. For that reason the basic documentary and custodial duties of the art historian have been treated in some detail because, in their particular and general orchestration, they are unavoidable in the consolidation of knowledge.

Art History

ART HISTORY IN TRANSLATION

TEXT	TRANSLATION
It has long been known that ...	*I haven't bothered to look up the original reference.*
... of great theoretical and practical importance.	*I found it interesting.*
Typical results are shown.	*The best results are shown.*
It is obvious that ...	*I can't explain it.*
It is suggested that ...	*I think.*
It is generally believed that ...	*A couple of others think so too.*
While it has not been possible to provide definitive answers to these questions ...	*Nothing worked out.*
Three of the samples were chosen for detailed study ...	*The results on the others didn't make sense and were ignored.*
It is to be hoped that this study will stimulate further work in the field ...	*This paper isn't very good, but neither are any of the others on this miserable subject.*
My results will be reworked at a later date ...	*I should live so long.*

1 Research

Research and Factors Conditioning Research

Arntzen, Etta, and Robert Rainwater. *Guide to the Literature of Art History*. Chicago: American Library Association / London: The Art Book Company, 1980

Chamberlin, Mary W. *Guide to Art Reference Books*. Chicago: American Library Association, 1959

Ehresman, Donald F. *Fine Arts. A Bibliographic Guide to Basic Research Works, Histories and Handbooks*. Littleton (Colorado): Libraries Unlimited, 1975. Purports to be the continuation of Chamberlin (q.v.) for the period 1958–73 'to guide the general reader, the beginning student, and the advanced student to the basic books in the history of art.'

Jones, Lois Swan. *Art Research Methods and Resources. A Guide to Finding Art Information*. Dubuque (Iowa): Kendall-Hunt Publishing, 1978^1, 1984^2

Kleinbauer, W. Eugene, and Thomas P. Scavens. *Research Guide to the History of Western Art*. Chicago: American Library Association, 1982

Muehsam, Gerd. *Guide to Basic Information Sources in the Visual Arts*. Santa Barbara: Jeffrey Norton / Oxford: ABC-Clio, 1978

Pacey, Philip. *Art Library Manual. A Guide to Resources and Practice*. London/New York: Bowker Publishing Company, in association with the Art Libraries Society, 1977

Wilk, Barbara. *Wie finde ich kunstwissenschaftliche Literatur* (Veröffentlichungen des Instituts für Bibliothekarausbildung der Freien Universität Berlin. Orientierungshilfen, 21). Berlin: Arno Spitz, 1983

Wittenborn Art Books, Inc. *Random Reflections on the Increase of Prices for Books on the Arts*. New York: Wittenborn, May 1979 (pamphlet)

Research: From Great Expectations to Bleak House

Sed plerunque non minus studiosos quam cupidos, quod viam per-
discendae rei ignorent, magis quam discendi labor frangit.
Alberti *De pictura* III 55

The only sane way to approach research is to know that you will do more
work, and a rather different type of work, than you anticipated. All this
is rather like a puzzle where one strives to establish the outlines, now fol-
lowing up particular lines of thought, then clusters waiting to be filled out.
When a piece does *not* work, one manipulates it until it does in the fulness
of time, even though its place and function are a far cry from one's initial
design. As one progresses, one 'sees' what is missing rather than 'sensing'
it, and the process becomes less reflective and more a question of simple
craft.

In a puzzle, one's original success is in joining pieces in the midst of
the table-top, with nothing adjoining. Later, enough has been established
to give general form – with awkward yet concentrated blanks – and a re-
sulting impatience to 'get it done' rather than to do it. One has become
sensitized to the pieces and their internal economy so that they add up
to a coherent picture, although the pieces may go together without quite
knowing where one is heading. Subtlety and nuance are required in deter-
mining the height, the angle of already joined pieces in respect of those to
be added.

Here the metaphor ceases, for while a puzzle ineluctably moves on to
a predetermined finish, research is different: one has no picture to follow,
no view of the whole to replicate. In an intellectual puzzle, the *size* of the
clusters to be joined gives no real indication of what can be completed
first. At a certain point, these 'negative values' may lead to frustration and
the feeling that the proverbial piece is missing. Unlike the picture puzzle,
however, as the intellectual pieces become clearer and drop into place, the
whole picture becomes less clear, resulting in a loss of interest and lack
of impetus. *More research is lost by the simple inability to put things together
than by constraints of time and access*. The following material attempts to set
down rather more observations than advice (and much more advice than
literature to consult) in the belief that the essay form is likely to be most
effective because it is inevitably irritating.

At base, research is Method in its widest sense; it is a very *personal* aware-
ness of things, some but not all of which can ever be taught rather than
lived. The result of proper method is knowledge, which is a function that

is legitimized only when accomplished by true judgment, not merely by notes on what someone else has written and said. Both method and knowledge are specific manifestations of Curiosity, which is essentially an altruistic selfishness. This can only be so when one is forced to survive intellectually only through commitment in an epoch where the great formative institution, the University, has been systematically undermined and destructured.

The low, the safe, level of 'acceptable' research has, with the rampant democratization of the field, become the gathering together of *membra disjecta*, i.e. nothing beyond what was known. More brutally framed, most people engaging in 'research' have no idea of what it involves or what it is about. This has its dangers in any historically based discipline requiring conceptualization: one must look for what is relevant, or might be. Facts become functions, for 'one doesn't see what one doesn't know.' The end of research is, then, to *provide* models, not follow them; to question, rather than accept. The field is antipathetic and unadapted to simple technicians, the contractually limited employee, the naïve enthusiast.

Most aspiring art historians are trained by the University. The field is therefore dependent upon those who are in theory prepared and trained, able and skilled at thinking and questioning. Once beyond the confines of the University, the scholar or museum curator must face on a daily basis the promises and risks of his own judgment. No dictionary or computer is of help when someone comes to you with the deceptively simple question: What is it? One must always know *to whom* or *to what* to refer, or whoever else might offer advice, which is what colleagues are for. While calculated daring makes the difference between a good and a mediocre career, whoever gets through the system should *at very least* come away with the broadest possible awareness of the art-historical past, and an awareness of the present. One is bound to be wrong in some or many ways, but *basic competence* must be presumed.

Research is largely a matter of what one can take for granted, or must not. Neither a body of knowledge nor the apparatus for its study remains static. Fundamental research is never finished. Applied research, that is, research related to some type of program such as an exhibition, is always deemed 'complete' at a given moment. Of course, there is always the temptation to go farther than is strictly required, to complicate things needlessly, or, more likely, not to know where to stop. *Too few people know why they are in the field*. Not having been formed to its history and needs, they do not know where they are going and are content to do what is asked of them without ever considering what should be done.

No, the central problem of research is – and remains – what happens as

a result of new evidence or thought brought to bear upon old subjects, and how to create new topics through the use of documentation in its broadest sense. As a result, Research surpasses possibilities and attention span, for it is a long-term commitment even if the time required to accomplish a *specific* piece of research – which can be as little as one footnote reference among many – depends largely on its framing and only then on circumstantial factors. It is usual to begin with rather *too restricted* an idea for the development of a topic; once it is realized that the topic leads in all directions, these different courses must be followed up without losing sight of the original goal. Then one compresses the richness and texture of the research into the topic as it has *come* to be.

Not all research ends up as a finished product. One may believe that the pursuit of knowledge is a proper goal in itself. Unfortunately, such knowledge is not *communicable* since it can only be brought to bear at a given moment and circumstance; it is not less worthy as a pursuit, but one should never think that it is sufficient in itself, for it cannot be *evaluated*.

Concentrated effort is required even to consolidate earlier thought and literature, so just as much effort must be presumed with what one makes of one's hard-won intellectual baggage. So, to return to our research metaphor, we find that it resembles Escher's *Drawing Hands* (1948), with its mental image of what should exist on blank paper but is not yet reality. Depending upon aptitude and capacities, it may be relatively easy for the researcher to determine what types of information are needed; which should be retained, and what is their relative value or their true significance. He may, if properly trained, have recognized configurations without being able to achieve them. By repeating the queries and manipulations the process becomes more intuitive – to the point that he finds himself suddenly picking up a piece of the puzzle, turning it around idly, and then, without apparent reason, finding his hand putting it in an entirely unexpected place. Where it fits.

Most research manuals treat problems of form and literature. None of them considers the philosophical and intellectual motions of assembling material that must be given form. It is left to the researcher to determine his own place and that of his research within the puzzle he is addressing.

The Research Process: Hard Times and Great Expectations

Ein *produktives Wissen um die Lücken des Erkenntnisgefüges* und um die Grossenordnung der Probleme wird gefördert, das Stellen sinnvoller und

exact formulierter *Fragen* gewinnt ein bisher nicht gekanntes Gewicht, das fragende Referat wird eine selbständige und produktive Form der Wissenschaftlichen Forschung.

Hans Sedlmayr, *Kunst und Wahrheit*

A reference librarian of my acquaintance once compared the research process to walking through a train: one knows where to walk, but not where one will be thrown, so one always needs one's wits about one in proceeding from one place to the other.

Whatever the subject field and one's prior experience, research presumes a symbiotic, even a catalytic relationship between personalities, procedures, expectations, and assumptions. These are but rarely satisfactorily fulfilled on a daily basis, but may always be improved. They are, moreover, initially dependent upon the availability of literature and a good level of public service complemented by understanding. The process itself gives rise to vastly different results, depending upon whether one has only a general (public) library to work with, whether one moves between general and special libraries, or has access to a top-flight research library. Regardless of the quality of the facilities, it is the quality of the researcher and his ability to adapt that ultimately make the difference.

In order to profit from any library or collection, one must first have formulated the problem so that it can be attacked, just as one must have decided the purpose of the research. The aims of a book, an article or shorter notice, and a catalogue are very different. This difference is reflected in their apparatus and mode of publication. There is also the research paper, the thesis and dissertation, and the public lecture. Finally, there is the process of simply informing oneself at a given moment (topical interest) or on some topic over a longer time.

Once the subject has been defined, it is usually found that the researcher (here modelled on the typical undergraduate student):

1 does not know the usual reference tools;
2 assumes that an answer is an answer, that is, is incapable of distinguishing between 'one-step, two-step, and three-step' reference questions as defined below;
3 cannot distinguish in a bibliography the periodical literature from monographs (a separate treatise on a single object or class of objects);
4 does not follow any logical sequence in research and is always off on tangents (cf. 2 supra);
5 is *put off* by problems inherent to research at a time when reference tools are becoming more numerous and more complex, particularly when they are made for machines but available in manual form.

These technical deficiencies or, if one will, functional inabilities are further exacerbated by the mistaken idea that research of quality can be effected within pre-set (arbitrary) time-frames without any prior knowledge of what may be involved in the topic itself. Even 'professional' readers make errors – most notably in assuming that what they are familiar with is *all* that there is. One can, however, work in the same ways and not arrive at the same level of information simply as a result of the topic; regardless of experience and sophistication, each time one starts something new one feels as if one proceeds from a vacuum. How, then, can one do things in the 'right' order?

The first question to be answered by the researcher is then: *What can actually be accomplished within the time available?* In simplest terms, this means that good research is not just a matter of knowledge and experience (otherwise it could not be *called* research), but rather the result of logical and intuitive processes, good work habits, and, most important of all, the will to continue beyond what one initially envisioned! The quality of perseverance distinguishes the experienced from the naïve researcher, for the latter presumes that material already exists (first fallacy) from which one may extract exactly what one wants (total fallacy), only to panic when he discovers this is not the case. The normal course of research is defined by false starts, false leads, and setbacks. If one cannot accept these and press on, one really should not clutter up the field.

Precision in formulation will save you and everyone about you much time, irritation, even frustration. Say what you are about – and why – in the fewest and best-chosen words possible; without this context nothing will come to mind that cannot be included in a simple answer. The ability to draw other people out and to explain lucidly usually indicates the ability to discern and establish research priorities and methods, and this means research competence when everyone's time is at a premium.

One might recall that the 'three steps' of reference questions represent different gradations not only of information, but also of relative immediacy of access to it:
– do you have it?
– where is it?
– what (or where) is related or other desired material?
It is further evident that these questions presume different things of the reader, for the first two represent by their objective nature 'pure' reference questions. The third involves suggestions that the reader must follow up on his own. After all, he would not expect the reference librarian to *read* the journal article, monograph, or catalogue arrived at through this process, so why should the reader expect him to continue the research process once

immediate needs – the identification and location of material at a basic level – have been satisfied?

This is no idle question, for a number of bad habits have been consciously fostered by public libraries over the last few decades, even if services are of late being cut back by the economic realities of public service. These expectations are the direct result of the public's being spoon-fed or else becoming indifferent to the staff of what seems to be simply another social or community centre. The assumption then runs that all libraries are somehow interchangeable – with the same organization and procedures, the same clientele, and ... the same collections. The public presumption of 'generality and uniformity' has, however, even more serious consequences in the blurring of distinctions: one regularly observes requests for *original documentation* that is confused with *published information*. (This is no laughing matter. The same confusion is to be remarked in museums and print rooms that have to field sempiternal requests for *reproductions* of art works, most usually not even belonging to that particular collection.)

Much the same attitude towards what passes for research prevails in what might be called the 'avoidance of literature' when this exists in indexes; the effort required to get at it seems too much to bear, and it is forsaken in favour of any material immediately present and retrievable. (In such cases, the naïve researcher requests all the material on a given subject at once, even though it cannot possibly be used simultaneously.) The most serious result of these and other casual attitudes is that students and many other classes of readers attach little importance to the handling and preservation of material communicated. Regardless of degrees of 'innocence' and blame, ignorance of the proper etiquette in different libraries and collections may result in being personally denied access to material, or of being denied access *as a class* as a result of some historical abuse.

Of course every library or collection has its classes of readers, but it is well to signal in passing the existence of three pathological types all too often encountered:

1 the 'problem' reader, who has a thesis worked out in his mind and is searching the documentation to prove it;
2 the 'obsessed' reader, persistent to a fault, but whose queries are specific even if one must listen a lot to assist him;
3 the photocopy-mad researcher who never selects, reads, or takes notes, but squirrels away copies for future use like nuts for winter.

These particular cases are usually countered by the run-of-the-mill readers (by far the great majority) and the 'professional' readers of all ages, chiefly characterized by craft and free exchange of problems and informa-

tion. In the latter case, the librarian knows why they are there, why they return, and that they will take the minimum time for the maximum effect. If one reaches this level, one gets a real sense for the field and the practical implications that must be faced by all concerned.

Even then, the immediate problem is to gauge how sophisticated the reader really is. *Any library or collection is an unreal world, with its own conventions and procedures all of which must be learned if one is to function properly within its confines.* This is a very different matter in a large and impersonal research library, often with open-stack collections and a small staff, and the personalized and often idiosyncratic atmosphere of a special collection. While librarians will normally inquire if a user – the fashionable term – is visibly bumbling about, most readers are probably not aware of the type of help they can and should ask for.

Sad to say, the librarian himself is not usually seen as a level of reader's tool. In reality he is the key to unlocking the printed or other works he serves. He is there to assist in locating material, not in exploiting it, and has been trained somewhat differently to this end. The topic is merely a vehicle for learning to use the tools he administers; he cannot fairly or logically be expected to have specific (detailed) research knowledge about everything he is asked, if for no other reason than many of the answers inevitably lie *outside* his collection. Fortunately, when the reader is a complete stranger or a novice, he tends to ask for assistance. But inquiry is not normally a function of knowledge; to the contrary, it may be more a function of intimidation as to *how* to approach the research facility, particularly if the reader has had a number of bad experiences in other collections. When the Moment of Inquiry comes, both sides of the desk must extract what each needs to know from what has been said. Terminology is often the problem, so paraphrase is required. In the end, *it is amazing how many people set to work without having inquired about such basic things as physical layout of the collections, services, and procedures.*

In most cases, the reader begins too specifically, forgetting to look for the more general topics (subject headings) that may encompass his subject. In contrast, general readers may know both the author and title of a work, but tend to look them up through the Subject drawers (the most difficult form of access, which is why there are whole volumes detailing them) rather than through the Author-Title drawers. Popular wisdom has it that libraries are for books, so it is often thought that there are books on all topics, no matter how specific. This means that the general reader often ignores the existence of journal literature and their finding indexes.

In the public catalogue, card-filing systems or their surrogates may be either 'word-by-word' or 'letter-by-letter' – with the latter being more gen-

erally understood by readers used to telephone directories. In all cases it is necessary to know one's alphabet to proceed further. Furthermore, there are three stages of precision in enunciating one's needs:

1 'I know what I want, but I can't think of the name / I saw a book reviewed about a year and a half ago';
2 half a reference only (no author, or an inaccurate title);
3 full precision (author, title, publisher, date – one could almost catalogue from it).

These difficulties mutually encountered by the reader and librarian normally result from the inability or unwillingness of the former to find and/or verify references in the catalogues of large public, particularly national, libraries: British Museum, Bibliothèque Nationale (Paris), Library of Congress, or the Metropolitan Museum (for art). Alternatively, they arise because one saw a footnote or bibliographical reference and did not take it down properly. In either case, the reader should learn the normal steps of reference and research and exhaust them in difficult situations, before ever presenting himself at the desk.

Readers, Reading, and Institutional Relations

> 'Oh yes, I understand you, Mr. Noggs,' said Mrs. Nickleby. 'Our thoughts are free, of course. Everybody's thoughts are their own, clearly.'
> 'They wouldn't be if some people had their way,' muttered Newman.
> Dickens, *Nicholas Nickleby*

The Record is always imperfect, incomplete. One engages in a never-ending process of verification and rectification, sometimes adding one's own errors even as one eliminates others. This sobering prospect only acknowledges the *formative* process of research, one that differs, however, according to the nature of The Record.

When dealing with visual evidence it is possible to extrapolate from what is known; insofar as its written evidence is concerned, it is found more or less opportunely, or not at all. Written record is more strictly a documentary process while the 'visuals' are data and *embryonic hypotheses*. This means that the brain is imprinted with all it has ever experienced, including much that can never be specifically transferred to others. Little can match the excitement of coming to grips with documentation; nothing can equal the knowledge derived from its careful analysis. In perusing vast quantities of material one distinguishes the routine, the representative, the significant anecdote or quotation, and the truly exceptional observation or

fact. These subconscious faculties are conditioned by timeliness and retentiveness of mind, of which only the last (retentiveness) is susceptible of modification through experience.

There is a time to do everything; in some cases, it may be deferred; in others, not. In some cases one anticipates what is needed far ahead of time. In any event the research process is never as obvious nor as straightforward as it seems from the *outside*. Even such a 'mechanical' process as note taking is fraught with distractions: one always finds interesting, even significant things, although they are not pertinent to one's immediate purpose. One has the choice of losing time by recording such interesting 'asides' or of taking note of their place and presumed import, if one does not altogether ignore them. But to do so would be to 'close down the horizon' and forgo the broadening aspect of historical research. While work on sizeable subjects and the constitution of resource facilities on well-known ones is often sanctioned by economic reasons, its direct result is the impoverishment of research topics. (In the Republic of scholars there is always a corner for the *odd* specialty.) One must decide *on what level* one is required to 'take note' and what level of information is *immediately* required. These decisions are easier by far if one has a large but consistent research topic into which all sorts of disparate information might go, but they are no less true of the tightly framed topic. In either case, one must always backtrack since there is the inevitable need to retrieve something that sets one back on the trail, and thus to what is eventually needed.

Some types of research involve many single responses, while other researchers sit all day for three months over something.[1] The results obtained none the less depend upon the *type* of work, not its intensity (the differences being both intrinsic and incidental). In like measure, there are fundamental differences between large-scale research projects, which should be able to be transmitted to as yet unknown continuators, and the individual curiosity that 'researches' to the extent of some relatively current interest only. For some topics 'once through' is for all time; for others – and they are the vast majority – one must redo (and rethink) as a result of increased sensitivity and acumen.

In joining battle with this morass, one is easily tempted to do too much at one time rather than to execute a succession of separate manipulations focused upon one (manageable) aspect at a time. The analogy of proofreading comes to mind, with its multiple verifications of textual *correction* (everywhere) and the *articulation* of each individual component. Some of these function together, as the footnote number and the footnote, or a textual reference to illustrations and photographic legends. Others function independently, as the Bibliography, but must find their proper order

within the various sections. Without a high degree of self-discipline, one works toward too many levels to be either consistent or accurate; nor does one address an operation 'all the way through to the end' only to turn one's attention elsewhere.

Yet this critical comparison does not, in the end, stand. It addresses a finished product – the typescript resulting from research – rather than a product coming into being. It is indeed necessary to 'follow one's head' through the highways and byways of a topic, but such a dispersal of momentary concentration must always be tempered by a sense of the object of one's research. After all, one's accumulated notes (the reliquat or *Nachlass*: what is left behind) are not normally very useful to others since not intended for other than one's own immediate usage. (They are, however, useful in establishing broad distinctions between the materials whose interpretation must nevertheless be susceptible to the construction put upon them.) In the end one is faced with a compromise, including what is important for oneself and what is *likely* to be important to others. Literary framing (exposition) should not be too personal in nature, although the material may require something more than a customary approach or apparatus if it is to be seen in its proper light. In art-historical terms, this means determining the part of
– the interest of the subject/topic;
– the interest of the composition;
– the interest of the technique;
and these, in turn, require a close appreciation of artistic and historical *level and intention* (causality/reception). Much mental cross-referencing is necessary and is, in the end, rather like the Multiplication of the Loaves without partaking of its miraculous nature. However contradictory this may seem, if one reads neither widely *nor* carefully, one gets no sense for materials in context and thus for the 'better' information.

Voracious reading is one way of comprehending scholarly process since it addresses a finished product and is at once selective and uncritical. One is always unconsciously formed by literary exposition and its manner of presentation, whether this be in primary or secondary sources. (The newspaper or, rather, different levels of newspaper illustrate this process.) One should rapidly be able to discern what is worth a second look, and why. One of the best means of understanding art-historical literature is to go through it as would a reviewer or someone preparing comprehensive examinations under the press of time. Why? *Because the purpose of scholarly apparatus determines its nature, just as the topic or objects treated in some way determine scholarly purpose.* What catches the eye may be presumed an indication of what was intended by the author, although everyone may be in

for some surprises when close reading reveals suppositions or inadvertent purpose. The reader has only to ask: What are the usable concepts and information so that I have something to work from and something to go back to? One accordingly extracts the general idea and a few salient examples, thus 'digesting' what is presented. This is somewhat more than a simple Abstract and somewhat less than a serious Review attempting to place the work in historiographic context. Rather than characterizing the work so as to arouse general interest, it concentrates on a utilitarian aspect – what one can *personally* derive from the published record.

Generally speaking, there are three major components in art-historical writing:
– a text;
– criticism (which includes apparatus such as footnotes and catalogues but fundamentally concerns the text itself); and
– illustration.
Using these to best purpose requires a certain doggedness and fastidious attention to detail. For example, it is probably more difficult to *correctly* title an article than a monograph, just as it may be exceedingly difficult to select the most pertinent illustration for a monograph whose synthetic nature precludes all the niggling points dealt with in specialized journals.

The commitment of author and reader is very different for a note or shorter notice, an article, a monograph, or something in the catalogue way. Only the author faces the difficult task of balancing short-term versus long-term goals which the reader takes as givens. Getting his research to print requires a series of decisions that, once taken, are not easily gainsaid; hence the more or less acerbic critiques of those second-guessing him. *They* never had to face the diminishing probability of returns in treating ancillary questions, much less the painful editorial process of determining what can be printed under given circumstances, if at all.

Publication is further complicated where a reference volume, *catalogue raisonné*, or index is concerned. *In these cases, the length of time required for their appearance always assumes second place to correctness*. The recent impetus toward machine readable items perhaps responds to the idea that something is needed on an interim basis, although these tend to treat more purely documentary items. Yet a cumulative index to a journal, whether in machine readable or manual (printed) form, does not entirely replace the need for a contents page for each issue or year; individual numbers must stand on their own, as must articles that form the basis of higher theoretical writing.

Given these complex recessive factors, the quality of your own research will depend in great measure upon that preceding you. Even then, it is by

no means restricted to the 'scholarly literature' but rather more to a range of institutional factors affecting research opportunity:
- custodial attention (collections/libraries)
- classification and identification (always subject to *addenda* and *corrigenda* from near and far)
- indexes and reference tools
- studies
- quality of staffing

None of these is quite immutable, but the first three are the most cumbersome and difficult to modify in view of *personal* needs. One must work within them as they have come to be, appreciating them for their differences. Even reference works are of *provisional* nature. Depending as they do upon the circumstances of the moment and their creators' quality of vision, they are always deficient in some way, always needful of completion and nuancing for purposes they never envisioned. They are, for all their specificity of information, *general* works. Like their institutional context, they aim to satisfy the more basic needs of a highly diversified clientele.

To be an effective researcher, one must then familiarize oneself with the institutions and learn how to work in them. *It is the appreciation of their internal problems through different expectations and cultural filters.* Remember that most collections are seriously underused, even wrongly used, by their readers. They are only too happy, even anxious to have their collections *used for something* so they can become better known. In so doing, they acquire more reputation or greater means with which to serve their users.

The reader/researcher can accordingly be said to perform a service to the institutions he employs. The normal way of signifying his gratitude is to inform libraries and art collections of the use made over the years of the highly specialized and unique tools. While one would not, of course, inform a library of a citation taken from a volume in their holdings, one would inform them of *discoveries* concerning a specific work. In all likelihood this would already have been done orally as a result of working with the material.

But when it comes to print, scholarly courtesy demands *formal acknowledgment and communication* of results corresponding to the *formal statement* that is the published findings. This is important in the case of manuscripts of all nature forming the basis of critical editions or studies; it minimizes the chances of several scholars undertaking much the same project. It becomes absolutely essential in respect of works of art, and is effected through the researcher and the institution since
- information concerning a work of art is kept at source where it is most useful to all because it is generally sought there;

– future researchers, not excepting those attached to the collection, are bet-
ter served than you were at the time because they are served through
your research.

Once published, the results of research are communicated to the source
through the addressing of an offprint or, when a question of more conse-
quential work, by the catalogue or book itself. This may be voluntary, but
it may also be subject to prior conditions.

Conditions of publication in the history of art normally are the result of
accepted controls upon the reproduction of photographs emanating from
given collections. They may be enforced at different moments depending
upon whether the photographs were obtained for *study* or for immediate
or eventual *publication*. In the latter instances, at the moment of the au-
thor's application, his obvious *commercial or scholarly intent* may be a de-
termining factor in the type of permission accorded by the institution, not
to mention its conditions. It is quite impossible to generalize the options
currently available, as these range from a simple courtesy reference iden-
tifying the source (the manner of acknowledgment may even be specified)
to firm requests for the published work in lieu of (or in addition to) the
settlement of a fee.

In some cases the fee may be subject to reduction or the author may be to-
tally exonerated, but these and other unforeseen matters must be attended
to well in advance of need. Among the normal photographic restrictions
may be riders that there be no overprinting of the images, no cropping,
or even no details without specific authorization. (For purely commercial
firms, there is a flat rate that may include reproduction rights never used
but which are invoiced so as to prevent fraudulent or confidential usage
and obviate further correspondence.) It should be remembered that the
sums derived are applied to the maintenance and improvement of facilities
too often taken for granted.

It is quite simply astonishing for the researcher to discover how much
bibliography he knows that the art institution ignores. Which is only to
restate the difference in focus between a research facility and the indepen-
dent researcher. Not only is this to be expected, it may reflect the more re-
grettable tendencies of the recent overexpansion in research activity: schol-
arly discourtesy and a bent of mind incompatible with the very aims of
research where the dissemination of knowledge is presumed.

And yet it is strange how, in such circumstances, scholars can be quite
vague about extant literature in their own field, whether current or anti-
quarian. As library representative of a department, I have on many occa-
sions compared notes on this score with librarians and collections develop-
ment people, not to mention dealers and through catalogues (which may

be quite informative) or simple price lists. In one such ritual exchange I mentioned to the head of a special library how depressing it was that many professors seem to ignore what is already on the shelves. 'So tell me about it,' returned the head, 'I've lived with that for years with curators who are always telling me we don't have what they *need*. But neither can they tell me what they *want*.' The presumption here seems to be, if only it could be voiced, that what is wanted must already *exist*.

Upon reflection, I concluded this mental state was because 'they' had become used to using the important titles *elsewhere or abroad* – or only when these were *needed* – and that memory failed if they had to speak generally of the important literature of the field, which they considered, remembered, *only when it was being used*. All this is natural enough since one is apt to be 'material-oriented' in courses and seminars: what you see on the screen is what you go after. Research is focused accordingly and only afterwards – perhaps – are the horizons expanded. And so it is that, beyond all reason and imagination, 'they' thought there must somehow be volume upon volume that could be acquired upon demand, even upon short notice, to enable work to be done in the easiest and the most expeditious manner. As a result, *desiderata* represented simple wishes or wistful thinking, not something firmly rooted in reality or considered as an object of continued usage. One can only pity these professors' students, for however deprived they may become, they will not likely give voice to legitimate complaints any more than a collection of art objects would.

What cannot, of course, be predicted is whether these same students are sufficiently enterprising to discover *what there is*, even *all that is available*, rather than accepting as *all there is* what is recommended through the normal bibliographies and reading lists. Such a situation represents a serious defect in training *when students are not made to follow the devious course of the whole literature in its stunning variety and all its qualitative variations*, for as curators and professors they will likely do no different than before.

Much naturally depends upon the nature of the topics assigned and whether these sufficiently test research skills in general rather than the subject at hand; or whether topic-framing sufficiently indicates the range of literature likely to inform art-historical topics. A useful analogy, for example, comes from realizing that the First World War 'interrupted but did not halt' publication pertaining to earlier movements but also gave birth to later writings of rather different nature. *Contemporary literature never respects historical periodization although it may come to reflect it.* Knowing this is perhaps the only way to get some hold on whatever the field is, for 'the field' never depends upon the specialized literature only, but on all

the types of literature that condition it. A fine piece of historical writing is likely to be one that is remarkable for the variety, the density of sources brought to bear, each in turn, on the issues within a general exposition. One may work from the general to the specific or from the object outwards, even both ways at once. But research is always a matter of compromise, and reasonably so *only when the nature of each compromise is realized*.

It is difficult enough to connect and insert works of art, known or unknown, into their primitive context; this is made more difficult when one must reconstruct 'lost' information or information once known but not retained or transmitted at a given moment. While this situation may result from the inattention or inexperience of the researcher, it is the normal result of historical selection. Otherwise put, it is already difficult enough to assemble the elements of the historical picture, why should things daily be made more rather than less difficult for others?

The researcher works within institutions that are themselves cultural manifestations. He must set an example by demonstrating that research is a cultural activity; it must be done by a *cultured*, not simply an educated person.

Archives and Their Denizens

> It calls, besides, for training in the historical method, that method which teaches not only how to weigh evidence in subjects concerned with any bit of the human past, but how to recognize what is relevant when it appears, and how to look for it when it hides.
> B. Berenson, *Three Essays in Method*

The 'intellectual migrant worker' that is the art historian, archaeologist, or archivist has both real and referential knowledge, which are derived from his sources and may be written or printed. They are used in differing proportions according to the period – perhaps the place – at which he works. Their access has not been general until a relatively recent period in time and their manipulation can never be universal. *Books can be read; sources must be deciphered*.

So it is that the question before us is whether the insurmountable mass of archival material bearing upon the arts can somehow be used to define taste and tradition when there is always much to interest but rather less to justify inquiry. When, moreover, the documents themselves are passive in nature, requiring a different type of intellectual effort than that needed

to examine interpretive or polemical writing; and when they are demonstrably the most voracious and pitiless devourers of time for the results obtained or obtainable through their consultation. Rather than intellectual abstraction, the dangers of archival research lie in the reduction of focus inherent in very specific information not less than the problems of putting it together in any intelligible fashion. All this and more, when 'all that one needs' lies right under one's nose!

The reasons for the increasing vogue of archives since the early nineteenth century lie in their authority.[2] This, barring the occasional fabrication of religious or political consequence, may be said to reside in their indispensability as records of public or private transactions within society as a whole, a type of 'laboratory' – the term is a recurrent one – for historical research of local, national, or international scope of either descriptive or comparative nature. By a striking analogy with the physical sciences, 'les documents se déposent au contraire dans les archives exactement comme se forment les sédiments des couches géologiques, progressivement, constamment,'[3] and this manner of constitution retroactively confers upon archival materials a historical thrust, or perhaps intent, not originally theirs.

Archives are, after all, dependent upon their origins (who generates them administratively for what purpose) and are not the result of piecemeal commissioning and collecting usual with works of art. Their 'factuality' assigns them an importance which inevitably 'anticipates the fact' for anyone frequenting the reading rooms of what amounts to innumerable documentary warehouses.

Their lure is as irresistible as it is everlasting. As one professional denizen put it and as anyone with half a mind can testify: 'Les dépôts d'archives ont cessé d'être exclusivement l'entrepôt des dossiers devenus inutiles pour l'expédition courante des affaires mais conservés en vue de leur utilisation certaine ou éventuelle.'[4] The romantic vision of this type of work is that if one looks long and hard enough one is apt-likely-bound to find something bearing the seal of History in all its unadulterated splendour. What does it matter if one be the seventh successive generation of scholars to consult the self-same register? It is there, authentic, and someone may have missed or mistranscribed something therein; by seeing and holding it, it is at last possible to understand!

As archival organization and access progressed, the writing of history naturally moved away from the marking personalities and events into more representative ones, thereby providing some measure of cultural leavening through the creation of artists' lexica, historical-statistical works, and local histories that resulted in a certain blurring of vision:

Die Gefahr, Geschichte in Statistik zu verwandeln, droht namentlich der deutschen Kunstgeschichte, seitdem eifrige, aber nicht selten bedenklich geschmacklose Lokalforscher aus dunkeln Winkeln und bestaubten Papieren Werke und Namen rastlos hervorsuchen, deren Werth für die engsten Lokalkreise unbestritten bleiben soll, welche aber für die Entwicklung der deutschen Kunst vollkommen gleichgiltig sind. Um sie in die Gesellschaft historischer Grössen einzuschmuggeln, werden ihnen nicht selten Eigenschaften zugeschrieben, welche das Auge des nüchteren Mannes, der nicht Lokalforscher ist, an ihnen vergebens sucht.[5]

In this Springer was doubtless right in characterizing the gulf remaining between the great formative currents and the lesser freshets and rivulets of art history. While these are parallel or overlapping, they rarely converge opportunely within shorter ranges of time. Their constant interaction continues to pose without resolving the question of whether the history of art concerns the *constitution* of great styles or rather documents their unending *dilution* through provincial and vernacular traditions.

This can only indicate a certain ambivalence in how, as citizen or scholar, you apprehend the past or, if you will, your predecessors; how, as well, this may colour your views as to what is significant, what is or can be retained, and why we study certain things and not others. There may also be a certain falsification inherent in our tendency to stratify art-historical discussion through marking events rather than traditions. Such models, easily structured and manipulated in terms of the *apparent* facts, are perpetuated without much reference to social and intellectual, even geographical traditions (Kunsttopographie) of long standing.

Art history, then, has its own archaeological tradition. Rather like the exploitation of archival (manuscript) sources and the constitution of collections, it serves to establish the boundaries of historical research. It should also have its History of Learning as much as or more than a surviving literature.[6]

However, art history has nothing to rival archaeology's ability to capture the universal imagination, and this lack has set up an enduring dichotomy between the settled and the known (art works created or collected) and all that is unknown or suspected – all that can be bodily resurrected through settlements, cemeteries, and hoards within defined context or continuum and oftener than not graced with scattered mentions in the ancient literatures. The determination of what constitutes the line between art and cultural artefact is bound to remain alien to those outside the field, even though it is the patent result of the stranglehold of the Graeco-Roman and Judaeo-Christian traditions upon collecting and scholarship.[7]

The type of correspondences that emerge from archives and annals formed for years an advantage over art history mutually shared by archaeology and antiquarianism. These set loose an informed speculation of higher nature than would have been possible from works of art – or texts – alone, for it is scarcely imaginable that folio after musty folio of documents alone would have aroused the Great Controversies – those questions that effected a general mobilization of critical and philosophical comment, even scientific interest, around a work of art or monument (the Elgin Marbles), a collection (Campana), or a site or province (Herculaneum and Pompeii, Napoleon's Egyptian Campaign). Whether the real provenance of archaeological finds or individual art objects was known or preserved,[8] at least certain collectors became pretty much the 'initial' provenance and inevitable reference for later studies.

And yet, insofar as art-historical literature is concerned, little curiosity has been shown for its 'intellectual provenance' – the conditions and centres representing the *earliest stages* of evaluation. In so doing, one forgets how important those who first undertake a problem are for the interest and method of succeeding generations. While the literature itself is a focus of meditation, rather like a cremation urn or crucifix, it comes from somewhere and has been crafted by persons, known or unknown, that can be seen within the context of a city, province, or realm over the centuries. This is perhaps Schlosser's greatest deficiency, transmitted en bloc to those who bother to consult him. Not only does he place too great an emphasis upon the admittedly strong and coherent Renaissance and Baroque intellectual tradition, he breaks down entirely for the eighteenth century because of a lack of understanding of context required to situate the literature then being created. Unlike Justi, he has no notion of the intellectual milieu from which this creation derives. Whatever its real merits, his work rapidly becomes a bibliography of 'what came his way,' without profound knowledge or grasp of the literature it cites.

It thus seems that a problem central to art history as a whole is the advantageous use of all documentation accessible at present, seen not so much as references to be used but rather as a cultural by-product. Perhaps in time it will be possible to discuss the flow of ideas, statistically controlled, in order to gain some idea of the circumstances of geographical diffusion between artistic capitals and provinces, between grand and vernacular styles and their subsequent modification.

Such 'transmutations and permutations' would necessarily have to take into account the class variances of the times that today must neither be written away nor passed over by those who, in the name of an egalitar-

ian art history, are inclined to do so by fashion or conviction. To illustrate, the incredible number of trade books from the Renaissance on testifies to the importance of craft traditions that once were inculcated and transmitted intact from generation to generation.[9] This is something rather different than the How-To books and treatises they are often represented as being. Significantly more attention is of late being paid the rise of the *Arts et Métiers*, but they must be inserted into the determining currents and phenomena which most art historians are incapable of treating. All this is in marked contrast to the idea of a history of art directly dependent upon the Three P's: Patronage, Purchase, and Plunder (four, if one includes Publicity). There is no doubt that additional and somewhat different formation will be required beyond that now deemed to serve and define the field.

The foregoing observation is crucial, for archival work is like going from one Dimension into another. Everyone knows he can 'dip into' a book, article, or catalogue at will, but palaeographical skills are developed only through their exercise, and archival discrimination only through experience. (And it really *does* help to know the language(s) you are trying to decipher.) For any such documentation directly concerning the arts, the rule of thumb is: if nothing happens, it won't exist. As a result, one hopes for as much 'movement' of works of art as possible (displacement, sequestration), numerous technical transactions (restoration, copying, engraving), or other controls of an administrative nature, lest one be left with only the summary, largely unintelligible inventories taken from time to time in view of other concerns.

All this implies a frame of mind wherein archives somehow 'fill in the blank spaces' for works of art between their creation and the moment you want to study them. And while it gives the illusion of knowledge, it is very easy indeed to get caught up in researching indifferent topics just because a certain familiarity has been built up. Not all archival work functions on an equal intellectual level any more than do other types of research and writing once you get into it in a serious way. Very much more indeed depends upon the importance of the subject dealt with.

The immediate problem, of course, is that archival work may be 'got into' at a very superficial level, documenting scattered notions that have no broader or more far-reaching context into which they can be placed. One needs always to remember that one is dealing with a conventional language, with its shorthand notions and repetitive formats, all of which place facts in relief and ideas into the shade. In the end, it is the specialist mentality that prevails and extends the mystique of archival research even if this is only one of many tools available to the art historian.

It all works so simply, so logically. Once you become so utterly con-

sumed by what you are doing, work begins to exist for its own sake and is seen to function on a different plane from that of mortal man. When this happens you are in trouble, for by 'funnelling down' to ever sharper focus, your concept disappears somewhere along the way. This is a sign of brilliance, not of intelligence. There must always be an element of concern in the young scholar's mind that he will end up as an anachronism, following patterns set decades ago that blind him to the possibilities of the materials themselves. To preserve some semblance of sanity – inevitably helped along by factors of time and expense – forays into archival work must be undertaken with stated intentions. These must not be lost from view although, as any scholar, you should be willing to modify your research plan along the way.

As with any other research and writing, then, some work should be done; then you should step away to see whether the results really justify the effort. It's not just uncovering the material that is ultimately important, it's how to evaluate it as it comes forth in dribs and drabs. The most rewarding type of archival work – the work surest of results – comes with undertaking the establishment and annotation of texts rather than through discovering innumerable bits and pieces of puzzles that are not yet established.

To public mind, Archives have something virginal about them even if they have usually been fingered beyond measure. This impression of purity only furthers the illusions that keep otherwise rational people going on against even reasonable odds. (What is really pure has been neither indexed nor summarily catalogued and is therefore incommunicable.) Such a mystique is doubtless inherited from work done in the nineteenth century under other social and historical conditions, but it is today about the most *inefficient* type of research that it is possible to do. The image of the isolated search for truth was inherited from the Romantic period of history. Instead of continuing on as an agreeable pastime for the curious and aged of the leisure class, it has become a corrupter of youth – particularly of students and scholars whose experience lies in local history and, more likely than not, problems of a nature that can be grasped and treated from sources conveniently at hand.

Somehow or other, the caricature of the parchment-faced rentier tranquilly passing his days in the bosom of History has carried over to archival researchers as a class, at least insofar as concerns the apparent intensity and duration of their labours and their recessive social implications:

'Why there's ... , I thought he died *years* ago.'
'Very much alive, actually, still working on that study on ...'

'But I though he brought *that* to a close ten years ago. (Come to think of it no one has ever seen anything in print.)'

'He did, or would have ... But *of course* you know that the Y ... family recently, perhaps five or six years ago, deposited twenty-five tonnes of personal archives which could complete and correct his work on certain points; and then there are the indispensable verifications.'

'Is it just me, or ... he doesn't look at *all* well, do you think?'

'Never really thought about it. No one's said anything to me, and he certainly *looks* no different ... But now that you mention it ...'

The presumption in all this? More than any other branch of learning it is that the work being done can only be 'of quality' – and that it will be of more quality yet, when completed, since based upon archival materials. I know of no other discipline or science that, consciously or not, so casually, so completely arrogates unto itself the exclusivity of Truth; or within which the true adepts just as regularly issue disclaimers to all who would listen.

Should you really believe the delightful fiction in circulation, talk to the people administering the depots as to who comes and what they search for – and what is or is not possible to do within different types and levels of archives and manuscript collections. Learn for yourself the percentage of work actually completed and published from the life forces of so many curious readers, and how much of this information is communicated (and in what form) to the archives that made it possible. Discover the social hierarchies existing between foreigners, nationals, and locals, between the neophytes and the experienced readers, between those who do their own work and those who are paid to do the work of others. Most of all, experience the gulf between the Occasionals and the Regulars, the latter of whom exchange hushed confidences among the fraternity as to the latest 'discovery' and take heart in the knowledge that Work ... is progressing.

Such analogies are far from being as forceful as they seem. They might be taken as proof that scholars need to concentrate on being Modern in much the same way that the use of archives permitted a revitalized research for their own day. The difference, however, is that the archival tradition was more a way of life than the means of ensuring instant authority and superabundant scholarly production it has become. *Selectivity* remains the key to research of consequence. You may choose your poison, but that held in archives is surely the most bitter, albeit the least effective.

So much for the nature of the beast, but what do you do when he is in hand? Probably discover, as do most archivists, that a fortnight after beginning work in earnest, they no longer have hands worthy of the name. That real paper or parchment handles differently than whatever has re-

tained the name; and that it can inflict nasty paper cuts that easily become infected with the dust of centuries. Washing hands becomes compulsive.

Now comes the exhilarating thought that you have left behind simple library work, put aside the frequent and sometimes violent alterations previously experienced in the direction of research. It is finally possible to sit down and concentrate on something. Then comes the realization that a certain amount of dog-work always has to be redone within your own perspective regardless of the quality of work of your predecessors. After that, comes the knowledge that no 'influential example' exists that can serve all needs in the daily struggle against archival paleography, probability, and potential. You are on your own.

Such a dilemma is inherent in archival records – how to 'enter into' the body and spirit of the documents, and then whether to take notes from or to transcribe them. It will be noted that these are quite different sets of mind, roughly comparable, these, to scanning a book or article for content, or copying a text to learn something from the way it is put down or for the communication of significant information. The first provides context while the second transmits what is usually considered 'usable' information. In reality, the first requires the exercise of discretion in its casting of wider intellectual nets for general understanding, while the latter presumes immediate significance in a detail, fact, or striking formulation. Some reconciliation may ultimately be had amidst conflicting claims to precedence and authority between these two camps in remarking that one without the other always leads to skewed, even flawed conclusions, while both require as a matter of course such niggling library work of the type you thought possible to avoid in turning away from the *printed* word.

Yet what are archival/manuscript materials but reductions of the spoken word cast into certain forms, transcriptions that after a certain time were – and still may be – thought of as an intermediary stage from word to print without, however, that transition having been universally presumed. Their form, for all its common and even picturesque tournures, may be considered as defective in certain regards as speech itself. They are but armatures that *then* could be filled out more easily than now.

Moreover, this *interim* commitment to paper has conventions in the same way typesetting does, conventions peculiar to place and period and for that reason difficult to seize for anyone lacking regular practice or formation in, say, mediaeval Latin, sixteenth-century French (with its floating orthography and shifts in accents not entirely accomplished by the eighteenth century), or visigothic German handwriting prior to the general adoption of Roman script in our own century. One should always think in terms of what would have happened had a competent editor of

the time got hold of an indifferently prepared manuscript to *prepare* it for publication.

Such preliminary evaluation is indispensable to the palaeographer cum editor as he considers the use that can be made of his sources and how best to present them. Two extremes lie before him: first, with the 'diplomatic' transcription common to mediaeval studies ('as is,' whatever its incidental or known eccentricities, however disconcerting), and second, with the 'normalized' readings punctuated and rationalized according to accepted modern usage. In classical texts, the amount of variant readings, interpolations, and discussion arising usually occupies a fair portion of the printed page; such is rarely the case for more recent periods unless one confronts something written by a relatively uneducated writer or, worse yet, a nonnative speaker whose texts overflow with *phonetic* deformities. But these problems vary in gravity depending upon whether the text is approached for its own sake or as a means of understanding something else, as required by the historical disciplines.

Within even this limited range of illustrations – and many more could be adduced – it is necessary to inquire to what extent quotation from archival materials is advantageous to the reader's comprehension, or whether, as with printed materials, it is preferable to 'give the gist' and content oneself with a simple reference. The difference in mode of scholarship reveals itself through the general inability to verify an archival source – as a function partly of location and partly of deciphering – as easily as a passage alluded to in a book or article likely to be held in at least the major libraries everywhere.

Research is in any case coming properly equipped to handle what you anticipate, the texts (in whatever form) assuming levels of complexity and variables with which you must be prepared to deal. A source is initially gone to for facts or a body of information; in so doing, a presumption is made that the reader has a fairly precise idea of what he wants and where he is going with it. But in finding it, other information is found. And once you leave the reading room and begin to absorb it, you are inevitably led in other directions, often *back to the source* for further reflection in the light not so much of what was found as for what has come of it. In this one respect, archival work is no different from any other type of reading.

At this point comes the suspicion (or fear) of your own precision in transcribing even if, at first encounter, you presumably had come to grips with *scribal error* in the sources consulted. Depending upon the level of suspicion, you feel obliged to return to confirm what should have been confirmed initially. Yet, if the source is not immediately available, access becomes not only a matter of time and expense, but of delay. This is why

there is so much demand for archival microfilm 'by the metre' so that the gross work can be done under optimum conditions and effort concentrated thereafter on the substantive issues. Still and all, this is a recent technological development and in many instances technically impossible to achieve for scattered materials as opposed to a given manuscript or *fonds*. More proof, if proof were needed, that research is the anticipation of what certain *types* of texts may offer as one reduces to the best of one's ability the element of surprise.[10]

Within the last decade, archives have made a grand entrance on the exhibition scene insofar as the establishment of biographical and other information is concerned. What can be used, however, largely depends upon whether one is discussing an artist, individual works, or the general context in which art evolves; and whether it is the artist's own archives that are the basis in whole or in part of the conclusions drawn. Archives are the handmaiden of the usage to which they are put. No individual scholar involved in the underpinnings of history can ever hope to gain the control or the coverage assured by a major exhibition with catalogue, put on as a vast and labour-intensive collaborative enterprise of specialists. Such *concentrated visibility* is fundamentally different from the occasional archival reference slipped opportunely into an article or book to nail down certain points, and one does well not to forget it.

Whatever the context of archival work, it all comes down to the three queries most likely to be asked first during a thesis defence: (1) What did you hope to accomplish in undertaking this work? (2) What could you have done with more time and better resources (and what you know now)? (3) Whatever you have accomplished, where does it all lead?

Practically speaking, the greatest single misapprehension concerning archives is that they have been constituted as one would wish them now (alternative reading: as one knows them now). In other words, there is a presumption that archives from all but remote antiquity employ *modern* terminology. In reality, their exploitation requires, beyond a mastery of the obvious linguistic groups, a conscious effort to 'translate back' to old words, older terms, other habits, and, most especially, *different coverage*. Whoever 'they' were, their habits and concerns are not ours; and the differences are often the more striking the nearer one comes to our own time even though superficial consideration presumes *closer identity* with the present.

In the archival landscape stretching from recently manicured gardens to the primeval wilderness, such assumptions prove to be a series of ha-has that suddenly and embarrassingly engulf the reader. This natural selection, more intimately concerned with manuscripts than with early printed ma-

terials despite a natural conformity with them, quickly weeds out anyone who accepts a momentary deficiency in historical context as a permanent barrier to his goal of knowledge 'taken from the sources.' In this sense particularly, the archival reader is both *formed* and *transformed* by his sources. Unlike scholarly works and critical editions built up over generations, archives have no explanatory footnotes, no introductions, no glossaries. Nothing but their own information.

This does not mean they lack personality. As any palaeographer will testify, the range of idiosyncrasies within documents emanating from any place or time exceeds *by far* what one has come to know through the printed word. (And for those who have never used quill pens, much less fluid ink, the cardinal rule is to repeat the hand motions required to get a certain shape in order to see what letter(s) might be, and to mouth series of words so as to gain the sense of a passage rather than simply deciphering its component parts.)

This means that each document or series has its own *systemic* problems that must be learnt and committed to memory so as to be able to extrapolate from them thereafter. Land records are not approached the same way as assessment rolls or the census, but they are all couched in handwriting of different qualities regardless of informational intent. How often is it that something illegible one morning suddenly 'comes into focus' the next, or just as one is ready to give up on it? *It is never the intensity of work but a relaxed and unhurried attitude that ultimately is most productive of scholarly result in archives.*

Admittedly there are epochs when letters are scarcely formed or distinguishable only with great effort; but there is always the *ambiguous* word or phrase upon which the whole meaning may turn. In the end, this is often a matter of vocabulary – another incentive to have done preliminary work in history and literature before venturing into pure documentation – when your first reading is seen to be another word altogether as it recurs over a period of time. Rather like an interview where one must be analytical while listening, what is read must be analysed in the context of the document at hand, as well as within one's accumulated experience.

Certain texts, certain queries may be quite outside what can be derived through normal archival frequentation – most people consulting them, by the way, are not archivists by formation – and are reserved to specialists, whether attached to or working away from a particular archival depot. In the purely current context of a bottleneck encountered on the way to something else, the alternatives are four in number:

– a moment's consultation with the archivist on duty or one of his specialist colleagues;

- a formal query to a recognized (non-resident) specialist in the field;
- working it out yourself, whatever the time it takes over the long term;
- hiring it done, in which case you cannot avoid out-of-pocket expenses rather than having free access to professional expertise.

All these are a step above the engaging ingenuousness of the beginning reader. His automatic reflex is to turn to anyone in sight who seems to be in familiar surroundings and has a comfortable, perhaps an authoritative, air.

This response usually occurs in foreign climes where the reading-room hierarchies and functions are at first less apparent and where one's own language deficiencies will be measurably eased when the recipient of the query is a native speaker. This does *not* mean that the charwoman or any-one else immediately at hand has a valid opinion on a fifteenth-century legal text any more than your contemporaries would have instant com-prehension of the period 1850–1950. Archival competence is a matter of acquired skills and insights. It can only be the result of much application seconded by even more imagination.

The best way of easing tensions and avoiding gaffes comes when the reader maintains an arm's-length relation with the institution that serves him. Each archival reading room maintains a variety of finding aids (card indexes, preliminary inventories, and published works) helpful in situat-ing its collections. There are never enough of them, but what exists usu-ally covers the basics and is all one can reasonably hope for. Put out over the years to different standards and levels of sophistication, the aids re-main helpful in varying degrees only. *Absolute consistency in description is no more to be expected here than in consulting the subject drawers of the public catalogue in your local library.* If there is no thesaurus governing the making of finding aids, the same items may be described in different ways and you will never know what you are requesting until it arrives, perhaps getting something rather different than you thought or wanted.

In the end, there is a principle at question as to *how detailed* archival find-ing aids can be made if they are to serve the mass both of materials and of readers. If too detailed or abstruse, someone is always needed to interpret them for the reader even if he has no direct knowledge of them. This in-creases the probability of misinformation or misdirection. Yet the reader is elsewhere accustomed to detailed information and often does not readily comprehend more global instructions to be followed through in order to *reach* the detail he wants.

Given these conflicting attitudes and experience, the two most useful questions the researcher can ask are 'Can you suggest ...?' and 'Do you know where I could find ...?' although he must be prepared to field a 'You

would be wasting your time to ...' Clearly, some preliminary organization is in order on the reader's part before he sets out on a topic. At base, he must ask what he wants to find, what institutions readily spring to mind (city, province, country), and what published helps or correctives are available in advance of consultation (guides, directories, bibliographies). Once these are digested, there remains the decision as to whether to telephone, write, or go in person, remembering that there are usually time limitations on staff service in respect of certain types of inquiries.

This limitation is only natural when one thinks about it. The experienced archivist can usually estimate the time required to search a particular type or area of request. These areas range from things so straightforward one had only to consult an index or directory, to research in original documents that is to all intents and purposes futile. Explain your aims, clearly and concisely, so you can be helped.

As repositories of information, then, archives are by definition 'incomplete, but not really inadequate.' It is quite impossible to keep everything documented; even were this possible, the result would only become 'not archival' in nature. In other words, if the information sought is of consequence *only to the researcher*, he cannot expect it to be kept. This admittedly severe principle of historical selection becomes clearer when one realizes that what most people consider to be important is quite often the opposite of what it historically proves to be.

Such distinctions and nuances come from what might be termed the Recognition Process and how quickly it sets in. Almost anyone can read a meaty letter or document and grasp its significance. But these are few in number. To be able to detect importance in an isolated fraction of information, casually framed, perhaps written by some obscure personality such as an Indian agent in Canada West, requires an understanding of the past. This comprehension may be rudimental or highly refined – and one always hopes for improvement – but it supposes that one can grasp the sequence of events and relate them to the dates, issues, and personalities. To return to the geological simile previously alluded to, the knowledge of the seasoned archivist comes from *mining documents and extracting gems*. Passing allusions and scattered references must be inferred through prior knowledge because, without it, names and issues mean nothing and most likely will not be recognized at all.

Primary documents accordingly provide only the raw material demonstrating the continuity between past and present; they are not created with the future or with history in mind. It is increasingly evident, however, that they are 'being mined' to yield information capable of defining or clarifying legal questions or administrative responsibilities. Archives

are fast becoming history-in-current-application, in marked contrast to the purer scholarly practice of intense examination and reflection, of study for lessons and social inferences. They are further susceptible to a new type of exploitation that can only be the preserve of the specialist – the creation of 'differential histories' concerning, say, agriculture, architecture, engineering, and technology rather than the traditional preserves of diplomatic, political, economic, and military history.

Whatever the context of archival research, the area of institutional concern is presumably confined to a well-ordered repository. However, the first-time researcher usually enters the premises with unrealistic expectations – what can be delivered in short order, with no prior warning, and while his car is running outside. But this is not the library work with which he has had at least a passing acquaintance. Two contradictory reactions then set in when readers

– think they will have *what they want* in a few minutes only; or
– become convinced after a few minutes that what they are about will now take *weeks or months* as they are overwhelmed by the process itself.

Their counterpoise is the Repeat Reader who comes with some grasp of historical context, whether formally acquired or through reading. Through frequent encounters of the archival kind, his acumen has developed to the point that he

– *glances* at a document and knows it is not for him;
– perceives that the *date* is wrong for what interests him;
– discerns that the document's *principles or content* are not what he is after.

Such ease and familiarity come with settling down into an area of research. This reader works with his document(s) on two levels, much like the wringer washer of our grandmothers: he mechanically extracts the generalities, then finishes the job with his hands so as to squeeze out anything that was missed in pertinent, significant details.

This returns us to the principal function of archival summaries and calendars, for all the hidden work of the personnel is directed to one goal – to *orient research* and make the contents *generally accessible* rather than describing them in numbing and unserviceable detail. The unparalleled archival affluence since the 1970s also deserves a word of explanation, since the increase in solicitation has gone hand in hand with a change in clientele.

From time immemorial, archives have been frequented by the family researchers (professional or amateur genealogists) whom many readers having other aims often wish would rapidly rejoin the ancestors they are so obsessed with documenting. Yet, until the late 1960s, academic readers were the general rule within the reading room. (In many ways they still are insofar as sustained research goes; it is simply that their age has gen-

erally diminished even as their numbers have increased.) And for good reason, for they are in a better position by virtue of training and temperament to *interpret, condense, and summarize* what they find and relate it to other sources and collections.

Depending upon the type and level of archives, as many as 50 per cent of today's readers may come in 'from the street,' having little preparation and less understanding of the research process *in general*. Diversification in the type of readers has of necessity brought with it an extension of what can be considered archival material rather than the manuscripts with which it is here considered synonymous. All this has also led to a certain dislocation in service as a result of the concentration of requests in the more recent periods. As a rule, the complexity and intellectual demands of archival consultation are such as to favour the serious researcher plying his trade and to discourage readers having a genuine but general interest.

Concerning art history in the large sense, the documents are where you find them once you have left the domain of government and society archives – hence the emphasis is placed upon private papers, for they are not so narrowly constituted around factions and interests because of their non-administrative character. In this context it is perhaps symptomatic that in speaking of the 'cultural fabric' of society, reference is usually made to galleries, museums, libraries, and the performing arts while the 'archival lining' common to them all is rather scanty and moth-ridden. It is surprising archives function as well as they do despite staggering limitations on personnel as well as the physical and monetary resources necessary to keep and preserve society's basic records. Although subject to the public-service ethic, they have no public image of consequence, and are rarely mentioned or discussed unless there is media attention to, say, the acquisition of the papers of some major figure. Ongoing interest in their fate seems limited to the regular readers and to those administering things from the inside.

In a society dominated by visuals (one tends to forget how many of these remain to be discovered in any repository), it is not surprising that archival work is somehow taken for granted. It is presumed to exist but is relegated to the status of an adjunct discipline, one of the *Hilfswissenschaften*. Perhaps it is, but its own archaeological processes appeal to and are equally served by hardened specialists as well as bright-eyed enthusiasts. It is through such curious bedfellows that the cultural fabric *as a whole* is kept in repair and added to, and for the reasons usual to any research:
– readers get more involved, and involved in more complex issues, than they expect;

- readers get interested in the archival process and go farther than they ever imagined possible;
- readers gain a first-hand appreciation, however superficial, of what it means to preserve and consult the past.

This circumstance suggests in no uncertain terms that archives possess basic affinities with other cultural repositories – museums, galleries, and libraries – through curiosity that has become focused attention, further extended and refined by browsing. Unlike art exhibitions, however, the exhibition of History that archives permit never yields its results in a straightforward or glamorous way. Properly approached, however, it is one of the ultimate intellectual pursuits because of its challenges. The rediscovery of sources is an expression of historical positivism in general, although it may be coloured by other concerns: Schlosser's decidedly Italian emphasis is as much anti-French as anything else. Whatever the motivation, such studies are one way of comprehending mechanisms of thought even when elevated to ends in themselves.

For all this, archives are somewhat more than mere sediments deposited in history's due course. Their very disposition obeys the currents and specific gravity of the liquids by which they are set down – to the point that it is almost impossible to find anything unless one knows *where* to look, because

- contracts (the art historian's favourite diet) are most usually part of the notarial archives; without the identity of the notary it is impossible to begin work; and this may depend upon the address of the artist, patron, or firm;
- correspondence (letters received and mailed) may be either dispersed or concentrated; while a letter may be copied for any number of reasons and remains entirely at the mercy of the recipient.

Most important of all, even 'original' documents may be only drafts and copies. Bringing together the sediments of such different archival currents presumes a different kind of commitment and timing than simple compilation.

In a discipline where new material is revered to the point of excess, or where a number of scholars sedulously compete within the same field or topic, predominance within the field means establishing a claim to *priority in discovery*, if not in subsequent publication. If preserved for more than the statistical purposes or indirect security measures they are, request slips become the means as well as a proof of scholarly activity.

In some institutions, requests for archival materials may be kept track of through a registration system, requiring approval or clearance at the highest level. (What happens behind the scenes is another matter; if ma-

terial once returned vanishes into a black hole, your only defence is absolute precision in signatures, register numbers, and other 'homing devices' to minimize the loss.) If first discovery is a concern – and it is an issue – it may not easily be upheld without the maintenance of bound notebooks, detailed photocopy or microfilm receipts, and the like. This procedure naturally says nothing of those who may have worked through the archives in years past, prior to the implementation of current registration systems; nor can individual proofs be easily verified at the source. These difficulties may have some advantages, however.

Concern with *priority of access* has been known to give rise to a type of academic espionage where colleagues, wives, or rivals have systematically recorded requests submitted, so that nothing is missed that someone else may have discovered. This method is highly inefficient in that your own research is then structured upon that of another, but such incidences are usually for high stakes and are less likely to concern scholars who are interested in mastering archival organization in view of future research, or doing the best they can with what can be found.

This effort provides a lesson: there is, then, advantage to be had in familiarity with the 'old men' who copy aimlessly, continuously, all their lives. Of all archival denizens, they probably know given archives best, are most generous with their accumulated experience, and are probably the most content with their lot. As Bouvard and Pécuchet realized, this is *copier comme autrefois*.

Treasures and Trash: Art and Its Literature through the Ages

> On ne dirige point les arts; on ne soumet pas le génie, pas même le talent, à une marche régulière; ils produisent ce qu'on ne leur demande pas de préférence à ce qu'on leur ordonne.
> Comte de Forbin, 1824

The standard reference for the *sources* of art history is and remains Julius Schlosser, *Die Kunstliteratur* (Vienna: Anton Schroll, 1924), which became in the course of three successive editions of 1935, 1956, and 1964 *La Letteratura artistica* (*Il pensiero storico*, 12) published in Florence by La Nuova Italia. Reprintings of the 1964 edition are now available in paperback from the same publisher. The Italian editions supervised by Otto Kurz have, for better or worse, deviated from Schlosser's original intent by the adduction of scholarly literature relating to the sources themselves. A general summary of the different categories of literature is as follows:

- Bibliographies relating to the Sources
- Theory and Practice of Art (later becoming Criticism and Aesthetics)
- City (topographical) Guides
- Travel Literature
- Autobiographies and Artist's Lives
- Architectural Theory
- Catalogues of Early Collections
- Antiquarian Literature
- Art Periodicals
- Early Histories of the Arts

With some exceptions this survey ends with the early nineteenth century, at which time the nature and volume of sources is transformed. Not discussed are the documentary sources such as catalogues of auctions, exhibitions, or dealers (vide Lugt) or institutional catalogues dating for the most part after the mid-nineteenth century. Such institutional histories are few and far between, one early example being J.J. Marquet de Vasselot, *Répertoire des catalogues du Musée du Louvre, 1793–1917, suivi de la liste des directeurs et conservateurs du Musée* (Paris: Hachette, 1917).

While circumstances may dictate that many students and practitioners are ignorant of the sources of art history, this cannot be said of the prominent or determining books within the field – articles of similar nature being more difficult to discern within the mass.

Should one ask what *are* the books that have formed the history of art, one meets with empty faces and vacant stares. Even with considerable prompting – 'books affecting the field for better or worse, which began certain genres of writing, or which formed the perceptions of one or several generations' – the result is no better. In the end, one may hear voiced some tentative analogies from current course work with emphasis on what may or may not be 'modern classics.'

This sad state of affairs is likely due to the organization of North American curricula around the Periods of art history, with a resultant emphasis upon Subject rather than author or specific works of literature and art. One searches for 'what can be found' on the period, medium, or problem and necessarily begins that search in the subject drawers of the public catalogue. *Whether and how quickly discrimination between authors and works takes place is another question.* Indeed, one wonders how long it takes to determine what is a standard work or an irregular or occasional publication not so much by its date of appearance as its nature. Are the 'determining' works of art history those which *au vrai et au figuré* go against the field, or merely take a different direction?

If pressed, one learns that a work was 'interesting' although disappoint-

ing in that it did not address the period or materials one would like, i.e. that one is interested in. This reflects the dilemma and potential of the field in the transference of ideas or methods to realms different from that in which the initial demonstration was made. It is *Sehenswürdigkeiten* transported to the realm of the intellect. The choice of determining works would then encompass significant approaches, ideas, or methodology rather than just the perfection of erudition and advances in book production. It would exclude on principle works that, while ingenious in approach or concept, have had *no following or significant influence* within academe or within scholarship as a whole.

Easy it is to examine current means and influence, rightly lamenting that 'it will be a sad day when we allow the techniques we have learned, or which we teach, to dictate the questions which can be asked in our universities.'[11] Is it not better to know when and whence come our influences rather than submit to them blindly?

Were we then to establish a 'bibliography' of such works, their chronological arrangement would permit seizing at a glance the changes in artistic literature itself. To be scanned, such a listing would have to be arranged, not sequentially, but by author. It would further require sectionalizing. Nor could it be the result of simple consensus, but represent a choice, a model. Only then would the 'recognition factor' come into play, rather like De Piles's *Balance des peintres. Our problem is to categorize the curious and serious literature that has informed, consciously or accumulatively, the field.*

'One man's trash ...' goes the saying. It has always been so for art and its literature, whose problems lie in the very differences of format – and of intent – that art-historical writing has assumed since its origins in the fifteenth century. How then to respect and illustrate the various branches of knowledge as well as the classic volumes that formed everyone's reference shelf through changing times and needs?

The field would normally be divided into three sections: Lives of the Artists, History and Theory of Art, and Architecture. Yet Architecture, if showy, is too specialized a branch of knowledge to be of general interest, the Lives too repetitive to stimulate thought, and Theory a shade too abstract for other than the concentrated reader. Limiting inquiry to the 'great' books within the field, while it might show the results of an enlightened (or unimaginative) acquisitions policy and the purse needed to effect them, could scarcely provide insights into the uses of art literature as opposed to mere bibliography on show. What classifications might then supplant the traditional ones and what might their results be?

Surely the art-historical literature is able to address the public on their

own terms; it is simply that the setting up of new and unexpected rubrics has to be very elastic. Rather than dividing books by genres or the usual categories that effectively prevent one from comprehending their other uses or recessive traits, categories should afford not only the greatest range but the highest possibilities for selection. In this way the same types of objects could be seen and understood in different lights much as, in mounting an exhibition, one could shift volumes from one category to another as space or intellectual whim dictate.

This process has resulted in some eight large groupings for a fictive exhibition (or bibliography):
– Provenance and Association
– Technical and Theoretical Works
– Exhibition and Collection Catalogues
– Translations and Re-Editions
– Connoisseurship and Criticism
– Reference Works and Albums
– Facsimiles
– Ephemera and Erudition
All these cumulatively describe (pace Schlosser) the publication and usage of known and less-known artistic literature.

Then as now, a great range of perceived and assigned values would be evident from their titles and layout. For the knowing scholar our choice would be typical of the problems of art history and the literature it generates: printed materials reveal themselves through their visual impact, whether they are illustrated or not. Catalogue (or descriptive) commentary could be restricted to a mention of the place each title might occupy on the reference shelf of History.

Many of the items discussed would not be in the standard books of reference because of their anomalous or ephemeral nature; others came to be the preferred editions in the recurrent (and ruthless) competition between scholars, booksellers, and bibliophiles. They would be typical of their times or revealing of their successive owners in the manner in which they are bound. (What is truly surprising is the number of more modest period statements that have come down to us in their original paper covers, and in good condition.)

Beyond this, there are the broad distinctions to be drawn between titles in the publishers' pressboard bindings, full contemporary calf, and other bindings for each period; then the *reliures aux armes* and the unusual collectors' bindings intended more for show and as demonstrations of taste, even of personal fantasy. How wrong were the authorities of the British Museum in their *Synopsis of the Contents* (24th ed., 1826) in maintaining that

'the first floor consisting of sixteen rooms, contains the Library of Printed Books. Strangers are not admitted into the apartments, as the mere sight of the outside of books cannot convey either instruction or amusement.'

All these books, once they left the presses and were transmitted from owner to owner, have come to be listed in catalogues, removed from more or less dusted shelves, and, in everyone's experience, sometimes picked up quite literally from the floor. Their appearance is in many cases quite inconsistent with their worth; whatever the number surviving – and bibliographers discover more with each passing day – their loss has been great in all periods.

Also, the major references of the seventeenth and eighteenth centuries were consulted, were *thumbed* to the point that it is rare to find a fresh copy anywhere; while many a text of questionable worth was sumptuously produced during the nineteenth century and remains a mute testimony to the deterioration in quality that always parallels a rise in popularity. Whatever its rarity today, and however much we study it as a prime example of the book arts, artistic literature was always meant to be *used*.

Once the exclusive preserve of historians and practitioners of the arts, not excluding the amateur or dilettante, art literature has become the preserve of several classes of professionals and publishers who think in terms of large formats and even larger press runs, more illustration, and 'remaindering the stock' once the season has passed. Few are the eccentric and interesting brochures of our own day, brochures presenting more than information and whose authors are passionately, intimately connected with real artistic issues to the point of sustained polemic. Material study of the design, page layout, and scholarly apparatus of earlier works brings with it an understanding of a general level of excellence that even today grips our attention.

In like manner, the study of art terminology and more especially of the level of thought and language prevalent in the heroic periods of art history is breathtaking in its implications for the modern scholar. As for the student, he has before him compelling examples of the influence and understanding of art through translation, the creation of lexica and reference books, albums, and even of facsimiles. All these really begin around 1750 and serve as a reminder that the field itself is still relatively young and underdeveloped.[12] Not so young, however, that it has failed to effect an early divorce between Archaeology and Art History, and to have favoured painting at the expense of other arts.

This factor has led to increased specialization in the literature; in so doing, the continuity and parallelism, even the dialogue between the arts have, it seems, been irrevocably broken. The Outline of Art is but rarely

attempted these days. In some ways it remains open only to those hav-
ing access to great quantities of earlier literature while being sufficiently
interested to pursue its highways and by-streets for their own sake.

This type of study leads to the perception of extremes within the litera-
ture itself, regardless of period. Early treatises on the arts seem curiously
general in nature, lacking in the quantity of specific information we have
come to expect since the nineteenth century. Meanwhile, writing on the
graphic arts proceeds, with its discussions of paper, watermarks, mono-
grams, repetitions, reversals, and counterfeits, as if no other world existed;
it feeds upon itself, refers to its immediate predecessors through a series
of imposing concordances or abbreviations of a nature to try the patience
of the most confirmed adept at information science. Discussions of paint-
ing tend toward the philosophical, while the decorative arts tend mainly
to collection catalogues in the absence of much theoretical literature. One
also remarks the difference between catalogues of public and private col-
lections, the latter of which, as Max J. Friedländer once remarked, 'are the
swan songs, or grave monuments of the collections' since they are dis-
persed forthwith. Yet it is the royal and public collections, infinitely more
extensive and varied, and carrying more authority, upon which earlier
standards of judgment were based. The private collection of note in the
eighteenth century was usually worthy of incorporation into a national
collection; those of the nineteenth century are often significant in inverse
ratio to their owners' pretensions.

What emerges from the literature is the constant flux of attributions and
provenance, as witnessed by the very amount of literature that art gener-
ates. *In respect to what was created, the number of works that can be identified
at any one time and that lend themselves to discussion are few indeed.* Faced
with this uncertainty, it is the apparatus of criticism and connoisseurship
that permits at least the educated guess, proposes likelihoods, offers doc-
umentation likely to be applicable to a category of objects. Even if it is not
useful, the apparatus exists and instantly informs the reader of the level of
scholarly ambition and the state of knowledge, or of ignorance.

One could only surmise what percentage of the paintings (only the
paintings) mentioned in the earlier literature may today be identified, be
located in public and private collections. In any event, the annotated sales
catalogue tells us more about taste as seen through the art market than any
other type of literature. It is, however, impossible to discuss intelligently
lots that were withdrawn from sale or whose composition is unknown.
Whatever its appearances, scholarly apparatus (the sales or dealer cata-
logue) is notoriously difficult to use. We learn little from it about the au-
thenticity of the works of art catalogued because there has always been

as much – or as little – of it as one cared to accept within what was known.

In its infinite variety, artistic literature also says much about the topical issues and social customs that have always conditioned those who write, no less than their reading public. We forget, for example, that the teaching of Christian archaeology was normally the preserve of seminarians of the nineteenth century. In contrast, everyone in the eighteenth century wrote verse, and among the most curious and delightful ephemera of the period are surely the Salon critiques in the form of vaudevilles set to traditional airs and hawked at the doors and on the staircase of the Louvre.

But whoever said that art history had always to be serious, much less reverent? Who can forget that a simple handlist of works exhibited or works offered for sale conceals – and dispenses with – all the comment, the conversation, even the acculturation through conversation that no one can hope to record but which just as necessarily fashions the attitudes of the next generation?

The real interest of artistic literature is that it concerns art with all its imponderables and uncertainties. The difficulties today of assembling a proper working library of sources are compounded by runaway prices and the availability of a title at a given moment or in a given condition. Nor may the proper description of editions, bindings, and condition be taken for granted in a catalogue, when one man's 'good' copy is only a working copy to someone else. Perhaps the most demoralizing realization for private and institutional collectors who wish to learn from the literature of art history comes when they discover the market is no longer national but international, and that the narrow (or moneyed) specialist will do anything to secure a title that interests him.

This problematic situation has been somewhat eased in recent years with the appearance of fine facsimile reprints. Rather than laboriously resetting the entire work, as in the nineteenth century, whole volumes are now done through photomechanical means. These facsimiles, be it said, often exceed the price of originals, but they are easily acquired and one need not fear using them once they are at hand.

The one thing they cannot offer is, of course, the 'look and feel' of the original editions. These defined their generation as surely as modern art publishing does ours. Most of these could be held in one's palm or placed in the pocket; and they were *all there was*. By engaging the attention of the modern reader or viewer, they provide ample food for art-historical thought.

Moreover, the selection of a number of titles because they stand head and shoulders above their contemporaries never restores to them their historical integrity any more than it considers them developmentally.

How might this be accomplished and the great 'currents' of art history defined?

I have always felt instinctively that the artist is at best a rather poor creature when compared to the deviser, the 'idea man' who stands behind him and usually remains faceless. However contentious this perception may seem – not be – in modern society, it is but a reflection of what *must* happen when examining the literature of art history. *Who has conditioned the field and what remains of that intellectual legacy?*

I dare say that any attempt to determine the course of the literature as a whole would leave the impression of a by now mighty stream formed through the combined affluence of its tributaries. Yet its waters would be similar to that found on the mysterious island described in Poe's *Narrative of A. Gordon Pym*, where 'we perceived that the whole mass of liquid was made up of a distinct number of veins, each of a distinct hue; that these veins did not commingle; and that their cohesion was perfect in regard to their own articles among themselves, and imperfect in regard to neighboring veins.' *Rather than preserving any real or apparent cohesion, the field has become full of incident.*

Things have gone from a world where there were few but excellent works to one that is reductive and diluted for all its apparent magnitude. Until the nineteenth century, one dealt with Prophets and Seers, each with his own realm within his historiographical desert. *The problem was to establish a tradition and the tools necessary for its perfection; little thought was given over to its maintenance.* As a result the general development since then could doubtless be outlined in terms of the rapid succession of
– The Structuralists
– The Codifiers
– The Struggle of Interpretation
– The Connoisseur-Critics
– Polemics and Nationalism
– Separate Issues
No wonder it has become so difficult to get a handle on the field. The first four categories now belong to History while the last two are the most properly constituted means of side-tracking people from their real work. Such a dismal outline requires explanation, however schematic in itself. What follows can be filled in or controverted by anyone interested enough to do so and possessing a stronger sense of system and inquiry than do I.

It is known that the history of art was fundamentally transformed in the course of the nineteenth century. It is also known that it passed into the able hands of Schnaase, Lübke, and Springer, who attempted – and succeeded – to create the first great syntheses of the field as a whole. Since virtually everyone used them, they exercised a disproportionate, if entirely

justified, influence on future generations of scholars who then brought out the great pioneering works of the late nineteenth and early twentieth centuries.

Since then, the myriad 'Handbooks, Manuals, and Histories of Art' have only attenuated while subverting the lessons of the Structuralists – to the point that the mere mention of a handbook or history of art has become synonymous with popularization and commercial enterprise. The work of Schnaase and his associates is like the School Books for the mediaeval and renaissance periods. One gains from it an idea of the level of attainment present within the first – *determining* – stages of study. With it comes some sense of how continuators have lost hold of the tradition they were entrusted with and in whose hands the results are neither especially encouraging to the field nor likely of marked improvement.

Even the Codifiers who followed found it impossible to escape Schnaase and Company. Yet behind them all lay the National Commissions of the 1830s and 1840s. Set up to catalogue monuments, such national inventories led inevitably to their study and preservation, at least as concerns architecture and sculpture. Parallel to this highly structured effort, bourgeois collecting took another path, concentrating on illuminated books, painting, and the minor arts – even as the church and palace collections became national in the period to 1848. This latter taste was formed, not by government bureaux and socio-ethnic imperatives, but by individuals. *Its chaotic if not to say anarchical nature has led to a fundamental distortion of the field*.

The Codifiers issued the first great encyclopaedias of a scholarly nature, that is to say, works that verified and documented rather than compiling hearsay. Among these were André Michel's *Histoire de l'art* and the *Handbuch der Kunstwissenschaft*, the Italians going it alone as they usually do, with Venturi's *Storia dell'arte italiana*. They were filled up and extended by the Crowe and Cavalcaselles, Van Marles, and Max Friedländers and seen against a background of the 'lists and locations' of Mrs Jameson, Waagen, and Thoré. At much the same time began the great collective lexica and dictionaries, one of which (Thieme-Becker) is just beginning its second time around.

In this climate of thought it was perhaps inevitable that certain personalities 'set the patterns' for study (Diehl, Dalton, and André Grabar for Early Christian and Byzantine, Kingsley Porter for Romanesque). Winckelmann's structures have been modified and institutionalized through what has become the Deutsches Archäologisches Institut in Rome, and those of Warburg transformed through the institute bearing his name, once circumstances forced its removal to London.

Against this background came the rise of Renaissance Studies, a field that turns on aesthetic criticism through authors writing (or influential) from perhaps 1890 to 1920 – Berenson and Morelli before him, Wölfflin, Roger Fry, and such prolongers of the tradition as the late Lord Clark and Sir Ernst Gombrich. The realm of the Connoisseur-Critics has ever since been a growth industry, attempting to do through verbal fireworks what one should be able to do within oneself as a professional. Its primary appeal is to those who can't see, who have the touching conviction that there must be a way of doing it that can be settled down on everyone like an inheritance, even though, when parcelled out, it amounts to only a few ha'pennies and farthings rather than a majestic pile of Napoleons. However interesting this tradition may be in its perceptional emphasis, whatever its real services within the realm of attribution, the Connoisseur-Critics can only undermine the academic tradition. The results are seen in a certain subjective approach in those who merely write on art rather than belonging to it. I hold with Barzun (*The Use and Abuse of Art*) that 'criticism through art must be held to the same standard as is required of criticism *about* art, that is: correspondence with the facts and the exercise of that rarest power of the mind which is called judgment.'

Concomitant with these minor currents and eddies arose the Struggle of Interpretation, seen most forcefully in the case of *Strzygowski vs Riegl* for possession of the Middle Ages. In turn, the contention between East and West was rapidly particularized and metamorphosed into Polemics and Nationalism – the Courajods, Hausers, and Antals, and the Cultural Bureaux of most modern states. All this time a Realia-oriented history of art was being discreetly erected, owing much to people such as Goldschmidt and Zimmerman, who established the Minor Arts as serious fields of study.

Now, through our daily work, we unthinkingly 'separate the veins' of Poe's stream ever more distinctly, forcing into them separations of the consistency of *cloisonné*. The specific and technical nature of many modern studies, the obsession with scholarly apparatus for subjects not requiring it, and the omnipresent concern with biographical detail – all these are profoundly transforming the mentality of art historians. This situation can only become more pronounced with time, while whole periods of time considered as 'unattractive' as the First Millennium have disappeared from the histories that once acknowledged their debts even to Barbarians. Whither the field from now?

One last word. It has become virtually impossible to select influential titles that, in the twentieth century, have truly changed scholarly perceptions (Wittkower's *Bernini* is perhaps one of this rare breed). The tendency, which accelerates with levels of production, is to consider authors and

their oeuvre instead. This may be justified, for one cannot really choose 'which' Panofsky is the one to have any more than one can choose one Emile Mâle over another – much less between the 'Romanesque' and 'Gothic' Lasteyrie. In speaking of Ruskin or Waagen one deals with the life's work as well, and the mechanization of art history will doubtless require further modification of attitudes as it progresses. It remains to be seen whether there will be more or fewer finely crafted and meditated works issued as a result of the proper use of technology rather than a never-ending stream of indifferent ones. The real future of art history hinges on a question.

The Usual Books of Reference

> Felix, qui potuit rerum cognoscere causas
> Virgil *Georgica* II 490

Induction into the literature of art history usually begins with what is available for a particular problem. In the absence of any formal place within the curriculum, early publications will likely be regarded as information or curiosities, not as a series of historically significant statements or particular attitudes. Such a reaction may be expected when students have problems set for them, are (perhaps) given a few readings, and then are expected to 'do the work' and present it; acquaintance with earlier historiography comes if at all through the use of the texts of the time in examining artists and problems arising.

Authority builds upon authority, and just as often fails to acknowledge it sufficiently. Bryan's *Dictionary* of 1816 has a list of 'Authorities Consulted' but they are not mentioned by edition and would today be replaced by a Bibliography. Nagler sees his *Monogrammisten* (1853–79) as the outcome of all the classic titles before him, outlines their nature, and discusses their relative advantages – which only goes to show the appreciation of prior literature and its creative use.

It is clear in the reading that the older books of reference were influenced by each other, sometimes to the point that one comes to anticipate the 'cross-references' and sources given, prompting us to remark their presence and to wonder how they relate to each other. Yet there is a significant change in the handling of material between the eighteenth and nineteenth centuries, and between these and the present century. *As with the corpus, dictionaries and lexica have, not less than their users, an allotted span of years.* Those that have now become standard are resolutely individual. This is to

say, they depend as much on original research as upon earlier sources and compilations, although their plans are highly specific. One goes to them for one type of information, not another.

So it is that the selection of the 'determining' books of art history in its widest sense is fraught with contradictions, all the more as we approach our own day with its embarrassment of riches. It is not that 'there's a new book out on ... ,' nor is it a question of titles that have become stock items on bookshelves – what is always current and constantly available, that which poses no worries since it can be had virtually anywhere. Alas, one might have to exclude titles that are too broad culturally (out go Burckhardt, Huizinga, and Frances Yates's *The Art of Memory*) because they don't add to the science itself; this, even though many treatises have because of their 'technicality' affected artistic production in a profound way. *There is an evident difference between going to a volume for instruction or for inspiration.* While both are necessary to progress in the arts it is the latter that become pre-eminent rather than *used*.

The 'first' treatment of any artist or topic theoretically determines the future, yet most such efforts are given the polite but distant curiosity accorded beached whales. More seriously, the choice is often between an 'early' and a 'late' book by a given author, one of which opened a rich vein not immediately mined but historically crucial to the discipline, which stuns by its embryonic maturity even as the latter is in every way 'accomplished' yet tired in spirit. Then come the authors, fewer in number in the early periods, whose reputation necessarily rides on a single book; there follows their modern counterparts, whose uneven reputation rests, in the end, on one book from an output worthy of a polygraph. It is not that their scholarly oeuvre may not contribute to the field, but that a selection has already been effected according to the wants of the day. *All these observations form part of a coherent historiographical pattern*; they must be judged within the changing proportion of one type of literature to another as well as against the introduction of new types.

The easiest way to identify a 'determining' book might be to see whether it was immediately used, quoted, whether it aroused interest in the field and somehow generated new research and thought on an unprecedented scale. This happens in the strangest ways through the interpenetration of genres, as when the third edition of Bryan's (1884) remarks all the modifications occasioned through the work of Crowe and Cavalcaselle. The timing, the appearance of scholarly literature defines art-historical epochs as much as the art discussed, whether through ideas, illustration, or the accumulation of facts and observations. Indeed, some of the great works of erudition are 'self-annihilating' in type, narrow and meticulous in ap-

proach, and comprehensive to the point that there is little use thereafter in going over the same ground to make the few minor rectifications or amplifications anyone should expect.

Similarly, one might except works that have not stood the test of time, although they were of paramount importance for their own day. (This only goes to prove changing modes of scholarship, or what passes for it.) One might also wish to avoid the merely national preferences and prejudices, if this can be done in art-historical studies, so as to favour works that advance the general understanding of the field for a period or form different generations of scholars. Unless, of course, we have reached the point of directing the field by the mere accumulation of literature, for the influence of a work seems more and more a result of its widespread use as much as – or more than – its intrinsic qualities.

Shifts in the 'balance of scholarship' are then to be expected, are quite unavoidable. They are recognized through their relative emphasis and direction in study and are best indicated through simple chronological listings, even if this may not indicate much more than when a title became available. When, however, something is translated or goes through many reprintings or editions, it merits our attention as surely as the title that was never reissued but is always sought after.

Chronological sequence is the surest way to know what was available for public or private reference over the years, and it is for this reason that we might choose to except works circulating in manuscript or in private circles that were not made public until much later. Editing these was the work of the nineteenth century, when Italian scholarship generated and reprinted sources and transformed the theoretical literature of the French into some semblance of modern publishing. It is amusing to note that many of the great national source publications come from the Romantic Era with which such notions seem least compatible. But that is not to reckon with incipient Historicism.

The appended lists, one for general purposes and one for dictionaries and lexica, are an attempt to reintroduce a sense of relative chronology to the field. They will be in need of much revision because even the national bibliographies are unsure of the number of editions, reprintings, and translations; even Schlosser is in this respect incomplete for many titles he does repertory. My idea is to list alphabetically by century, placing greatest emphasis on authors from the earlier periods; their descriptive titles may be scanned and annotation forsworn accordingly.

There perhaps can be no consensus on the titles given, scattered as they are over some five hundred years. While they cannot constitute a Ready Reference shelf, taken in clusters they surely indicate what types of inter-

est were current and what then composed the Standard Reference shelf. Even if the titles are scarcely known or accessible or are recognized but imperfectly, readers may gain more real insights into the older literature than they will ever use. What more could one ask?

DICTIONARIES AND LEXICA

This branch of literature repertories in alphabetical order the *personalities* and *technical terms* that illustrate the field, sometimes the *concepts, attributes, and symbols* that may be laid down alphabetically as well (Ripa). In many cases the plan follows Félibien in believing that 'ce n'estoit pas assez de faire un simple Dictionnaire, mais qu'il estoit à propos de traiter d'abord des Principes de chaque Art en particulier, pour en donner une notion general à ceux mesme, qui ne veulent pas s'y appliquer entièrement.' The titles run the gamut from the scholarly to the popular, from the historical to the contemporary. There are also instances in which 'new' publications have simply been cribbed from older ones with varying degrees of elegance and efficacy – even of acknowledgment – although the occasional one succeeds in focusing information on an entirely new topic. The first run-through of highly specialized reference works is likely to be disappointing; yet it represents a start that can, in time, be followed through.

Art-historical lexicography must always rework and incorporate new, more specific, more correct material in its search for an always elusive comprehensiveness and perfection. This is perhaps why early reference works lean heavily towards prints, monograms, and 'identifying marks' while, for lack of specific information, the study of painting was subsumed into Theory and Lives. As these works are redone and added to, all gain greater cohesion and consistency of approach, with new entries more easily finding their proper form and place within the stream of universal history.

The following selection of dictionaries and lexica is cited in *first edition* only. Ideally they should be followed by 'small-print' sections listing the reworkings or re-editions through which they exerted new influence or reaffirmed their predominance. This listing would, however, form a repertory in itself; in so doing, it would weaken and destroy any understanding derived from the relative chronology just established by mention of the first editions. (This fact can be attested by anyone who has followed the torturous paths of edition of Chambers and Pilkington.) Occasionally, an edition is *deemed* first (Alciati) when the work was provided with standard indexes and began to serve more as a dictionary than as a literary reference.

Approaching our own time, we find an amoebic proliferation, often be-

cause of small or marginal publishers, of 'special interest' dictionaries. These may treat national, provincial, or municipal affiliations – even represent artists working within a certain genre or historically representing it, like the Victorian Flower Painters. Clearly, some attempt must be made to reduce the clutter to reasonable proportions, and this is best done by assigning an order of importance based upon universal scope and accomplished scholarly commitment. Contemporary dictionaries are often the equivalent of telephone or professional directories – for current use until the next compilation. Anyone interested in these can easily assume the responsibility for searching them out.

1500–1599

Alciati, Andrea. *Omnia Andreae Alciati V.C. Emblemata adiectis commentariis et scholiis, in quibus Emblematum ferme omnium aperta origine, mens auctoris explicatur, et obscura omnia, dubiaque illustrantur*; per Claudium Minoim Divionensem. Antwerp: C. Plantin, 1573

Cartari, Vincenco. *Le Imagini con la spositione de i dei de gliantichi.* Venice: Francesco Marcolini, 1556

Giraldi, Lilio Gregorio. *De Deis Gentium varia et multiplex Historia, in qua simul de eorum imaginib. et cognominib. agitur, ubi plurima etia hactenus multis ignotia explicantur, et pleraque clarius tractantur ... Syntagmatum decem et septem huius Operis, ac rerum quae singulis tractantur seriem, proxima post Praefationem pagella indicabit. Accessit quoq. omnium quae toto Opera continentur, nominum ac rerum locuplex Index.* Basel: J. Oporinus, 1548

Ripa, Cesare. *Iconologia overo Descrittione dell'imagini universale cavate dall'Antichita et da altri luoghi da Cesare Ripa Perugino. Opera non meno utile, che necessaria a poeti, pittori, et scutori, per rappresentare le virtu, vitij, affetti et passioni humane.* Rome: Heredi di Gio. Gigliotti, 1593

Valeriano Bolzani, Giovanni Pierio. *Hieroglyphica sive de Sacri Aegyptiorum literis commentarii Joannis Pierii Valeriani Bolzanii ...* Basel: Isengrinius, 1556

1600–1699

Baldinucci, Filippo. *Vocabulario toscano dell'arte del disegno.* Florence: Santi Franchi, 1681

Félibien, André. *Des Principes de l'architecture, de la sculpture, de la peinture et des autres arts qui en dépendent. Avec un dictionnaire des termes propres à chacun de ces arts.* Paris: J.-B. Coignard, 1676

Graevius, Johannes Georgius. *Thesavrvs antiqvitatvm romanarvm, in quo continentur Lectissimi quique scriptores, qui superiori aut nostro secolo Romanae reipub-*

licae rationem, disciplinam, leges, instituta, sacra, artesque togatas ac sagatas ex-
plicarunt & illustrarunt, congestus a Joanne Georgio Graevio accesserunt variae &
accuratae tabulae aenaea. Traject. ad Rhen./Lugd. Batavor.: apud Franciscvm
Halman/Petrvm van der Aa, 1694–99. 12 vols

Gronovius, Jacobus. *Thesvarvs graecarvm antiqvitatem, in quo continentur Effigies*
Virorum ac Foeminarum Illustrium, quibus in Graecis aut Latinis monumentis ali-
qua memoriae pars datur, & in quocunque Orbis Terrarum spatio ob historiam, vel
res gestas, vel inventa, vel locis nomina data, ac doctrinam meruerunt cognosci;
Item variarum regionum miranda, quae celebrata apud antiquos saxisque & aere
expresse occurrent, omnia ex veris sincerisque documentis petita, & pro serie tem-
porum disposita; Adjecta brevi descriptione singulorum, quae aut in corum vita
aut in horum propriretate spectabilia percipi & intelligi refert; ubi variis occasion-
ibus nummi, lapides, inscriptiones, etiam auctorum loco explicantur & emendatur.
Lvgdvni Batavorvm: Excudebant Petrus & Baldinvs Vander Aa, caelabat
Hildebandvs Vander Aa, 1697–1702. 12 vols and index

Mander, Carel van. *Het Schilder-Boeck waer in voor eerst de leerlustighe iueght*
den grondt der edel vry schilderconst in verscheyden deelen wort voorghedraghen.
Daer nae in dry deelen t'leuen der vermaerde doorluchtighe schilders des ouden, en
nieuwen tyds. Eyntlyck d'wtlegghinghe op den Metamorphoseon Pub. Ovidij Naso-
nis oock daerbeneffens wtbeeldinghe der figuren, alles dienstich en nut den schilders
const beminders en dichters ooek allen Staten van menschen. Haarlem: Paschier
van Wesbusch, 1604

1700–1749

Chambers, Ephraim. *Cyclopaedia; or An universal dictionary of arts and sciences*
... the whole intended as a course of ancient and modern learning. Compiled from
the best authors, dictionaries, journals, memoirs, translations, ephemerides, &c. in
several languages. London: Printed for J. & S. Knapton, 1728. 2 vols

Orlandi, Fr. Pellegrino Antonio. *Abecedario Pittorico. Nel quale compendiosa-*
mente sono descritte le Patrie, i Maestri, ed i tempi, ne' quali fiorirono circa quat-
tro mila Professori di Pittura, di Scultura, e d'Architettura. Diviso in tre parti. La
Prima contiene gli Antichissimi; La Seconda gli Antichi, i Moderni, ed i Viventi;
La Terza cinque Tavole copiose, cioè: La I. De' Sopranomi, e Cognomi connotanti
i proprj nomi de' Virtuosi descritti. La II. De' Libri, che trattano della Pittura, e
della Vite de' Pittori, e de' Scultori. La III. De' Libri spettanti alla Prospettiva,
ed all'Architettura, La IV. De' Libri utili, e necessarj a studiosi del disegno, con
l'Anno, e Paese in tutti, dove, e quando stampati, La V. Delle Cifre, e Marche
legate, e sciolte usate dagl' Inventori, e dagl' Intagliatori nelle Stampe, con le
spiegazioni loro: Il tutto disposto in Alfabetto per maggior facilità de' Dilettanti.
Bologna: Costantino Pisarri, 1704

1750–1799

Blankenburg, [Christian] Friedrich von. *Literarische Zusätze zu Johann George Sulzers allgemeiner Theorie der Schönen Künste, in einzelnen, nach alphabetischer Ordnung der Kunstwörter auf einander folgenden, Artikeln abgehandelt.* Leipzig: Weidmann, 1796–8. 3 vols

Fontenai, [Louis-Abel de Bonafous, Abbé de]. *Dictionnaire des artistes ou notice historique et raisonnée des architectes, peintres, graveurs, sculpteurs, musiciens, acteurs et danseurs, imprimeurs, horlogers et méchaniciens.* Paris: Vincent, 1776

Gori Gandellini, Giovanni. *Notizie istorische degli intagliatori.* Siena: V. Pazzina, Carli e Figli, 1771. 3 vols

Heinecken, Karl Heinrich von. *Dictionnaire des artistes, dont nous avons les estampes, avec une notice détaillée de leurs ouvrages gravés.* Leipzig: J.G.I. Breitkopf, 1778–9. 4 vols (all published)

– *Neue Nachrichten von Künstlern und Kunstsachen.* Erster Theil (all published). Dresden/Leipzig: J.G.I. Breitkopf, 1786

Huber, Michel, and C.C.H. Rost. *Manuel des curieux et des amateurs de l'art, contenant une notice abrégée des principaux Graveurs, et un Catalogue raisonnée de leurs meilleurs ouvrages; depuis le commencement de la Gravure jusques à nos jours. Les Artistes rangés par ordre chronologique, et divisés par Ecoles.* Zurich/Paris: Orell, Fussli et Cie, 1797–1808. 9 vols

Meusel, Johann Georg. *Teutsches Künstlerlexikon oder Verzeichniss der jetzlebenden Teutschen Künstler. Nebst einem Verzeichniss schauswürdiger Bibliotheken, Kunst-Münz- und Naturalienkabinete in Teutschland und in der Schweitz.* Lemgo: Mayer, 1778–89. 2 vols

Pernety, Dom Antoine-Joseph. *Dictionnaire portatif de peinture, sculpture et gravure; avec un traité pratique des différences manières de peindre, dont la théorie est développée dans les articles qui en sont susceptibles. Ouvrage utile aux Artistes, aux Eleves et aux Amateurs.* Paris: Bauche, 1757

Pilkington, Matthew. *The Gentleman's and connoisseur's dictionary of painters, containing a complete collection ... of the most distinguished artists ... in the art of painting ... from the year 1250 ... to the year 1767 ...* London: Printed from T. Cadell, 1770

Roland Le Virloys, Charles-Francois. *Dictionnaire d'architecture, civile, militaire et navale, antique, ancienne et moderne, et de tous les arts qui en dépendent; Dont les termes sont exprimés, en francois, latin, italien, espagnol, anglois, et allemand. Enrichi de cent une planches de figures en taille-douce, pour en faciliter l'intelligence, auquel on a joint une notice des architectes, ingénieurs, peintres, sculpteurs, graveurs et autres artistes les plus célèbres, dont on rapporte les principaux ouvrages.* Paris: Libraires associés, 1770–1. 3 vols

Strutt, Joseph. *A Biographical dictionary; containing an historical account of all the*

engravers, from the earliest period of the art of engraving to the present time; and a short list of their most esteemed works. With the cyphers, monograms, and particular marks, used by each master, accurately copied from the originals, and properly explained. To which is prefixed an essay on the rise and progress of the art of engraving, both on copper and on wood. With several curious specimens of the performances of the most ancient artists. London: Printed by J. Davis for Robert Faulder, 1785–6. 2 vols

Sulzer, Johann Georg. *Allgemeine Theorie der Schönen Künste in einzeln, nach alphabetischer Ordnung der Kunstwörter aufeinander folgenden, Artikeln abgehandelt* ... Leipzig: M.G. Weidemanns Erben u. Reich, 1771–4. 2 vols

[Watelet, Claude-Henri, et Pierre-Charles Levesque]. *Encyclopédie méthodique. Beaux-Arts. Ou par ordre de matières; par une société de gens de lettres, de savans et d'artistes. Précédée d'un vocabulaire universel, servant de table pour tout l'ouvrage.* Paris: Pankouche, 1788–91. 2 vols, album

1800–1849

Bartsch, Adam. *Le peintre graveur.* Vienna: J.V. Degen [- Pierre Mechetti, ci-devant Charles], 1803–21. 21 vols

Bryan, Michael. *A Biographical and Critical Dictionary of Painters and Engravers, from the revival of the art under Cimabue, and the alledged discovery of engraving by Finiguerra, to the present time: with the ciphers, monograms, and marks, used by each engraver; and an ample list of their principal works. Together with two indexes, alphabetical and chronological. To which is prefixed, an introduction, containing a brief account of the painters of antiquity.* London: Printed for Carpenter & Son, J. Booker, Whittingham & Arliss, 1816. 2 vols

Fiorillo, J[ohann] D[ominicus]. *Geschichte der zeichnenden Künste in Deutschland und den vereinigten Niederländen.* Hannover: Brüder Hahn, 1815–20. 4 vols

Immerzeel, J. *De Levens en Werken der hollandsche en vlaamsche Kunstschilders, Beeldhouwers, Graveurs en Bouwmeesters van het begin der vijftiende eeuw tot Heden,* eds Ch. & C. Immerzeel. Amsterdam: J.C. van Kesteren, 1841–3. 3 vols

Milizia, Francesco. *Dizionario delle belle arti del disegno estratto in gran parte della Enciclopedia Metodica da Francesco Milizia.* Milan: Pietro Agnelli, 1804. 2 vols

Millin, A.L. *Dictionnaire des Beaux-Arts.* Paris: Crapelet/Desray, 1806. 3 vols

Nagler, G.K. *Neues allgemeines Künstler-Lexikon oder Nachrichten von dem Leben und den Werken der Maler, Bildhauer, Baumeister, Kupferstecher, Lithographen, Formschneider, Zeichner, Medailleure, Elfenbeinarbeiter etc.* Leipzig: Schwarzenberg and Schumann, 1835–52. 25 vols

Robert-Dumesnil, A.-P.-F. *Le peintre-graveur francais, ou catalogue raisonné des estampes gravées par les peintres et les dessinateurs de l'École francaise; ou-*

vrage faisant suite au peintre-graveur de M. Bartsch. Paris: G. Warée, 1835–71. 11 vols

Ticozzi, Stefano. *Dizionario degli architetti, scultori, pittori, intagliatori, in rame ed in pietra, coniatori di medaglie, musaicisti, niellatori, intarsiatori d'ogni età et d'ogni nazione.* Milan: Gaetano Schiepatti, 1830–3. 4 vols

Zani, Pietro. *Enciclopedia metodica critico-ragionata delle belle arti* Parte prima [indice generale, A–Z (nomi)]. Parma: Tipografia ducale, 1819–24. 19 vols
Parte seconda [soggetti]. Parma: Tipografia ducale, 1817–22. 9 vols

1850–1899

Andresen, Andreas. *Der deutsche peintre-graveur oder die deutschen Maler als Kupferstecher nach ihrem Leben und ihren Werken, von dem letzten Drittel des 16. Jahrhunderts bis zum Schluss des 18. Jahrhunderts, und in Anschluss an Bartsch's Peintre-Graveur, an Robert-Dumesnil's und Prosper de Baudicour's französischen Peintre-Graveur.* Leipzig: Rudolph Weigel, 1864–6. 3 vols

Bellier de la Chavignerie, Emile, and Louis Auvray. *Dictionnaire général des artistes de l'École française depuis l'origine des arts du dessin jusqu'à nos jours. Architectes, peintres, sculpteurs, graveurs et lithographes.* Paris: Librairie Renouard, 1882–7. 5 vols

Daremberg, C.V., and E. Saglio. *Dictionnaire des antiquités grecques et romaines d'après les textes et le monuments. Contenant l'explication des termes qui se rapportent aux moeurs, aux institutions, à la religion, aux arts, aux sciences, au costume, au mobilier, à la guerre, à la marine, aux métiers, aux monnaies, poids et mesures, etc., etc.* Paris: Librairie Hachette, 1877–1919. 5 vols in 10

Gabet, Charles. *Dictionnaire des artistes de l'Ecole francaise, au XIXe siècle. Peinture, sculpture, architecture, gravure, dessin, lithographie et composition musicale.* Paris: Mme Vergne, 1831

Havard, Henry. *Dictionnaire de l'ameublement et de la décoration depuis le XIIIe siècle jusqu'à nos jours.* Paris: Quantin, [1877–90]. 4 vols

Kramm, Christian. *De Levens en Werken der hollandsche en vlaamsche Kunstschilders, Beeldhouwers, Graveurs en Bouwmeesters, van den vroegsten tot op onzen tijd; ... strekkende tevens tot vervolg op het Werk van J. Immerzeel, Jr.* Amsterdam: Gebroeders Diederichs, 1857–64. 7 vols

Le Blanc, Charles. *Manuel de l'amateur d'estampes.* Paris: P. Jannet, 1854–90. 4 vols

Nagler, G.K. *Die Monogrammisten und diejenigen bekannten und unbekannten Künstler aller Schulen welche sich zur Bezeichnung ihrer Werke eines figürlichen Zeichens, der Initialen des Namens, der Abbreviatur desselben etc. bedient haben. Mit Berücksichtigung von Buchdruckerzeichen, der Stempel von Kunstsammlern, der Stempel der alten Gold- und Silberschmiede, der Majolicafabriken,*

Porzellan-Manufacturen u.s.w. ... Mit den raisonnierenden Verzeichnissen der Werke anonymer Meister, deren Zeichen gegeben sind, und der Hinweisung auf die mit Monogrammen oder Initialen bezeichnete Produkte bekannter Künstler. Ein für sich bestehendes Werk, zugleich auch Ergänzung und Abschluss des Neuen allgemeinen Künstler-Lexicons und Supplement zu den bekannten Werken von A. Bartsch, Robert-Dumesnil, C. le Blanc, F. Brulliot, J. Heller, Andresen, Passavant u.s.w. Munich/Leipzig: G. Franz, 1858–79. 5 vols

Pauly, A.F. von & Georg Wissowa. *Real-Encyclopädie der classischen Altertumswissenschaft.* Stuttgart: J.B. Metzler [- Munich: Alfred Druckenmüller], 1894–1963. 24 vols in 47
Supplement. Stuttgart: J.B. Metzler [- Munich: Alfred Druckenmüller], 1903–78. 15 vols
Zweite Reihe. Stuttgart: J.B. Metzler [- Munich: Alfred Druckenmüller], 1914–72. 10 vols in 19

– Gärter, Hans, and Albert Wünsch. *Paulys Realencylopädie der classischen Altertumswissenschaft. Register der Nachträge und Supplemente.* Munich: Alfred Druckenmüller Verlag, 1980

Roscher, W.H. *Ausführliches Lexikon der griechischen und römischen Mythologie.* Leipzig: B.G. Teubner, 1886–1937. 6 vols in 9
Supplement. Leipzig: B.G. Teubner, 1893–1921. 4 vols

1900–1949

Ancona, Paolo d', and Erhard Aeschlimann. *Dictionnaire des miniaturistes du Moyen Age et de la Renaissance dans les differentes contrées de l'Europe. 2e ed. revue et augmentée contenant un index ordonné par époques, régions, ecoles.* Milan: Ulrico Hoepli, 1949

Bénézit, E. *Dictionnaire critique et documentaire des peintres, sculpteurs, dessinateurs et graveurs de tous les temps et de tous les pays, par un groupe d'écrivains spécialistes francais et étrangers.* Paris: Gründ, 1924. 3 vols

Briquet, C.M. *Les filigranes. Dictionnaire historique des marques du papier dès leur apparition vers 1282 jusqu'en 1600.* Paris: A. Picard et fils, 1907. 4 vols

Brun, Carl. *Schweizerisches Künstler-Lexikon, herausgegeben mit Unterstützung des Bundes und Kunstfreundlichen Privater vom Schweizerischen Kunstvereins.* Frauenfeld: Huber & Co., 1905–13. 3 vols

Cabrol, Dom Fernand. *Dictionnaire d'archéologie chrétienne et de liturgie.* Paris: Letouzy et Ane, 1907–13. 3 vols

Lami, Stanislas. *Dictionnaire des sculpteurs de l'Ecole francaise.* Paris: Librairie Honoré Champion, 1898–1921. 8 vols
Du Moyen Age au règne de Louis XIV (1898)
Sous le règne de Louis XIV (1906)

Au dix-huitième siècle (1910–11), 2 vols
Au dix-neuvième siècle (1914–21), 4 vols
Reallexikon zur deutschen Kunstgeschichte. Stuttgart: J.B. Metzler [- Munich: C.H. Beck], 1937– (at present to Firnis)
Singer, Hans Wolfgang. *Allgemeiner Bildniskatalog.* Leipzig: Karl W. Hiersemann, 1930–6. 14 vols
– *Neuer Bildniskatalog.* Leipzig: Karl W. Hiersemann, 1937–8. 5 vols
Thieme, Ulrich, and Felix Becker. *Allgemeines Lexikon der bildenden Künstler von der Antike bis zur Gegenwart.* Leipzig: Wilhelm Engelmann [- E.A. Seemann], 1907–50. 37 vols. 2nd rev. ed.: *Allgemeines Künstler-Lexikon (AKL). Die bildenden Künstler aller Zeiten und Völker.* Leipzig: E.A. Seeman, 1983– (at present to Andrea)
Wasmuths Lexikon der Baukunst. Berlin: Ernest Wasmuth, 1929–37. 5 vols
Wurzbach, Alfred von. *Niederländisches Künstler-Lexikon auf Grund archivalischer Forschungen ... Mit mehr als 3000 Monogrammen.* Vienna/Leipzig: Halm & Goldmann, 1906–11. 3 vols

1950 to the present

Filip, Jan. *Enzyklopädisches Handbuch zur Ur- und Frühgeschichte Europas / Manuel encyclopédique de Préhistoire et protohistoire européennes.* Stuttgart: W. Kohlhammer Verlag, 1966–9
Groce, George G., and David H. Wallace. *The New York Historical Society's Dictionary of Artists in America, 1564–1860.* New Haven/London: Yale University Press, 1957
Künstler Lexicon der Schweiz. XX. Jahrhundert. Frauenfeld: Verlag Huber & Co., 1958–67. 2 vols
Lexicon Iconographicum Mythologiae Classicae (LIMC). Zurich/Munich: Artemis Verlag, 1981– (at present to Athena)
Norsk Kunstner Lexikon. Bildende Kunstnere-Arkitekter-Kunsthandverkere. Oslo: Universiteitsforlaget, 1982–3. 2 vols
Reallexikon für Antike und Christentum. Sachwörterbuch zur Auseinandersetzung des Christentums mit der antiken Welt. Stuttgart: Anton Hiersemann, 1950– (at present to Heilgötter)
Reallexikon zur Byzantinischen Kunst, eds Klaus Wessel and Marcell Restle. Stuttgart: Anton Hiersemann, 1966– (at present to Kommagene – Kilikien – Isaurien)
Réau, Louis. *Dictionnaire polyglotte des termes d'art et d'archéologie.* Paris: Presses Universitaires de France, 1953; reprint Osnabrück, Zeller Verlag, 1977, 'augmentée de tables de renvois en allemand, anglais et italien'

Scheen, Pieter A. *Lexicon Nederlandse Beeldende Kunstenaars, 1750–1950.* The Hague: Kunsthandel Pieter A. Scheen, 1969–70. 2 vols

Schiller, Gertrud. *Ikonographie der christlichen Kunst.* Gütersloh: Gerd Mohn, 1966–80. 4 vols in 5, index

Schmidt, Rudolf. *Österreichisches Künstlerlexikon von den Anfängen bis zur Gegenwart.* Vienna: Edition Tusch, 1980– (at present to Dressler)

Svensk Konstnärs Lexikon. Malmö: Allhems förlag, 1952–67. 5 vols

Tervarent, Guy de. *Attributs et symboles dans l'art profane, 1450–1600* (Travaux d'Humanisme et Renaissance, XXIX). Geneva: E. Droz, 1958–9

Supplement and Index. Geneva: E. Droz, 1964

Vollmer, Hans. *Allgemeines Lexikon der bildenden Künstler des XX. Jahrhunderts.* Leipzig: E.A. Seemann, 1953–62. 6 vols

Both biographical and terminological dictionaries may be evaluated by what they repertory and to what degree of complexity, i.e. whether they are reductive or are the result of serious research and compilation. In the present state of recordkeeping, the former should, unless national, doubtless be more selective than they are at present, while the latter are truly more problematic.

The art-historical lexicographer still faces, as did Félibien, the option of deriving his knowledge from practitioners or from consecrated usage; like Roland Le Virloys, he comes to the realization that 'les termes sont les premiers matériaux des Sciences et des Arts, comme les mots sont ceux de toutes les Langues. Il est indispensablement necessaire de bien connoître les termes d'une Science, avant que de l'apprendre, ou d'en parler; de même qu'on ne peut parler une Langue, sans en savoir tous les mots: dans l'un et l'autre cas, on emprunt le secours des dictionnaires.' The question remains whether one can progress in the arts without any prior historical formation and, thus, any basis for comparison.

SOME 'DETERMINING' STUDIES

Alberti, Leon Battista. *De re aedificatoria.* Florence: 1485

Borsook, Eve. *The Mural Painters of Tuscany from Cimabue to Andrea del Sarto.* London: Phaidon, 1960. 2nd ed. rev. and enl. Oxford: Clarendon Press, 1980

Colonna, Francesco. *Hypnerotomachia Poliphili.* Venice: Aldus Manutius, 1499

Félibien, André. *Entretiens sur les vies et sur les ouvrages des plus excellens peintres anciens et modernes.* Paris: 1685

Fiorillo, J.D. *Geschichte der zeichnenden Künste von ihrer Wiederauflebung bis auf*

die neuesten Zeiten. Göttingen: Johann Georg Rosenbusch [- Johann Friedrich Römer], 1798–1808. 5 vols

Jantzen, Hans. *Ottonische Kunst.* Munich: F. Bruckmann, 1947

Lanzi, Luigi. *Storia pittorica dell'Italia dell'ab. Luigi Lanzi antiquario della R. Corte di Toscano.* Bassano: A spese Remondini de Venezia, 1795–6. 3 vols

Laugier, Abbé. *Manière de bien juger des ouvrages de peinture.* Paris: C.-A. Jombert, 1771

Lermolieff, Ivan [Giovanni Morelli]. *Kunstkritische Studien über Italienische Malerei.* Leipzig: F.A. Brockhaus, 1890–3. 3 vols

Menestrier, RP Charles-Francois. *La Philosophie des images, composée d'un ample recueil de devises, et du jugement de tous les ouvrages qui ont été faits sur cette matière.* Paris: R.J.B. de la Caille, 1682–3. 2 vols

Milanesi, Gaetano. *Le vite de' più eccellenti pittori, scultori ed architettori scritte di Giorgio Vasari pittore aretino.* Florence: G.C. Sansoni, 1873–85. 9 vols

Panofsky, Erwin. *Dürers Kunsttheorie, vornehmlich in ihrem Verhältnis zu der der Italiener.* Berlin: 1915

Quellenschriften zur Kunstgeschichte und Kunsttechnik des Mittelalters und der Renaissance, ed. R. Eitelberger von Edelberg. Vienna: Wilhelm Braunmüller, 1871–82. 17 vols

Richardson, Jonathon. *Traité de la peinture, et de la sculpture; par Mrs Richardson, père et fils.* Amsterdam: Herman Uytwerf, 1728. 3 vols

Riegl, Alois. *Spätrömische Kunstindustrie.* Vienna: Verlag der österreichischen Staatsdruckerei, [1927]

Ruhmor, Carl Friedrich von. *Italienische Forschungen.* Berlin/Stettin: Nicolai, 1827–31. 3 vols

Sandrart, Joachim von. *Teutsche Academie der Edlen Bau-, Bild- und Mahlerey-Künste.* Nuremberg: 1675–9. 2 vols

Schöne, Wolfgang. *Über des Licht in der Malerei.* Berlin: Gebr. Mann, 1954

Sedlmayr, Hans. *Johann Bernard Fischer von Erlach.* Vienna: Herold, 1956[1], 1976[2]

Simson, Otto von. *The Gothic Cathedral. Origins of Gothic Architecture and the Medieval Concept of Order* (Bollingen Series, XLVIII). New York: Pantheon Books, 1956[1], 1962[2]

Waagen, Gustav Friedrich. *Treasures of Art in Great Britain; being an account of the chief collections of paintings, drawings, sculptures, illuminated Mss. &c. &c. by Dr. Waagen, Director of the Royal Gallery of Pictures, Berlin.* London: John Murray, 1854. 3 vols

Wackenroder, G.W. *Herzensergiessungen eines kunstliebenden Klosterbruders.* Berlin: 1797

Wittkower, Rudolf. *Gian Lorenzo Bernini. The Sculptor of the Roman Baroque.* London: Phaidon, 1955[1], 1966[2], 1981[3]

Worringer, Wilhelm. *Formprobleme der Gotik*. Munich: R. Piper & Co., 1910

Collected Essays and Commemorative Volumes

> Oeuvres d'Étienne Falconet, statuaire; contenant plusieurs écrits relatifs
> aux beaux-arts, dont quelques-uns ont déjà paru, mais fautifs: d'autres
> sont nouveaux.
>> Lausanne: Société Typographique, 1781. 6 vols (title page)

Beyond any impulse given by zealous widows and colleagues, or the understandable desire to see oneself in a more imposing 'collected' format, such publications from the reader's point of view afford the convenience of a single volume for what given authors have *said* or *published*. The first instance is doubtless a more secure basis for judging the problems of transferral from an oral to a written format and permits one better to understand the thought, diction, illustration, and scholarly apparatus involved. It is also an incitation to concision and lucidity.

There is, of course, a fundamental difference between the assembling of commissioned and illustrated lectures (Bollingen Series, Wrightsman Lectures, Franklin Jasper Walls Lectures) and those (such as the Reith Lectures for the BBC) whose intellectual impulse derives from the *word* alone. In like manner, the collection of at least the major articles published in a scholarly lifetime is likely to have less consistency in topic and approach than a series of published lectures on a given subject. All must be accepted for what they are – and represented – at the time, keeping in mind that the convenience of the book format may not entirely reconstruct the force of the author's personality or serve the context of his argument.

This publishing vogue is by and large directed toward the stellar personalities and to scholars, and they are surprisingly few in number, who have had such active intellectual careers as to have produced sufficient bibliography to be gathered together in one or several volumes. Such a collection permits the reader to seize their bent of mind in dealing with specific problems of documentation and interpretation; these may well be more interesting, certainly more detailed, and doubtless even more 'typical' than the larger synthetic works for which their authors are known.

It is sometimes difficult to determine the 'interest,' i.e. the lasting value of specific contributions to the literature, and a poor choice usually provides object lessons in the use of the periodical and the public lecture. One must always ask what are the benefits derived from reprinting (or reworking) an earlier essay; much of the answer depends upon the originality of

the topic and, usually, the quality of theoretical writing in addressing it. Much of the 'recognized interest' if not necessarily the 'utility' of an author's scholarly output may depend upon the range of inquiry within the discipline and the more or less esoteric nature of the topics he addressed. This is rather more a question of market, normally defined as for university and college use. But it will be remarked that collected lectures are normally by persons whose names have become classic, whose work represents past generations, whose ideas are being more or less intelligently exploited now. Or, the commemorative volumes are either purely national, even institutional, publishing endeavours or else contain contributions in all the normal language groups of the discipline.

As to the *Festschriften/Mélanges* containing essays or contributions addressed to an intended recipient, these have the eminent advantage of giving his collected bibliography, most usually upon a significant anniversary or at the time of retirement from a museum or, more usually, the university. These volumes are a more or less spontaneous gesture of gratitude or esteem for those who keep the field going on a day-to-day basis, all the more so in that the contributors, whether as colleagues or students of the recipient, allow one to ascertain the state of health of the discipline.

The *Festschrift*, for the German term seems generally to have prevailed, permits the admeasurement of real personal influence within a field as well as from generation to generation. In real terms it may bring to light hidden and worthwhile personalities, just as the volume itself provides the opportunity to publish smaller pieces of consequential or incidental research than could otherwise appear. Unfortunately, the bibliographical anomalousness of such volumes combined with their long and difficult gestation in the face of other commitments may mean that contributions are virtually lost since one *must have* the volume (often issued by subscription) at hand and cannot casually run across a contribution as one examines the latest issue of a periodical.

The normal source of reference is P.O. Rave, *Kunstgeschichte in Festschriften. Allgemeine Bibliographie kunstwissenschaftlicher Abhandlungen in den bis 1960 erschienen Festschriften* (Berlin: Gebr. Mann, 1962).[13] After that time you must hope to have dynamic acquisitions librarians and bring to their attention anything you yourself come across in the literature or in professional correspondence. By far the greatest concentration of such literature is found in the N 7442 range of the Library of Congress classification, but contributions on art may be inserted into a *Festschrift* in any other discipline.

One might mention two special problems relating to the publication of lectures, essays, and articles. There is a regrettable tendency in bibliogra-

phies and footnote citation to omit the series name and number so that the reader believes the work in question is a simple monograph. This is an error in that a named series usually contains in each volume a recapitulation of prior contributors and titles whose names, given the extremely varied content of this type of series, would not otherwise be linked. A rather different problem of order and magnitude is whether the volumes were issued with the participation of the author (much more important in the case of lectures than other categories of literature) or were delegated to others as a result of disinterest, sudden death or disability, or posthumous publication. The latter instance, often emanating from a scholar's unformed *Nachlass* or *Publicanda*, carries with it certain responsibilities and risks for even the most trusted collaborator; even when working from 'developed' notes and ideas, the result is apt no longer to be the statement of its putative author, and no one will ever be able to ascertain the validity of the argument except *in embryo*. If translated, essays may have to be verified against the originals.

The following represents a highly selected listing of lecture and essay titles from an ever-increasing literature:

Benesch, Eva. *Otto Benesch. From an Art Historian's Workshop: Contributions to the Oeuvre of Dutch and Flemish Artists. Paintings and Drawings.* Lucerne: Gilhofer & Rauschburg, 1979
Benesch, Otto. *Collected Writings.* London: Phaidon, 1971–3. 4 vols
Chastel, André. *Fables, formes, figures.* Paris: Flammarion, 1978. 2 vols
Dvořák, Max. *Gesammelte Aufsätze zur Kunstgeschichte.* Munich: R. Piper & Company, 1929
– *Kunstgeschichte als Geistesgeschichte. Studien zur abendländischen Kunstentwicklung.* Munich: R. Piper & Co., 1924
Gombrich, E.H. *Art and Illusion. A Study in the Psychology of Pictorial Representation.* New York: Pantheon Books, 1960[1]; 1962[2], 1968[3], 1972[4] (imprint varies)
– *The Heritage of Apelles* (Studies in the Art of the Renaissance, III). Oxford: Phaidon, 1976
– *Ideals and Idols. Essays on Values in History and in Art.* Oxford: Phaidon, 1979
– *The Image and the Eye. Further Studies in the Psychology of Pictorial Representation.* Oxford: Phaidon, 1982
– *New Light on Old Masters* (Studies in the Art of the Renaissance, IV). Oxford: Phaidon, 1986
– *Norm and Form* (Studies in the Art of the Renaissance, I). London: Phaidon, 1966

- *The Sense of Order. A Study in the Psychology of Decorative Art* (The Wrightsman Lectures, 9). Oxford: Phaidon, 1979
- *Symbolic Images* (Studies in the Art of the Renaissance, II). London: Phaidon, 1972
- *Tributes. Interpreters of our Cultural Tradition.* Oxford: Phaidon, 1984

Janson, Horst W. *Sixteen Studies.* New York: Harry N. Abrams, 1973

Kaschnitz von Weinberg, Guido. *Ausgewählte Schriften.* Berlin: Gebr. Mann, 1965. 3 vols

Krautheimer, Richard. *Studies in Early Christian, Mediaeval and Renaissance Art.* New York/London: New York University Press / University of London Press, 1970

Kurz, Otto. *Selected Studies.* London: Dorian Press, 1977–82. 2 vols

Longhi, Robert. *Opere complete.* Florence: G.C. Sansoni, 1956–76. 8 vols in 11

Meiss, Millard. *The Painter's Choice. Problems in the Interpretation of Renaissance Art.* New York: Harper and Row, 1976

Middeldorf, Ulrich. *Raccolta di scritti that is Collected Writings.* Florence: Studio per edizioni scelti (SPES), 1980. 3 vols

Pevsner, Nicolas. *Studies in Art, Architecture and Design.* London: Thames and Hudson, 1968. 2 vols

Pope-Hennesy, John. *Essays on Italian Sculpture.* London/New York: Phaidon, 1968

Riegl, Alois. *Gesammelte Aufsätze.* Augsburg/Vienna: Dr Benno Filser Verlag, 1929

Schapiro, Meyer. *Romanesque Art.* New York: George Braziller, 1977
- *Modern Art: 19th & 20th Centuries.* New York: George Braziller, 1978
- *Late Antique, Early Christian and Mediaeval Art.* New York: George Braziller, 1979

Sedlmayr, Hans. *Epochen und Werke. Gesammelte Schriften zur Kunstgeschichte.* Vienna/Munich: Herold, 1959. 2 vols

Warburg, Aby. *Gesammelte Schriften. Die Erneuerung der heidnischen Antike. Kulturwissenschaftliche Beiträge zur Geschichte der europäischen Renaissance.* Leipzig/Berlin: B.G. Teubner, 1932. 2 vols; reprint Nendeln: Kraus, 1969

Weitzmann, Kurt. *Studies in Classical and Byzantine Manuscript Illumination*, ed. H.L. Kessler. Chicago/London: University of Chicago Press, 1971

Wind, Edgar. *Art and Anarchy* (The Reith Lectures, 1960). London: Faber and Faber, 1963

Wittkower, Rudolf. *Idea and Image. Studies in the Italian Renaissance.* London: Thames and Hudson, 1978
- *Studies in the Italian Baroque.* London: Thames and Hudson, 1975

Wormald, Francis. *Collected Writings.* Oxford: Oxford University Press, 1984–

Transcribed Lectures

The rarest and most difficult form of tribute to a scholar is collaboration between students and colleagues to reconstitute the scholar's lectures, notes, or drafts, not only in content but so that they resemble completed and readable works. The following selection bears witness not only to different epochs and styles (even schools) of lecturing, but also to the many problems of transcription and choice of illustration that result when the author is no longer there to assist.

Courajod, Louis. *Leçons professées à l'Ecole du Louvre, 1887–1896*, ed. H. Lemonnier & A. Michel. Paris: Alphonse Picard et fils, 1898–1903. 3 vols
Dvořák, Max. *Geschichte der italienischen Kunst im Zeitalter der Renaissance. Akademische Vorlesungen* [1918–1920]. Munich: R. Piper & Co., 1927–8. 2 vols
Panofsky, Erwin. *Problems in Titian Mostly Iconographic* (The Wrightsman Lectures, II). New York: New York University Press, 1969
Saxl, Fritz. *Lectures* [1933–1948]. London: Warburg Institute, 1957. 2 vols
Swoboda, Karl M. *Geschichte der bildenden Künste* [Lectures, 1946–1960]. Vienna/Munich: Anton Schroll & Co., 1976–82. 8 vols

Periodicals and Series

> Les Lecteurs, qui n'aiment pas les notes, et sont pressés d'arriver à la fin de la lecture qu'ils entreprennent, n'ont qu'à les passer et avoir la bonté de croire l'auteur sur sa parole; ils lui feront honneur, s'épargneront de l'ennui, et feront connoître qu'ils aiment mieux croire que d'aller voir.
>
> L'Abbé Guasco, *De l'usage des statues chez les Anciens*, 1768

The Periodical is a peculiarly 'modern' phenomenon in its supposition of individual use, a wide but immediate dissemination, and a short attention span. To this end it is traditionally available by subscription while, closer to our own time, it has become increasingly visible on newsstands. At one time, it was immediately classifiable as 'popular' or 'serious' according to the number of illustrations and footnotes; this is still true insofar as only the 'glossies' can afford the predominantly coloured illustration that is synonymous with large press runs.

The Periodical is first and foremost for momentary or incidental use, both as it appears and in retrospect. It is in some ways defined more by its apparent luxuriousness of production, although (in libraries everywhere) the number

of 'short runs' bears mute testimony that the genre is inherently unstable
and dependent upon high-risk capitalization.

The survival of the genre may be threatened as it multiplies exponen-
tially, if only from not 'finding an audience' rapidly enough to assure sur-
vival. Then, there is the general deterioration in mail service, rising postal
rates, and an equally rising number of claims for loss and damage that
must somehow be met. Maintenance of periodical subscriptions continues
to be one of the central issues affecting the survival of libraries everywhere.
This may be a policy question. Some journals have primarily if not exclu-
sively an institutional intent confirmed by two-tiered subscription rates.
Little of this seems understood by readers, who tend to use and abuse ex-
pensive and irreplaceable journals as they would their weekly news mag-
azines. In fact, the turning-point in public (private) discipline in the use of
public collections has become alarming since the early 1970s, and is curi-
ously coincident with revisions in production and pricing measures that
are now fully upon us.

All this perhaps reflects the growing assumption that art, however dis-
cussed, has become sufficient unto itself rather than being part of a general
cultural context. *It is true that art periodicals must have a 'curiosity factor' built
into them to survive; this may be defined as broadly or narrowly as the publisher
wishes, but at his risks and perils.* Interest groups may be targetted for a jour-
nal's creation through sophisticated marketing research, and the smash
can be spectacular indeed if there is miscalculation on this *purely commer-
cial* level. This level alone defines the modern era, for periodicals have tra-
ditionally worked to keep going, not to maintain a healthy profit margin.
It follows that the most successful journals have traditionally been those
that developed specific interests to high levels of sophistication through
special knowledge and commitment. Indeed, it might be said that the cre-
ation of art publications in this line has defined whole eras even though
the public at large was unaware of their existence at the time.[14]

It is therefore essential that contributors and readers have some real idea
not only of journals currently available, but of the course of specific serials
and their evolution within the period of maturity that continuous pub-
lication represents. As a serial publication, a periodical is extended into
time; and while it may be vaguely understood that such extension involves
change, no one can anticipate changes in policy that are chameleon-like,
running the gamut from scarcely perceptible subtleties to wild contrasts.

These colouristic transformations are the result of Editors and Editorial
Boards, variously defined, and also come from general and imperfect un-
derstanding of the genre. Public expectation and the media have lowered
standards of expression – and attainment – to the point where one more or

less consciously writes in a popular vein, the assumption being that readers are *not to be bothered* to understand. This cannot be said of the resolutely scholarly journals, sometimes to the point of true intellectual distress, but it is clear that art periodicals of a popular nature have come to predominate by their number. Curiously enough, their readers seem rather unable to differentiate between the many levels of popular writing that do exist. In any event, one may safely say that what seemed popular yesterday is, if not any more scholarly now than then, at least seen to be 'elevated' today. All the production values in the world cannot given the appearance of substance to simple filler; in fact they usually make its emptiness the more apparent.

It is important to differentiate between the history and influence of a periodical, and of periodicals in general. Both are cumulative in nature, although the first is linear and the second, random. Editors are concerned with getting their publication out on time, and this concern is an absorbing one. It usually takes five years of concentrated effort for a periodical to reach a certain maturity; ten is approaching stability, and twenty verges on the phenomenal. In this sense, a scholarly journal that *does what it can* is more likely to survive than a trendy publication whose public matures, disperses, or simply desires change.

Within historical perspective, however, it is only when enough periodicals have appeared of both general and specific nature that anyone may have a sufficient bibliography from which to work. As any other bibliography, this will be general by topic and highly specific by interest within that topic. Because even the strongest editor can structure a journal only to a certain degree by deciding what *not* to publish, he remains somewhat passive in the face of current interest and production. It is only at the moment of the annual index that his activity is summarized, or when a cumulative index is done for a period of years. Even these only concern individual journals, not what *is found* in journals; hence the increasing concern with analytical indexes to the periodical literature as a whole.

The first step is always to establish what periodicals have existed, under what name or names, and with what running dates, and only then their locations and the relative completeness of the runs. In reality, this is done on the basis of existing collections.[15] If the repertory of periodicals is known or established, then analytical indexes and bibliographies may be done systematically, the results of which are always surprising by their richness and variety.[16] It goes without saying that any number of specific research needs can be met once the basic tools exist, just as it stands to reason that the automated data base, properly thought through and applied, can render great service to the field over a period of years.

We may, then, take for granted that art documentation exists at two levels within the Periodical, as something within a larger social context and as a form of specialist literature. These elements are of necessity structured differently. For example, most contemporary art documentation is not presented in coherent or structured historical form; rather is it presented more as a 'piece of writing' than as the written proof, evidence, or illustration that is at the basis of the documentary urge.

How is this apparent or made manifest? By seeing how easily one can determine *what is* the article on a page; or by following it through the labyrinth of insertions and advertisements; or yet by seeing how it continues on randomly scattered pages and then ends somewhere 'in the back.' *The seriously minded periodical presents its thoughts as units.* Admittedly, it does not have to contend with publicity of all sorts that invades and pervades the glossies.

What is startling in examining design principles as applied to thought is that the advertisements lose force and individuality because of their number and since less classic design impedes 'skimming' – thereby impeding selection. The more perverse among us might say that it is more tiring to follow systematic clutter than to apply oneself to real arguments. For anyone interested in clarity of focus and utilization of material, it is easier to abandon than to join the fray in what often seems to be the expensive work of amateurs.

The Periodical must be intellectually penetrable if its diversity is to serve. The serious periodical accordingly presents its information *continuously paginated* so that it can be off-printed handily, even photocopied for research files. (The offprint is in any case a *sine qua non* of art-historical usage and courtesy.) At the same time, the novelty formats and dispersion of writing on contemporary art reveal a tacit assumption that the material will be historically valuable no matter how poorly it is presented. It must equally be presumed that the writers have never had to 'card' a bibliographical entry for something evidently intended only to be read, when the pagination for an article reads something on the order of: ... , pp. 15–17, 19, 35–6.

Such genial visual schizophrenia extends to intellectual focus as well. In many art magazines one scarcely has the impression that *art* is being talked about at all. There is much biography and correspondingly less analysis of the works of art themselves, perhaps compensated by (colour) illustration.

After reaching astounding heights in the last decade or so, *reportage* and interviews seem somewhat rarer in journals and somewhat more evident in dealer and exhibition catalogues. In fact, one is most likely to find discussion of specific works in any depth or detail only in the latter. Moreover,

many contemporary periodicals eschew time-frames or dates. *The reader often needs to scan the entire article to see what is really dealt with, or to locate mentions of the works of art illustrated.* Titles are usually of little help, often being in the commemorative or exemplum line, as 'Jack Bush at 58,' or else of a striking or literal nature ('Jack Humphrey and the Maritimes') with-out really being informative or controversial. Whether stated or not, titles chronicle the timely, the topical, and the partisan.

In all, there seems to be a general tendency to split content between artists and trends or movements along the line of Perspectives and Retro-spectives. If one is interested in Artists or Phenomena, one must run to the glossies whose stock in trade this is. For a modest outlay, students can have a single issue hot off the press that is a relatively luxurious but affordable substitute for a book or exhibition catalogue – and situated somewhere above the popular (which bides its time and works on the truly exemplary rather than its lesser manifestations).

This realization must lie at the base of such revisions in editorial policy as that of the *Art Journal*, which was to become from 1980 on 'a journal of ideas and opinion and to focus on critical and aesthetic issues in the visual arts of our time.'[17] Along with its new format came the novel concept of Guest Editors, with both editors and themes selected by the Editorial Board of the College Art Association whose permanent staff must assure continuity and give form to the most varied propositions.

It must be observed that such resolutely 'thematic' periodical publi-cation may be practicable with a quarterly and quite impossible for a monthly. The question of commemorative or thematic issues must be re-solved either in a timely manner or through sovereign indifference as to date of issue. Not every periodical can marshal, as does the *Burlington Mag-azine*, international connections and research to fall *à point nommé*; yet one can scarcely imagine the *Burlington* as a succession of thematic numbers, no matter how interesting. The name of the periodical game is Variety and likely will remain so. For the semi-annuals and annuals it is doubtful that other solutions are possible.

Another sign of the times is the publishing of collected writings taken from journals. If taken from a single journal, they resemble the infamous Readings on which there is usually no scholarly agreement but which are somehow intended to undermine reliance on a textbook by shifting atten-tion to writing of a more detailed nature. If by an author eminent enough to merit this attention, the work likely will have appeared in many different journals and be of unequal significance unless selection is exercised. Such publications cannot replace periodicals, although in certain cases they may reduce wear and tear upon them. It is rather more a testimony to the

basic function of the periodical, which is to permit sallies into the unknown, whether factual or theoretical, within a scholarly pot-pourri. One will find that certain authors or representatives of the national schools of art history have entrance to particular periodicals, but no one interested in personal reputation publishes in one place only.

There is more. In its balancing out of details within general ideas, the Periodical is *the* apprenticeship in Methodology. Because of its infinite range of topics one might draw an analogy with a series of casual love affairs. You may change the object of your affections; with it, you also change problems. How to avoid loss of historical perspective is a result of the constant and often unconscious analysis of materials that is Method.

At base, Methodology is a diagnostic process most often misunderstood, misapplied, or presumed to be other than what it is. In offering for years a seminar in Bibliography, Methodology, and Historiography, how often have I been taxed for not using Methodologies since the implication *must* be that I was concerned with my method alone. This is revealing in the extreme. Surely no one would claim that Tapestry or Iconography is less comprehensive, comprising both abstract and concrete entities, whilst the latter is restricted to physical objects. The one could well address the 'causal sequences' necessary to the understanding of the history of art, whilst the other would be merely descriptive (analytic).

So it is that Methodology is not a set system but an attitude or series of attitudes as to what one will have to do in respect of the materials with which one works. It is not a specific method or training, although these may to some degree contribute to its understanding. Nor is it exclusive. In reading scholarship, it is the ability to decide whether an author has used the appropriate method for the problem undertaken. It is the moment when certain things automatically 'clock in' by virtue of larger experience or comparison in ascertaining fact. It is the capacity of *when and where to see or not to see and acknowledge,* or the *involuntary reflex that recognizes potential for study or development.*

As Gottschalk remarks, the writing of the history

of any particular place, period, and set of events, institutions, or persons reduces itself to four bare essentials:
1 the collection of the surviving objects and of the printed, written, and oral materials that may be relevant;
2 the exclusion of those materials (or parts thereof) that are inauthentic;
3 the extraction from the authentic material of testimony that is credible;
4 the organization of that reliable testimony into a meaningful narrative or exposition. An understanding of those four steps, and a set of standards of

competence for each of them, are required for the intelligent reading of what historians have written.[18]

Were these standards unremittingly applied, the number of art historians worthy of the name would be greatly reduced, and with them the number of non-articles written. *Methodology permits the evaluation and extension of knowledge.* Once it can be masterfully applied to the 'lesser genres' there is hope for the 'greater,' which is to say the synthetic ones.

The signal danger in the writing of articles and catalogue entries is likely to be overwriting. Although often thought to be a stylistic attribute, it is more a problem within given texts than within personal style as a whole. In rudest terms, it is overstating a point.

To overwrite is to forget, even momentarily, the reader's expectations and needs. Once a point has been made and the reader can reasonably be expected to have absorbed it, many writers none the less continue on and on to the point that the point itself is weakened or lost, its edge blunted at very least. No one really expects a major concept to be fully elaborated in the space of two or three short paragraphs (except, perhaps, in exhibition catalogues); conversely, lesser concepts should not occupy the reader for several, often painfully long, pages.

The avoidance of overwriting is the result of knowing one's material and giving it a relative weighting so that one knows *where to stop* in the process of elaborating points or issues. The writer becomes a technician of sorts, one who has compiled information and comes to deal with it virtually with eyes closed – at least as concerns its manipulation, for the overriding concern must be the point at which the process becomes second nature and intuitive. *A well-written article commends itself by its author's fluency, not by his desire to establish the technicality of his discipline.*

Ceding to the temptation of overwriting may therefore result from a more or less conscious writing stance, not imperfect intuition combined in some measure with lack of practice. Once past the novitiate, conscious overwriting may be a form of contempt for the reader that is likely to be repaid – usually with *dommages et intérêts* – by the reader's own contempt and indifference. On the part of authors, this attitude usually manifests itself through an abiding concern for detail for its own sake. In turn, *inability to see the forest for the trees is apt to be the direct result of overspecialization, with its corresponding overemphasis of matters that would have found their proper place in a larger context.* This context is as much an intellectual one as that inherent in a given topic. If one accepts the aim of the history of art as a questioning process, of ideas put forth by material and not the material itself, one wonders how the premature narrowing of focus in current art-

historical curricula can ever produce people capable of dealing with the *field*, not just given topics.

The crux of the matter is what the reader will tolerate in 'in-depth' analysis. This is not just a question of agreeing or disagreeing with the argument – if there is one – but the potential for deadening the critical senses through laboured argumentation. Art history is rather like a good stew: everything goes into it, but what comes out should be palatable. Authors should be prepared to make the gallant gesture of reducing an argument from ten to two pages, not only for the incredible discipline it requires, but simply to maintain focus and readability. It is better by far to 'trip over' something than to be forced to accompany an author through a labyrinth of his own making.

Thus, art historians should be more aware that their writing is on the whole considered *poor, boring, and irrelevant*. This perception can be circumvented only when the reader can determine within short order whether an article satisfies reasons of good composition – pithy introduction, a meaningful body, a conclusion that addresses the issues raised – through the relative prominence and articulation of its different aspects.

When an article is well written, the reader can more easily examine its content and significance despite its density. *Poor writing brings simple discredit on the field while raising the possibility that the reader may have missed what could have been important points*. The more one is swamped with information indifferently put together, the more expertise is required to 'see things as they are.' Anyone lacking the expertise will prefer not to join battle with the enemy. How, then, to provoke the least disaffection in the Reader? He will, after all, determine from the first two or three paragraphs whether his foretaste of things to come means he will enjoy – or profit from – the article or not.

This is no negligible observation. He who reads art-historical literature is looking for something by predisposition and interest rather than being an idle reader lacking in expectations. This inherently favourable predisposition may be adversely affected by the *tone* employed in framing the article, in the *level* at which it is written.

By writing too simply, the field is automatically reduced and the sights of reader and writer alike are lowered. The next generations, having in the main been exposed to ideas expressed in the most basic compositional structure, suffer in even greater proportion, albeit unknowingly. (What is wrong here? Something is wrong here and in general, but what is it?) At the opposite pole lie the excesses and applications of art-historical Newspeak, which is currently thought justifiable through the predominant and tiresome documentary approach to the field: find something, anything; pub-

lish it for its own sake; forget about good composition, much less the proper articulation of the argument.

This is to say that the needs of good composition – which is to say good communication – necessarily precede and inform those of specific content in art-historical exposition. Sentence structure should be capable of reflecting even complex thought with ease, a difficult task in an age where grammar is so little understood.

There is nothing like reading a five-line sentence that reads beautifully while saying something about a work of art. If, in contrast, one's efforts are limited to the two-and-one-half-line sentence, the result must be a staccato-like presentation that is just sufficient for the transmission of information. Longer, more complicated sentence structure can be both accurate and pleasurable while stimulating art-historical literacy. This style need not be self-conscious to a fault; nor does it need to establish that the history of art is a science for which a given piece of writing serves as proof. The reader cannot fail to be impressed by an article containing many dainty morsels (subtleties, nuances, asides) that are simply stated, leaving him to wrestle with them, giving him the choice of following them up or leaving it at that. *Writing is, in the end, intuitive, not a list of standards leading one to enquire whether it satisfies this or that condition.* 'Style is incremental [taking] its final shape more from attitudes of mind than from principles of composition.'[19]

Aping the sciences is perhaps one of the reasons for the decline of art history. One has only to examine the OED Supplementary to note the astonishing degree of specificity in word creation, which kills (or tortures) humanistic expression if the terms have no larger applicability. Actually, the problem lies less in the use of such words than in the propensity of many writers to *misuse or misdirect* technical or other terms, or to use them in inappropriate context. The article should in a literary sense be like the temporary exhibition: one has pleasure in finding even known facts and works of art presented in new and unexpected context and closely argued. The necessary compositional and intellectual techniques, once mastered, may then be applied to the *more compact* literary genres of the monograph, catalogue, or repertory, at which time they function at a correspondingly higher level because they are less evident in the application.

Periodicals change. One may be conscious of this while not being terribly objective in their analysis. Personal preferences are followed by looking through them so as to determine what to read or not. For the scholar, periodicals are appreciated for their news value: one learns who is working on what, or when, or in what way. More often than not, one hears that 'I have no time to read them any more.' Such a statement is subject to

interpretation, but seems mainly dependent upon the *regularity of appearance* of a publication. If it seems lapsed – or else so irregular that it drops from mind – a periodical, whatever its quality or stated periodization, is a contradiction in terms and will likely fail.

Individual impressions of periodical publications are apt to be influenced by experience and by the number of titles available locally – titles that can be examined, whose contents can be scanned. Otherwise periodical titles are only so many names and nothing more. Of course, one may deduce that *Arte Veneta* is an annual for a select group publishing primarily (or only) in Venetian studies, but the titles of many journals are steadfastly uncommunicative of their real contents.

The wealth of periodicals available in research centres may result in some contempt for the genre when one searches fruitlessly for something in one's line of interest, much less something that seems interesting or significant in the reading. Quantity blurs distinctions. In areas having only a limited number of titles, or titles selected only on the basis of a language group, library holdings may themselves form *beyond common measure* perceptions about the field. In the first instance, prospective authors may experience a sense of futility about even their best work, feeling that their contribution(s) may, in the flood of publications, be washed away into the tidal plain of undistinguished and indistinguishable literature. This observation may, in turn, condition attitudes toward the genre, resulting in the public display of work that is substandard or has reached a dead end: 'I'm not going to do more with this, so I might as well get it out.' Like the seemingly lapsed journal, unsophisticated perceptions about this type of writing provide real disincentives toward good research and writing.

To appreciate periodicals one must develop the habit of looking at them regularly, not as mere spot-checks. An understanding of their intrinsic qualities cannot be based on simply glancing through or reading into them. Rather like a medical journal, periodicals provide *the latest information*, so one should take a few hours every week or so to get some measure of the 'pulse' of the discipline. Yet failure to extract the maximum from their data is usually the direct result of insufficient training or discipline in their use. *When all is said and done, the only 'key' to periodicals is how frequently they are used.* How easily they are used depends on how well versed the reader is in the normal bibliographic tools.

Too much valuable time is wasted by not using periodical indexes prior to consultation, an acquired (and unthinking) attitude when one 'goes through' historical journals as though they were current issues. Yet the work has already been done for the researcher if he but knows where to look, without which there is first delay, then increasing and finally compounded frustra-

tion. It is possible to ease one's physical and intellectual distress immeasurably by mastering the normal reference tools, failing which results in curiously uncoordinated research. By way of example, if one were interested in a major exhibition from the 1930s, the average reader will secure the catalogue and read it, all the while unsuspecting (or consciously neglecting) contemporary periodicals to see what was *said* about the exhibition. This is rarer for the earlier historical periods where one is *conscious* of the lack of evidence – and probably is a more accomplished researcher – but for the modern era such information is to be had for the asking. Alas, it is rarely followed through to its logical conclusion.

Other factors inform the reception, use, and understanding of periodicals. For current publications the caveat is that what is on display is not necessarily all that is received; it likely represents a selection based on perceived or likely interest – what is most asked for locally. Since display space may be limited, and the choice also subject to the maintenance of reasonable security, the browser is cut off from the literature he does not see. Again, as in most research situations, the ultimate recourse is the public catalogue.

Even this is for the general reader a series of assumptions based on what is visible. For example, if there is a current subscription displayed, readers tend to assume that the library has the entire run, rather than a run from the moment the subscription was begun. Most libraries have periodicals represented by a few issues only, whether grouped or widely separated; in the public mind this fact seems inconceivable and logically inconsistent: a title represents a journal and it *must* be there. Since librarians cannot carry such details about in their heads, there will be an inordinate number of exchanges of the 'Do you get this? – Have you looked in the card catalogue?' variety, at which time the search is usually abandoned by the general reader. Clearly, there is no middle ground between casual and sharp interest.

If one has a wider interest, periodicals are the best, the only way to satisfy curiosity; even if they are just skimmed, they measure trends. Because of their modest size, their information may prove *more accessible* to most readers. Reading a review of an exhibition catalogue may provide all the information one may want to know; in other fields, such as contemporary art, periodicals will tell all one needs to know – even what one doesn't want to know, but about which one will find out. To profit from them does require that one be rather 'book-oriented' and have a wide curiosity rather than following only immediate interests. Periodicals can be ends in themselves or means to many ends; the choice is the reader's.

So it is that library staffs use periodicals in an *anticipatory* or service-

oriented sense, more for current information concerning exhibitions, catalogues, and other publications, events, and institutions. The general reader, not excluding the curatorial, professorial, and student contingent, may have a passing interest in these functions, but is really interested more in contents as a *bibliographic resource*. Neither usage really exhausts the possibilities inherent in the genre.

The type of consultation just mentioned is to some degree predicated on the Special Library. *It is in the open-stack situation where the best research methodologies go up in smoke.* Here, the physical and intellectual proximity of titles through subject classification encourages a certain laxity of an inner voice whispering 'I'll have a look here and see what I can find.' For all its ease of access, the open stack can contribute to a marked deterioration in research skills, blunting rather than honing them because of an unvoiced presumption that *most if not all* one is likely to need is in front of one's nose. This view does not reckon with the problems of applied subject classifications and further makes for a brutal transition to closed-stack research, particularly in other countries and languages.

The acid test of such well-intentioned policy (for it is presumed that the reader has *control enough* to locate at least one major title and will, as a result, inevitably find more) would be to see how many students using a major university library would encounter real difficulty in using the accepted reference tools if the stacks were closed for a given period. (One has the impression that the line-ups would be colossal.)

Of course, this discussion model excepts periodicals because, once located in the stacks, they are there (and increasing) forevermore. When, however, one overhears at Catalogue Information queries on quite unproblematic and classic periodicals ('How do I find the *Art Bulletin*? / Where is *Queen's Quarterly*?'), one cannot help but feel that fundamental lacks in research skills condemn most readers, like the Wandering Jew, endlessly to traverse the length and breadth, not of the stacks but of the library itself. Computer scanning and on-line public catalogues are likely further to reduce logical competence in research; like cigarettes, these may have to bear warnings that their protracted use 'could be deleterious to your (intellectual) health.'

Of course, the one area in which this prescription fails utterly is with Comprehensive Examinations. Here the idea is probably to know to some degree 'the last ten years' of scholarship and controversy as a whole, rather than following one's personal interests – eminently understandable when the recent periodical literature is deemed to give the state of the question and of the field.

It may be here the failures in understanding periodicals are finally, al-

beit momentarily, corrected. In undertaking such wide-ranging work, one comes to know the *chronological or thematic limitations* of at least the major periodicals of the field. One will no longer accept the 'cover image' as the entire content or editorial policy of a journal, so the average reader's idea of magazines used and defined by subject area is given the lie. It is at this point that one discovers that the *Burlington Magazine* has extensive coverage of Modern art with which it is not generally associated in the public mind.

Open- and closed-stack situations suppose different levels of bibliographic control as well. By way of illustration, suppose that one has the usual incomplete periodical reference, in this case only the volume or year and not the month or season. Some periodicals – *Apollo*, the *Gazette des Beaux-Arts*, the *Revue universelle des arts* – have two volumes per year, not one. This might be surmised if one notes that the *Revue de l'Art ancien et moderne* had seventy-one volumes from 1897 to 1937, but this clue is usually picked up only by adepts because 'volumation' is presumed to be 'one a year.'

The point of this excursus is to suggest that inattention to such details compounds frustration on all sides, as well as the wear and tear caused by unnecessary displacement of the volumes for thumbing. Even if one has all the requisite information for locating an article, there may still be anomalies inherent in a given periodical run that put the most accomplished notation to question.

There are, for example, the 'irregular periodicals' such as *ARTnews*, a monthly except in summer when it becomes quarterly, or *Art in America*, with its ten monthly issues except for July and August. More likely to occur are those 'volumes' spanning more than one year, usually because of the date at which publication commenced. This position *à cheval des ans* may reflect historical accident, just as it may represent an occasional lapse in periodicity so as to avoid the appearance of being stale-dated. The result is in any case the same – the likelihood of confusion when something that should be regularized seems somehow curious or even wrong.

The best and worst of this may be seen in something like *Deutsche Kunst und Dekoration* in its original fine bindings, each part of the year being noted on the spine for convenience in filing (1905, Bd. I–II), an idea occasionally retained in *Gazette des Beaux-Arts* citations of yore. Yet rapid verification of the title pages shows that Bd. I–II of 1905 spans parts of three years, with XV being Oktober 1904–März 1905 and XVI being April 1905–September 1906! Full bibliographical notation can always be simplified at some later date, but it must always begin with the noting of distinctions and anomalies.

One may retort that the contents pages will remedy any difficulties, yet it is always best to start with information derived from periodical indexes to locate specific matters unless one *wants* to acquaint oneself with the contents of an entire volume. (When the wrong one arrives, a certain sense of fatality sets in and one may well 'see what is there' to while away the time or extend one's idle curiosity in no particular direction. This may be beneficial in a general way, but it is totally irrelevant for one's stated purpose.) Contents pages may not be well set out, and even bound-in cumulative indexes may be only summary, requiring one to scan the entire issue to determine what the general headings really mean. This type of consultation is best reserved for current periodicals where one has – or makes – the time for casual and unstructured reading because discovery is its purpose.

Few are the periodicals that explain themselves in any real sense.[20] It is left to the reader to infer from what he sees, and he may not see the forest for the trees. One justified criticism of periodicals is that their research and writing is done in a vacuum, comes in when it will, and is published as one can. In a word, it lacks context. This is the mirror image of trying to put together some coherent piece of research from overly fragmented information; periodical publication asks one somehow to insert a piece of apparent research into some historiographical and intellectual context that is never present. *This is not an inborn process; it is learned.* Scholarly mechanisms are rather like sophisticated automobiles – one opens the hood, examines the works, and begins one's career with a 'very nice, I am sure, but I haven't the faintest idea of how it all works.' *Scholarship is not just working in isolation to produce something, but learning how to respond to the past and to the present.*

In this sense the *Burlington Magazine* more than any other is a 'periodical of dialogue' that is vastly different from a succession of mere Letters to the Editor in respect of an article where one has been misquoted, misunderstood, or whatever. With writing on issues such as those of the Great Picture-Cleaning Controversy of the 1960s, it provides, more than any purely thematic issues, a real forum, an immediate 'critical mass' on given questions and artistic personalities. The apprentice scholar, if he wishes, can follow through how others have responded to what has been put forward, noting how others turn insight into thought, thought into argument, noting at what point the tone of writing changes, when it becomes angry or irritated and why. *Most important of all, he learns when further argument is useless for the moment.*

This type of scholarly formation is a far cry from the 'simple' recapitulation of arguments co-ordinated by a single person to his own ends and through his own eyes only. Such exchanges develop an ability to deal with sudden and

unexpected deviations of perspective through observations and documentation to which one may have had no access, perhaps no intimations of its very existence. Their value lies in a certain type of *serialization* within the periodical format.

Serialization has been around for some time, although it is less practised now for good and sufficient reasons. The *Gazette des Beaux-Arts* had from its earliest years serialized articles. They are, however, clearly identified as such in the contents pages (2e et dernier article) and were sectionalized because of their inordinate length. This is to say that they were *already written*.

This is not usually the case in our day. The reader sometimes goes away with the impression that serial publication is rather like getting one's foot in the door; that is to say, it often seems an attempt to undercut the competition by staking out territory. In its most generous form, it is 'opening a parenthesis' in the hope of continuing problems too subtle or complex for the normal forms of publication. In either instance, the difficulties encountered by author and reader alike come when the work has not yet been done (or properly structured) prior to its launching.

Unfortunately for all concerned, the serialized article has the same problems of issuance as the periodical in which it appears: if extended too far into time, its impact and information are apt to be lost to all but those who are vitally concerned. Otherwise put, the range of topics suitable to such treatment is sure to be limited. Art-historical writing is not noted for its enduring literary value, nor is it likely to be on a par with Dickensiana – published in instalments prior to issuance in book form. The instalments should in any case be *cross-referenced* (backwards) so that the following up of a chance discovery can be accomplished with a minimum of fuss and bother, as with Denys Sutton's 'Aspects of British Collecting, III,' *Apollo* CXIX (May 1984), which makes reference to earlier sections appearing in November 1981 and December 1982. If serializing there must be, it is still better to do so in three successive issues than over a three-to-five-year period, the point at which the work itself loses its implicit coherence.

One of the few instances in which coherent writing in this form could have been gathered together as a quasi-monograph was Anthony Blunt's 'Poussin Studies, I–XII,' *Burlington Magazine*, LXXIX (1947) to CII (1961), with a lapse in publication from 1951 to 1958. Such a chronological spread is excessive by any criterion, and it must be remembered that no one will know or care some years hence *why* something was not continued in a timely manner, only *that* it was not. (If a serialized article is begun, it should be completed, even if its scope and proportions must be restudied to do it.) That the Poussin Studies were entirely of a speculative nature is acknowl-

edged by the author in later writings, which is why they were not gathered together. Not all articles on or around a topic 'go' together in the long run; unless one has one's own journal, as Longhi did with *Paragone*, it is better to reject the serial format altogether in favour of the well-executed single contribution.

There is, in the end, a series of compelling reasons not to undertake a series of articles. *They may never appear because of insufficient quality, flagging interest, health, or the discovery that the intended topic was not sufficiently elastic to be developed or subdivided.* Better by far to publish a series of studies and essays so that one is in full control than risk encountering the general feeling that one set about to 'get the maximum' out of a slim or ill-considered topic.

Also, one may presume that there is some degree of editorial responsibility as to what is published within a journal's pages. Insofar as the art magazines are concerned, one can usually tell their nature by the advertisements they accept. Not those that are offered, but those that are printed. In *Master Drawings*, they are never too far afield from the stated concern of the publication, informing readers of the personalities, firms, and services necessary to the field. *Parachute* accepts what reflects its editorial policy of documenting contemporary art, while *Flash Art* in its three parallel editions (Italia/France/International) is a florilegium of international dealers in art. The advertising pages of the *Burlington Magazine* reflect a unique and long-standing association with certain auction houses. This, as with *Apollo* in different circumstances, results in having to go through from a third to half the issue in order to find the title page. Historically, this excess resulted in many libraries omitting advertisements from the bound volume in order to save money; more often it resulted in their loss, along with the covers, or separate binding, so that given issues have to be reconstituted rather than seen as the entire historical documents they are.

For reasons that may be imagined, this 'loss of identity' through the stripping away of covers is more serious by far for journals than books when the integrity of each issue is imperceptible in the mass. To return to our initial premise, however, it is usually a firm indication of a popular intent when a magazine's advertisements are evidently paid insertions of no particular leaning. In the end there is but one general rule for periodicals. *It is not enough to put one down when you have found what you were looking for unless you have retained some sense of the probability you will use it again.* If so, you should take the time to learn its system so that the next time you will return to an old friend rather than just to another face in the crowd.

2 Bibliography

On Bibliography

> The historian may applaud the importance and variety of his subject;
> but, while he is conscious of his own imperfections, he must often accuse
> the deficiency of his materials.
> Edward Gibbon

The main purpose of bibliography is the *location* and *retrieval* of information. Not only should notation be consistent, but references should be complete enough so that readers may with some ease locate a source or follow the exposition.

Bibliographical notation is not an abstract and purposeless exercise but rather a very concrete method of transmitting your thoughts and those of your predecessors to a 'faceless' audience who, as your contemporaries or an intellectual posterity, will judge you solely on the basis of the *written* word. Thus your writing style and your notation are inseparable. The history of art, properly approached, deals with a myriad of textual and figural documentation[1] that must be given a structure unified in both thought and form. A lucid exposition *sive* demonstration is essential if you are to create an interpretative statement worthy of reading, much less of remembering.[2]

For all intents and purposes, notation permits the *verification* of your sources and the *comprehension* of the development of your thesis. Should your readers not be able to retrace your thought in footnotes (which, by definition, are at the *bottom* of a page rather than notes grouped at the end of a chapter) and in text, they will most likely assume that you are at best unreliable and at worst incompetent. In either case, you will appear unhistorical in orientation and betray the very basis of your discipline.

You are probably accustomed to the use of primarily *monographic* or *pe-*

riodical (serial) literature, which is almost undoubtedly restricted to that extant or locally accessible in the history of art. Such literature is by no means even the majority of *printed* documentation potentially relevant to your subject, which includes sales and exhibition catalogues[3] and national artistic inventories.[4] Subconscious restriction to the first-named categories ultimately means spending a lifetime engaged in scissors-and-paste work – citing authorities rather than considering the problems posed or, worse yet, the artworks themselves. All disciplines are more or less parasitic if not downright incestuous, but rarely is a discipline so endangered by this mentality as the history of art. Where the *catalogue raisonné* reigns supreme, there is perhaps a greater risk of intellectual rarefication and resultant stultification. The process is rather like throwing a pebble into still waters, save that the concentric circles fall inward rather than extending themselves infinitely, if sometimes imperceptibly, into uncharted water.

Your subject is one that depends upon the heightened maturity and refinement of observation brought about by *leisure*: it is futile and pretentious to assume one may really sit down and 'research' some problem at will. That people have nothing to say does not prevent them from talking copiously. The same is true of writing, with but one qualification: the essential difference between an oral and a written expression. M.J. Friedländer's example of the colleague blithely stating 'Unfortunately, I have no time, being busily engaged on other important work; otherwise I would take up the Hubert and Jan van Eyck question and settle it' is a sad, but all too typical, instance. The fallacies are twofold: that a definitive work (as opposed to a definitive statement for a given period) is possible in the Humanities, and that you may be the only person capable of producing it.

The history of art in North America is almost without exception taught in the universities rather than autonomous institutes. You will doubtless face an unconscionable physical dispersion of even the obvious literature as a result. But unless you cultivate the habit of browsing the stacks and of following up footnote citations, you will probably never remark the proportion of literature in other types of publications.

Among the most important of these are the Foreign Academies, which provide an official reportage of the state of knowledge in the various disciplines. They are bibliographically anomalous (like the *Festschriften*).[5] Within the covers of one volume may be found a series of independent studies, lacking only an abundant or an all too familiar illustration in colour separation processes. One such, celebrated, study is

Schlosser, Julius von. *Die Wiener Schule der Kunstgeschichte. Rückblick auf ein Säkulum deutscher Gelehrtenarbeit in Österreich* (Mitteilungen des Österreichischen Instituts für Geschichtsforschung. Ergänzungsband XIII, Heft 2). Innsbruck: Universitäts-Verlag Wagner, 1934, pp. 145–228.

Not only is this effectively a separate title within a serial (not a series!), it is an additional, numbered title that may or may not have been bought or bound in with the main series. The Österreichisches Institut may have had more series than the *Mitteilungen*, and they may have existed in several different formats, e.g. in-4°, in-8°, in-fol. This may mean nothing in North America where only the in-folios are generally separated into their own stack areas, but in Europe, where shelving is often done by arbitrary format to effect economies of space and the resultant physical preservation of the books as objects, these areas may be materially separated to the point that, without marking legibly the format along with the general press-mark, you will never locate the tome requested. Also note that if the title is separate within the series, the whole volume for 1934 may be continuously paginated; I say nothing of *separata* that may or may not retain the original pagination.

As a final caveat, be aware that the notation above, which is taken directly from the title page, may or may not correspond to that under which you may find the series in the card catalogue of libraries.[6] In an attempt to standardize form, it might (assuming there were these additional subseries) be found in this manner:

Vienna. *Oesterreichisches Institut für Geschichtsforschung.* *Beiträge.*
 Mitteilungen.
 Mitteilungen. Ergänzungsheft.
 Studien.
 Vorträge. (usw.)

This seems straightforward enough. But much depends upon whether the library has *analysed* the series (i.e. whether titles are individually bound and catalogued by author and title) or whether all volumes are uniformly found under the series title followed by the fascicule number. In the latter case, to know author and title would not be sufficient to enable you to locate the volume in question.[7] You would then have to know the series, volume, or numbered fascicule, year of issue (*and* supply a printed source of information, should you apply for an Inter-Library Loan in the

Reference Department); this information you may not have recorded because it seemed 'inessential' or since you were 'hurried' that day. Obviously, the sooner correct notation becomes habitual and unthinking (as typing), the more quickly you will be able to undertake serious work and avoid backtracking. But without linguistic tools, you will none the less be stopped short because literature on European subjects is not obligatorily in English.

No mention has been made of the frightful tendencies of serials
- to possess several series, confused by truncated citations;[8]
- to change names or to merge publications;[9]
- to possess and be cited under several names or subtitles;[10]
- to repeat an identical title at different epochs.

These and many more delights await you as you progress in the general literature and your chosen field.

To return to the problems of notation: only rarely are abbreviations of journal titles acceptable unless accompanied by a corresponding list of complete citations. You may imagine the confusion when *arch*. may signify *architecture* or *archéologie* and *ant*. either *antiquaires* or *antiquités* and the like.[11] The fuller the notation for your *working* bibliography, the easier the completion of your paper with the literature actually *employed*. Consider yourself fortunate if the ratio between these is no more than 3 to 1. Most libraries maintain normal 3 x 5 cards as scrap paper, which may be transformed into your own instant public card catalogue for most-used or most-needed items; cultivate this habit.

The point is, I trust, made that bibliography is not simply institutionalized torture but the very foundation of your discipline. Any truly knowledgeable person is, despite or rather because of his education, an autodidact. Notwithstanding the proliferation of research assistants and invidious *travail en équipe*, no one else can do your work for you; otherwise put, you will never know what has *escaped* notice. Even if you never publish a work, you have no right to summarily dismiss a problem without having tried it out. Negative results are just as important as positive ones in the progress of knowledge, just as the things that are omitted in a study may be of as much or more importance as those that are said.[12] Even if your own work adds up to nil, the selection must be done in order to justify this assertion.

This selection is explicable in that the entire mode of thought and publishing can be said to have changed at a date that I shall arbitrarily set at the Congress of Vienna. The traditional curriculum of the University as everywhere comprehended up to this time remained fixed in range and content

and required only discursive exegetics. Were we, for example, to abandon subject classification systems of the nineteenth century and reunite all materials prior to 1815, Toronto would be one of the few institutions on this continent possessing the equivalent of an integral *ancien fonds* of the type that makes work in Europe essential for this discipline. Once one abandons this tradition of the *disposition méthodique* (which is still eminently defensible as well as the point of reference for all further research) for the idea of historical research, one must have the *original* sources in the proper editions, as well as the secondary literature, *regardless of superannuation*, in order to have at hand the sources of thought and scholarship. Most of these become with time lost to view or unacknowledged; they are no less fundamental withal.

In dealing with these problems, remember above all that you will find no material on your subject (e.g. Raphael) unless it already bears the appropriate *catchword*. Although this circumstance indicates that someone has preceded you in the cataloguing process, whether of printed books, manuscripts, drawings, or engravings, it in no way indicates that no further material is to be found. If one looks through even the most classic problems, one always finds something; unfortunately there is a point of diminishing returns for the effort expended and any researcher should learn to recognize it.

A recent aberration is that of automated information systems, microfiche suppliers and their ilk. Most of the 'controversy' ensuing over the last decade or so in this matter concerns *how* it should be implemented, not *whether* it should be employed![13] Since most of these systems are of a purely *commercial* interest, you should become aware of the fact that your working habits and thus your results will be in large measure conditioned by the fact that you must first work things through *their* way before transforming your findings into your language and form. It is safe to say that the majority of scholars will never break the constraints of enforced research approaches that result in the further intellectual impoverishment of art-historical studies. Also, one is removed yet another step from the object itself, a process that reinforces the idea of research as the mere *accumulation* of information, regardless of its reliability.

A final word: there are two schools of thought about the typographical errors such as you may have noticed in any *variae lectiones*. The first assumes that errors are unavoidable; the second, that an error is simply multiplied by the number of copies of the edition. A workable compromise is the avoidance of substantive error, but it is wise to aim for perfection in formal presentation.

Bibliographies

FORM AND FUNCTION IN HISTORICAL WRITING

These are the most current manuals and handbooks addressing the field along with a number of selected titles from the theoretical and publishing spheres. This list may be extended somewhat, but not much. The titles themselves should be consulted for ideas and models since most of them are unreadable by almost any definition.

Argan, Giulio Carlo. *Guida a la storia dell'arte*. Florence: G.C. Sansoni, 1974

Badt, Kurt. *Eine Wissenschaftslehre der Kunstgeschichte*. Cologne: Dumont, 1971

Barnet, Sylvan. *A Short Guide to Writing on Art*. Boston: Little, Brown, 1981

Barzun, Jacques. *The Use and Abuse of Art* (Bollingen Series, XXXV.22). Princeton: Princeton University Press, 1974

Bauer, Hermann. *Kunsthistorik. Eine kritische Einführung in das Studium der Kunstgeschichte*. Munich: C.H. Beck, 1976

Belting, Hans, et al. *Kunstgeschichte. Eine Einführung*. Berlin: Dietrich Reimer Verlag, 1985

Carey, G.V. *Mind the Stop. A Brief Guide to Punctuation with a Note on Proof-Correction*. 2nd ed. Harmondsworth: Penguin Books, 1976

The Chicago Manual of Style: For Authors, Editors, and Copywriters. 13th ed. rev. Chicago/London: University of Chicago Press, 1982

Eco, Umberto. *Come si fa una tesa di laurea*. Milan: Fabbri, Bompiani, Sonzogno, 1977^1, 1985^2

Fowler, H.W. *A Dictionary of Modern English Usage*. 2nd ed. rev. by Sir Ernest Gowers. Oxford: Clarendon Press, 1965

Frankl, Paul. *Das System der Kunstwissenschaft*. Brúnn/Leipzig: Rudolf M. Rohrer Verlag, 1938

Goldman, Bernard. *Reading and Writing in the Arts: A Handbook*. Detroit: Wayne State University Press, 1972

Gottschalk, Louis. *Understanding History. A Primer of Historical Method*. 2nd ed. New York: A. Knopf, 1969

L'Histoire et ses méthodes (Encyclopédie de la Pléiade, XI), ed. Charles Samaran. Paris: Gallimard, 1961

Hurt, Peyton. *Bibliography and Footnotes. A Style Manual for Students*. 3rd ed. Berkeley: University of California Press, 1968

Lavalleye, Jacques. *Introduction à l'archéologie et à l'histoire de l'art*. 3e édition. Gembloux: Duculot, 1972

Maltese, Corrado. *Guida allo studio della storia dell'arte* (Strumenti per una nuova

cultura. Guida e manuali, 15). Milan: U. Mursia, 1975

Methoden der Kunst- und Musikwissenschaft, eds Martin Gosebruch, Christian Wolters, Walter Wiora. (*Enzyklopädie der geisteswissenschaftlichen Arbeitsmethoden*, 6. Lieferung.) Munich/Vienna: R. Oldenbourg, 1970

The MLA [Modern Language Association] Handbook for Writers of Research Papers, Theses and Dissertations, eds Joseph Gibaldi and Walter S. Achtert. New York: Modern Language Association, 1977. NB: This work is *not* to be recommended for art-historical purposes.

Pointon, Marcia. *History of Art. A Student's Handbook*. London: George Allen and Unwin, 1980

Scholarly Publishing. A Journal for Authors and Publishers. Toronto: University of Toronto Press, 1969–

Stark, Carl Bernhard. *Handbuch der Archäologie der Kunst. Systematik und Geschichte der Archäologie der Kunst*. Leipzig: Wilhelm Engelmann, 1880

Thuillier, Jacques. 'Conseils pour la rédaction des mémoires de maîtrise et thèses de IIIe cycle en histoire de l'art moderne et contemporain,' *L'Information d'histoire de l'art*, xx (septembre–octobre 1975), pp. 151–79

Tietze, Hans. *Die Methode der Kunstgeschichte. Ein Versuch*. Leipzig: E.A. Seemann, 1913

Turabian, Kate L. *A Manual for Writers of Term Papers, Theses, and Dissertations*. 4th ed. Chicago: University of Chicago Press, 1973. NB: If you have no other such manual, you should have *this* one!

Wiles, Roy McKeen. *Scholarly Reporting in the Humanities*. 4th ed. rev. Toronto: University of Toronto Press, 1970

There can be no absolute agreement on the above matters; even when using a manual, nothing can replace common sense and discernment when confronting notational problems. Rather than looking up solutions as deadlines approach, it is better to commit to memory general rules, treating aberrant cases as they present themselves. (Local suppliers of the *Chicago Manual* and Turabian always go out of stock at thesis time each year.)

PERIODICAL CATALOGUES

Of all the literature this is the most difficult to analyse because of its range, catch-all nature, and its abiding detail. Whatever its faults, it is better than nothing; indeed, without periodical catalogues the field would collapse.

Some indexes are based on the periodical holdings of a given institution, although most are issued by research institutes of national or quasi-

international mandate. Some duplication of effort in coverage is inevitable, but there are always a number of unique features present in the various approaches to the indexing itself.

Just how difficult the periodical indexes are to handle is seen when the 'annual' repertories contain addenda from the year(s) preceding – normally a question of the date of issue or receipt of periodical numbers – or have 'skewed' years. Others are issued at intervals and then cumulatively. The old standbys are the *Art Index*, *Répertoire d'art et d'archéologie*, and *RILA*, the latter of which can be read almost like a periodical in itself – as the means of deciding what to read rather than going to the journals themselves.

Annuario bibliographico di storia dell'arte. [Istituto Nazionale di archeologia e storia dell'arte.] Modena: 1952–

The Antiquaries Journal, being the Journal of the Society of Antiquaries of London, LXIII (1983). Periodical Literature

Art Index. New York: 1929–

Bibliography of the Netherlands Institute for Art History. [Rijksbureau voor kunsthistorische documentatie.] The Hague: 1943/45–

Bibliothèque d'art et d'archéologie (Fondation Jacques Doucet). Catalogue général. Périodiques. Nendeln: Kraus-Thomson, 1972

Columbia University. Avery Index to Architectural Periodicals. Boston: G.K. Hall, 1963. 12 vols

 2nd edition (1973), 15 vols

 2nd edition, first supplement (1975)

 2nd edition, second supplement (1977)

 2nd edition, third supplement (1979)

 2nd edition, fourth supplement (1985), 4 vols

 2nd edition, sixth supplement (1986), 4 vols

Fasti archaeologici. Florence: 1948–

The Frick Art Reference Library. Original Index to Art Periodicals. Analytical Bibliographies of Art History and Archaeology. Boston: G.K. Hall, 1983. 12 vols

Germania. Anzeiger der Römisch-Germanischen Kommission des Deutschen Archäologischen Instituts [Frankfurt a.M.], LXI (1983). Zugänge der Bibliothek

Index to Art Periodicals compiled in Ryerson Library, The Art Institute of Chicago. 11 vols.

 First supplement (1975)

L'Information d'histoire de l'art. Paris: 1956–76

Kunstchronik. [Zentralinstitut für Kunstgeschichte.] Munich: 1948–

Répertoire d'art et d'archéologie. Paris: 1910–65; nouvelle série, 1965–

RILA. *Répertoire international de la littérature de l'art / International Repertory of the Literature of Art*, 1975–
Schrifttum zur deutschen Kunst. Berlin: 1933/4–
Zentralinstitut für Kunstgeschichte, München. *Bibliographie zur kunstgeschichtlichen Literatur in Ost- und Südosteuropäischen Zeitschriften*, I (1971)–

SOME INDEXES TO SPECIFIC PERIODICALS

The Art Bulletin. An Index of Volumes I–XXX (1913–1948), comp. Rosalie B. Green. New York: Columbia University Press, 1950
– Index to Volumes XXI–LV (1949–1973), comp. Janice L. Hurd. New York: College Art Association, 1980
The Burlington Magazine. Cumulative Index, Volumes I–CIV (1903–1962). London: Burlington Magazine, 1969
– 10-Year Cumulative Index, Volumes CV–CXIV (1963–1972). London: Burlington Magazine, 1974
– Ten-Year Cumulative Index, Volumes CXV–CXXIV (1973–1982). London: Burlington Magazine, 1985
Gazette des Beaux-Arts. Table centennale, 1858–1959. Paris: Gazette des Beaux-Arts, 1968
Journal of the Society of Architectural Historians. Index to Volumes I–XX (1941–1961), comp. Shirley Prager Branner. New York: The Society, 1974

A SELECTION AMONG INSTITUTIONAL CATALOGUES

Bibliothèque Forney. Catalogue Matières: Arts décoratifs. Beaux-Arts, Métiers, Techniques. Paris: Société des Amis de la Bibliothèque Forney, 1970–4. 4 vols. Supplément 1979–80, 2 vols
Catalog of the Library of the Museum of Modern Art, New York. Boston: G.K. Hall, 1976. 14 vols
Catalog of the Library of the Whitney Museum of Art, New York, New York. Boston: G.K. Hall, 1979. 2 vols
Catalog of the Warburg Institute Library, University of London. Boston: G.K. Hall, 1961. 2 vols
2nd edition (1967), 12 vols
First supplement (1971)
Catalogue of the Avery Memorial Architectural Library of Columbia University. Boston: Microphotography Co., 1958. 6 vols
2nd edition (1968), 19 vols
2nd edition, first supplement (1972), 4 vols
2nd edition, second supplement (1976), 4 vols

2nd edition, third supplement (1977), 3 vols
2nd edition, fourth supplement (1979), 3 vols
2nd edition, fifth supplement (1982), 4 vols

Catalogue of the Gennadius Library, American School of Classical Studies at Athens.
Boston: G.K. Hall, 1968. 9 vols

Catalogue of the Harvard University Fine Arts Library. The Fogg Art Museum.
Boston: G.K. Hall, 1971. 15 vols
First supplement 1976, 3 vols

Catalogue of the Library of the National Gallery of Canada. Boston: G.K. Hall, 1973.
8 vols
First supplement 1981, 6 vols

Catalogue of the Public Archives Library, Public Archives of Canada, Ottawa, Ontario.
Boston: G.K. Hall, 1979. 12 vols. NB: Vols 10–12 include a Chronological List
of Pamphlets, 1493–1950

Catalogues of the Berenson Library of the Harvard University Center for Italian Renaissance Studies at Villa I Tatti, Florence, Italy. Boston: G.K. Hall, 1972. Author
Catalogue, 2 vols. Subject Catalogue, 2 vols

*Dictionary Catalogue of the Byzantine Collections of the Dumbarton Oaks Library,
Washington, D.C.* Boston: G.K. Hall, 1975. 12 vols

Dictionary Catalogue of the Library of the American Numismatic Society. Boston:
G.K. Hall, 1962
First supplement 1962–67 (1967)
Second supplement 1968–72 (1973)

Katalog des Kunsthistorischen Institutes in Florenz. Boston: G.K. Hall,
1964. 9 vols
Erster Nachtragsband (1968), 2 vols
Zweiter Nachtragsband (1972), 2 vols
Dritter Nachtragsband (1972), 2 vols

Kataloge der Bibliothek des Deutschen Archaeologischen Institutes, Rom.
Autoren und Periodica Katalog. Boston: G.K. Hall, 1969. 7 vols
Systematischer Katalog. Boston: G.K. Hall, 1969. 3 vols
Zeitschriften–Autoren Katalog. Boston: G.K. Hall, 1969. 3 vols

Kataloge der Bibliothek des Zentralinstituts für Kunstgeschichte, München. Munich:
K.G. Saur, 1982–4 (microfiche)
Alphabetischer Katalog and *Supplement*, 1982–4
Katalog der unselbständigen Schriften (Aufsatzkatalog) and *Supplement*, 1982–4
Sachkatalog, 1984

Library Catalog of the Metropolitan Museum of Art, New York. 2nd ed. rev. and enl.
Boston: G.K. Hall, 1980. 48 vols
1st edition (1960). 25 vols and seven supplements (1962–77)

Library Catalogue of the Conservation Center, New York University, Institute of Fine Arts. Boston: G.K. Hall, 1980
National Art Library Catalogue. Victoria and Albert Museum, London, England. Author catalogue. Boston: G.K. Hall, 1972. 10 vols
The New York Public Library. Astor, Lenox & Tilden Foundations. The Research Libraries
 Dictionary Catalog of the Art and Architecture Division. Boston: G.K. Hall, 1975. 30 vols
 Supplement 1974
 Dictionary Catalog of the Prints Division. Boston: G.K. Hall, 1975. 5 vols

SOME INDISPENSABLE TITLES

Beyond lexica and dictionaries, these are works that, while not strictly *of* art history, are indispensable to its pursuance. They represent many collateral issues or fields for which art-historical training does *not* prepare, but which are crucial for its insertion/reinsertion into general history and culture. It can be presumed that researchers exercise a certain mastery over their own discipline; the problem is their degree of mastery of or dependency upon the 'state of the art' in studies whose importance only becomes visible in a moment of need.

The art historian must therefore learn to use the reference tools and basic works of other fields as he starts out on research that complements or informs his own; these must become part of his thinking, even a second nature. Because of their exotic qualities one cannot just 'get into' them as would a Mr Fixit. So simple an instrument as a hammer has all the problems inherent in reference works – so forthright in appearance as to suggest it can be effectively used without any significant preparation. But if one has no idea how to swing or aim, or no sense of how a blow (or issue) may be deflected and what its results may be, one is likely to get hurt.

In scholarship the resulting wound, when examined by specialists, is variously known as 'overextension' or 'superficiality.' Since, however, every field intersects or addresses other fields, multidisciplinary work is inevitable and should be accepted for the necessity it is. Otherwise the field feeds upon itself and becomes progressively impoverished, not potentially enriched.

General training and attitude enable the researcher to 'refer' to something to get what he wishes – or to find that it isn't there and must be worked up from scratch. Indispensable works of reference not only follow

patterns but create them in an attempt to satisfy, even to anticipate, research demands once the essentials have been covered. The reader should be able to tell at a glance to whom the work is addressed and at what level of complexity it is written; nor should one have continually to consult the Introduction in order to master the contents and apparatus of the body.

The art historian must necessarily have more than passing acquaintance with the Old Reliables of many and varied disciplines he previously could never conceive as influencing his own. Beyond this, he must know the 'usual' titles that enable him to direct correspondence at home and abroad for specialized matters such as photographic procurement not less than general enquiry.

Bolgar, R.R. *The Classical Heritage and Its Beneficiaries*. Cambridge: Cambridge University Press, 1963

Bowers, Fredson. *Principles of Bibliographical Description*. New York: Russell and Russell, 1962

Cappelli, A. *Cronologia, chronografia e calendario perpetuo*. 3rd ed. Milan: Ulrico Hoepli, 1969

– *Dizionario di abbreviature latine ed italiane usate nelle carte e codici, specialmente del medio-evo, riprodotte con oltre 14000 segni incisi; con l'aggiunta di uno studio sulla brachigrafia medioevale, un prontuario di sigle epigrafiche, l'antica numerazione romana ed arabica ed i segni indicanti monete, pesi, misure, etc.* 6th ed. Milan: Ulrico Hoepli, 1961

Caron, Pierre. *Manuel pratique pour l'étude de la Révolution française* (Manuels de bibliographie historique, V). Paris: Librairie Auguste Picard, 1912. Contains a Concordance des calendriers républicain et grégorien (5 octobre 1793–22 septembre 1809), pp. 221-69

A Checklist of Painters c. 1200–1976 represented in the Witt Library, Courtauld Institute of Art, London. London: Mansell, 1978

Enciclopedia dello spettacolo. Rome: Casa editrice Le Maschere, 1954–1962. 9 vols
 Aggiornamento 1955–1965. Rome: Unione Editoriale, 1966
 Index. Rome: Unione Editoriale, 1968

Fredericksen, Burton B., and Federico Zeri. *Census of Pre-Nineteenth-Century Italian Paintings in North American Public Collections*. Cambridge: Harvard University Press, 1972

Havard, Henry. *Dictionnaire de l'ameublement et de la décoration depuis le XIIIe siècle jusqu'à nos jours*. Paris: Quantin, [1887–90]. 4 vols

Henkel-Schöne: Henkel, Arthur, and Albrecht Schöne. *Emblemata: Handbuch zur Sinnbildkunst des XVI. und XVII. Jahrhunderts*. Stuttgart: J.B. Metzler, 1967[1], 1976[2]

Hoffman, S.F.W. *Bibliographisches Lexikon der gesamten Literatur der Griechen.* 2nd
ed. Leipzig: A.F. Böhme, 1938–45, 3 vols; reprint Amsterdam: A.M. Hakkert,
1961

Holst, Niels von. *Creators, Collectors and Connoisseurs. The Anatomy of Artis-
tic Taste from Antiquity to the Present Day.* London: Thames and Hudson,
1967

Hunger, Herbert. *Lexikon der griechischen und römischen Mythologie, mit Hin-
weisen auf das Fortwirken antiker Stoffe und Motive in der bildenden Kunst, Lit-
eratur und Musik des Abendlandes bis zur Gegenwart.* 6th ed. Vienna: Brüder
Hollinek, 1969

International Directory of Arts 1987/88. 18th ed. Berlin: 1987. 2 vols
 I: Museums, Universities, Associations, Restorers, Experts, Names
 II: Antique Dealers, Numismatics, Art Galleries, Auctioneers, Publishers,
 Periodicals, Booksellers, Artists, Collectors

International Directory of Exhibiting Artists (annual), ed. Veronica Babbington
Smith. Oxford/Santa Barbara: Clio Press, 1981–
 I: Painters, Printmakers, Draughtsmen, Collagists
 II: Sculptors, Ceramicists, Photographers, Textile Artists, Jewellers, Glass
 Artists, Metal Smiths, Conceptual Artists, Video Artists, Assemblage Artists,
 Performance Artists, Environmental Artists

Koch, Georg Friedrich. *Die Kunstausstellung. Ihre Geschichte von den Anfängen bis
zum Ausgang des 18. Jahrhunderts.* Berlin: Walter de Gruyter, 1967

Kurz, Otto. *Fakes. A Handbook for Collectors and Students.* New Haven: Yale
University Press, 1948

Lehmann-Haupt, Hellmut. *Art under a Dictatorship.* New York: Oxford Univer-
sity Press, 1954

Lemprière's Classical Dictionary of Proper Names Mentioned in Ancient Authors, ed.
F.A. Wright. London: Routledge and Kegan Paul, 1949

Nash, Ernest. *Pictorial Dictionary of Ancient Rome.* London: A. Zwemmer, 1961.
2 vols

Peultier, Étienne-Gantois. *Concordantiarum universae Scripturae Sacrae Thesaurus
ea methodo, qua P. de Raze disposuit suum concordantiarum SS. Scripturae manuale
adornatus et tabulis synopticis locupletatus.* Parisiis: P. Lethellieux, 1939

Pigler, Andreas. *Barockthemen. Eine Auswahl von Verzeichnissen zur Ikonographie
des 17. und 18. Jahrhunderts.* 2nd ed. Budapest: Akadémiai Kiado, 1974.
3 vols

Praz, Mario. *Studies in Seventeenth-Century Imagery* (Sussidi Eruditi, 16). 2nd ed.
Rome: Edizioni di Storia e Letteratura, 1964

*Publisher's International Directory with ISBN Index / Internationales Verlags-
adressbuch mit ISBN-Register.* 12th ed. Munich: K.G. Saur, 1985. 2 vols

Riggs, Timothy (comp.). *The Print Council Index to Oeuvre-Catalogues of Prints by*

European and American Artists. Millwood (NY): Kraus International, 1983

Schlosser, Julius von. *La Letteratura artistica. Manuale delle fonti della storia dell'arte moderne*, tr. Filippo Rossi. 3rd ed. Florence: 'La Nuova Italia,' 1964

Schramm, Percy Ernst, Florentine Müthrich, and Hermann Fillitz. *Denkmale der deutschen Könige und Kaiser* (Veröffentlichungen des Zentralinstituts für Kunstgeschichte in München, II, VII). Munich: Prestel Verlag, 1962–78. 2 vols
 I: Ein Beitrag zur Herrschergeschichte von Karl dem Grossen bis Friedrich II., 768–1250 (1962)
 II: Ein Beitrag zur Herrschergeschichte von Rudolf I. bis Maximilian I, 1273–1519 (1978)

Schweiger, F.L.A. *Bibliographisches Lexikon der gesamten Literatur der Römer*. Leipzig: F. Fleischer, 1830–4; reprint Amsterdam, A.M. Hakkert, 1962

Tervarent, Guy de. *Attributs et symboles dans l'art profane, 1450–1600* (Travaux d'Humanisme et Renaissance, XXIX). Geneva: E. Droz, 1958–9
 Supplement and Index. Geneva: E. Droz, 1964

Travlos, John [Traulos, Ioannis]. *Pictorial Dictionary of Ancient Athens*. New York: Praeger, 1971

Troescher, Georg. *Kunst- und Künstlerwanderungen in Mitteleuropa 800–1800. Beiträge zur Kenntnis des deutsch-französisch-niederländischer Kunstaustauschs*. Baden-Baden: Verlag für Kunst und Wissenschaft, 1953–4. 2 vols

Verzeichnis der Zeitschriftenbestände in den kunstwissenschaftlichen Spezialbibliotheken der Bundesrepublik Deutschland und West-Berlins (VZK), ed. Marianne Prause. Berlin: Gebr. Mann, 1973

Waetzoldt, Wilhelm. *Deutsche Kunsthistoriker von Sandrart bis Rumohr*. Leipzig: E.A. Seemann, 1921

The World of Learning, 1987. 37th ed. London: Europa Publications, 1986

Wright, Christopher. *Paintings in Dutch Museums. An Index of Oil Paintings in Public Collections in the Netherlands by Artists born before 1870*. London: Sotheby Parke Bernet, 1980

Yates, Frances A. *The Art of Memory*. London: Routledge and Kegan Paul, 1966

SOME NOTABLE APPROACHES TO SUBJECT

> After thirty I began very slowly to want not only to be informed, but to understand. It is the problem with which I have been increasingly occupied ever since.
> B. Berenson, *Sunset and Twilight*

A Notable Approach is the ability to choose, define, or develop a subject so that it appeals to the imagination and extends the range of the field; it is works that depart from the established norm, works that amplify it

in unexpected ways. As a result, such works are less likely to be mono-graphic studies of artists or movements and may consolidate the field by assuming the form of a bibliography, lexicon, or bibliography of bibliographies.

More often than not, Notable Approaches represent incursions into art history by other disciplines whose experts see in its documentation things of interest to them; the question then becomes what the results mean to the field pillaged rather than the field served.

Such 'art history without artists' brings together elements of the cultural fabric not seen or detected prior to the study of literary and artistic *Realia*. It is like antiquarianism without its false modesty and is rather more a form of depersonalized erudition, certainly not the highly elusive essay, given over to artistic phenomena or products. Who at the time could have imagined all that has come directly or indirectly from disaster conserva-tion following the Florentine flood of 1966? Yet Notable Approaches only affect discrete portions of the field. More characteristically, they represent a choice rather than a necessity.

Such studies may be fragmentary or comprehensive in nature, often comprising highly technical discussions. *Their importance in published form comes on the realization that one really had no idea that the evidence now presented could be so copious, so fulsome.* As time has not yet been taken to assimilate the topic into the art-historical mainstream, some works will give rise to general, even heated controversy, while others are so particular as to be seen only as *curiosities* within the literature.

Seen with the patina of time, a work (initial reaction to which was of the 'Five hundred pages on this?' variety) may quite exhaust its usefulness as a mere study only to become an Approach, its qualities being recog-nized as its method emerges and is codified. In this context a catalogue puts all artifice aside, becomes more than a catalogue since its interpreta-tion or reinterpretation arises from unusual and highly focused evidence. The following list is deemed sufficient to recognize the genre when it is encountered.

Allen, Jelisabeta S. *Literature on Byzantine Art, 1892–1967.* London: Mansell for
 Dumbarton Oaks Centre for Byzantine Studies, 1973–6. 2 vols
Alpers, Svetlana. *The Art of Describing: Dutch Art in the Seventeenth Century.*
 Chicago: University of Chicago Press, 1983
Bailly-Herzberg, Janine. *L'eau-forte de peintre au dix-neuvième siècle: la Société des
 Aquafortistes, 1862–1867.* Paris: Léonce Laget, 1972. 2 vols
Baxandall, Michael. *Painting and Experience in Fifteenth Century Italy: A Primer in
 the Social History of Pictorial Style.* Oxford: Oxford University Press, 1972

Bieber, Margarete. *Ancient Copies. Contributions to the History of Greek and Roman Art*. New York: New York University Press, 1977

Boisserée, Sulpice. *Histoire et description de la Cathédrale de Cologne, accompagnée de recherches sur l'architecture des anciennes cathédrales*. Stuttgart: l'Auteur & J.G. Cotta / Paris: Firmin Didot père et fils, 1823

Bredius, A. *Künstler-Inventare. Urkunden zur Geschichte der holländischen Kunst des XVIten, XVIIten, und XVIIIten Jahrhunderts*. The Hague: Martinus Nijhoff, 1915–22. 8 vols

Brendel, Otto J. *Prolegomena to the Study of Roman Art*. London/New Haven: Yale University Press, 1979

Brion-Guerry, Liliane. *L'Année 1913. Les formes esthétiques de l'oeuvre d'art à la veille de la Première Guerre mondiale. Travaux et documents inédits*. Paris: Klincksieck, 1971–3. 3 vols

Buchanan, W. *Memoirs of Painting, with a Chronological History of the Importation of Pictures by the Great Masters into England since the French Revolution*. London: Thomas Davison for R. Ackerman, 1824. 2 vols

Dacos, Nicole. *La découverte de la Domus Aurea et la formation des grotesques à la Renaissance* (Studies of the Warburg Institute, 31). London: Warburg Institute, 1969

Denucé, J. *Kunstausfuhr Antwerpens im 17. Jahrhundert. Die Firma Forchoudt*. Antwerp: 'De Sikkel,' 1931

Eitner, Lorenz. *Géricault's Raft of the Medusa*. London: Phaidon, 1972

Errera, Isabelle. *Répertoire des peintures datées*. Brussels: G. van Oest, 1920–1. 2 vols

Frommel, Christoph Luitpold. *Der Römische Palastbau der Hochrenaissance* (Römische Forschungen der Biblioteca Hertziana, 21). Tübingen: E. Wasmuth, 1973

Haskell, Francis. *Patrons and Painters. A Study in the Relations between Italian Art and Society in the Age of the Baroque*. 2nd ed. New Haven/London: Yale University Press, 1980

Kier, Hiltrud. *Der mittelalterliche Schmuckfussboden unter besonderer Berücksichtigung des Rheinlandes* (Die Kunstdenkmäler des Rheinlandes, Beiheft 4). Düsseldorf: Rheinland-Verlag, 1970

Klesse, Brigitte. *Seidenstoffe in der italienischen Malerei des 14. Jahrhunderts* (Schriften des Abegg-Stiftung Bern, 1). Bern: Stämpfli, 1967

Lehmann-Haupt, Hellmut. *Gutenberg and the Master of the Playing Cards*. New Haven/London: Yale University Press, 1966

Locquin, Jean. *La peinture d'histoire en France de 1747 à 1785. Etude sur l'évolution des idées artistiques dans la seconde moitié du XVIIIe siècle*. Paris: Henri Laurens, 1912

Lücke, Hans-Karl, ed. *'Alberti-Index'. Leon Battista Alberti. De re aedificatoria*,

Florenz 1485. Index Verborum (Veröffentlichungen des Zentralinstituts für Kunstgeschichte in München, XI). Munich: Prestel-Verlag, 1975–9. 3 vols, text, facsimile

Marette, Jacqueline. *Connaissance des Primitifs par l'étude du bois du XIIe au XVIe siècle.* Paris: A. and J. Picard, 1961

Mayor, A. Hyatt. *Prints and People: A Social History of Printed Pictures.* New York: The Metropolitan Museum, 1971

Meiss, Millard. *French Painting in the Time of Jean de Berry. The Late Fourteenth Century and the Patronage of the Duke.* London: Phaidon, 1968. 2 vols

Mély, Fernand de. *Les Primitifs et leurs signatures.* Paris: Geuthner, 1913

Moir, Alfred. *Caravaggio and His Copyists.* New York: New York University Press, 1976

Pevsner, Nikolaus. *Academies of Art Past and Present.* London: Cambridge University Press, 1940

Pinder, Wilhelm. *Das Problem der Generation in der Kunstgeschichte Europas.* Berlin: Frankfurter Verlags-anstalt, 1926

Pollitt, J.J. *The Ancient View of Greek Art: Criticism, History and Terminology* (Yale Publications in the History of Art, 25). New Haven/London: Yale University Press, 1974

Ringbom, Sixten. *Icon to Narrative. The Rise of the Dramatic Close-up in Fifteenth-Century Devotional Painting.* Abo: Abo Akademi, 1963

Sandström, Sven. *Levels of Unreality. Studies in Structural Construction in Italian Mural Painting during the Renaissance* (Figura, n.s. IV). Uppsala: Almqvist & Wiksell, 1963

Schlosser, Julius von. *Die Kunst- und Wunderkammern der Spätrenaissance. Ein Beitrag zur Geschichte des Sammelwesens.* 2nd ed. Leipzig: Klinckhardt & Biermann, 1978

Sparrow, John. *Visible Words. A Study of Inscriptions in and as Books and Works of Art.* Cambridge: Cambridge University Press, 1969

Speth-Holterhoff, S. *Les peintres flamands de cabinets d'amateurs.* Brussels: Elsevier, 1957

Stechow, Wolfgang. *Dutch Landscape Paintings of the Seventeenth Century.* London: Phaidon, 1966

Thiem, Gunther, und Christel Thiem. *Toskanische Fassaden-Dekoration in Sgraffito und Fresco, 14. bis 17. Jahrhundert* (Italienische Forschungen, III). Munich: 1964

Verheyen, Egon. *The Palazzo del Te in Mantua. Images of Love and Politics.* London/Baltimore: Johns Hopkins University Press, 1977

Wackernagel, Martin. *Der Lebensraum des Künstlers in der florentinischen Renaissance. Aufgaben und Auftraggeber, Werkstatt und Kunstmarkt.* Leipzig: E.A. See-

man, 1938. Trans. by Alison Luchs as *The World of the Florentine Renaissance Artist*. Princeton: Princeton University Press, 1981

Weitzmann, Kurt. *Illustrations in Roll and Codex. A Study of the Origins and Method of Text Illustration* (Studies in Manuscript Illumination, 2). Princeton: Princeton University Press, 1947[1], 1970[2]

THE CORPUS: A REPRESENTATIVE SELECTION

A Corpus is a body of work and a body of knowledge. *It does not exist within itself and must be drawn together for study and/or publication*; at times, the constitution of a corpus is sufficient unto itself. The corpus has a specific focus; its issuance presumes a pace commensurate with the difficulties inherent in its subject since a presumption is made that every reasonable effort has been made to ensure completeness. While there is no real agreement on the size a corpus must assume to justify the name, it apparently is more and more rarely the life's work of one person or of several working *en société*.

While it may cover only what is in a given collection, its realization as a series presumes knowledge of all that is available or exists. Close and continued relations with scholars and museums the world over are necessary to its advancement. For certain topics it may be organized on an institutional and national basis, becoming an international enterprise whose fascicules appear at different speeds. This practice has some pragmatic basis in fact: when work is done within the framework of an *entente* over many years or generations, there is difficulty in giving undivided attention to something that surpasses immediate needs and becomes a monument to science.

There exists also a basic difference of aims and attitudes according to the type of corpus or repertory undertaken. The usual cleavage between archaeology and art history was well summarized in Berenson's opening words to the *Italian Pictures of the Renaissance: Venetian School* (1957): 'No slightest or pettiest bit of "Antique" vase painting is left out of the Corpus Vasorum that is being replenished continually. Surely the average Italian painting from 1300 to 1600 is not inferior in draughtsmanship and composition, while more varied in subject matter.' Any number of similar assertions might be made for Coptic textiles, Romanesque churches – or any well-nourished *catalogue raisonné* that for major figures assumes monumental proportions.

In general, however, *the Corpus is based on Realia, not attributions; it represents the accumulated identifications and localizations of generations*. It can as well be a simple (classified) list as an illustrated one, or a publication

with extensive commentaries. Even when the reader tends to look at plates as documentary adjuncts to the catalogue, one can be sure that the objects were gathered and photographed prior to extensive library work and correspondence.

In normal circumstances the Corpus is rather like the major dictionaries and lexica that no individual or generation sees to completion; its progress is measured from the time one first noticed the title to the last time one cast a glance its way, only to rejoice that it had finally reached *Empfängnis Mariae, unbefleckte*. The vast scope of the larger publications provides a working laboratory from which more specialized works of reference may be distilled; their progeny and succession is inconceivable, although these include the inevitable sport or simple-minded relation.

My brief listing aims at providing models for a number of specialized classes of objects from Antiquity to the present day, each of which has its own traditions of terminology and description. Much ultimately depends upon whether artefacts or works of *declared art* are concerned (much less the subclasses of the expected media), while other sectors are laws unto themselves.

Perhaps the most important thing to remember is that a Corpus, whatever its stated rationale, is sooner or later a *developmental history carrying its own comparisons within its pages*.

Antike Gemmen in deutschen Sammlungen: Berlin, Braunschweig, Göttingen, Hamburg, Hannover, Kassel, München. Munich: Prestel-Verlag, 1968–75. 4 vols in 8

Die antiken Sarkophagreliefs [Deutsches Archäologisches Institut, Rome], 1890– (imprint varies)

Berenson, Bernard. *Italian Pictures of the Renaissance. A List of the Principal Artists and Their Works with an Index of Places*
 Central Italian and North Italian Schools. London: Phaidon, 1968. 3 vols
 Florentine School. London: Phaidon, 1963. 2 vols
 Venetian School. London: Phaidon, 1957. 2 vols

Corpus der barocken Deckenmalerei in Deutschland, eds Hermann Bauer and Bernard Rupprecht. Munich: Süddeutscher Verlag, 1976–

Corpus der minoischen und mykenischen Siegel, eds Friedrich Matz and Hagen Biesantz. Berlin: Gebr. Mann, 1964–74. 13 vols

Corpus Palladianum. Vicenza: Centro internazionale di Studi di Architettura 'Andrea Palladio,' 1968–

Corpus Rubenianum Ludwig Burchard, 1968– (imprint varies)

Corpus vasorum antiquorum, 1922– (imprint varies)
– Crous, Jan W. *Konkordanz zum Corpus vasorum antiquorum*. Rome: Bretschneider, 1942

Corpus vitrearum Medii Aevi, 1922– (imprint varies)

Degenhart, Bernard, and Annegrit Schmitt. *Corpus der italienische Zeichnungen, 1300–1450*. Berlin: Gebr. Mann, 1968–80. 8 vols

 I: Süd- und Mittelitalien (1968), 4 vols

 II: Venedig. Addenda zu Süd- und Mittelitalien (1980), 4 vols

Goldschmidt, Adolph. *Die Elfenbeinskulpturen aus der Zeit der karolingischen und sächsischen Kaisern, VIII.–XI. Jahrhundert*. Berlin: Deutscher Verlag für Kunst, 1914–26. 4 vols

Lehmann-Brockhaus. *Lateinische Schriftquellen zur Kunst in England, Wales und Schottland vom Jahre 901 bis zum Jahre 1307* (Veröffentlichungen des Zentralinstituts für Kunstgeschichte in München, I). Munich: Prestel Verlag, 1955–60. 5 vols

Lehrs, Max. *Geschichte und kritischer Katalog des deutschen, niederländischen und französischen Kupferstichs im XV. Jahrhundert*. Vienna: Gesellschaft für vervielfältigende Kunst, 1908–34, 9 vols, 9 atlas; reprint Nendeln: Kraus, 1969

Millin, Aubin-Louis. *Antiquités nationales ou recueil des monumens pour servir à l'histoire générale et particulière de l'Empire françois, tels que tombeaux, inscriptions, statues, vitraux, fresques, etc. tirés des abbayes, monastères, châteaux et autres lieux devenus domaines nationaux. Présenté à l'Assemblée Nationale, et accueilli favorablement par elle, le 9 décembre 1790*. Paris: M. Drouhin, An 2–An 7/1790–7. 5 vols

Mollard-Besques, Simone. *Musée national du Louvre. Catalogue raisonné des figures et reliefs en terre cuite grecs, étrusques et romains*. Paris: Musées nationaux, 1954–72. 3 vols in 6

Offner, Richard, et al. *A Critical and Historical Corpus of Florentine Painting*. New York: 1930–

Les Primitifs flamands. Corpus de la peinture des anciens Pays-Bas meridionaux au quinzieme siècle, 1951– (imprint varies)

Richter, G.M.A. *Kouroi. Archaic Greek Youths. A Study of the Development of the Kouros Type in Greek Sculpture*. London/New York: Oxford University Press, 1942; London: Phaidon, 1960², 1970³

Trendall, A.D. *The Red-Figured Vases of Lucania, Campania and Sicily*. Oxford: Clarendon Press, 1967. 2 vols. Supplements 1970, 1973 as Supplements 26 and 31 of the University of London Institute of Classical Studies *Bulletin*

Vorromanische Kirchenbauten. Katalog der Denkmäler bis zum Ausgang der Ottonen (Veröffentlichungen des Zentralinstituts für Kunstgeschichte in München, III). Munich: Prestel-Verlag, 1968–75. 3 vols

Winkler, R. Arnim. *Die Frühzeit der deutschen Lithographie. Katalog der Bilddrucke von 1796–1821* (Materialien zur Kunst des 19. Jahrhunderts, 16). Munich: Prestel-Verlag, 1975

AUCTION AND EXHIBITION CATALOGUES

> Ma volonté est que mes dessins, mes estampes, mes bibelots mes livres,
> enfin les choses d'art qui ont fait le bonheur de ma vie, n'aient pas la
> froide tombe d'un musée, et le mégard bête du passant indifférent, et je
> demande qu'elles soient toutes éparpillées sous les coups du marteau du
> commissaire-priseur et que la jouissance que m'a procurée l'acquisition
> de chacune d'elles, soit redonnée, pour chacune d'elles, à un héritier de
> mes goûts.
> Edmond de Goncourt

This literature has two branches, that of the *repertory* of information as it is
created and published, and that of information *once analysed and ordered up*
for historical research. It represents a 'dispersal literature' intended to fix a
moment in history, after which its aims and usages are entirely divergent.

No other type of exhibition has the consistency of those held by the var-
ious Academies and Societies from the seventeenth century to the 1920s,
and *they chronicle the work of their members as well as the decline of Societies in
general*. They are most valuable – and much more interesting – for the early
periods, becoming over the years simple registration units. Organization
of such catalogues is by national or some smaller unit, by purpose or else
by some medium (as watercolour) held in common interest.

Today these catalogues assume the form of facsimiles complemented
with analytical indexes, or reprintings of one kind or another (reset, typed
out) adopting some point of view. *Emphasis can be on the cumulative exhibi-
tion record of all members or upon the integrity of each exhibition*, the one being
the inevitable means of understanding the other when dealing with simple
listings. Without such publications one must consult the internal records of
the institutions themselves, many of which have changed course or stature,
or been brought low. One tends to forget that the Societies kept in touch
with members and necessarily possess biographical and other data that
is often hard come by in any other way. The number of French artists in
Bénézit alone having celebrated their centenaries and more shows what
happens when one doesn't exhibit regularly and retires to the seaside or a
trou de campagne.

Bénézit, now in its third extensively revised edition, remains unique in
its attachment to documentation within a nineteenth-century context (at-
tributions), as stated in its first preface of 1924, 'estimant que nous ne
pouvions mieux répondre aux désirs des amateurs qu'en multipliant les
éléments d'authentification des oeuvres d'art.' To the usual biographical
details is appended a Union List of sorts, giving locations in public col-

lections, and then a list of prices obtained at auction. Although invariably 'out of date,' one has confidence that, unlike most such dictionaries, new insertions will be made – and that there will be a revised edition over the horizon. Universal coverage is attempted with, for more modern periods, mention of artists having attained a certain notoriety in the art world.

No survey however brief of literature can omit the pioneering efforts of Frits Lugt, whose work remains unsurpassed to our day. While the *Répertoire des catalogues de ventes* establishes a standard abbreviated notation for sales to 1925, the *Marques de collections* repertories the identifying marks public and private owners have apposed to establish ownership and, eventually, provenance. The latter title also contains the best thumbnail sketches of the dominant artistic personalities and events yet available. The 1956 supplement nearly doubles the original coverage of 1921, and while the use of collector's marks is on the decline, the *Répertoire* and its 58,704 sales is rather like the 16,112 watermarks identified by Briquet and his continuators. Not everything is there and much could be intercalated here and there, but both give *locations* for their materials as of date, which no one did before. And both were created far in advance of anyone else's need.

Still and all, Lugt sensitized scholars and curators to the possibilities of a meaningful universal notation (Lugt 811) in catalogue entries and bibliographies. Briquet paved the way for the understanding and dating of families of watermarks whose intricacies are best seen when comparing the most common families (Grape: 12,991–13,219) rather than the resolutely individual families and their sports. Most serious print and drawing catalogues now include appendices devoted to watermarks, whether or not these are drawn or registered through beta-radiographs, just as they include in their individual entries mention of the marks and collections through which the works have passed. We therefore are provided with yet another diagnostic technique for works to which it is applicable.

As for sales catalogues, they are the true ephemera of the discipline and are but rarely gathered together in sufficient numbers except institutionally or by the auction houses themselves (hence the utility of Lugt numbers when attempting 'identification by correspondence'). By the later nineteenth century, these catalogues had become more descriptive, often being illustrated by some of the most surprising names, while their prefaces were done by writers and critics of some note; never having been repertoried, they are lost to the field. This documentary approach was doubtless significant only when considering individual collections whose sale or transfer was an event.

Since the early 1950s, many such catalogues are simply assembled 'for clearance' and must be gone through and regarded in a very different way. The earlier catalogues are, as well, sought out and consulted for their *annotations* – even for the extraordinary documentary sketches by Saint-Aubin and others that have rendered such unsuspected service to generations of art historians and museum curators. Of course, this is to forget that straw men and agents have always been important to the conduct of auctions, while the intricacies of working through auction house and notarial records are only for those who can survive them.

Since the 1970s, the auction catalogue has through modern printing methods assumed attractiveness and even a quasi-luxury of format – coated papers, coloured illustrations – and a price to match. The Houses may themselves retain research staff capable of putting out 'ready-mades' – dossiers for prospective buyers – of a type where retrenchment is likely if the firms themselves are to survive, much less institutions wishing to acquire their catalogues.

In certain instances these catalogues function as embryonic articles or monographs; if not got *en série* or by subscription, they are almost impossible to secure individually without great attendant effort and expense. Yet for the significant works that pass through auctions, one can only be heartened that such work is being done and will be preserved somewhere. In other cases one has the impression that the *over-produced* auction catalogue is a form of publicity 'hype' intended for the lesser levels of merchandise and will not really affect attitudes toward items of first rank. The field has become so organized that the informed auctiongoer will resist the fashionable enthusiasms to secure what he knows and wants.

The lists following are meant to suggest the range of approach possible in such publication, republication, and analytics. Their range is not great since one is dealing with information concerning *who exhibits* and *what is exhibited*; readers will probably be more intrigued to discover the names and activities of early societies whose existence they never suspected than with their activities and production.

This is as it should be, for a comprehensive bibliography of what is *available* can be found elsewhere or through personal research. Its inclusion here would be only topical and very rapidly outmoded. That this literature exists at all, and is so well done, proves that the enormity of such endeavours, where the odds are so fundamentally against one, are none the less vulnerable to small gestures. Taken cumulatively, these add up to new solutions when certain documentary problems just won't go away.

Reference Works Based on Auctions and Exhibitions

Bénézit, E. *Dictionnaire critique et documentaire des peintres, sculpteurs, dessina-
teurs et graveurs de tous les temps et de tous les pays, par un groupe d'écrivains
spécialistes français et étrangers.* Paris: Gründ, 1924, 3 vols; 1948, 8 vols; 1976,
10 vols
The Boston Athenaeum Art Exhibition Index, 1827–1874, Robert F. Perkins, Jr and
William J. Gavin II, comp. and ed. Boston: Library of the Boston Athenaeum,
1980
Briquet, Charles Moïse. *Les filigranes. Dictionnaire historique des marques du papier
dès leur apparition vers 1282 jusqu'en 1600.* Paris: A. Picard et fils, 1907, 4 vols;
Leipzig: K.W. Hiersemann, 1923, 4 vols; Jubilee Edition, ed. Allan Steven-
son [facsimile of the 1907 edition with supplementary matter contributed
by a number of scholars], Amsterdam: Paper Publications Society, 1968,
4 vols
Cust, Lionel. *History of the Society of Dilettanti. Reissued with Supplementary
Chapter, List of Members, &c.* London: Macmillan and Company, 1914
Gordon, Donald E. *Modern Art Exhibitions, 1900–1916* (Materialien zur Kunst
des 19. Jahrhunderts, 14). Munich: Prestel-Verlag, 1974. 2 vols
Graves, Algernon. *The British Institution, 1806–1867. A Complete Dictionary of
Contributors and Their Works from the Foundation of the Institution.* London: G.
Bell and Sons / Algernon Graves, 1908
– *A Dictionary of Artists Who Have Exhibited Works in the Principal London Ex-
hibitions from 1760 to 1893.* 3rd ed., with additions and corrections. London:
Henry Graves and Company, 1901
– *The Royal Academy of Arts. A Complete Dictionary of Contributors and Their
Works from Its Foundation in 1769 to 1904.* London: Henry Graves and Co. /
George Bell and Sons, 1905–6. 8 vols
– *The Society of Artists of Great Britain, 1760–1791. The Free Society of Artists,
1761–1783. A Complete Dictionary of Contributors and Their Work from the Foun-
dation of the Societies to 1791.* London: George Bell and Sons / Algernon
Graves, 1907
Guiffrey, J.-J. *Collection des livrets des anciennes expositions depuis 1673 jusqu'en
1800.* Paris: 1869–72. 42 fascicules
– *Table generale des artistes ayant exposé aux Salons du XVIIIe siècle suivie d'une ta-
ble de la bibliographie des Salons, précédée de notes sur les anciennes expositions et
d'une liste raisonnée des Salons de 1801 jusqu'à 1873.* Paris: J. Baur, 1873
Die Kataloge der Berliner Akademie-Ausstellung von 1786–1850, ed. Helmut
Börsch-Supan (Quellen und Schriften zur bildenden Kunst, 4). Berlin: Bruno
Hessling, 1971. 3 vols
Lejeune, Théodore. *Guide théorique et pratique de l'amateur des tableaux. Etudes sur*

*les imitateurs et copistes des maîtres de toutes les écoles dont les oeuvres forment
la base ordinaire des galeries. Par Théodore Lejeune, artiste peintre, restaurateur de
tableaux, par suite de concours, des Musées impériaux, du Ministre d'Etat et de
la Maison de l'Empereur, Conservateur des Galeries Duchâtel, B. Fould, de Mor-
nay, Soulte de Dalmatie, etc. Chevalier de l'ordre royal d'Espagne.* Paris: Vve Jules
Renouard, 1864–5. 3 vols

Lugt, Frits. *Les marques de collections de dessins et d'estampes. Marques estampillées
et écrites de collections particulières et publiques. Marques de marchands, de mon-
teurs et d'imprimeurs. Cachets de vente d'artistes décédés. Marques de graveurs
apposées après le tirage des planches. Timbres d'édition, etc. Avec des notices his-
toriques sur les collectionneurs, les collections, les ventes, les marchands et éditeurs,
etc.* The Hague: Martinus Nijhoff, 1921–56. 2 vols

– *Répertoire des catalogues de ventes publiques intéressant l'art ou la curiosité.* The
Hague: Martinus Nijhoff, 1938–64. 3 vols (vol. IV published in Paris by Fon-
dation Custodia)
I: c. 1600–1825 (1938) III: 1861–1900 (1964)
II. 1826–1860 (1953) IV: 1901– 1925 (1987)

McMann, Evelyn de R. *Royal Canadian Academy of Arts / Académie Royale des
Arts du Canada. Exhibitions and Members, 1880–1979.* Toronto: University of
Toronto Press, 1981

Rutledge, Anna Wells, ed. *Cumulative Record of Exhibition Catalogues: The Penn-
sylvania Academy of Fine Arts, 1807–1870; The Society of Artists, 1800–1814;
The Artists' Fund Society, 1835–1845* (Memoirs of the American Philosophical
Society, XXXVIII). Philadelphia: American Philosophical Society, 1955

Salvadori, Fabia Baroni. 'Le esposizioni d'arte a Firenze dal 1674 al 1767,' *Mit-
teilungen des Kunsthistorischen Institutes in Florenz*, XVIII (1974), pp. 1–168

Smith, John. *A Catalogue raisonné of the works of the most eminent Dutch, Flemish,
and French painters; in which is included a short Biographical Notice of the Artists,
with a copious description of their principal pictures; a statement of the prices at
which such pictures have been sold at public sales on the Continent and in Eng-
land; a reference to the galleries and private collections, in which a large portion
are at present; and the names of the artists by whom they have been engraved; to
which is added, a brief notice of the scholars & imitators of the great masters of the
above Schools: by John Smith, dealer in pictures, late of Great Marlborough Street.*
London: Smith and Son, 1829–37, 8 vols. Supplement, 1842

Wildenstein, Georges. 'Table alphabétique des portraits peints, sculptés,
dessinés et gravés exposés à Paris au Salon entre 1800 et 1826,' *Gazette des
Beaux-Arts*, VI/LXI (janvier 1963), pp. 9–60

*Works Exhibited at the Royal Society of British Artists, 1823–1893 and at the New
English Art Club, 1887–1917*, comp. Jane Johnson. Woodbridge (Suffolk):
Baron Publishing for the Antique Collectors Club, 1975. 2 vols

Institutional (Public Card) Catalogues

Auction Catalogues of the Library of the American Numismatic Society [New York].
Boston: G.K. Hall, 1962. Becomes with First Supplement, 1967, the *Dictionary and Auction Catalogues.*

Catalogue des catalogues de ventes d'art, Bibliothèque Forney, Paris. Boston: G.K.
Hall, 1972. 2 vols

Catalogue of the Harvard University Fine Arts Library. The Fogg Art Museum.
Boston: G.K. Hall, 1971, vol. 15; First Supplement (1976), vol. 3

The Metropolitan Museum of Art Library Catalogue. Boston: G.K. Hall, 1980, vols
46–48; First Supplement (1982)

National Art Library Catalogue. Victoria and Albert Museum, London, England.
Catalogue of Exhibition Catalogues. Boston: G.K. Hall, 1972

THEORETICAL AND PRACTICAL LITERATURE ON EXHIBITIONS

Theoretical

Babelon, Jean-Pierre. 'Expositions et Musées d'Archives,' *La Gazette des Archives,*
n.s. no. 38 (7 décembre 1962), pp. 99–119

Bell, Michael. 'Canadian Galleries and Their Catalogues,' *Queen's Quarterly,*
LXXXVI (Summer 1979), pp. 254–63

Feld, Alan L., Michael O'Hare, and J. Mark Davidson Schuster. *Patrons despite
Themselves: Taxpayers and Art Policy. A Twentieth Century Fund Report.* New
York/London: New York University Press, 1983

Finlay, Ian. *Priceless Heritage: The Future of Museums.* London: Faber and Faber,
1977

Haskell, Francis. *Rediscoveries in Art. Some aspects of taste, fashion and collecting in
England and France* (The Wrightsman Lectures, 7). Ithaca: Cornell University
Press, 1976

Haskell, Francis, and Nicholas Penny. *Taste and the Antique. The Lure of Classical
Sculpture, 1500–1900.* New Haven/London: Yale University Press, 1981

Jones, Lois Swan. *Art Research Methods and Resources. A Guide to Finding Art
Information.* Dubuque: Kendall-Hunt, 1978[1], 1984[2]

Key, Archie F. *Beyond Four Walls: The Origins and Development of Canadian Muse-
ums.* Toronto: McClelland and Stewart, 1973

Kubler, George. *The Shape of Time. Remarks on the History of Things.* New Haven:
Yale University Press, 1962

Lee, Sherman E. *On Understanding Art Museums. Background Papers prepared for
the 46th Annual Assembly (Arden House, November 1974).* Englewood Cliffs:
Prentice-Hall, 1975

Meyer, Karl E. *The Art Museum: Power, Money, Ethics. A Twentieth Century Fund Report.* New York: William Morrow and Co., 1979

Taylor, Hugh A. 'Documentary Art and the Role of the Archivist,' *The American Archivist,* XLII (October 1979), pp. 417–28

Practical

Art Gallery Handbook, eds W. McAllister Johnson and Frances K. Smith. Toronto: Ontario Association of Art Galleries (OAAG), 1982

Dudley, Dorothy H., and Irma Bezold Wilkinson. *Museum Registration Methods.* 3rd ed. rev. Washington: American Association of Museums, 1979

Manual of Curatorship, ed. John M.A. Thompson. London: Butterworth, 1984

Parks Canada Parcs. *Canadian Inventory of Historic Buildings. Exterior Recording Training Manual,* by R. Bray, et al. Ottawa: 1980

Witteborg, Lothar P. *Good Show! A Practical Guide for Temporary Exhibitions.* Washington: Smithsonian Institution Traveling Exhibition Service (SITES), 1981

CANADIANA

This listing, which can be ignored by anyone not interested in the subject, is restricted in large measure to reference works in catalogue, article, or monographic form. To the reader intrigued by its curious composition some explanation is due, even if the discussion virtually obviates the listing.

Most Canadian studies in the history of art have until now been based upon either a sporadic knowledge of the principal collections or the concentrated knowledge of single collections. Such work necessarily supports the collections most closely related to the researcher himself; none the less, such investigations may not be considered altogether objective, but rather more as the justification of collecting activity, whether past, present, or future. The small amount and rather uniform nature of any substantial literature on Canadian art within the last two decades remains, even today, a serious preoccupation. A rapid glance into the bibliography as a whole reveals either anthologies or else a disconnected series of monographs or *catalogues raisonnés.* The ideas and institutions that conditioned the art are as yet largely neglected, while much of Canadian art history has yet to be written at more than a popular level.

In time, even the major institutions will likely prove less and less able to survey the field broadly, given the increasing pressures of provincialism and parochialism. This unwillingness has often resulted in the in-

ability (or unwillingness) to consider Canadiana 'from the outside,' that is, from its European and American context. Through captive and willing local audiences this attitude has resulted in the characterized inability to explain Canadian phenomena for non-Canadian audiences: art is approached through the values it *must* and *should* project rather than through what it is and has in large measure closed down the intellectual horizon and contributed to, perhaps even determined, the rather indifferent level of art curating.

While formed to some extent by universities, most Canadianists have pursued their investigations within extant municipal, provincial, or national collections. How sad that more has not been seen in print as a result of all these years of devotion to search and order. Such 'career-based' research also has the inherent weakness of proceeding upon a false assumption – that of obsessive specialization – within the wide variety of artistic phenomena commonly described as Canadian.

The greatest constant disadvantage under which Canadian researchers labour is the geographical magnitude of the country and the knowledge that such concentrations of original materials as do exist are scattered in the great regional concentrations – Halifax, Fredericton, Calgary, and Vancouver – or in the 'Golden Triangle' of Toronto, Montreal, and Ottawa.

Beyond this, the Museum and Gallery have been funded increasingly for exhibitions and acquisitions; as a result, public attention has been forcefully drawn to specific works of art or artists to the point of assuming that an exhibition is the normal, perhaps the only way of dealing with Canadian art. In this view the public is right without knowing it. Were a series to be devoted to the systematic publication of exhibition catalogues and reviews, a coherent body could be constituted to stimulate general work. Were another series constituted that undertook to publish only miscellany from all the different periods, regions, and provinces without arranging them by preconceived ideas or linguistic groupings, one might actually understand the formative sources and all that proceeds from them. Together, these series would establish the true repertory of art and artists implicitly in even the most haphazard collection of source material. *But only if it is in one place and format.* It is all so simple; which is why it will never be done.

Because most art publication in Canada is directed at loan exhibitions, the collection catalogues are either far outdated or few in number and far between. It could hardly be otherwise when the art institutions themselves have not realized the importance of the curator any more than they have acknowledged the role of research and custodial duties.

Nor are things (bibliographically) what they seem, if one but knows that a number of titles that *are* books *were* exhibitions; while many exhibitions have been drawn – and more or less well identified as such – from permanent collections. Still others are *catalogues raisonnés* of a hybrid sort that began by investigating that portion of an oeuvre held in a public collection, usually resulting from scattered purchase and an important bequest, and then filling out the picture.

As of 1983, one periodical, *RACAR*, created a rubric Collections 'to encourage art institutions to publish illustrated summary catalogues of coherent collections and sub-collections,' but it remains to see whether such an initiative can make substantial inroads into the collective inertia. It will always be necessary to consult the *Catalogue of the Library of the National Gallery of Canada* in an attempt to piece together relevant bibliography. One likewise awaits the issuance of the revised second edition of Hubbard's catalogue of the Canadian collection, the first dating from 1960 only.

The listing below is intended more to illustrate the types of literature available than to put together even a moderately coherent picture of the bibliography as a whole.

Allaire, Sylvain. 'Les canadiens au Salon officiel de Paris entre 1870 et 1910: sections peinture et dessin,' *Journal of Canadian Art History / Annales d'histoire de l'art canadien*, IV (1977–8), pp. 151–4

Allodi, Mary. *Canadian Watercolours and Drawings in the Royal Ontario Museum*. Toronto: Royal Ontario Museum, 1974. 2 vols

– *Printmaking in Canada: The Earliest Views and Portraits* (Royal Ontario Museum, Toronto, 18 April–25 May 1980)

Bayer, Fern. *The Ontario Collection*. Toronto: Fitzhenry and Whiteside for the Ontario Heritage Foundation, 1984

Burant, Jim. 'Art in Halifax: Exhibitions and Criticism in 1830 and 1831,' *RACAR*, VIII (1981), pp. 119–36

Catalogue of the Library of the National Gallery of Canada. Boston: G.K. Hall, 1973. 8 vols

 First Supplement. Boston: G.K. Hall, 1981. 6 vols

Catalogue of the Public Archives Library, Public Archives of Canada, Ottawa, Ontario. Boston: G.K. Hall, 1979. 12 vols. (Vols 10–12 include a Chronological List of Pamphlets, 1493–1950)

Clark, Jane. *Reference Aids in Canadian History* (Reference Series, 14). Toronto: Robarts Library, University of Toronto, 1972

The Concordia University Art Index to Nineteenth Century Canadian Periodicals, ed. Hardy George. Montreal: Concordia University, 1972

Directory of Canadian Archives / Annuaire des dépôts d'archives canadiens. Bureau

of Canadian Archivists / Association of Canadian Archivists, 1981 (imprint
varies)

Dictionary of Canadian Biography/Dictionnaire biographique du Canada. Toronto/
Québec: University of Toronto Press/Presses de l'Université Laval, 1966–

*Guide to Canadian Photographic Archives / Guide des archives photographiques
canadiens,* ed. Christopher Seifried. Ottawa: Public Archives of Canada /
Archives publiques du Canada, 1979[1], 1984[2]

Harper, J. Russell. *Early Painters and Engravers in Canada.* Toronto: University of
Toronto Press, 1970

– *Painting in Canada. A History.* Toronto: University of Toronto Press, 1966[1],
1977[2]

Kallmann, Helmut. *A History of Music in Canada, 1534–1914.* Toronto: Univer-
sity of Toronto Press, 1960

Lacroix, Laurier. 'Les artistes canadiens copistes au Louvre, 1838–1908,' *Journal
of Canadian Art History / Annales d'histoire de l'art canadien,* II (Summer 1975),
pp. 54–70

*The Lorence Lande Collection of Canadiana in the Redpath Library of McGill Univer-
sity; a bibliography collected, arranged and annotated by Lorence Lande* (Publica-
tions of the Lorence Lande Foundation for Canadian Historical Research, 1).
Montreal: McGill University Press, 1965

 First Supplement to the Lande Bibliography (Publications of the Lorence Lande
 Foundation for Canadian Historical Research, 6). Montreal: McGill Univer-
 sity Press, 1971

Lowrey, Carole D. 'The Society of Artists & Amateurs, 1834: Toronto's First Art
Exhibition and Its Antecedents,' *RACAR,* VIII (1981), pp. 99–118

Mackenzie, Karen, and Larry Pfaff. 'The Art Gallery of Ontario: Sixty Years of
Exhibitions, 1906–1966,' *RACAR,* VII (1980), pp. 62–91

McKenzie, Karen, and Mary F. Williamson. *The Art and Pictorial Press in Canada:
Two Centuries of Art Magazines* (Art Gallery of Ontario, Toronto, 10 February–
25 March 1979)

 Review: 'Two Looks at the Art Press,' *RACAR,* VII (1980), pp. 113–16

Mainprize, Garry. 'The National Gallery of Canada: A Hundred Years of Exhibi-
tions. List and Index,' *RACAR* XI (1984), pp. 3–78

McMann, Evelyn de R. *Montreal Museum of Fine Arts, formerly Arts Association of
Montreal: Spring Exhibitions, 1880–1970.* Toronto: University of Toronto Press,
1988

Milrad, Aaron, and Ella Agnew. *The Art World. Law, Business and Practice in
Canada.* Toronto/Vancouver: Merrit Publishing Company, 1980

The Official Directory of Canadian Museums and Related Institutions, 1987–1988.
Ottawa: Canadian Museums Association, 1987

Pfaff, L.R. 'Lawren Harris and the International Exhibition of Modern Art. Rec-

tifications to the Toronto Catalogue (1927), and Some Critical Comments,'
RACAR, XI (1984), pp. 79–96

Reid, Dennis. *A Concise History of Canadian Painting*. Toronto: Oxford University
Press 1973[1], 1988[2] (2nd ed. extends chronological limits from 1965 to 1980)

*Report and Recommendations of the Task Force charged with examining federal policy
concerning museums / Rapport et recommandations du Groupe de travail chargé
d'examiner la politique muséologique fédérale*. Ottawa: Minister of Supply and
Services, 1986

Research Collections in Canadian Libraries, 6: Fine Arts Library Resources in Canada.
Ottawa: National Library, 1978. 2 vols

Retfalvi, Andrea (comp.). *Canadian Illustrated News (Montreal). Index to Illustra-
tions (1869–1883)*. Toronto: Department of Fine Art, University of Toronto,
1977–

Singer, Loren, and Mary Williamson. *Art and Architecture in Canada: A Bibliogra-
phy and Guide to the Literature / Art et architecture au Canada: une bibliographie
et un guide de la littérature*. Forthcoming.

The following lists variations on permanent-collection catalogues.

Agnes Etherington Art Centre. Permanent Collection. Kingston: Agnes Etherington
Art Centre, Queen's University, 1968

Ainslie, Patricia. *Images of the Land. Canadian Block Prints, 1919–1945* (Calgary:
Glenbow Museum, 21 December 1984–17 February 1985)

Art Gallery of Ontario. The Canadian Collection. Toronto: McGraw-Hill, 1970

*The Arts of Italy in Toronto Collections, 1300–1800, based on the Holdings of the
Art Gallery of Ontario, The Royal Ontario Museum and Private Collections in the
Toronto Area* (Art Gallery of Ontario, Toronto, 19 December 1981–14 February
1982)

Bell, Michael. *From Annapolis Royal to the Klondike. Painters in a New Land*.
Toronto: McClelland and Stewart, 1973

Brooke, Janet M. *Études et petits formats du 19e siècle / 19th Century Paintings and
Small Sketches*. Montreal: Musée des Beaux-Arts, 1980

Building a Collection. Selections from the MacKenzie Bequest and Other Gifts (14
July–6 August 1978); *Selectons from Purchases made 1953–1977* (11 August
1978–3 September 1978). Twinned catalogues, Norman Mackenzie Art
Gallery, University of Regina

*The Canada Council Art Bank Catalogue / Conseil des Arts du Canada. Catalogue
de la Banque d'oeuvres d'art (September 1972–March 1975)*. Ottawa: Canada
Council, 1975. (Revised edition as *Art Bank Catalogue / Catalogue de la Banque
d'oeuvres d'art, 1972–1984*. Ottawa: Canada Council, 1985)

Canada in the Nineteenth Century. The Bert and Barbara Stitt Family Collection (Art

Gallery of Hamilton, 22 March–29 April 1984)

Confederation Centre Art Gallery and Museum. Permanent Collection. Charlotte-
town: Confederation Centre Art Gallery and Museum, 1986

Cooke, W. Martha E. *W.H. Coverdale Collection of Canadiana. Paintings, Water-
colours and Drawings (The Manoir Richelieu Collection).* Ottawa: Public Archives
of Canada, 1983

Haldane, Alexandra L. *Canadian Art Collection. Paintings, Drawings, Prints and
Sculpture from the Collection of the University of Western Ontario.* London:
McIntosh Gallery, 1983

Hubbard, R.H. *The National Gallery of Canada. Catalogue of Paintings and Sculp-
ture, III: Canadian School.* Ottawa: National Gallery, 1960

Le Musée du Québec. 500 oeuvres choisies. Quebec: Musée du Québec, 1983

*National Gallery of Canada. Catalogue of European and American Painting, Sculp-
ture, and Decorative Arts, I¹: 1300–1800,* eds Myron Laskin, Jr and Michael
Pantazzi. Ottawa: National Gallery of Canada, 1987. 2 vols

Ness, Kim G. *The Art Collection of McMaster University. European, Canadian
and American Paintings, Prints, Drawings and Sculpture.* Hamilton: McMaster
University Press, 1987

Oko, Andrew J. 'The Prints of Carl Schaefer,' RACAR, X (1983), pp. 171–98

The Society of Canadian Painter-Etchers and Engravers in Retrospect (Art Gallery of
Hamilton, 14 September–15 October 1978; published 1981)

Tovell, Rosemarie L. *Reflections in a Quiet Pool. The Prints of David Milne.*
Ottawa: National Gallery of Canada, 1980

University of Saskatchewan. Permanent Art Collection. Saskatoon: University of
Saskatchewan, 1980

Watson, Jennifer C. *The Robert McLaughlin Gallery. Permanent Collection.*
Oshawa: Robert McLaughlin Gallery, 1978

Wight, Darlene. *The Swinton Collection of Inuit Art* (Winnipeg Art Gallery, 13
September–8 November 1987)

3 Writing

On Quality in Writing

Pour juger impartialement, il faudrait avoir lu toutes les histoires, tous les mémoires, tous les journaux et toutes les pièces manuscrites, car de la moindre omission une erreur peut dépendre qui en amènera d'autres à l'infini. Ils y renoncèrent.
 Flaubert, *Bouvard et Pécuchet*

Quality in writing is recognized by its absence. Its relative absence is usually a result of people not having written enough at an early stage of life or not having their work undergo proper scrutiny at critical moments.

In academic context, indifferent writing is almost invariably the result of inflated enrolments and unchallenging topics where emphasis is placed upon the correctness of information rather than any elegance in statement. The danger is that one unconsciously comes to accept this turn of events; worse yet, it insidiously and effortlessly transforms the modes of thought and expression that should be employed in good writing.

Scientific writing necessarily supposes an armature of facts and observations ordered by grammar and syntax.[1] Translated into art-historical context, this means that even the highest visual literacy cannot wantonly be grafted onto history; nor should the opposite obtain, since the two should merge as a result of thought. Such a process is not restricted to the young: Gombrich and Panofsky became master stylists of English at a rather advanced age.[2] Although their aptitude was certainly exceptional, it was but an extension of their sensitivity toward *all* written sources. Few may legitimately aspire to the status of such models, while everyone may hope to ameliorate his linguistic tools and, therefrom, his understanding.

All appearances to the contrary, written and oral expression have very different ends now that rhetoric has become a lost art; the first lends itself

to close examination and reflection, the latter serves a purely 'evacuatory' function. The measure of success in writing is when it seems effortless in the reading. In this respect, the written and oral modes may complement each other in their concern for clarity of expression. It may prove helpful to 'voice' what one writes, much as Flaubert recited his novels in the wilderness, ruthlessly extirpating hackneyed phrases, tautologies, and repetitive vocabulary. Many stylistic or even substantive infelicities may satisfy the eye; when sounded out, they reveal themselves for what they are, simple puffery. Some middle ground must be found between platitude and pretentiousness.

In one's working life – I consciously avoid the term career – one must confront grim realities. Foremost among them is that, in the time allotted one, it becomes imperative to decide whether research topics are worth developing; once they are found to be feasible, one must necessarily resolve all questions arising in the course of their elaboration. Perhaps they are not worth committing to paper after all and best represent the interiorized intellectual discovery that should be expected over the years. It must be assumed that readers are willing and able to sigh '... and then?' or else to sniff '... so what?' No little part of their reaction (for people do react subconsciously to things they might not openly appreciate) depends upon the level of language employed in an exposition. How revealing it is when your article is refused – mainly, it seems, because 'you also use a very complex syntax that may be difficult for our readers to follow.' (The tradition of writing in certain fields or journals may well determine standards and unconsciously limit expectations.) Where does the blame really lie?

Beyond the obvious lapse or the typographical error, the misuse of conjunctions and adverbs is among the more classic faults in writing. Like documents, conjunctions and adverbs may serve more than one purpose or function at several levels; the mere compilation of all available references on a subject becomes in time rather like the bibliographical entries in exhibition catalogues. Reference *is made*, but no corresponding distinction as to context or essential difference *is given* – unless, of course, the historiographical route is retraced in its entirety. Still, an abundance of literature may serve to obscure the object of discussion, that is, the work of art. Intelligent use of conjunctions not only relieves monotony, it serves your argument by the subtle infusion of *nuance*. 'And' is the weakest of conjunctions. Because it is enumerative, it could just as well be replaced by a period. (For some reason, the semicolon has fallen into disuse, while many North Americans hardly use the dash or the parenthetical aside.) Adverbs are best used sparingly as they tend to take on an absolute quality, although, when used restrictively, they usually do not survive in quo-

tation. An editorial stance is asked of every competent journeyman, which status is of late some attainment in itself.

Technicity is a sword of Damocles. Where, for example, should footnote numbers and figure references be placed lest the mind's eye be inopportunely distracted? At base, technicity may be as little as the avoidance of elision in elevated discourse, the use of the double quote on the typewriter to counterfeit an *umlaut*, or the ordering of illustration (and there is much abuse of their number) so that juxtaposition or sequence 'gives the argument' without prior reference to the accompanying text. It might well be the thoughtful composition of pictorial legends. Once of purely factual nature, the discursive legend is a recent trend (*Gazette des Beaux-Arts* via *Apollo*) that briefly gives the document's interest; it is surely a genteel way of suggesting that today's reader is unwilling to plough through too many pages to find the gist of an article. *It follows that the length of an exposition is a function of what should be said, not what one can make of it!* (In passing, Gombrich has publicly lamented the vogue of the 'ingenious' hypothesis that cannot be disproved any more than it may be proved but which, once uttered, has a life and influence all its own.) All in all, 'diminished powers' should result from the ageing process or the poor choice of a topic; they just as surely presume the existence at some higher level of acquired skills. One must particularly beware of 'problems' that may be set up and knocked down with consummate ease: these are usually 'not-problems' giving the illusory, if comforting, sense of competence to novices or vested interests within the field. Self-doubt is a *constructive* force. Created by circumstance, it is rather like unto the dilemma of the now-fashionable zero-based budget, based upon known situations and proven needs, but requiring constant rethinking.

One must be charitable in the appreciation of an author's intent, severe in the evaluation of what results. We are all subject to forces beyond our control, fully responsible for what is within our grasp. Even a *bad* article can be of use; even imprecise or quite deficient formulations, much less the unknown document suddenly revealed, may set off an associative process. What a pity we are all not more creative, yet the real problem is avoiding stagnation or intellectual bankruptcy.

As untold hecatombs of forests are regularly offered up to personal vanity, it can be said that most people are so anxious to get into print that they fail utterly to consider how their contributions will look some years hence. One must know where to stop or when to abstain, how to recognize the elusive point of diminishing returns. In a word, *how best to avoid scholarly overkill*. One usually abstracts even the most involved theses, distilling into the fewest possible sentences those points that, however painstaking

their demonstration, are deemed of universal applicability. In like manner, amputation of verbiage or superfluous apparatus in typescript (paper and typographical composition are rapidly becoming more costly than illustration) normally results in that salutary diminution of submitted length – by perhaps one-third or more – that is likely to be more in accord with an article's *real* content. The injunction to do unto others is the putting into practice of a certain modesty. One reads more than one will ever write. If only it could be felt worth the time spent, for the more recapitulation is involved, the less is the impact made:

The ceaseless growth of bureaucracy has recently been expressed by a formula ('Parkinson's Law') according to which the less work (w) is done by more persons (p), the more time (t) it takes to do it: $t = p^2/w$. The equally ceaseless growth of scholarly literature, particularly in the history of art, is dominated by the somewhat analogous rule that the more research (r) is done on a smaller number of subjects (s), the more our understanding (u) seems to diminish: $u = s/r^2$. If A writes four pages about a given problem, it takes B sixteen to refute him, and C needs sixty-four to restore – more or less – the status quo.[3]

A word on unpublished documents. In an age when archival research is as obligatory as it has become fashionably trivialized, it would be a relief to find precise summaries of information contained in documents presenting for the most part no particular problems of formulation or nomenclature. *Greater issues must be introduced or clarified with economy, while fastidious accumulations of references not borne out by extant documentation must be rejected except when some principle is involved.* Only in this way can one of the better functions of the critic – to provide a verbal structure that distils the controversies surrounding objects so that future readers may exercise their capacities at a significantly higher level – be satisfied with exemplary disinterestedness.

Not all evidence *does* speak for itself; close reasoning and a matter-of-fact presentation assume that readers should be capable of coming to grips with facts, concepts, and even the governing and omnipresent abstractions: *à bon entendeur, demi-mot*. The corollary is not to rush into print insubstantial or unsubstantiated reactions upon the discovery of a catchword passed over in some foul and neglected papers. (After all, why bother questioning its true import when reputations can be made from the fact that it *is* unpublished and when journals may require space-filler.)

Of course one should be concerned with the literature that is not yet written, with subjects as yet unplumbed that could restructure for generations to come the commonplaces we so blithely mouth. Unfortunately this concern seems to require uncommon discretion when one navigates the waters between the Scylla of diverting triviality and the Charybdis of pompous barrenness common to all classic problems. These efforts are normally suitable only as scholarly exercises, as testing grounds of the moment requiring one to declare oneself according to the maturity of one's present faculties and experience. They are confronted at every stage. Their practical equivalent would be the presentation to a number of scholars of a given documentation at identical moments and in identical order, then asking the scholars to make something of it. It would be seen, alas, that exclusivity of source material has little to do with exegetical quality.

Once committed to print, deathless prose becomes terribly mortal, not to say comic. Once given over to the public like a whore, it assumes its own destiny. The writer's craft is far from absolute in practice, its rules elastic rather than formulary: common sense and good taste are always in demand, always of use in such situations. Precedent is a guide to *acceptable* even more than accepted usage. Beyond what is common to all good writing, different problems necessarily require the adaptation of method to the circumstances. In this regard, one is always creating the sources of the future by determining what is treated and in what way. The documentary nature of dealer catalogues is absolute; in contrast, temporary and permanent exhibition catalogues are less the result of independent (uncommissioned) research than official documents meant to serve other people's needs. It is impossible to reply to the anticipated needs of others except by setting forth what is pertinent to an understanding of the objects catalogued. Admittedly, every excursion into scholarly writing represents a learning experience; but would you wish to use fifty years hence what you are now inflicting on the reading public? Such foreknowledge requires a supremely objective effort of the imagination on your part to determine what should prevail and what must go unrecorded.

In sum, the aim of scholarly writing in any discipline is to see whether a received opinion or consensus view is coincident with all pertinent information, imbued with a solid critical sense. The catalogue notice is an essential evil, a special craft (and not a *lesser* one) in the history of art. In more normal circumstance, the question is how to apportion effort between the text proper and footnote reference or discussion. Some literary sense on your part assures progression of thought leading your reader ever onward

to a proper conclusion, the conclusion of a work that has been prepared for his pleasure as well as his profit.

The Writing of Art History

> En un mot, comme on désire avec ardeur un bonheur, sans l'espérer; on doit tendre avec effort à l'infaillibilité, sans y prétendre.
> Malebranche, *De la recherche de la vérité*

One of the more serious misapprehensions about the writing of art history is that its entire critical and documentary infrastructure – what it takes in hidden work to get to the point one *can* write – is forgotten. All this depends upon what may be termed the Four H's:

1 *heuristics* (a system of education under which the pupil is trained to find out things for himself [OED])
2 *hermeneutics* (the art or science of interpretation [OED], as opposed to exegesis, which is exposition or practical explanation)
3 *historical method* ('the process of critically examining and analyzing the records and survivals of the past'[4])
4 *historiography* ('the writing of history, i.e. the imaginative reconstruction of the past from the data derived through historical method'; in greatly restricted sense, 'the critical examination of history books already written'[5])

These components are to some degree learned and to some degree absorbed. Once mastered to a reasonable degree and kept in mind, the researcher need only consider their specific application.

All four require the emission of value-judgments – 'I know this, but there is a better (or more recent) source or explanation' – and further presume the intellectual means to ignore literature or conversation that addresses not the aims of one's own work. They imply, as well, the less challenging but unavoidable *subserviences*, such as flipping through fifty volumes of periodical indexes for bibliography on a given artist, worthwhile or not.[6] Application of the Four H's is largely a matter of conscience. Taken together, they represent a constant interaction between practical and more abstruse faculties that, all of them, pass through what may be considered 'general organizational ability.'

It is conveniently disremembered that a term or research paper is a limited exercise indeed, and that the establishment of scholarly levels of distinction only comes with the *thesis, memoir, or dissertation*. Even this is two-faced or, if you will, schizophrenic inasmuch as writing in the history of art serves the double purpose of

– an *apprenticeship in research*, which must nearly always consist of a study having at least one 'original' aspect; and

– a *university exam* permitting the professor and jury to verify the student's extent of knowledge, aptitude for research, and experience acquired.[7]

This dual purpose, were it only recognized early enough, illustrates well the cruel paradox of having to learn the tools of the trade at the very moment one is expected to provide an 'accomplished' piece of research for others to evaluate. (It would be a kindness at this point to inform unsuitable students of the stark realities of the field: that they stand no chance of success, however moderate.)

The results obtained from formal university writing may in some manner depend upon more purely cultural factors (linguistic competence, literary expression) or even a given intelligence quotient. None is sufficient to itself. Nothing is assured, and it is often only a decade or so after the completion of training that the scholarly world has some inkling of the result. Still it can be said that a more or less favourable evaluation at the training stage *calculates the risks* and serves as an Early Warning System for relative success or failure within the field. The evaluation obtained must accordingly be projected into the future so as to estimate as closely as possible what the candidate *has a chance of becoming* as a result of more experience, better facilities and guidance, greater maturity, and increasingly demanding problems.

Assuming the student, here taken in the broadest sense, is reasonably alert, only reasonably aware of the implications of what he is going through, he must, even at this primary level, confront the spectre of Doubt. It intervenes at every waking moment, at every level of the research process; it often supervenes when comparing his own experience with the accumulated work of the ages and, most often, of superior minds; it will increase as rapidly as he learns. One's relative insignificance and inability to execute 'in the manner one would wish' the most simple art-historical research runs in its most solemn injunction:

L'homme de science a l'obligation de douter et de n'accepter, sans examen personnel, aucune affirmation, aucune observation, aucune référence, aucune lecture de textes, aucune interprétation, aucune hypothèse. Il lui faut tout contrôler par soi-même, tout repenser; il ne peut admettre l'apport d'autrui sans l'avoir vérifié très sérieusement. Ce qui revient à dire que, pour l'homme de science, l'argument d'autorité n'a aucune valeur.[8]

Such a formulation can only be an ideal statement. It is quite simply *impossible to execute* in practical terms without leading to mental anguish and

intellectual paralysis. Everyone must at one time or another take short cuts, trust to others in the impossibility of verifying oneself the sweep of history and all its tangible and inferred vestiges. Like the jury evaluating a thesis, one must calculate the risks, take some chances – and recall that Saint Sebastian had *two* martyrdoms only one of which was due to the slings and arrows of outrageous fortune.

The amount of work required within the context of the aforementioned ideal research conditions necessarily varies with the topic and/or art object. Much depends upon the degree to which it is 'unknown,' that is to say:

– has *not* been dealt with previously;
– is *mentioned* in a footnote or in passing;
– has been *illustrated* according to the means of the period;
– is the object of an *extensive or sophisticated literature* over a greater or lesser period of time.

None of these 'conditions of access' is to be taken as proof of intrinsic worth, only as a rule of thumb as to the type and level of critical interest accorded a work of art since its creation. In the case of a larger topic, these are rather more indications of the prevailing taste or orientation of thought and in no way preclude the counter-currents. This is to say that *cultural inferences* exist at many levels, and these levels are unthinkingly perpetuated unless subjected to cogent reasoning and qualitative evaluation. Thus the antiquarian is to the art historian what the genealogist is to the historian, 'plus un collectionneur qu'un savant, un minutieux érudit qui sait étiqueter un objet mieux qu'en donner une interprétation complète et le situer dans l'évolution historique.'9

The aforementioned definitions also have more general applications. Firmly rooted in the type and degree of 'descriptive' and 'interpretive' tasks, they concern literary, scientific (laboratory), and visual data. They can be written up at three levels: the popular, the scholarly, and the pedantic; in turn, these levels are distinguished by greater or lesser *competence*. Actually, there is not much difference between the 'pedantic' and the 'erudite' when the latter term is used to describe extraordinary mastery of the literature unmatched by the ability to do anything intelligent with it. Erudition takes on contradictory and sarcastic flavours in some mouths in its indication of unrivalled ability to compile references without thinking about them. (One is left with a vision of little shoe-boxes in the head, filled to bursting with 3 x 5 note cards.) This, unfortunately, is the naïve and general assumption about the nature *and* end of Research. The realities are rather different.

The different levels and modulations of Art History are determined by

and recognized through their handling – now more liberal, now more theoretical in tone. Facts or demonstrations, however flawed, may in more sophisticated hands be useful in the *clarification of issues* and the *discussion of ramifications*. The real value of the local historian lies in the steady infusion of documentation representing a type of knowledge more likely to be in local custody or represent regional tradition. He writes accordingly, perhaps attracting attention to his results so that they may be combined by higher beings within the hierarchy to give a more general or nuanced picture.

This is to say that the writing of art history is only secondarily a matter of vocabulary or data, and primarily the result of *knowing what one needs to say*. We might imagine a researcher who has assembled several cubic feet of photocopy that can only be held in reserve for a given problem – and there may be many – inherent within it. It is unusable for immediate purposes as it can never be scanned by the mind's eye. Worse yet, it is *written at a variety of levels*. Regardless of whether it is well or poorly written, it will be more or less well *thought out*. In worst instances, it may treat nothing *worth* mentioning by any objective standard.

The Search for Form, then, exists in direct proportion to one's perceived intent, which is not entirely one's simple intent in writing. The search for 'tone' in writing assumes a consistent vocabulary and syntax, progression and variety in exposition, and emphasis where required. It exists in direct proportion to the *qualities* of the material with which one works and not otherwise, just as it unfolds in the conditions under which one works (the 'logistics' of research). Otherwise put, one does what one can for the material in relation to one's possibilities and its perceived utility to others.

It is often better to make notes only to ignore them in writing, perhaps using them only as aides-mémoire rather than the very armature of one's writing. Indeed, the literalness of insufficiently adapted and meditated material is always recognizable; it is also a form of plagiarism revealing an insufficiency of intellectual fibre. This may usually be avoided by asking oneself *why* some fact or observation made the impression it did. Was it really the first time the light dawned? If so, was it because of the force of statement or its repetition in different contexts? Did it represent such an *idée commune*/general idea that it was rejected as 'too obvious' in order to pursue some more glamorous or recondite concept commensurate with a false idea of the research process? Whatever the origins of fundamental observations, they are the only foundation for work: mere detail, detail alone, has no context. Writing should aim at recognition of the issues and the strengthening of comprehension and insight.

Choosing and Developing a Topic

> – Cependant, monsieur, dit le notaire, il y a des principes!
> – Qu'est-ce que vous me chantez! Une science, d'après Condillac, est d'autant meilleure qu'elle n'en a pas besoin! Ils ne font que résumer des connaissances acquises et nous reportent vers ces notions qui, précisément, sont discutables.
> Flaubert, *Bouvard et Pécuchet*

The patchwork quilt (more likely, the crazy-quilt) of research is dependent upon the intervals within or between the motifs. The size and direction of the stitches must be minded, for they will *always* be visible. So must the 'quilting' process itself, which results in a certain texture and richness for the whole not present in any of the parts. The selection and development of a topic normally assumes three major literary forms:

1 the commented passage or the annotated edition of someone else's writings;
2 the creation of one's own text of whatever size and complexity;
3 the catalogue or *catalogue raisonné* necessarily including the analysis of one or many works of art.

To these may be annexed a fourth orientation – the high generality of the public lecture that involves the same problems but is conceived in the main for oral delivery alone.

The literature of art history not less than that of any other field represents a choice. Exercised over the years, this means that certain topics are treated to death and others not at all. *Choice exercised at a given epoch means that the printed record is necessarily incomplete for future generations.* However much is printed (Vasari) or printed only partially in respect of the original manuscript (Baldinucci's posthumous continuation after his own papers; Crespi's complements and 'rectifications' to Malvasia; the quite posthumous edition of Passeri), the very choice of a topic and its appropriate treatment are too often taken for granted. How could it be otherwise, when the difficulties authors encounter exist in direct proportion to their scholarly ambition and the sophistication of their scholarly apparatus? So it is that for author and reader alike, the *existence of literature* conditions research possibilities.

It is not always realized how important *titling* of articles and books is as a means of intellectual control for research. We know, we accept, that it is impossible to know what is actually involved without consulting the publication itself; nor can we discern entirely the *level* to which research has been carried out without having had access to the original and not

its abstract. Yet a working title is a useful way for a prospective author to examine his chosen topic because he is forced to see it through others' eyes. In so doing, he defines a level of complexity and relative importance for his own research.

Most researchers adept in the use of periodical indexes should remember their own frustrations in following up leads that were, in the end, not worth the time and effort. They would spare future generations the same frustrations by the avoidance of titles that are so poorly thought out, allusive, or 'literary' that they are meaningless to the reader and even to computers. Although punctuation would normally fill this gap, designers usually abhor its inordinate restrictions on their freedom and thereby compound their readers' problems, inordinately.[10]

Perhaps the best way to know *what not to do* is to look at the flyers for talks to be given by members of professional and learned societies (there is a vast difference between the two) at their annual meetings, colloquia, or symposia. It will be seen that the titles given are usually

1 unwieldy (not only do they *not* roll off the tip of one's tongue, one is positively choked by them);
2 topical (often the result of the imposition of a conference theme to which all *must* adhere);
3 trendy (what are the popular questions to be answered at this time and place?); or
4 overly ambitious (unrealistic in respect of what can be accomplished in a twenty-minute oral presentation that may *prove* publishable with a certain amount of reworking).

Who has not suffered through someone's reading of his latest article, nose to paper and eye contact be damned; and who has not perused a lecture miraculously transformed into an article revealing all that can be gotten away with through personality and collective indifference, one that betrays intellectual pretentiousness or barrenness when scanned by the eye and not the ear? The creative effort is limited to a laboured title. Yet, in articles, *titles are a function of retrieval* because, as opposed to books, they are not usually blessed with extensive subject indexes and cross-references.

Fortunately, such 'command performances' rarely pass into printed form and can be accepted for what they are, verbal fireworks with the powder magazine more or less dampened. Their flaws and deficiencies are in some measure attributable to and inherent in any translation from oral to written form. But their problems are quite as applicable to the development of topics intended for print from the start. The difference is rather more one of length and intensity of scholarly commitment. The printed page is structured information supplemented by an arsenal of scholarly

apparatus and complemented by a removal from the distractions occasioned by being in a public place. What is intended is a consciously developed record for one's own time and for the future.

Anyone who has studied the literature of art history – here 'all that has been produced, whether as a source or as a commentary' – or who has used it thoughtfully, is aware of the increasing *specialization* of that literature. While we may choose to accept or reject this body of writing, whether in whole or in part, we must try to understand as well the choices and attitudes it historically reflects. Some of our own problems doubtless result from the greater or lesser sense of responsibility of past authors, as well as our difficulty in grasping what their work meant for a given generation. All topics are seen through their antecedents (historical continuity). When works of art are concerned, they are illuminated precisely by the variety of ways in which they have been studied.

Surely the single most powerful influence upon the direction of art history in our times is the 'application to a funding body.' Here, in several pages, the research topic is reduced to possibilities, probabilities, programmed logistics, and all the factors of economic feasibility that may fall under the catchword 'public accountability.' It is my contention that this has accelerated the emphasis upon highly focused work that, taken in itself, may not do justice to the research process or to the field it purports to serve. While justified to some extent, this is but one approach to research and not inevitably the better one.

Highly focused topics are rather like the proverbial needle in the haystack. We forget that the needle is important because it has been lost in History, not because it is necessarily so important in itself. (It may *become* so, but this is in no way assured at the moment of seeking it.) Whether in an intellectual or a material sense, each generation adds to the pile of topics through its creative force and removes from it as well through the collective forces of neglect or wanton destruction – all of which are to some degree governed by fashion. Certain high-sounding topics – most notably the Critical Fortune of an artist – are likely to prove a snare and a delusion because it is assumed that there will be renewed interest and attention with each succeeding generation. But new generations generally refuse to research inherited topics and are content to pass on received information on things no longer current. The result is the constant shifting of interest through dilution, and the rediscovery of interest and past knowledge through literature.

Can greater understanding of a topic be gained entirely, even predominantly, from an accumulation of literature when we know that literature spawns further literature regardless of quality? Surely no one would reply

that the more literature there is, the more important the topic; unless, of course, it was a study of the literature itself. To affirm this primacy would be to ignore the study of art, which necessarily reposes upon the study of objects, and the ideal aim is to achieve a balance. No, *the problem is when the preparation necessary to situate the topic becomes the major obstacle to its completion.*

Research is agglomerative in nature, punctuated by genius but 'brought along' by everyone, however sporadically, who has engaged in its pursuit. By its inductive or deductive basis, the choice of topic usually distinguishes the level of art historian, and his maturity. Certainly the Critical Fortunes and their ilk are but rarely the work of accomplished scholars, who know that such exercises serve as a means of apprenticeship in the problems of early literature and are a form of mental gymnastic. Properly approached, however, such topics permit the understanding of sources no longer current, pose terminological and methodological problems – their unstated raison d'être – and otherwise assist in 'forming' a prospective scholar to the problems of his topic and, eventually, to his field. *Their study leads to the realization that the 'approach' to a topic may prove its very formulation, even be the topic itself.* This type of understanding necessarily exists at one level if it is done once and for all (the usual course of events). It means quite another thing when a committed scholar returns to his sources over the years.

All this only restates a dismal truism. Access to sources, whether literary or artistic, is no guarantee of greater understanding or finer conclusions *as a result of that exposure.* At the higher levels, the temptation is always to look for whatever has been missed, a source that remains unknown or unpublished, something of 'exclusive' nature that can be attributed to the author, as if the meditated consolidation of available evidence, of basic principles, were not a prime intellectual task because of the greater demands it places upon the historian! Such preoccupations, however laudable in themselves, may result in the most curious lapses in elementary research method, such as noting one's source. The number of researchers telephoning libraries and collections fifteen minutes before Friday closing to verify simple title-page information is appalling. This action is performed at the ninety-ninth hour, when the researcher notices an *inconsistency* in something he has been working with for hours, days, even months or years. In its most favourable light, this verification represents the sudden realization or break-through that may occur at any time; in its worst incarnation, it is the result of the mental 'distancing' from everyday realities that is inherent in the research process, where familiarity breeds contempt until the final reckoning of some deadline. While such requests, as a problem, have been

fully integrated into the public-service mentality, every attempt should be made to reduce these impositions to a minimum.

Bibliographic control is said to be the key to the successful development of a topic. This is true only to a limited degree, and true only in the limited sense of intellectual access to secondary literature. *Knowledge* of the sources is acquired by very different means indeed. Only a fraction of the literature can ever be used for specific purposes even were it readily accessible, which it *never* is. On the contrary, the researcher proceeds rather more 'on the bias' than 'directly into' a topic and its development, although he may not perceive it in these terms.

This hazardous assertion may be confirmed by examining the bibliography in any *catalogue raisonné*, ascertaining in the process how many unusual and unexpected things, not less than their extraordinary dispersion, may be brought to bear upon its subject. It is even arguable that secondary literature, by its comprehensive nature, affords better insights (through the provision of models) into problems as the simple result of generations of intellectual workers; accordingly, that the sources themselves are, by their exclusive focus, of interest only (or only primarily) to the specialist or bibliographer. *Nothing, however, can replace the 'penetrating' mind, which alone provides insights of essential nature.* The importance of a research topic is never defined by its immediate impact or the possibility of usage and assimilation within the field unless these are seen in some fundamental way.

Perhaps the easiest way of orienting oneself and one's studies is to categorize rapidly, regardless of date and origin, the *type and usefulness* of the existing literature. One must determine where the greatest emphasis lies, then consider the lesser emphases in their descending order within an intellectual scheme. Is the text or commentary itself the main contribution? Or is it the repertory of illustrations or catalogue, biography, or bibliography, the discussion of a specific work (or works) whether in itself or seen in a specific context? To what degree is the book capable of standing alone – as a monument to erudition – or of serving other purposes?

Scholars are always on the lookout for new approaches or modifications of known ones that may prove to be a 'fruitful compromise between the general life-and-work type of monograph, with its inevitable oversimplifications and limited value as an instrument for research, and the book that has a single painting as its subject.'[11] This simply inquires into the proportion maintained between *specifics and generalities*, between the possibilities for general orientation and specific, detailed developments. We are all formed by the literature of art history. Its influence, at once pervasive and pernicious, goes more or less consciously unacknowledged by its practitioners.[12]

The general literature is often, and rightly, disdained by scholars when it concerns uncontrolled publishing efforts. Yet one might recall that this literature always serves to provide 'instant context' for topics of research. It may not, because of its very ubiquity, be casually dismissed or denigrated. (In most cases it is to be combated or at very least undermined, and the battle enjoined is likely to be a very uneven one because of quantitative differences in press runs in which the 'serious' literature is seriously disadvantaged.) To its credit, the general literature permits one to comprehend the 'common' or 'popular' understanding (two distinct levels of generality not always realized as such) for topics of public interest. In research terms, this means that one should not expect to find monographic material on topics – those proportionately in the great minority – that have not already filtered down into the public domain. At this time, the scholar is thrown back onto periodicals, exhibition catalogues, and other forms of *less accessible* literature. Failing these, one goes back into *primary research*, that is to say, combining from various sources. This generally happens when the artist or annexed phenomenon one wishes to know more about (or better) is too well known, only moderately known, or not at all known save in his time and place.

So it is that the scholarly literature taken broadly provides a sense, however fleeting, of recurring and topical problems. These are usually discussed in the prefaces of exhibition catalogues and, most particularly, in any well-conceived Introduction setting forth problems and methods within specific context. While these expositions are not to be taken over unquestioningly, they do provide much food for thought. The more's the pity that they are not more regularly and attentively read, for the author's *statement of purpose and the reasons for his adoption of a particular method, organization, or scholarly apparatus* must be simply put because of the simplifications inherent in book-length treatment; in an article they may, at best, be *inferred* through a strong introductory paragraph.

More important, the reader usually learns why an author undertook a given type of study, what types of difficulties he faced, perhaps what impelled him to continue when he could, after all, have contented himself with an article or shorter notice. (For the purposes of the present exposition, the 'promotion-and-tenure' monograph is deemed not to exist.) Last but not least, we discover what types of compromises he has had to make, what motivated them, and what are, in his opinion, the presumed effects of these constraints. It is normally most instructive to sense what was behind 'unusual' or 'unpopular' topics that have come to fruition, some of which appear in the section 'Some Notable Approaches' (chapter 2). This said, it is evident that such conceptually 'sophisticated' topics are also 'mature'

ones quite beyond the range and imagination of most of us. Whatever the importance of such work, *most would-be art historians must first get down the catalogue notice and the article before proceeding on to more fundamental or esoteric matters.*

This is simple acknowledgment that long-term research and writing are different in mental set and mechanics than topics undertaken for shorter durations. (It is important to realize this fact when the 'simple' choice of a thesis topic may haunt one for years, often orientating research through as yet unperceived affinities for years thereafter, perhaps even blighting the remainder of a working lifetime.) Everyone awaits with bated breath the useful, essential, or great work that has been 'so many years in progress,' which sense of expectation may be deceived upon the work's appearance. But the problem is not there, it is when the author dies or is incapacitated (flagging interest, dispiritedness, and burn-out being the usual forms of scholarly incapacitation) so that the work never appears. *In the intervening time the public has been unjustly deprived of the work undertaken and of insights of more modest but just as essential a nature.* Research itself has been to no avail because it dies along with its author; for that reason alone, the article and shorter notice are essential as a *structured form* of Research in Progress.

The article and shorter notice usually assume four levels of interest, here presented in no particular order:

1 re-examination of 'classic' topics (usually investigations of the seminar type, intended to give a sense of the greater orientations);
2 'discovery' or 'invention' topics, involving the shifting of viewpoint through transposition or extrapolation;
3 the 'shorter notice' or 'commented document,' presented for and assuming proportions of neither more nor less than intrinsic worth; or
4 the 'creation' by whatever means of a topic of discussion that has never existed or been properly acknowledged.

Here separated for intellectual convenience (and further presumed to attain rather different physical dimensions), these categories are in reality the *normal scholarly operations* required to attack and surmount any reasonably complex art-historical problem. They require much the same mental faculties and experiences *at any level of exercise* and are to all intents and purposes the same intellectual manipulations, albeit *directed to different ends.*

There is, then, no sure way of isolating a 'workable' topic inasmuch as the topic may be expected to develop as a result of research. Normally it is the unassuming topic honestly researched that has the greatest potential importance; one knows not where it will lead or how it will be generally

applicable, whilst splendid titles often become set-pieces for the accumulation of an abundant, usually undistinguished literature leading to a type of source-book of questionable value. A certain amount of preliminary work ('spadework') is required in all cases to determine the *general feasibility* of a topic. More of this is perhaps required for the Shorter Notices in that their higher 'degree of resolution' may mean that the essential documentation or thought has already appeared or been incorporated as part of *someone else's footnote*, or has simply gone lost in an unexpected source or obscure gazette of years past.

Whatever the problem undertaken or the level at which it is done, everyone is agreed that the three decisive elements for the development of a topic are, from most to least evident:
- the availability of material (locally, regionally, nationally, or spread all over the globe);
- personal attitudes (immediately recognizable skills based upon prior experience); and
- personal affinities ('likes and dislikes,' whether innate or acculturated, usually paralleled to some degree by personal aptitudes).[13]

The latter two of these may be misleading, even tragically so, in that they go relatively unrecognized for what they are and how they originate. They likewise may encourage the researcher to build *on* strength rather than *from* weakness and to choose topics that neither challenge nor develop the intellect and its skills. *A balance must be struck between the too-cautious and the incautious subject, for the first is too comfortable and the last much too general to benefit the researcher himself.* We should recall, with Jacques Thuillier, that 'en général elles [les découvertes d'importance] procèdent, non de grandes déclarations de principes, ou de confidences, même touchantes, sur les états d'âme personnels, ou de la reconstruction, même géniale, de l'univers artistique, mais de l'enquête humble révélant le petit fait qui permet soudain de déplacer le point de vue admis.'[14]

The important art-historical statements are born of a myriad of little facts and observations that illustrate them. The great art historian is capable of linking ideas or objects *only tenuously related in appearance* precisely through his greater analytic and synthetic abilities and the passage of time. Like anyone else, he is often dependent upon the humble fact that someone else has unearthed, but which has lain on fallow ground. Through engaging in research, he, as any other practitioner, discovers things he can do that he never thought possible, and realizes that his strong points were perhaps not so strong at all.

Whatever the degree or illustriousness of one's intellectual credentials as opposed to intellectual production, the impassioned defence of one or

another 'approach' to the history of art in its best and most general sense is likely to be specious and self-serving.[15] *The choice and development of a topic make no essential distinctions between the trained art-historian and the autodidact.* Both are tested and found wanting.

Taking Note

> We are flooded with exhibitions, and glutted with picture-books; and these vast aggregates of available images are absorbed with an eagerness and, I may add, with a degree of intelligence that would have left less adaptable generations dazed.
> Edgar Wind, *Art and Anarchy*

Taking Note is a form of intellectual focus. One can be myopic, presbyopic, or astigmatic, and one should be all three; for the first corresponds to immediate issues, the next to their distant correlations, and the last is the most important of all through its 'deviation of angle.'

As opposed to 'taking notes' in a lecture or from manuscript and published sources, Taking Note is the first step in everyday observation that makes some instant judgment about the familiarity or unusualness of phenomena, of experience. It is a means of coming to grips with one's ability to be concerned with (and profit from) whatever offers itself for consideration. It is the profession itself.

Once enunciated, this topic loses its interest forthwith. Yet its importance as intellectual discipline manifested through curiosity can never be understated. It asks: 'What can I take away from this encounter, however fleeting, while I am really doing something else?' *It is the passage from interiorized thought towards verbalization, which in turn is the first and unavoidable step towards the formulation of general ideas leading to print.* It is likely to be the single most important, self-imposed training one ever has. It poses questions that 'cannot be answered as yet' but which, taken cumulatively, form a lifetime of mental discourse.

Taking Note in art history is the equivalent of the neo-Platonic struggle with form and idea. The proverbial characterization of someone who 'thinks on his feet' is here appropriate, even an essential analogy. It is always easy to formulate when one is *already concentrated* on a problem; much less so, when the problem is incidental, random. Concise verbal formulation is essential if one is to reduce the experience of a lifetime into an effective data base that, through repetition or analogy, can be called into play at will. Otherwise, although imprinted on the brain, it remains dormant – but not less useful for all its recessive nature.

The impulse towards verbalization is so fundamental as to require neither statement nor explanation; the distinction is that mental discourse or conversation is not necessarily with anyone else, quite the opposite. *No one else need be present, and if others are, their presence is immaterial.* This highly personalized mental effort usually manifests itself in the experienced scholar through verbal snatches, onomatopoetic voicings, and even strings of involuntary expletives. Not to worry, this is part of the professional deformation resulting from creation under pressure, under deadlines.

In calmer moments, Taking Note through verbalization is a serene process detached from reality. It depends upon immediate reactions and proceeds independently of erudition. One might even go so far as to say that it is the ultimate confrontation with works of art and the questions they provoke. It may seem perfect in its *mental voicing*, yet be difficult if not impossible to enunciate even though it has just been silently 'rehearsed.' Without being voiced it can never be entirely possessed, much less become part of one's intellectual baggage.

The very effect of *elucidation and intelligibility* through different generations, each with very different resources pitted against a common problem that is a work of art, sets up a *dialogue* between the dead and the living. The dialogue is necessarily one-sided, yet is grounded in fact *as long as the art itself persists*. Even should it disappear, it remains in discussion emanating from the literature and, to varying degrees, from reproductions.

It is therefore humbling to see the *quality of results* obtained in the face of so many obstacles of yesteryear and the relative poverty of results of generations nearer to our own time, of those who have made so little of the fruits of past generations and of their own potential. Taking Note through implied mental discourse and the real effort of verbalization permits one to escape what might be called the 'tyranny of facilities' and compensates by *pure intellectual application* for the relative disadvantagement of one's own epoch and colleagues because it is an *entirely personal* attainment! It is the faculty of re-creation, of simultaneous experiencing of a problem that is likely to distinguish the exceptional teacher from one who sticks to his notes and simply goes through his paces; it is certainly the faculty of the 'pregnant aside' that characterizes the impressive public lecturer. It makes the unknown both visible and tangible through words.

Such internal discourse is very personal inasmuch as it depends upon one's temperament and basic disposition (personality). Taking Note manifests itself through *intention*. One finds something and 'notes' it because one is in search of it, because attention is directed towards something. And

one takes note at two levels or, one might say, at two rates of progress:
- hunting (intensive, even aggressive, but *short-term*); and
- angling (leisurely, contemplative, for the *long haul*).
Thus it is that the overall make-up of the researcher *precedes the intention* and necessarily conditions and produces specific questions. This is a question of the metaphysics and psychology of Taking Note, but is also a function of the nature of one's objective – the problem – in that one attunes oneself and works to the degree required (and permitted) by the problem. For example, Taking Note is, within the context of a *catalogue raisonné*, that realm of awareness which is possible within a comparatively narrow realm of possible facts to be unearthed. Its counterpoint, perhaps its diametric opposite, is the conceptual range of the Topic. This is three-dimensional, but is further subject to the Fourth Dimension, which is the researcher's available time.

Of course, none of this effort is made easier by an inability to distinguish between 'fact' and 'evidence' and the degree to which the Topic is a function of rapidity or regularity in research method (probability). Does a given topic really *justify* publication, or is it at best a casual observation or first foray into the field or problem?

The response, in turn, may be a function of the importance one attaches to publication. In conservative view, publication presumes a high degree of distillation and enrichment of texture as normal, even to the point of attaching an almost neurotic importance to the concept of *scripta manent* (reactions to this *pensum* will necessarily be functions of the level at which one works, and no one can respond better than the individual). This viewpoint means that Publication is reserved for evidence that, after so many days, weeks, months, or even years, is finally 'put on display.' The work is deemed to have sufficient quality (and qualifications) to merit *being a fact* (a published fact) since the evidence supports it.

In contrast, *verba volant* is part of an ongoing process of clarification, scrutiny, and experimentation – the establishing of what might grow to be solid enough to be picked up for development. In more aphoristic style, *a well-put question is the answer in disguise*. It adds weight and texture to observations, lending and eventually conferring authority; it 'puts the facts in' and assigns them parts within a larger conceptual framework that cannot exist without them. (This, by the way, puts documentary and archival publishing in its proper place, which is a necessary, but minor part of theoretical writing.) The required versatility is possible only through long training and apprenticeship combined with the *exercise of judgment*. Taking Note is part of this process.

In the absence of a photographic memory, Taking Note becomes the tak-

ing of notes, the keeping track of things. One's success is, yet again, a function of the sophistication and complexity of the topic, for ideas fade and disappear. Even if they are retained, they are only ideas and need somehow to be transcribed and brought into order. Yet time – and concentration – affect memory. Things go cold, nuances disappear along with the broader picture and even with specific facts. A retentive mind is usually widely read and has exercised this trait regularly; *retentiveness is best applied to sources, rather than to the secondary literature of art history*.

The reason for this should be evident, for the sources have usually lost their integrity through parcelling out and incidental quotation rather than being known for their own sake. The serious art historian will thus have some idea of the development of his discipline and more than passing acquaintance with its benchmarks. Yet the phenomenon of reading has become an issue in itself. *Who reads today, and what, and how?*

Taking Note from literature is often confined to sources not easily available, as it may be with the monuments themselves. How often has one returned from a trip with a suitcase full of scribbled papers, only to realize that one has taken down the *wrong* thing, or omitted something that *now* appears essential? No one would say that 'once is for all time' in research trips to see the monuments any more than to the library, but one sees immediately the necessity of regular access to well-stocked (chosen) library shelves.

The dilemma of poor or inappropriate choice in notation remains, in slightly altered form, since the advent of photocopying technology. For protracted study, the photocopying is equivalent to a declaration of independence from the constraints of travel. As commonly practised, however, the photocopying of documents, while entailing real and serious risks to the material copied, also creates bulk and storage problems for what it is said to preserve. While not so 'efficient' a process as is photocopying for documenting material, excerpting puts – and keeps – things in mind as a result of the first level of mental effort that is required of the scholar. For it cannot convincingly be argued that photocopying what one thinks one needs will obviate any necessity of consulting a text thereafter, any more than does note taking in the traditional sense. Writing by hand 'puts into mind' more effectively than scanning a text ever can in that it is the first step towards understanding through analytical processes. For all its convenience and expediency, photocopy is the first step in self-deception and quite as treacherous as the photographic process itself when dealing with originals.

In Taking Note from a text or from a monument, intellectual implications are major or minor. So with verbalization; initial naïveté must be

overcome so that one does not read or interpret sixteenth or eighteenth-century French like twentieth-century texts of easy access; nor should one apply modern semantics to textual criticism or terminology. In examining the writings of others one can, if one but knows the sources themselves, immediately determine the level of the writer from his use of a certain sentence or, more particularly, of quotations. Historical and linguistic study is part of the ideal make-up of the committed art historian, although he will often have to seek help from specialists to determine what the possibilities of interpretation are. This, obviously, is rather different than using a quotation as evidence one has *visited* the sources, although using it as a constant and culture-free fact guaranteeing historical truth not less than that of one's interpretation of it.

Thus it is that 'the reading of monuments' is a twofold translation: what one sees, transformed into words. This, be it said, is an *essential* rather than a trivial shift of focus. Taking Note through verbalization provides the essential communication between object and self just as the lecturer is mediator between his material and his listeners. Either way, verbalization is the key to understanding; it attempts to answer clearly 'yes or no?' or 'is it this, or that?' Often, it does so *before the question is asked* by anyone. This 'anticipatory' quality is one of the prime virtues of Taking Note because it is abstract rather than applied thought.

Taking Note accordingly involves the taking of sketches, even compositional sketches, to clarify the objects dealt with and the possible arguments arising from them. It exists as an intermediary stage and at a certain level of observation only. Rather like the *pensiero, studi,* and *ben compito disegno* of the Renaissance drawing ateliers, it fixes and only then develops concepts. In asking a question, Taking Note is already responding to the challenge of the work of art; it is rather like hearing something and wanting from a brief encounter to know more. It is like responding to a knock at the door.

In this sense, verbalization concretizes Reflections and Speculations as much as or more than Facts. It lends itself equally well to both, and both are as much disconnected as the phrases entered in a commonplace-book. The entries are chosen either for their intrinsic interest or because they strike some responsive chord. (For this reason they must be put down along with their precise source lest one be faced with the annoying and very time-consuming process of reconstruction – 'Ah, yes, yes, that's it; but where is it, the *Mercure de France,* the *Journal de Paris;* unless it was the *Chronique des arts?*')

Since reflections and speculations are necessarily disparate, it is left to the speaker (and the hearer or reader after him) to bring them into a certain order and pattern. It is rather like building a fieldstone fence around a field,

more likely yet the *building* itself. Since the stones are not drafted, they are of all sizes, shapes, and colours; in putting them into place, some fit and some must (as with scholarly notes) necessarily be left out, even *cast* out, as unfit. The intellectual effort required in verbalization then becomes the mortar holding them together as seamlessly as if they were ashlar blocks; at a certain level, no mortar is necessary as the *manipulation* of the stones is more expert. The metaphor is readily understandable in that the art historian, working as he does with other people's works of art and commentary, is necessarily working with *Findlingsteine*. These are the result of his own explorations.

Taking Note verbally, whether or not as a preliminary to written form, is a matter of saying something, after which one is forced to make and to sustain an argument. It is the creative tension of 'what to do next?' and at this point it may help to have people hanging on to your every word in a class or public lecture. While this process works (and splendidly) for some, in others it leads to freezing more solidly than any experiment in cryogenics. More likely it is that The Sketch or The List will assist in finding the transition point between the image/monument and the word. Not only are they more manageable, but the sketch clarifies and situates within some larger scheme. Beyond this virtue, the mimetic response set up gains breathing time while 'opening up' the observation to a larger audience. The observation is then shared and experienced concurrently, with all the individual variations that can be imagined. This is perhaps what Max Friedländer meant in writing (*Reminiscences and Reflections*) that 'language is so riddled with imagery that only the seeing author can employ it felicitously. Most authors, especially the scholars, do not see. Artists and art connoisseurs ought to write better than, say, jurists or philologists, because they are accustomed to seeing. Now and then this advantage is noticeable, but only now and then.' Taking into account Friedländer's known aversion to traditional scholarship, in which context his bias towards connoisseurship is crying, we are speaking of the art historian, who should be a connoisseur at base and then go further. Most of us are not connoisseurs, and will never be. But the difference is that the art historian 'puts the question' while the connoisseur aims at resolving a question, and in a certain way only.

Perhaps the educated person claiming some authority in humanistic studies *needn't* write well; but he *must* have the capacity to be articulate in the act of transformation from observation (Taking Note) to an audience, whether a listening or a reading one. His literacy is his language as it is applied to Description; his literacy is language itself.

Assumptions

> Hypothesen sind Wiegenlieder, womit der Lehrer seine Schüler einlullt;
> der denkende, treue Beobachter lernt immer mehr seine Beschränkung
> kennen, er sieht, je weiter sich das Wissen ausbreitet, desto mehr
> Probleme kommen zum Vorschein.
> Goethe, *Wilhelm Meisters Wanderjahre*

The History of Art is, in the last quarter of the twentieth century, firmly and finally established in public conscience. One has only to read the public papers and magazines, listen to radio, watch television, go to see documentary films. These may, of course, be provided to fill the interstices of regularly programmed events, but even such random trivialization indicates their importance in contemporary life.

Much of this ground swell lies in the realm of national patrimony and is an expression of constructive – or scarcely understood – nationalism. This may well have come with the discovery that both nature and culture, broadly defined, are endangered by modern technology and assumptions. In such a climate, nostalgic attitudes result and can be fostered to the degree they concern 'cultural values' whose survival is thought to be threatened by current levels of awareness, values, and attitudes.

Even when reduced to local and regional preoccupations – which have their place within a healthy discipline – art history has gained greater profile and understanding within the public at large. Unfortunately, in its practice there is such a wide range of subject-matter that the level of argument ranges from the *scientific analysis* of materials to *simple conjecture* – which is quite all right if admitted to. Whether in conversation or in print, the 'official declaration' of art history is necessarily a mixture of facts that can be claimed as such, and a series of conjectures, proposals, and hypotheses. These must be given form, proportion, and weight if they are to mean anything, and it is at this point that Assumptions rear their ugly heads.

It is natural enough that in addressing the history of art one should refer to basic insights or documentation from the near and distant past as one tries to make sense of the problem at hand. *This act comprises in varying proportions what others have known, thought, or discovered, and these same elements in oneself.* The idea that 'this is mine and that is yours (or his)' in scholarly contributions is ultimately irrelevant when trying to make up one's mind on the basis of The Evidence.

Sources must be acknowledged as they are used, while in the examination of inherited models (through teachers and the accessible or extant literature) one must be attentive to the critical construction of argu-

ments. These lie at what might be termed the 'second level' of Assumptions concerning:
- Observation
- Argumentation
- Formulation
- Historical Resonance

The last-named is of course the effect or influence of its three predecessors (genitors is perhaps the more appropriate term) extended into time. Yet all these have to do with the distinctions that may or may not be drawn between *evidence* ('visibility' in its etymological emphasis) and *documentation*, and only thereafter in their *usage*.

There are few real rules of thumb in the application of historical method to art history. One asks for methodological information and at the same time refers to very different types of endeavour. What is clear and incontrovertible to one is not to another; what may be only inferred here needs to be stated there; some minds are easily convinced while others are wilfully, even calculatedly, recalcitrant. Some minds can address problems and subtopics having the complexity of pomegranates, while others should be happy with their apples and pears. Any description or formal analysis of a work of art is a function of the quality of one's mind and then of one's vantage-point or prejudice, acknowledged or not. One sees what one *wants* to see – or *is given* to see – as writer and reader, lecturer and audience. It is, as a result, necessary to be aware of what one can do well, or only tolerably.

What might be considered the nature and importance of Proof? To begin with, any document is nothing in itself but a paper or other support having a scribbled or more elaborate notation. Like one's notes, a consciously constituted document supposes a conceptual infrastructure – its intent – and is a function of a certain response to a given question. Considered as *Realia*, documents are a function of a certain point of reference; otherwise they are simply Matter. They represent history – or a course of events – seen from varying points of view in need of examination and, if possible, reconciliation. In the strictest sense they are nothing in themselves but *proof of evidence*.

If the research process that engages documentation is thought to be systematic, what it unearths must be systematically treated in order to make a point or points. *It is not sufficient to locate and present information; to serve any real purpose, it must be argued.* Thus our first level, that of Observation, must *claim* validity in order to be recognized rather than inferred. Carried to the status of publication, Observations require interlocutors. Since Observations need substantiation (proof; evidence as the ultimate part of the

research process), Argumentation becomes the equivalent of constructive advice. It proceeds from the way one argues, how one puts the pro and con on display. Thus it is often easier to start with a statement of general nature with which you disagree rather than to introduce arguments into a vacuum.

At this second level there are perhaps three nuances of attack depending upon the topic. Anything treating the mystic or irrational aspects of art and thought is not likely to be 'demonstrable' through the more traditional methods of historical authority and evidence. At the same time, art history of a conceptual nature is challenged in the matter of evidence that can be said to underlie, inform, and demonstrate the concepts, failing which it becomes history with appended illustrations. The material history of art (*Realia*) has far fewer – and less complicated – problems in that its proof is the very existence of the monument or work of art. In all three categories of endeavour the deductive and inductive argument enters in different proportions. The next level of essential problems is in reference to authority, i.e. to literature.

In general, one faces problems or issues upon which there exists a large and relatively complex, but structured, literature or else a small and incoherent one. The researcher often begins by constituting The Bibliography, which, if he but wished and could, might well form his reading for the remainder of his life without any real effect. What, then, is the role of bibliography? It is the end of the research process rather than its beginning, once it has been focused so it concerns only what has been of real use in a particular concern. This means that what is usually called Bibliography (and seems an end in itself) is in reality *bibliographical control and selection* – the ability to find and locate what one might need, the acumen to distinguish between real and pretended contributions, an exercise of selectivity.

Putting this process into practical context, one will consult works that are evident or likely sources for a topic, after which the secondary literature provides further bibliographical indications. One may have nobody to whom one can make direct reference. This is more true when the topic relates to many different disciplines rather than to art-historical literature in the narrow sense, resulting in a bibliographical potential of thousands rather than hundreds of items. Whatever the context, this type of reference will likely concern only the general ideas or provocations that have been found useful enough to be incorporated into your own work.

The third level of exegesis, Formulation, concerns not only problems but the type of issues addressed. The increasingly recognized 'public utility' of art history has doubtless resulted in essential modifications in its method

and practice since the Second World War. These concern the political aspect – public relations – that concerns, governs, and defines the position of the discipline in society not less than the resultant necessity of teaching and supervising large and disparate groups of people. Thus it is that Historical Resonance is usually the result of proper formulation, of capturing the imagination of the public as much as and perhaps more than close argumentation.

Alas, the vast increase in the number of art-history practitioners has led to a series of Assumptions whose results are among the more disquieting aspects of the deterioration in art-historical craft. These are three in number and everywhere encountered:

1 lack of historical method (ignorance of rules of evidence, its admissibility or inadmissibility in practical application);
2 casual inference and even quite ahistorical understanding of the art historical linchpin that is the 'influence' of personalities, monuments, or concepts;
3 insufficiently rounded-out argumentation, having many and even good points, but points that are simply not tied together so as to be sufficiently perceptible to other scholars, much less the public.

The seriousness of such failings depends in great measure upon the nature of the evidence that, still and all, is documentation placed within a context so that it seems convincing, becomes evidence. As Bernard Berenson put it:

Knowledge is not information. Most research leads to more information and stops dead. Information is a tombstone while knowledge is a bay tree. Knowledge discusses not facts, no matter how satisfactory they may be, but problems. Real knowledge is continually discovering new ones ... Universities and Academies still love the scholarship that consists of digging up infinitely minute or insignificant facts that seldom if ever suggest or open the way to, or even impose new problems.[16]

Of course it must be understood that there are problems of different order and magnitude. It is possible to talk objectively of geometrical and mathematical problems concerning art. Colour is difficult, differing as it does through memory, light, and atmospheric conditions, even the physiological and psychological conditions of its reception. While simple (formal) argumentation is blessed with no such problems if handled with good reason, cause-and-effect relationships and inferences are rather less straightforward than they seem.

In the society of ants art history has become, few outstanding person-
alities capture – or hold – the imagination. Despite legions of intellectual
workers on the loose, there is today little of excitement within the disci-
pline, but hidden promise for the future. The examination and treatment
of documentation-on-the-way-to-evidence distinguishes the masters from
the journeymen from the hordes of eternal apprentices.

The differences in approach are most apparent in the founding of ar-
gumentation on older texts, which was once an integral part of the hu-
manistic bases of art history, now fallen into distressed circumstances.
Whether based on originals, translations, or bilingual plans, one of the
greatest services that could be rendered to the discipline is the establishing
of carefully meditated critical editions such as those in the literary spheres.
(This type of research is a world unto itself and certainly not for the faint-
hearted or hurried scholar.) If several editions exist, particularly from dif-
ferent periods, they should be compared among themselves and against
the originals.[17]

If there are no critical editions, you are on your own and must turn
to specialists (language itself has evolved irrespective of the intricacies of
early and persistent dialects); in the use of and quotation from early texts it
will be necessary to state how a text was used and what advice was taken.

Humanistic study of the sources of art history may be revived with time,
but it will certainly be on a different level than what was, and it will cer-
tainly have a less 'philological' bent than was previously accepted. There is
the distinct possibility as well that the American sense for the *fact*, which
is often very sound and strongly developed, may come to exert its force
in the fructifying of the more abstract methodological exercises of, say,
the French. But this is an assumption as well, if it is not simply wishful
thinking.

When all is said and done, there are many levels of assumptions that nec-
essarily increase or decrease with the passage of time. With great minds,
Assumptions rest upon a lifetime's accumulation of thought revealed in
published work and through the invisible influence that is their pupils or
adherents. It is the Uninformed Assumption that is potentially the most
destructive of all. Rather like the mosaicist, naïve and uninformed art his-
torians approach their craft piece by piece, inserting *tesserae* where they
seem to fit without any real idea where the process leads. They repeat pat-
terns and models unconsciously in the absence of any conceptual ability;
more often, the space is 'filled' without either pattern or progression. At
base, their work is still less dangerous than that of sectarian art historians
who know the points to be made – and which ones to avoid or suppress.
Before trying to convince other people, first convince yourself.

On Imitation and Emulation in Art History

> She read, with an eagerness which hardly left her power of comprehen-
> sion, and from impatience of knowing what the next sentence might
> bring, was incapable of attending to the sense of the one before her eyes.
> Jane Austen, *Pride and Prejudice*

An initial and perhaps fugitive distinction is to be made between art his-
tory as a discipline, dependent upon historiography, and the history of art
as the thing itself. Both deal more or less directly with what has happened,
what has been written, and how one perceives and talks about art.

Most students have little real sense of the progression of genres in art
history and its literature. As a result they cannot identify the *determining*
books of the discipline, nor have they read them. This perception is as valid
for the majority of professionals as well. It is surely compounded by prob-
lems of access to the titles in the correct (or only) editions not less than
of the linguistic tools needed to penetrate them in order to master their
contents.

This circumstance is no less true for the literature of the nineteenth cen-
tury than for each preceding century where there is less and less *formal*
(printed) literature serving the field as a whole. One may, of course, say
that the 'problems' of the discipline are no longer the same, thereby dis-
pensing one from such investigation. The fact remains that certain titles
were – and remain – central to our understanding of the discipline. Failing
any direct familiarity or practice, one should, through Schlosser, at least
know which they are.

If one accepts the monument as the ultimate authority in art history,
one must not mistake its messengers (authors) for its complete message.
How, then, to avoid the problems of what is inevitably a rather complex
phenomenon? The answer is that there must be some fundamental dis-
position or awareness that makes it possible for one to 'receive' the mes-
sage and then, perhaps, to 'understand' it. This may be on a personal and
private level (art appreciation) or on an art-historical level (the craft born
of training that develops the capacity to be addressed and to respond).
Inculcating historical awareness, historical position, and historical con-
sciousness in at least their general outlines is normally incumbent upon
professors.

Historical consciousness is perhaps the most important for the reader or
practitioner of the history of art. It is the result of categories that underlie
the streams and cross-currents of history: some issues go dormant, others
appear and disappear, may change in their appearances and sometimes
their essence. These modulations are as much the result of fashion as any-

thing else. Structuralism and semiology may tomorrow be as outmoded as yesterday's Social History of Art. Such terms are in any case only words for whole categories of issues or endeavours; they are subject to caution in their use and, more pertinently, in their application. They include all the 'isms' as well as the normal preoccupations of art history – stylistic and iconographic problems (form and content), aesthetics, and techiques that underlie not only universal art history but any fashionable approaches to it.

In practice, most people cannot be aware of historical issues and usually *do what they see*. Indeed, scholarly approaches are usually judged by their usefulness to immediate needs. Yet the schools of art history associated with different institutions of higher learning are also associated with certain outlooks and methodologies, each related to an area of concern personified by some individual and his continuators. To seize these approaches 'as they were and have become' requires a large and accurate fowling piece so one may catch them on the wing.

Insofar as Schools are concerned, Imitation says as much as Copy. *It dispenses with originality and stresses affiliation as one gives oneself over to the 'instructions' of a model or example.* This may be a more or a less conscious process, becoming with time a cumulative endeavour that surpasses immediate consciousness of the influence or example. Normally it is the result of respect, fascination, or admiration for a personality or with the results he has obtained. One accordingly attempts to do as well as, if not better than, the model. Methods become instruments so that the School provides the *instrumentarium* to be used.

In speaking of Method in its general sense, one is naturally expected to learn how to handle what exists – the means at hand – before stepping out on one's own. Going out to 'discover' a new method is a contradiction in terms. New methods result when least expected, through fundamental work and by accident. Therefore, method is but an instrument and no methodology can be absolute. *Emulation is a more personal and institutional show in a competitive sense and may be Imitation gone wrong through impure motives.* Imitation and emulation are a type of double-entry bookkeeping with false figures and equivalences: one cannot *be* a second Panofsky, but one can be a 'second-rate' Panofsky; one may be 'as brilliant as' but never *be* Panofsky in opening boxes that others have put aside or never noticed. One must have a sense for things, then demand whether they constitute a topic of investigation that, after all, can only be a by-product of curiosity. Everything thereafter depends upon a decision to 'go on with it,' or to drop it in part or in whole.

Yet people are so far removed from the history and practice of art history that they too easily abdicate their responsibility before the field. It is, for example, far easier to note that 'X is publishing this type of work while Y and Z form part of an unofficial consortium,' only to conclude that *'this must be the thing to do.'* For all the institutional co-operation, for all the presumed scholarly tradition and relations that may exist, the art historian works in small, tightly defined vacuums. Only the better minds see the larger picture wherein everyone has a function and works with what is at hand. They ask what is needed to do something, by whom, and when it might be done.

Is there or has there been life in the discipline? Yes, and most likely when one is driven by some personal need to the point of satisfying one's curiosity. At another and more mundane level, it may be realized that one's living (profession) is dependent upon the formal activities of re-search and publication. Visceral commitment to the field is usually the most productive, the most life-sustaining both to the person and to the discipline; anything else usually feeds upon itself. Both courses steer per-ilously close to the nasty question of the Social Relevance of the history of art.

The most direct approach to this complicated and treacherous topic is to note that art history survives on a fiscal basis when society acknowledges some sense in what it is doing even if the activity is incompletely under-stood. *Although the history of art does not produce consumer goods in the usual sense, it will likely be needed, if not for survival, then as a nice ornament.* The cataloguing and curating of art collections – a public and private concern since time immemorial – will always be in demand and will always require good training for best results.

There is, then, a distinction to be made between the production of art – which goes on regardless – and art history. The discipline justifies its existence through the curiosity of others and is dependent upon creative effort. It exists at varying degrees and levels to match those of the public, but not all of these are compensated according to their real or even their potential value.

It is always possible to write a world art history that serves as a compe-tent introduction for the general public and goes no farther, but one must also 'do the real thing' as exemplified by increasing levels of specialization and professionalism.

It must also be said that there is a certain hypocrisy on the part of the Powers that Be (as of the Public) who are all too willing to accept 'purpose-less research' of fundamental nature in the natural sciences. Regardless of the absence of long- or short-term objectives since such research, too, is de-

rived from pure curiosity, it is handsomely funded. Yet society as a whole could not care less about art history even when, like the sciences, it is best when it has its finger on the pulse of Discovery rather than representing applied research. It may be futile to enquire whether the discipline can in our day either satisfy or substantiate public expectation; probably it is best to avoid the query altogether so as to spare oneself much unintelligent discussion.

None the less, what gives Art History authority is precisely the moving away from the 'expected' topics and clusters of topics to the documentation and discussion of what, in an immediate sense, serves only the purpose of *historical description*. History is to be written and can only exist in written form, oral histories and data banks notwithstanding. It is already effected in a very practical sense through the administration of large bodies of artistic patrimony in museums, galleries, and libraries, without which one could not work. Institutional resources upon which we are all dependent are probably better organized than ever before because of greater interest and solicitation. The impression remains that there is an increasing political awareness of the importance art has for a healthy society.

One may well ask how one can be aware of what is going on in such a diverse and increasingly international field as the history of art. Art history is rather like a stock exchange, but one of information rather than the assigning of speculative values of art works that some would reduce it to. Browsing the current periodicals usually gives a better sense for the field than consulting monographs and repertories of overlong gestation. In all this and more, one's possibilities are a function of where one lives and the facilities to which one has access.

Art historians are often obsessive – living, eating, drinking, and sleeping the field as well as their fellow art historians. Yet Scholarly Generosity enters this equation from the moment one creates a more public format through circulating oneself or one's work. This may be reduced to those people living from their connections and relations only – those involved in art history *from the outside* – and those who experience these same factors only indirectly; that is, *from the inside of scholarly activity*. Reading will always be essential, but equivalent and perhaps greater stress and weight should be placed on Conversation to remedy the lack of daily communication that exists among colleagues in the same departments and institutes as a result of the press of daily routines.

In some cases inability to communicate is the direct result of over-specialization, with little remedy being possible. Perhaps the greatest reason mitigating against freer art-historical conversation is simple fear of

theft. (While there are those who can take an idea and make it better, far better than it was, they are rare; and they usually acknowledge their sources.) *Simple theft is perceptible as an act by an inability, under questioning, to extend or document more than the basics.* Not only is this act fundamentally detrimental to individual and collective progress within the field, it is a sin against the spirit. It is imitation and emulation reduced to sham.

The Mechanization of Art History: The State of the Art

> I have all the material assembled
> I just have to put it together.
> Traditional Air

There are occasions where airing a truth is an offence against good breeding. This may be one. There has been no significant textbook produced in the British Isles or North America in the twentieth century. One that nearly filled the bill, Gardner, has become unrecognizable in the sixty years since its appearance in 1926.[18] Whither the textbook since today's Histories of Art are a vastly changed genre from the grand tradition of the nineteenth century, prolonged in most instances to the First World War?

If written 'for the market,' such works probably do not satisfy the various markets any more than they serve the field. One may well ask whether bigger is better, whether more illustration and greater emphasis on 'interpretation' rather than the 'outline' of the history of art is justified when students as a whole manifestly can't handle it. The question is whether survey texts, although written by scholars, do not reduce singularly intractable matter into formulae to permit the one-year-survey course thought suitable to matriculants of all persuasions.

What are a survey's text's results, its effects? Most likely surveys cover less and less of the outline of history (or have to be team-taught to do so) while less and less of the outline is *there*, so whole periods go by the boards. Can it be true that if one has a survey text one is stuck with it, while without it there *can be* no survey?

Students often have the impression that surveys are all the same thing anyhow, implying that whatever their differences may be, they are not all *that* different. Of late years, however, there is so much to choose from that one may never know what has been read unless there is a clear contradiction between the general tenor of papers or examinations and their specifics. *The experienced lecturer knows that people will use anything that comes to hand and that he can do virtually nothing about it.* The rise in pop-

ular art histories and survey texts has dispersed rather than concentrated attention, often making it impossible for the non-specialist to assemble a coherent picture about periods or works of art within the mass of conflicting detail put before him.

Under hard questioning, colleagues often sigh that such and such 'will do,' as if there can be no real criticism any more than real acceptance of survey texts: Gombrich may be favoured for a thirteen-week survey because of the smallness of his units, Hartt for twenty-six because of his longer ones. The hope is clearly that the literature will not impart the worst kind of research methods or false information, or that a given work may do the least harm. The survey remains a *genre sui generis* continuing the hoary but respectable tradition of bibliographies in English only, or at least in English translation. *Like many reference works, they are geared to the audience of the country in which they are published.* For those going on to serious work, what can be the immediate and lasting effects of sudden weaning from such convenient breasts?

It may be hoped that lecturers themselves are well read and well prepared and have some bases of comparison. Students do not, although they may know what they like and dislike. The difference perhaps lies in the knowledge that one *can* judge a truly important book or article by its lasting contribution, whereas for the survey texts judgment may be clouded or debased altogether. *If a text 'fills a gap' and has no competition, if it is there first, it forms the field.* Who will know what is not there, what is wrong or tendentious?

Older surveys had facts, the newer ones have concepts. Both face in different ways the spectre of over-compression inherent in the genre, although the very *factuality* of the earlier ones acknowledged that the outline of art history was a relative matter. *In even the best of circumstances the 'surveyor' must be distanced enough from his material to give proper time and relative emphasis to that outline.* The old-fashioned structured outline presumed that readers could look up, fill in, and put together what was needed, when it was needed; its austerity of presentation was compensated by the vigour of intellect and commitment expected from its users. The newer surveys – or the newer editions of the older ones – seem based on the modern will *first to look at the images and only then to turn to the text.*

Somewhere along the way it was decided that incoming students needed an illustrated, well-rounded and well-formulated text that has since become a recipe book of easy formulations about ideas, periods, and styles. (As with advanced scholarship, the more one dwells on visual analysis, style, or iconography, the more history and documents are pretty well excluded.) Its advantage lay in the reader's ability to 'dip into, run to, or consult' a single volume that might back up or confirm intuitions or else

provide information at a basic level. Such strengths may be dangers because of the authority vested in the more complex survey texts and become patent in the simple ones. It is significant that some of these volumes are now 'dividing and multiplying' so as to treat more and more periods 'in depth.' *The survey mentality is progressively being extended to other sectors.*

This fact should be seen as admission that the survey cannot serve all purposes or fill all needs save that of commodity. What are the lecturers doing except to present their material 'following the text' and carrying over their own passivity into the more specialized courses of study? One suspects that art history has become marketable and that in an attempt to show how 'coherent and developmental' it is, authors are writing with little more than immediate concerns on their minds.

Perhaps the survey text as it exists today has already become an anomaly that, like most aberrations, has become self-perpetuating within the vacuum of scholarship. Models may be sought by seeing what's on the market, by noting what one can do, how to be different, original; but through the posing of such conditions one already undermines the purpose of the survey – *the recording of a certain consensus in handbook form.* It may be that survey texts can now be written only by authors of a certain standing or inclination, not by those who could and should, even as the current models must be watered down even more. *At what point can something override what exists and who will assume responsibility for writing it?* Unless all this means that books can be written *and* used for college and university surveys, but that one hesitates to address the existing literature and commit oneself to some years of work to compose *for* use in the same institutions.

Now in any contention between literature and works of art, the former often prevails because of its relative accessibility. Before the rise of facsimile reprints in the 1960s, much travel was required simply to *get to* the sources; nor was reprography out of its infancy. These two technologies have revolutionized the field by opening up access to the older literature. The amount of recent publication in reference tools, general and specific texts, has been nothing short of phenomenal. The field is covered to the point where the eyes become glazed if shown too many things.

In an Age of Reductive Analysis, such encapsulation and dissemination render certain services, although they make the determination of options rather more difficult. Yet, when compared with other disciplines, the standard works in the history of art are on the whole quite decent, whether restricted to English or extended to foreign languages. Furthermore, whether by accident or miracle, the Library of Congress numbers assigned to Art have a rare consistency (whether in the subject Ns or the bibliographical Zs) as opposed to other areas of the classification.

Librarians having before them an ambitious reader of any age or level can be virtually assured, therefore, of his finding almost all that is on the shelves within this subject area; they can be reasonably confident that something useful can actually be had, not just that the readers can be got away from the desk. Since the general Library of Congress classifications (N, NA, NB, NC, ND, NE, NK, NX) are by now unavoidable, they punctuate the literature much as the normal punctuation of a complex sentence. Whatever their inconsistencies and constant internal permutations, they are a form of world-wide reference of distinct advantage to any user having mastered the system; notwithstanding this fact, they have nothing to do with the amount and quality of art-historical writing; they merely process it.

Library or other classifications can then point the way to, lead to, direct, and even accompany the user on his way, but they only attempt to do this much and no more. While they inform and condition mental sets, their manual counterpart is the automation of services begun around 1960 and steadily gaining on the field as a whole. This technological development is much more portentious. With it has come the expectation, which always outruns the capacity to deliver, that whatever one wants is instantly available, even though this is hardly ever the case in present circumstances. *The assumption is then made that mechanization will 'speed up' research as much as it allegedly speeds the transferral and delivery of information.* Alas, the natural inadequacies of indexing always become more evident once placed into computerized retrieval systems.

The greater part of art-historical literature deals with relationships or with abstract issues. These are virtually impossible to address in mechanized retrieval except in grossly simplified form. If the automated systems are to serve rather than hinder users, one will have to do more 'enhancing' of titles in the humanities as a whole. Humanists are no longer used to truly descriptive titles such as those on which the sciences are based and developed; as a result, subject searches are bound to be ambiguous because the language employed has all kinds of meanings and overtones that can scarcely be retained once translated into machine language. *The result is that information is delivered out of its real context.* The researcher is then likely to lose more time 'reconverting and retranslating' than if the tracings were done by the traditional methods; and he will have no other recourse before him.

It may be said that the fragmentation of perception and a corresponding loss of focus are inherent in the dual process of popularization and mechanization. Users are thought capable of absorbing and reconstituting in different form piecemeal observations that have been delivered more

or less instantly to them in a form not of their choice. *The general context is removed, and with it the integrity and homogeneity of the historical sources themselves.* With the inexorable progress of such modernization of institutions and procedures, there is a real likelihood that whole generations of research will be 'lost' as a result of the implementation of new ways and means.

Once engaged, there can be no question of stop-and-go experimentation or of distinctions between requirements. Hence there will be a more personal impact on art history than in the sciences where errors are anticipated, where the scientific process is geared to intensive activity that thereafter can be rejected in toto. The progressive and combinative nature of art history presumes selection and focus as the means of isolating things for study from the mass; it requires not simple access, but the means of distinguishing things within the mass of common documentation or ideas held in suspension with other disciplines.

The art historian is totally dependent upon the institutions and cannot simply retire to his laboratory. If the mechanization of services in archives, libraries, and museums is done without sufficient insight into what is really needed, the field as a whole will be worse off than ever. It is one thing to find the work you need is in binding or out on exhibition somewhere, and quite another if it is processed in forms that multiply the steps and levels of access and consultation. It will be still another if research becomes so dehumanized that it is confounded altogether.

Scaling Up and Scaling Down

> Nicht Kunst und Wissenschaft allein,
> Geduld will bei dem Werke sein.
> Ein stiller Geist ist Jahre lang geschäftig;
> Die Zeit nur macht die feine Gährung kräftig.
> Goethe, *Faust*

The aim of research is not so much to pass judgment on the past but to make one's own contemporaries aware of what artist X or object Y meant to theirs, and why. Nor is it the simple use of documentation but its understanding and the transmission of that understanding with clarity and economy. Thus it is that the ability (or inability) to 'scale' research appropriately becomes one of the most important single indicators of competence.

The reasons for this are obvious when one but thinks about it. Large projects require attention beyond a given length of time; they require not only 'keeping the thread going' but keeping the attention that they demand – and create. This is rather different than working hard and concentratedly on the article and essay formats and getting them out of the way.

Whatever their level of attention (and perhaps of result), research projects fall into two general types, the Conceptual and *Realia*. The first is read for its accumulated insights, perhaps resulting from a lifetime's work and certainly of a nature that cannot be put down *in detail*. The second is time consuming and effort-heavy. It requires much acumen and circumspection and leads normally to something of the density and articulation of the *Kunstdenkmäler* and *Reallexica*. The *catalogue raisonné* probably lies near their midpoint.

Distinction must also be made between the essay and the article, which have essential differences in rhetorical style and requirements. The former often seems to be written without real substantiation (documentation). In the sense of one who attempts or essays, its role is to open up, stimulate or provoke, or intrigue; it may even lead to the study of *Realia*. The art historian's authority shows in his judgment, which is, after all, why he may exercise his profession without being part of it. Once the Rubicon of professionalism has been crossed, whether as professor or an arts administrator, the researcher has an obligation to make his mark, manifest his competence, become in some way influential. For museum and gallery personnel, competence will likely be defined on a day-by-day basis and its 'additioning up' over a period of time. The university affiliation supposes the more classic route of publications of varied nature and complexity. In either case, one may never need do a book, but neither should one fall back on the 'hybrid' genre of the exhibition-catalogue notice as full measure of one's capacities and reputation.

In determining the scale of one's activities (which is also their direction), one must find what is personally congenial. There are those who are as absolutely unable to write as they are absolutely disinterested in writing books; perhaps they should be let lie like sleeping dogs. One hopes by way of compensation that their forte is in pursuing details, doing synopses, getting straight to the point. In so doing, they may effect minor revolutions in the context of an existing field or create one where it never existed. As Panofsky often remarked, 'it is nice to go to unknown countries.' But this, too, has its risks.

The book (monograph) is usually preceded by one's own articles or essays on specific matters, although this is not invariably the case. How-

ever, these three formats normally are differentiated by quantity and then by level of approach. In general, the book answers requirements of thoroughness and scale absent in the more specific issues served by notes and treated in articles and essays. As its etymology suggests, the article (*articulum/membrum*) is only a particle of something larger. It contributes only a part to a greater view, such as a certain problem, subtopic, or discussion.

While there should be no intrinsic differences in their real importance, these different levels of publication have been assigned hierarchical values. One has only to follow out a logical process to see why the monograph is more valued in public mind than shorter pieces of research, however jewel-like and dazzling. To begin with, the book stands by itself, while the article/essay appears in conjunction with other contributions and must accordingly be *searched out*.

The book is also easily spotted because it is given individual reviews from which it gains prominence. Rather than a perfunctory review, it may become the subject of an extended review (review article) in which another expert may virtually compose an article or small book that, for one reason or another, he has not written. Even the merely competent reviewer may find himself in the delicate position of wondering aloud whether a topic could have been treated more pertinently in article form. Indeed, the true monograph in its traditional sense is becoming rarer as extended articles or lectures assume through scandalously luxurious production values – wide margins, selected papers, and large type-face – the proportions (but not the content) of books. But this problem cannot be dealt with here, although everyone has his own list of candidates for this dubious but flattering distinction.

Yet it is surprising how often books and articles of great, even seminal, importance are unknown or simply drop from view. This circumstance is most obvious in the interdisciplinary literature bearing upon several areas of interest. For purposes of argument, we will suppose that there has everywhere been a maturing of individual disciplines over the years coupled with a rise in the level of approach (which is why the secondary literature 'dates' so rapidly when seen in retrospect).

What is clear is that between the literature *confined* to a field and *other* literature, the middle ground represented by 'interdisciplinary studies' has been much contaminated and brought into disrepute by its practitioners. This is not the case when a subject such as Leonardo da Vinci is treated by scholars in the history of science and technology. But it is more than likely to be the case in the so-called interdisciplinary studies that are 'labelled' and, as such, warrant suspicion. Nor do we mean the collective effort around a topic that is similar to a marriage of convenience, but rather a

more complete approach to a topic by an individual. True interdisciplinary study, in this view, is normally done by highly competent people in a certain area who move toward its accepted confines, examine its borderline or frontiers, and have *interdisciplinary aspirations while remaining firmly committed to their point of reference*. This goal is doubtless less frequent now that art history has lost to some degree its humanistic, literary, and philosophical bases: conceptual hand-me-downs go poorly with the thorny problems of *Realia* and *Rezeptionsgeschichte*.

In all cases, however, the quality of the writer is shown in his use of quotations and of source notes. How refreshing it is to see the sources addressed directly, to remark a single well-chosen quotation where it is really appropriate, where it has been woven into the exposition rather than being one among many quotations *everyone knows*. Similarly, it is not the amount but the quality of notes that matters. At their best they may be more interesting and provocative than the text they seem to serve. At their worst – a failing of quotations as well – they contribute nothing that is essential, not even essential asides. So it is that one must avoid anything that is distracting or irrelevant. One must not be dragged down by the routines of research and one must have the gift – the ability – to make sudden shifts in research strategy as required. This is largely a question of proper work habits.

The best advice that can be given to the prospective author of a book or article is to *set a time limit and adhere to it*. In so doing one accepts the givens, which are highly variable depending upon the nature of the topic and where one is working. No one can be said to have exhaustive knowledge on any topic, so there must be compensation through effort. This effort cannot be interminable if one is to retain any semblance of physical and psychological health. The diminishing returns of the research process are rather like topping off a pyramid: how long you spend depends upon the angle of its inclination, and the pyramid must slope inwards rather than outwards if it is to be finished at all.

In essence, then, one does not just sit down and write an article, much less a book: one must *want* to do so. An article often springs from observations that, upon reasonable testing for feasibility, determine whether it could be done. One has only to multiply this process exponentially in the case of a book or repertory.

At this point there are 'criteria of exclusion' to be applied if the projected work is to be successfully completed without inflicting undue mental cruelty upon the writer and everyone around him.

For articles and essays: Assess what you want and need to say. Determine

what remains to be done for the topic to be viable and presentable. Assign a date, say, four months hence, and not a day later; work to it. If not, you may be shocked to discover you are writing a chapter of a book rather than the article you set out to write. Since the two genres have nothing in common, you have more than you need and have already committed yourself to a larger, more difficult, and perhaps more subtle work.

For books and repertories: Know that the effort and commitment required are far less easily calculated than for the lesser genres and that the equation is complicated incalculably by its subject-matter. Do what needs to be done as it comes up. Given the length and complexity of this type of publication you must begin immediately to *sectionalize* it so that it becomes both intellectually manageable and readable. You will have to resist the temptation to treat everything that comes up if you want to put the book to bed and turn your back on it.

This says in veiled terms what it is necessary to say brutally. *The more oriented one is toward subject-matter, the more one is tempted to satisfy one's (insatiable) curiosity.* This indulgence, while seemingly trivial, inevitably makes one forget about immediate goals unless one is exceptionally well disciplined. While you may not 'make' your deadline, you must have one – an *early* one – while building in a reasonable delay for the second – *firm* – deadline to which you do adhere. Otherwise you will 'lose control' of your project.

If one has done much research intended for publication, experience teaches what the common practice is: at a given moment, if one has not finished a project, one never does it or else it becomes extremely difficult, perhaps impossible, to complete. *Losing control is losing focus; through time and the multiplication of ancillary matters, everything becomes less clear.* Rather than intellectual fruit ripening on the tree, it will drop off of its own weight, or be spoiled by the withering breeze of Perfection – which has no season and, alas, no assigned direction.

The problem, then, is to find a criterion to bring things into order and focus and not to deviate from it except, perhaps, in minor details. Here enters the spectre of Completeness. *Instead of spending thought on the quality of what one has, one increases the quantity in the hope of 'knowing' more.* In so doing, one destroys the possibility of firm intellectual reference necessary to make useful documents of written or visual material. With every addition of questionable or irrelevant matter, cohesion suffers; rather than adding a reference or expanding the argument, one is taking away the vital force of selection and emphasis. At this point, many researchers give up the ghost to a spectre of their own making.

It then seems that if there is no early diagnosis, the progress of the research disease cannot be controlled. Rather like the cancer victim, *one seeks the cure in material one doesn't have, material that may not exist.* It always appears that larger and larger comparison groups are somehow easier to work with than individual issues or works of art. In reality they are like the discussion of newly discovered works: they must be inserted into context while respecting their particularities to discern where they fall. The reconstitution of 'lost' information, or information once known but not directly retained or immediately transmitted, assumes differing proportions in an article or book. Even as one's queries anticipate what might come out of the problem at hand, they constantly look back at what has been accomplished, reviewing where and how something began and evolved.

While the book or article is decidedly one's *own* decision and responsibility, the Dissertation only rarely grows from personal interest. It is in some way 'recommended,' although the evidence may lead one through many a tangled web. In all these works, not excluding the repertory and *catalogue raisonné*, a wrong initial choice, compounded by indifferent work habits, can only lead to an aborted or deformed publication. It is in determining the number and level of likely obstacles that one decides to undertake a topic, or renounces it so that it lies fallow in the expectation of someone more qualified.

Above all, while collecting material, see to its precise bibliographical documentation from the first moment on. Otherwise an incredible amount of time is wasted as the accumulated frustrations take an incredible toll on the nerves. Cross-reference as you go so as to permit displacement or multiplication of ideas and topics, for no bit of information gleaned will have one use and one use only.

In the end, there is a specific type of person who engages in the larger research projects that are the book, *catalogue raisonné*, and repertory. He possesses stamina, perseverance, and is rather like the marathon runner who doesn't give in. Extensive projects are very demanding on mental and physical health, although they can also be executed with some success by creative hypochondriacs who do not exceed limits known only to them. *One must, however, be in control of one's subject in its essentials while committing oneself unreservedly to the unknown.* It is one thing to do a local topic in the library; it is quite another to use local facilities but to calculate working days in other cities and countries where everything is a variable.

As there is a specific personality who engages in long-term research, so there are specific differences in the scaling of different types of intellectual work. Personality is more perceptible in smaller formats such as the note,

article, essay, and perhaps in some books. This is not a matter of decision but the immediate reflection of talent and the result of tighter focus. Major intellectual work – repertories and reference books – is by nature more a question of constructive selection, collection, and display than of the spark of a free spirit.

Personality is not thought proper nor should it be perceptible in work of larger scale and duration, even if the result is usually a monument to its author. This type of writing is not a function of natural personality but of an assumed one to which real and apparent objectivity are assigned. It serves as a *Nachleben* rather than a *Nachlass*.

Scholarly Generosity

> J'ai le bonheur de penser, comme pensoit en grand et au physique
> l'illustre Comte de Caylus, qui disoit: qu'il étoit même beau d'obliger
> des ingrats.
> Hugues-Adrien Joly to C.H. von Heinecken, 8 April 1781

Scholarly generosity results from knowledge that individuals can never use themselves, whether it be from their own efforts or those of others. It is the more-or-less conscious apportioning of excess intellectual baggage where it is deemed to be of best use. It is oral or written in nature, and perilously close to casting pearls before a variety of swine in that there are absolutely no assurances that it will *come* to anything. Still, it must be given, or consciously withheld.

Its best exercise depends upon one's personal and institutional relations and upon happenstance; its best results are the casual or inadvertent enrichment and texturing of facts, arguments, bibliography, and insights. It has a *formative* as much as an *informative* function not unlike conversation, and as many possibilities of use and abuse.

The scholar of any age is always in communication with people having greater or lesser experience – often of much the same experience through generation and outlook. Any of these levels must eventually come into communication with others proceeding from different, even acculturated assumptions and addressing specific problems. It is often the chance comment, the overheard discussion, the probing of differences in training, approach, vocabulary, that set the stage for disinterested intervention.

It is always easier to give to a beginner than to a rival: the former often lacks the experience to use the information in other than a literal manner while the latter recognizes its profound sense to at least some degree.

Since much scholarly generosity is an *unconscious* process, as the result of conversation that provides the context for specific information, one comes to realize who, appearances to the contrary, is potentially dangerous and who is genuinely interested. In most cases, a scholar's reputation precedes him and is directly or indirectly transmitted over the years; in the case of 'first offenders' in intellectual theft, it is necessary to discern the thin line between the naïve and the calculated, and how long it persists.

In some instances scholarly generosity is a process of criticism that may better be given by someone outside the field than within it, particularly in a time of narrow specializations. This is rather like a meeting of minds occurring when, for example, several students study independently for comprehensive examinations but meet together for general revision, or when trusted friends discuss matters of mutual interest in an improvisatory manner. This latter exchange represents the most precious level of scholarship, whether it occurs between equals, between different generations and levels of experience, or between the awesome personality and the exceptionally competent, but discreet, intellectual worker. It is a comedy of manners where the casual allusion, the dropped name, the unknown fact or unusual presentation, all have a formative role within the field as a whole. What it is not is simple gossip or shop talk. At least, not in the best hands.

If not restricted to oral communication, scholarly generosity requires letter writing (keep a copy for your files) of a fastidious or burdensome nature. Correspondence is one thing when replying to a query well put and quite another when something is unsolicited, being merely ventured into the blue. Whether factual or interpretive in nature, transmissions should be concise, complete, and of a tone appropriate to the correspondents. Often several exchanges are required, particularly with strangers, to determine whether one should go further; in such cases, the first letter is tentative and does not reveal all one knows. With friends it is, or should be, unguarded. The only strict rule is to *answer* all letters, and to do so within a reasonable period of time.

The counterpoise of scholarly generosity is proper acknowledgment! Whether general (in prefatory material) or particular (at a given point in text or apparatus), Acknowledgment is recognition of the contributions of the living in quite the same way as a note and bibliographical citation honour the contributions of the dead or otherwise inaccessible. There are three levels of acknowledgment:
- the *formulary* (perfunctory acknowledgment of collections and curators unless they have performed unusual or outstanding service);
- the *circumstantial* (incidental acknowledgment of specific information of whatever nature);

– the *continuing* (usually some mentor or correspondent of long standing whose contributions go so far beyond the specific as to be indefinable).

Writing up properly acknowledgments for a book, weighing them by their nature, frequency, and importance and varying one's expression accordingly, is then a major literary exercise of deceptive simplicity. These should not be of a dreary sameness indicating lack of application, but neither should they be mere exercises in style. The thing to be avoided at all cost is the type of phrasing that in oral delivery could be inflected to give a certain sense but which, in written form, seems gratuitous or undignified. Say what you have to say, plainly and according to its importance for your work, and you will not go far wrong.

It should be obvious that the real measure of scholarly generosity is revealed in undergraduate and postgraduate teaching. Your charges are as dependent upon you as orphans. Whatever their capacities and aptitudes, they must be given something to work with, something that is formally structured so that it may be grasped, something within that structure that is conjectural, that advances them more rapidly than one was able to do at a similar stage of development.

And yet, the nature of scholarly generosity is such that it can never really be acknowledged. It is invisible, transient, and most usually so when it 'keeps things moving' that otherwise would be stopped short – the flow of advice and counsel, letters of reference, recommendations, scholarly adjudications, administrative duties, and all the matters that pass by in the night and leave no trace, no carbon copies.

It is perhaps inevitable that such things are taken for granted within the academic community because they are usually seen through the eyes of students who think of them as transactions without understanding their timing. What it means to 'get them out' at a given moment is never fully realized until later, perhaps only once one is fully enmeshed in the academic system with all its dispiriting happenstances. Only when a certain stage in life is reached is one brought to realize just what was once taken for granted, and what such seemingly incidental tasks mean in Time, whose usage and passage is as incalculable, exorable, and shifting as the sands.

For who except a colleague who really knows you and your work can fully measure the implications of his request to do scattered verifications once it is known you will be in Berlin, Prague, or Amsterdam? Often the time required is in inverse proportion to the apparent simplicity of the request, *unless he has been there before you and knows what is involved*. Even then, no one who has not done this type of grace and favour knows what it means to fit *yet another* bit of scholarly business to his timetable. There usually results an inner dialogue as to whether the matter could really have been handled by correspondence, whether it is merely a personal conve-

nience, whether it has become a pressing necessity (small but important, or the result of some publishing deadline), or whether it represents a callous or thoughtless imposition. And yet, if it is for a friend in need, the additional research will somehow be worked in, not so much in the faint hope of reciprocation but because a piece of work can be made better. This kind of give and take extends to the taking over of seminars or classes on short notice and, in worst instance, to putting out a book left in proof (even in manuscript) for a colleague who dies suddenly. In these and many other contexts, scholarly generosity is presumed.

And rightly so, for scholarship has its particular aura and its applications, most of which are not seen for what they really are by those who would use them. Some years ago I was asked how I might define my own activities in respect to libraries, museums, and art galleries; more particularly concerning the Friends of this or that. My response – a personal one increasingly dictated by surer instincts for survival – was that I had neither the time nor the inclination to act in their behalf in any *regular* or *organized* fashion; that it sufficed to give freely of expertise and advice where this seemed called for, but that payment was required in certain contexts.

The unexpectedness of this framing left my interlocutor nonplussed, for I contended that in most cases my *timely* intervention (and that of others who might never be seen or heard from again) was quite as necessary and perhaps quite as important as that of the regular staff and volunteers. That in reality we were speaking of distinct levels and types of intervention that must on no account become confused in anyone's mind just because they were within reach and brought to bear on the same issue at the same time; that scholarly input was, in the nature of things, not something that could be enrolled, impressed into service, counted in the annual statistics. In a word, that it and its invisibility were likewise presumed.

In an era where academic 'presence' is actively sought, even considered a form of necessary community service, it may be difficult for the art institutions and academics to appreciate the profound reasons they are momentarily brought together. After one particularly draining advisory board meeting I was led to lament the difficulties of the moment in concentrating on my scholarly work. I sat back stolidly amidst the universal exhortation to 'get your priorities sorted out,' all the while musing that *if I had*, I would be conspicuous by my absence. Then I found myself wondering whether I could easily be replaced, or whether I was there rather more out of a vague sense of obligation than an interest that surpassed reason. For the time invested on all sides, I have always found it difficult to say who receives more or better insights, *whether acted upon or not*.

Surely there is no better way of suggesting the 'confidential' nature of

Scholarly Generosity, much less all the ways it may be taken advantage of. Whether giving a bibliographic reference or orienting students, whether by talking over the forms that a colleague's monograph might take or sharing his expertise intermittently at the more rarefied levels, *the scholar knows he has no power of enforcement.* All these things may fall wide of the purpose, but they are all necessary to it. In this lies the scholar's strength, and much of his vulnerability.

When Writing for Periodical Publication

Le but de l'étude est d'augmenter le savoir et d'éviter les erreurs.
A.-L. Millin, 1796

One of the real pleasures of an Editor is knowing what is being done and being able to work with authors who must often be 'brought along' to scholarly maturity. In briefest terms, one strives to give better form to *whatever* is submitted. Since each potential contribution has its particular problems, one winds up individually crafting everything from content to expression, whilst not neglecting form.

Many potential authors, even those with considerable experience, work on the supposition that one journal resembles another. Nothing could be farther from the truth; in fact, each publication has its own house style, its editorial policy and purpose. Whether in every issue or at intervals, each periodical gives instructions as to notation, abbreviations, and photographic legends as well as to the preparation of the typescript itself. Familiarize yourself with them in a wide variety of reputable journals. Gain some idea of their editorial policy, if it is not stated formally, by examining over a period of years what has been published. (This is in itself an incentive to browse regularly through the periodical literature, thereby keeping pace with current developments and controversy.)

A fundamental misapprehension of many authors is to take too much (or not enough) for granted in their audience, when the audience varies necessarily according to the journal. It might be rather different if one writes for a purely Canadian audience, for example. But most journals aim for a national, continental, and international readership. Authors must accordingly work to the accepted norms, situating their method, their *reason* for writing, because this is often not self-evident. They must also document their work according to accepted practice.

Most important of all, they must think how their work *will look* some five, fifteen, or even fifty years hence instead of thinking only how to *get* some-

thing into print – less elegantly put, to 'sprint into print.' In this context, the difference in *level of approach* that we normally term 'scholarly or popular' defines the different levels of journals and what one expects of them. Any periodical becomes the repository for future generations of what one hopes is the best documentation and interpretation possible – serious in intent and form, readable, and often sophisticated in content and presentation. In time one discerns what is 'a footnote matter' or not worth publishing at all. After a certain time, one realizes that *documentary* publication forms the backbone of the scholarly body but that *theoretical writing*, to which not all can attain, is its nerves. There may be instances where one can only appreciate the quality of argumentation, where no clear-cut answers are possible or even likely. In such cases concision is the order of the day.

The sign of the novice is the accumulation of references without much thought or direction in their use. Proficiency comes only through experience; indeed, it may be said that the rapid generation of quantities of material forces one to concentrate on *essentials*. Only through continued commitment to research and its written or verbal communication will one distinguish the relative value of current research because it must be inserted within a *larger* context.

Illustration, as textual exposition, may be closely argued or allusive. In the first case, the eye is immediately struck by resemblance (motif, style); in the second, function may not be immediately apparent since the illustration is directly dependent upon the text and cannot be understood separately.

Outside our own field, illustration remains an (unacknowledged) adjunct to the argument because it is not the basis of study and comparison in historical context. Within the discipline, it may be a given (and one *must* work with the givens) or else it becomes somehow integral to what one is writing and, as a result, needs to be assembled around a topic. In this latter case, if one could but choose from many examples (forgetting for the moment their origins and the circumstances of their assemblage), it would become apparent that their final choice cannot be determined *in vacuo*. At the same time, the demonstration to be made from them depends upon what *has been* chosen. (Imagine, for instance, a given argument made on the basis of an entirely different set of examples than those commonly known and referred to; or else an argument built around a consensus of significant images varied by secondary examples.) Since one cannot illustrate even the essentials in periodical publication, much less the comparative material, one must think in terms of what is 'necessary' while by the same argument recognizing what 'need not' be illustrated. In sum, the second in-

fallible sign of a tiro is an inability to select – and thus to restrict pertinently – one's visuals.

Scholarly apparatus is a delicate balance that must be maintained between 'three lines of text and sixty of notes' or a more purely discursive text with no foot-, side-, or end-notes. Citations of any length are to be avoided, particularly if they are awkwardly inserted rather than being woven into the fabric of exposition. The absolute sign of amateurism – what one expects at the secondary school level but not thereafter – is the alternation of transition phrases or paragraphs with citations set off from the text. And this to the point that the reader has the impression of a *millefeuille* pastry. (This normally indicates that the writer has no intellectual fibre or else has not digested the material.) In the enthusiasm of discovery, the naïve writer relies on the specious reasoning that the 'exact wording' or the 'phraseology of the period' says it better than one can today. If so, it is best kept to a footnote or given in an appendix as the document it is, although few documents are so richly textured and interesting from beginning to end to warrant this treatment. Thus, *quotations* should be retained only if they provide 'significant insight' into a problem or lend themselves to several interpretations that might be judged by the reader.

A final word: periodical publication is perhaps the most highly *structured* type of historical exposition. It is emphatically *not* a data base. It requires a detail not possible in the monograph and a readability not often apparent in the *catalogue raisonné* or exhibition-catalogue entry. It must accordingly be closely reasoned and documented so that its real or provisional conclusions can be discussed and evaluated (or completed) by others. But it is never in its best form a tedious and exhaustive compilation of references. One should never be able to utter, at this level of historical writing, the most damning critique of all: 'Yes, X has a writing problem, if you think writing has anything to do with thought.'

Reviewers and Reviewing

> La *mauvaise* critique est aisée, mais celle-là seulement. On pourra même observer que, dans l'histoire, le nombre des grands artistes est beaucoup plus élevé que celui des bons critiques.
> Julien Benda, *La France byzantine*

Reviewing is not, as commonly supposed, as much a creative exercise as a retrospective judgment upon an author's choice and development of a topic. The Review is the penultimate step of the art-historical process;

it supposes maturity, deliberation, and distancing on the part of the Reviewer because his opinion – and it *is* an opinion – may be sought *in place* of reading the work itself, just as it may be *consulted* for an additional opinion or insight to see what one's own critical stance is worth.

Articles and notes are not usually reviewed, only *used* – which is a form of review for immediate and limited purposes – while the number of exhibition catalogues reserved for this treatment reflects their proportionate increase in the literature. One is never assured of 'being reviewed' any more than one is of receiving a 'good' (which is to say a flattering) review.

Books, *catalogues raisonnés*, and repertories are, in contrast, most subject to review as one is called upon to sanction or disapprove what a publisher has seen fit to produce and how it has been given form and substance through the assessment process and, ultimately, publication. Publication itself represents a choice, a selection, upon which the publisher's reputation depends as much or more than that of the author(s); the validity of the publishing process must be shown as much as that of the decision itself – a serious matter indeed in view of the costs involved in putting an extensive work before the public. And of publicizing it, of which the Review is an integral part.

Before one ever has the volume or volumes to hand, there is a primitive stage of review involving the author as he develops his concept to the point of submission to an editor. Then comes another stage, involving evaluation or assessment from people deemed reputable in the field, which may involve greater or lesser revision, whether of details or of more substantive matters. Here is the prime level of critical intervention: not only does it determine *whether* something is given over to the public, but it also determines to some degree *what form* it must assume when all the economic and commercial factors – including the potential audience – are accounted for. This is the price of scholarly work, and it is scarcely recognized by most people in the field until they have gone through the process, by which time it is normally too late for anything but a post mortem or, at very least, a very bruised ego.

These preliminary levels of reviewing are, in Gottschalk's words, aimed at doing 'what they can to diminish the rate of increase' of historical work in general in the hope that work of real quality can be produced to its needs; in which context his five questions are eminently worth recall:

1 Does it [the book] establish its factual details by a strict application of the historical method?
2 Does it have a philosophy or 'frame of reference' that is of more than transient and local significance and of more than private validity?

3 Is it written in a style that helps rather than impedes the reader's understanding?
4 Is it merely a piece of hackwork repeating an already known story, or does it present new data or new interpretation of old data?
5 No matter how limited its subject may be, does the author seem aware of the questions that men at all times in all places persist in asking?[19]

Such questions attempt to define the place and rank of the work proposed for publication and whether it merits passing into print with all the time, work, and expense this involves. Reviewing in the usual acceptation of the word can only take the printed work as a fact, although it may enquire surreptitiously into the quality of prior assessment and decision. While these may already have resulted in a much improved piece of writing, the reviewer is not normally privy to this information. The publication must be taken for what it is.

Most journals provide detailed instructions to potential reviewers that specify length, critical approach, and such elements of 'house style' that virtually determine the *type* of reviewing possible. This has its ripple effect: a scholar interested in a problem will examine as many different types of reviews as possible of the work before him in the hope of profiting from the experience of others; a reviewer must, in contrast, confront the work before him without reference to other reviewers if his own work is to bring into relief his own perceptions and knowledge. Of course, a reviewer tends to evaluate by his own interests unless he is broadminded and even more broadly trained, but it remains to be seen whether his personality is perceptible rather than assumed for the occasion – or whether he is doing violence to his perceptions in adapting them to the editorial stance of the journal concerned. This is to say that the critical texture and approach permitted by an editor or journal may simply reflect the discipline or field. It is hoped that it is possible to stand outside oneself and look at oneself *as a reviewer* while looking at the book as well.

Because of its ultimate compaction, the review process is long and arduous and usually secret in its verifying and following up of references and of comparisons that have not been illustrated. But what *degree of detail* is really necessary? Reviews of catalogues seem always to include lists of *addenda* and *corrigenda* because attributions are at risk. One may also be able to suggest additional documentation on historical figures, ensembles of certain issues that have been raised. Attention is concentrated, even focused, upon what has been included and excluded, so it is only natural that one examines the logical and documentary processes implicit in such work.

Extended to the *catalogue raisonné*, the reviewer is on shaky ground, even

in quicksand, unless he is a specialist in virtually the same area – and this may arouse and fan the flames of internecine warfare among not only scholars, but institutions as well. This is best called The Regrettable Omission and usually assumes variant forms of the nature of: 'I know X would have added *our* drawing to his catalogue since he told/wrote me he believed in it shortly before his death.' In these circumstances, a death at eighty-five is just as untimely as one at thirty-seven, but such elegantly contained sorrow, when it issues from the major collections and dealers, never addresses *why* X never had time to include their art work in all his years of study and visiting. One should take note while relegating the observation to the nether regions of benign indifference unless there is reason to do otherwise.

The great problem is that most reviews are simply in a section forming the hinder quarters of a periodical. Publications are forwarded from publishers as a result of lists drawn up in advance. They are sent to journals qualified on a scale from 'essential' to 'likely' in a hierarchical scale determined by reputation, discipline, and quality of reviewers. It is therefore essential that authors be as familiar with the scholarly periodicals as publishers and reviewers. No one wants to 'waste' an expensive illustrated volume whose royalties one has perhaps had to forswear in order to get it published by sending it to a review with no real interest in art. At the same time, one has to weigh the relative advantages of a review in, for example, the *Art Bulletin, Burlington Magazine,* or *Renaissance Quarterly.* The first would ideally aim at a professional audience, the second, just as specialized an audience but in Britain, while the last would aim at the field. And one goes on from there, pondering the merits of various national journals, their audience, and also the market, although in some cases one wishes simply to be known and picked up within a reasonable time by the national bibliographies.

But what purpose does reviewing serve? Is it some defined purpose or must it be some lesser activity, or even a sham? While most people have consulted reviews over the years, how often can one cite – or recall – a *memorable* one? Is the amount of space accorded this activity consonant with its quality, even with its motives? More pertinently, what should one make of someone whose curriculum vitae is overburdened with reviews at the expense of other types of publications? On the one hand, some journals (the *Journal of the Warburg and Courtauld Institutes* is one) employ the equivalent space for more articles, notes, and documents, and this reticence should give pause for reflection. On the other hand, the *Kritische Berichte zur kunstgeschichtlichen Literatur* (1927–38) is, as the present *Kunstchronik*, essentially a review of reviews assigned to specialists, the density

and texture of whose arguments are certain to be essential in any future discussion.

Reviewing is, in the end, a type of apprenticeship in critical acumen brought to bear upon an object (book, catalogue, or repertory) that enables a focused discussion. Intended for print, it is a more formal statement than what might be said in private or between trusted colleagues – some volumes by eminent authors are never reviewed because of potential embarrassment and confusion to all concerned.

The Review also is an assessment of types of activity and their evolution within the art-history and publishing fields. It has occasion to treat work where the novelty of concept or treatment is the main critical statement; work that, as the repertory, is so firmly rooted in History as to be either a reconstruction or a reconstitution, although no less susceptible of controversy for it; and work that has gone underground for long years to emerge full-blown to the point that it would be foolhardy to think of redoing it at all.

Reviewing is a testing ground for the discipline through its full and quite unpredictable range of topics, some of which one would never seek out unless they were offered for view quite by chance, the chances of what has been assembled over months for inclusion in a given issue one happens to pick up or consult. However, all this study could be done on one's own without 'going public' and the quality of the reviewing process would in no wise be diminished, only contained. The number of reviews, and their quality, that should be published is theoretically as much subject to the laws of selection as any other published work. It is, regrettably, probably a minor art in that it is fundamentally misunderstood and misapplied.

If there is a cardinal rule in reviewing, it is: *Do not attempt to rewrite the book!* Confine yourself to the pertinent aspects of the work by
- addressing the topic (i.e. what the author has attempted to do, and how);
- noting the types of problems encountered or that emerge from his treatment);
- stressing the results of his (and your own) critical reading and enquiry;
- defining its position in the literature and how it might be used hereinafter as a monument/tombstone to the mind and to research;
- noting problems arising from the author's approach, including what might be treated elsewhere, the degree of factual/historical control, faulty logic, or whatever;
- remembering that reviews normally cannot rely upon illustration to make points and that literary formulation and compression are tested to their highest degree in this type of exercise.

It is felt, not without some reason, that Reviews may occupy space that might be better reserved for Research. This view conveniently forgets that even in these days of inflated production one cannot hope to fill periodicals with worthwhile research. Reviews attempt to consolidate knowledge periodically through making sense of current production and inserting it into the historiographical and scholarly developments from earliest times. This is their best and ultimate justification, but only if approached in the proper spirit.

Diminished Powers, or a Sense of Proportion

> Der Kreis ihrer Bewegungen ist zwar beschränkt; doch diejenigen, die ihnen zu Gebote stehen, vollziehen sich mit einer Ruhe, Leichtigkeit und Anmut, die jedes denkende Gemüt in Erstaunen setzen.
> Heinrich von Kleist, *Über das Marionettentheater*

The method of art history is essentially a process of elaboration and the seeking of detail for its own sake in the hope that something significant will *come* of it.

At a certain point, however, even systematic investigation becomes less than meaningful given the diminishing returns repetitiveness brings because, in Barzun's words, 'Only lessons of fused intellect and imagination could exercise our minds by repetition.' It is then time to simplify, to compose, to orchestrate, even to re-orchestrate the various elements into an intellectual equivalent of a *spare* musical line having only the telling detail. Youthful works are to some degree recognized by their laboured qualities, while mature works may attain expressions of almost childlike simplicity.

This is perceptible mainly in scholars who have pursued their craft over a lifetime; it is far less apparent in those whose intellectual production is scant or scattered, although such attainment is not necessarily denied them upon occasion. Perhaps it is because the *juvenilia* represent scholarly qualifications and remain always provisional (anticipatory) in nature. Scholarly *performance* is – and must be – apparent.

Where it becomes apparent is in its ability to handle the variables, even the imponderables that study brings, and to reduce them to manageable proportions. This effort was once largely restricted to a great corpus or catalogue that represented the crowning achievement of a life of study and was 'prepared' by a coherent series of notes and articles that came to provide the major articulations of the final work. Rather like the standard critical editions of the most eminent poets, a publication had full and penetrat-

ing consideration of the different works, variants, and influences, and was accompanied by the concise historical and biographical detail that *fixes* attention. One wonders to what degree all this is possible in our day; if not, then criteria for judging the 'mature' article, monograph, or exhibition catalogue must be found. Somehow it does not seem quite the same; nor does it seem to afford possibilities for other than *fragmented* intellectual effort.

The consummately 'mature' work is likely to be that of a specialist who is sufficiently inquiring of mind to have situated his interest and taken his time in putting it out properly. The essential modesty of his statement belies long experience brought to bear upon a restricted subject having greater implications. Fundamental to this process is an ability to suppress oneself and other non-essentials.

The reason for this suppression should be evident. Recapitulation carries with it the inherent danger that one has already laid the bases for a thought process that henceforth proceeds quite independently of literature and experience. While others begin the process anew and may experience the need to articulate and verify matters of detail, one's own intellect presses onward as a result of only essential observations. So it is that return to a scholarly problem left behind some years ago necessarily implies selection, lest the effort be wasted on trivia.

There are, admittedly, rash books that can only be written when young; others that have the force of virility; and yet others – the mature works – in which Thought invests and transforms the dreariest of facts. All have their place, but few so represent the distillation of experience as the mature work whose opaque yet pellucid style stimulates the reader to 'supply the blanks,' to 'complete' the facts that are consciously missing, to *know* his outline of history so as to situate problems in ever more recessive, more allusive context.

Mature works are often impenetrable to the novice and superficial reader alike; they are potentially dangerous in what they take for granted in their readers and but rarely find. Even their apparatus becomes rarefied in its essentiality, for it cannot be assumed that their authors are unaware of the latest bibliography. *This means that the works are addressed, not the works concerning them.* Would that this lesson were learned earlier and more generally, even if we must all pass that way to get there.

No one can speak of mature works without considering all that lies behind them. (Declining will or interest is usually more at fault than truly diminished intellectual force.) Research, if done well, *hurts*. Physically, psychologically, financially. Research is best done when there is a financial squeeze combined with the determination to get something done or find something out. The more one travels in pursuance of intellectual work, the

more one recognizes the different national styles of art history and why – technically, historically, and organizationally – these exist. Without such insights, one becomes too *settled* as to what is possible within the field. With this experience, and provided one has a strong intellectual personality, it is possible to fashion one's own art-historical style.

Whatever his status, the working scholar has usually been the unwilling compiler of a *Michelin du Chercheur*, rating the institutions necessary to his work in terms of
– cadre,
– comfort,
– collection(s),
– catalogues, and
– competence.
In his years on the move he has acquired the fine discrimination of hens in the poultry-yard, covering vast amounts of territory, pecking around to get just what interests him at the moment, while somehow taking in the patterns for future reference. In this he differs from the moles, who perpetually make mountains of whatever they are doing but who, because they work only from the molehill, never see the mountains of important (but to them unrecognized) things that are continually being thrown up. Moles are eventually stricken by exhaustion because they cannot choose and are not critical, or by paralysis because they are not critical and therefore cannot choose. *Hens rely on almost statistical choices based on instinct and intuition, while moles never seem to mature.* Content with the appearances of work, being very publicly engaged in research, moles never go the 'step beyond' that is vital to basic, real art history: to reflection, the sifting of evidence, sharpening of the perceptions, and the use of all the inductive processes.

While the moles grind on, the maturing art historian will long since have turned from editing articles and books to editing the number of people and institutions with which he regularly works, or can work. Time becomes more a presence than a personification, and his great question is whether something better or more comprehensive can be done in whatever time remains. But the problem is not there entirely; it is whether his expectations may have been determined by prior experience without quite realizing it, through his having too close a knowledge of a few institutions and presuming others follow suit (they do not). Secure in his knowledge of prevailing local conditions, it becomes far too easy to abandon what could be done *if he still wished to pay the price.* Younger and less experienced art historians may, as a result, tend to be more innovative simply because they cannot calculate so finely; they take things as they seem to be, not as they are.

Extensive travel and intellectual discomfort are not in themselves guarantors of better research and writing. These come from better minds taken in combination with solid training and the type of experience that forces one to sort out the constant modulations in the conduct of art history. (What previously did not exist is now fashionable, and even historical thinking has its own history and changing functions.) The research climate will have changed since one's initial training as well. Ten to twenty years later, when one has reached one's forties, is the proper time to take stock of oneself, one's colleagues, and the different generations. Then follows the period to retirement that should see the mature works *within a career context*, followed by the spiral of decline thereafter in which only those firmly committed to the field can flourish.

This scenario is more or less apparent in individuals, perhaps to the individuals themselves. But it is rare that anyone not already active within the field, anyone not already having demonstrated promise, makes in his later years a few grand statements rather than a few more publications. This dilemma parallels that of society in general, so well characterized in *Emma* by John Knightley's aside to Miss Jane Fairfax: 'When I talked of your being altered by time, by the progress of years, I meant to imply the change of situation which time usually brings. I consider one as including the other. Time will generally lessen the interest of every attachment not within the daily circle.' What constitutes the 'daily circle' of the life of the mind in the art historian?

For one thing, the working scholar will have had to pick and choose, to sense where his interest and capacities really lie and how they can be used. He likely will have reconciled himself to *working below his level* as a result of linguistics – of having something to say and not being able to say it adequately, although communicating his basic needs or intentions. At home or abroad, his work is advancing (or consolidating) the discipline. And if a balance is to be drawn between day-to-day matters and crises, and between these and the truly unusual or exceptional situations, he must have clarity and simplicity of vision, not just details.

Rather than the closely defined artistic and social circles of yesteryear, with their cohesive exchange (or none at all) between cities and regions, today's art historian moves in a cultural vacuum. More than he might wish to admit, the quality of his formation depends upon where and how he works, whom he sees, and in what order access is had to materials. *It is only by keeping – or creating – time for reflection that one defines proper intellectual activity*. Otherwise, intermittent or concentrated mobilization of resources is meaningless, perhaps even dangerous. In the end, diminished powers mean something more positive than the simple concentration of effort and attention attendant upon age. They are rather more

the result of sustained intellectual effort in general application, of knowing the right moment to stop and put things together in an enlightened style.

Such growth in time belies the ease of apparent mastery (slickness, smoothness) that comes from exercising craft on the usual, filtered subjects. That we have all seen and recognized for what it is, shadow and not substance. Real maturity within the field presumes a distancing process throughout the conduct of one's entire work in progress. It also means sensing – through the printed page or in conversation – anyone not respecting historical thinking and the authority of the monument, and avoiding him insofar as possible. This means those who lack visual literacy even if they meet other requirements – those who should do anything else but art history but who, if ambitious, can be good, if narrow to a fault, and do irreparable harm through their example. In this sense, defining the qualities of a good art historian, young or old, can hardly be satisfied through his success in Management. One may be an excellent politician far removed from the pleasures of dealing with works of art. Careerists of any age are often not good as art historians because they lack the peculiar mix of intelligence, thoroughness, circumspection, and imagination that complete inventory and archival work: in other words, *a highly developed sensuality put under the control and discipline of the brain.*

To be a mature art historian is to be (or become) a voyeur, attentive but disengaged. This requirement is built into the field because lectures, seminars, colloquia, and the like see people *performing in turn*; or, in more out-of-the-way places, *presented as events.* Presentations are rarely discussions, and a few scattered questions at the end, often poorly framed at that, are rarely penetrating. How much more 'informative' it would be to see several authorities speaking on the same topic among themselves, responding to each other as things develop. If they disagree, yet respect each other, the audience gains some sense as to why a particular method or hypothesis is unacceptable; why someone's reputation is deserved, or is somewhat different from what one has heard; and why some should have a reputation while still others are recognized for no apparent reason. The public meeting of minds usually orients, if not into camps, at least into sectors that can be played off one against the other so as to form future generations.

The field ages along with its practitioners, bringing its own version of a lack of grasp – more properly, of a sense of proportion. Selection has always been fundamental to good art history and is becoming more so every day. It was possible in 1673, 1738, or 1845 to collect material without recognizing more than its monumental quality. By the 1750s or so, it was known *what was needed to work.* While this orientation was not uniformly

followed at the time, leaving much for historians to discover and exploit in our day, the nineteenth century saw the first attempts to put things together as well as to generate documentation, which few people consulted, and fewer yet used. As late as 1914 and perhaps as late as 1945 it was still relatively easy to know what was published, what was appearing, and – eventually – to have access to it. Obviously one did not work to modern deadlines.

This is no longer the case. Given the expense, the manifest impossibility of going to and consulting material at the very moment it is needed, a shift in thinking has occurred from without the field that aspires to deliver the material to the doorstep. In the guise of Information and Computer Science has come what might be called the Logistics and Cost of Dissemination, since the material is not really 'acquired' in the traditional sense. Yet Art History poses, as perhaps no other field, inherent and usually unforeseen problems because of its sliding scale of values and the sheer quantity of evidence. The challenge becomes not the usual publication of little quality, but too much unstructured (or restructured) documentation. Although anyone's research may be 'facilitated' by having access to material formerly beyond his reach, the question remains whether it is worth having, or using. What is worrisome is that there is little present sign that students of art history are able to use the material already in hand, much less all that could come their way. The irony for the historian, the difficulty of his situation, now becomes apparent. The diminished powers of earlier generations were attributable in the main to ageing processes within the human organism alone. These have since become questions of how the intellect functions within a totally destructured study environment. What if that environment becomes dependent upon outside sources and professional purveyors of information?

Fortunately, determining what work is rich in historical and methodological implication is the traditional preserve of those who have worked all their lives to get there. Perhaps the seminar system might change in order to accelerate the recognition of the different talents necessary within the field – teaching, erudition, curatorship, inventory, and archival work. My own instinct would be to distribute photographs having little apparent relation to each other, but representing unfinished work with many ramifications. Everyone would research them independently and write them up as a 'first article' that could be circulated within the seminar and given unrelenting criticism on all points.

Such a system would doubtless be considered cruel and unusual punishment, but it has merit in its acceptance that only a few within the field can handle all the aforementioned talents tolerably well in combination,

while the field seems somehow to be reorganizing itself into very separate (specialist) issues. The recognition and development of talent is likely to be a greater problem than ever before if Art History is to mature satisfactorily. If no one gives thought as to how best to meet this challenge, the discipline will be more inherently diminished than it is at present, albeit for rather different reasons. Much, perhaps too much, will depend upon the quality of those already in place during their declining years.

Night Thoughts

> Toutes les grandes choses ont beaucoup de raisons pour qu'elles ne soient point entreprises, mais elles ne laissent pas de produire de grands effets lorsqu'elles sont soutenues.
> Colbert

Whether written or spoken, the art-historical word 'strikes a chord' rather different from what it actually is. To the inexperienced and naïve it informs of the existence of questions or problems while it resonates with totally unexpected harmonies for the mature, active scholar or curator. It has a 'ripple effect' not only in one's own work but for the work of others, even that of generations far removed in time and place. It has an autonomous existence that ultimately belies the merely fashionable and which, as a result, is probably the best argument for resolute non-specialization that can be made.

This said, there is reason to fear for the discipline in its specific applications and structures, most particularly in the degeneration of university tradition. The proliferation of half-time and cross-appointments, and the contractually limited appointment, may be said to 'enrich' the field through the admittance of greater numbers of minds and the resultant lightening of repetitive and even deadening curricula. But this is unlikely to be a constructive much less a consolidating force in the intimate workings of departments and institutes once a certain staff percentage has been reached. After all, someone has regularly to staff the garrison against administrative *revirements* and their immediate and recessive effects on research and teaching programs.

Since the majority of problems within the discipline seem to come 'from the outside' it is inescapable that much of what can be done to forestall the inevitable depends upon institutional 'balance of power' or, more properly framed, on *the politics of scholarship within and without the field*. Unfortunately, it is not so much the apparent forces that most affect the course

of art history, but the invisible ones of attitude, the type and level of training, and, in unvarnished terms, the *hard costs* of supporting art-historical scholarship that come upon one like a storm-cloud. These are, I submit, more varied and onerous than for most other fields because the 'movement' of art – and all that goes with it in terms of custodial care, classification, and documentation – further dilutes an already diffuse research commitment, one going rather much beyond travel and living expenses and their anticipated discomforts.

To take only the question of photographic procurement as witness, the average cost of an 18 x 24 cm photograph at time of writing is, depending upon source, somewhere between $5 and $25 regardless of whether an existing negative is being printed or a new negative taken. Nor does this take into account the rights that may be payable in whole or in part for its reproduction. The combinative nature of art-historical study exacerbates this process in its presumption of many small transactions. Only the committed scholar who pays on a regular basis the bank charges for foreign drafts (often with additional surcharges of a more or less formal nature to cover the bank charges of the payee) is likely to have any real idea of the impact of currency fluctuations on operations within the field. And registration and postage charges will likely be identical for one or several photographs, depending upon the internal procedures of the institutional or commercial purveyor. One then gains incalculable insight into work entirely dependent upon illustration – *catalogues raisonnés*, repertories – as opposed to merely appended illustration, or only such illustration as is required to make a focused argument.

The split focus inherent in the name of the field – History of Art – further indicates the wide range of qualitative variation, of comprehension, possible in this as any other humanistic pursuit. The larger patterns are there if one but searches for them, but the health of the field is an individual responsibility given the intensely *personal* nature of problems encountered on a daily basis, problems requiring great physical and moral stamina to surmount. In practical terms, one must ask if we are not already reduced to doing what can be done *comfortably*: what is planned for, has institutional and public approval, is capable of reasonably rapid response.

One would like to presume that anyone can do a research paper, write an article or even a book, although few should attempt a reference work or a *catalogue raisonné* and fewer yet are likely to pull them off. Much is taken for granted in all this. What results is criticized in its details when it does exist and damned under one's breath when it does not because of the preliminary work that must be done before doing what one originally set out to do. It is within this context that one must admit that art history at

the university level has become a training field for jobs. And that, in North America, these positions for the most part lie *outside the field so far as any intellectual work is concerned.*

The progressive and in some cases enforced organization of research facilities (museums, libraries, archives) since the end of the Second World War has brought mixed blessings as well. True organization is never entirely a factor of anticipated use or immediate public solicitation but exists in its own right. Whatever the enhanced institutional ability to meet public demand (from the utterly trivial to the serious and sustained) something was lost in the translation to the point that these collections and concentrations are mistaken for art history itself. This is rather like a colleague's student who went to the Zentralinstitut für Kunstgeschichte in Munich, only to marvel at the books and periodicals suitable for his topic that were unavailable locally. When asked about his contacts with the Zentralinstitut's community of scholars (what he should have made time for, since the collections can be taken for granted), he replied with genuine amazement 'What do you mean?' At first I was appalled; but then, he was not my student and, on the positive side, the Zentralinstitut's staff were surely spared a waste of valuable time and expertise. This anecdote provides the other, tarnished side of the humanistic research coin, personal research doggedly undertaken within a cultural and intellectual vacuum, even within a human void. Actually, I would put the case more strongly yet: *There is now a lavishing, even a squandering of sophisticated resources and techniques upon problems too simple by far.*

Indeed, it remains to be seen what effect the vaunted 'new technologies' will have on a field where the older ones – mainly intellectual virtues – are as yet insufficiently mastered. While one can be reasonably optimistic about the virtues of word processing in the creation and issuance of catalogues, repertories, and inventories, formatting is a necessary preliminary step (know what you wish to do or, more bluntly, what you're doing) that can be either divorced from or conditioned by technology itself. You may access a computer or word processor with a ten-megabyte (10 million character) capacity, but how many art historians are engaged in that type of work?

It will naturally be argued that such data base capabilities facilitate intellectual work of smaller focus; but someone has to create them for work in given areas. One wonders whether art historians who cannot put out an interesting note or article through choice of topic and marshalling of currently available evidence are likely to have the vision necessary for anything other than immediate interests. But this is a failing not restricted to art history. The currently fashionable areas and approaches, the dreary set-

pieces foisted off on – and accepted by – public and peers alike, the sup-
port groups and professional societies engaged in the same type or area of
work, abound.

Upon reflection, determining an exhibition's character is remarkably
similar to that of scholarly work in general: one must recognize and find
for a visual or a didactic approach, or the halfway house that is context.
In ascending order of difficulty – and appearances are always deceiving –
one can put out a 'postcard or gift shop' show, or a more ambitious 'ideas'
show; but when it comes to a 'curator's show' in the best sense, one simply
has to buckle down the study of the object and its historical implications.
Thereafter, production values are not really an immediate function of qual-
ity; they are rather more the result of knowing, or sensing, what should be
stressed and the best way to get it across.

Once the exhibition or publication can be viewed, as Balzac observed,
'on doit observer que la censure a ses bornes. Il est un point où la cri-
tique doit s'arrêter et se piquer d'être indulgent' (*Catalogue de caractères
et ornements typographiques de la fonderie Balzac*). And yet, in a field where
many tread the same furrows, how can one fail to perceive the level of
thought and expression brought to bear upon a topic's definition and
development?

Once we accept as givens the resources and possibilities of the day, there
is a yet more fundamental way of establishing distinctions, of determining
what may upon occasion be consulted and what will be seminal, enduring.
Whatever an author's degrees, training, even his experience, one should
never put down his work only to say 'I *don't like* his way of thinking.' There
is a middle ground between doing conscious or merely unintelligent vio-
lence to the material, but it is not in sizing art-historical potatoes, candling
its eggs, or shelving its tinned goods for easy reach. It if is, you probably
wasted your time and money on this book.

4 University and Public Life

Seminars and Pro-Seminars

> Si nous ressentons quelque plaisir, ou quelque degout; si notre Esprit trouve quelque chose d'instructif, ou de choquant, nous devons en rechercher la cause.
>
> J. Richardson, *Traité de la peinture*, 1728

Seminars are rightly presumed to be at a higher level than mere course work. Their principle is not the conveyance of knowledge that students could normally hope to pick up, write down, and commit to memory; it is to provoke questions and investigate the 'black holes' of knowledge and to re-examine selectively the accepted galaxies of the history of art.

Seminars represent the ultimate scholarly exercise in coming to grips with historical perspectives and problems too large – or too small – to grasp in any immediate way. They are intended to effect a transfer of rigorous method when facing the unknown, and that unknown includes oneself.

Normally, all seminar participants work through the same material together, thereby determining context and focus. As a result, the three most useful skills for seminar research (and later careers) are without doubt

- the ability to *use resources*,
- the acquisition of superior *analytic* skills, and
- the ability to *define* a problem,

since one is faced with documentation drawn from 'all over the map' in its physical aspects (archives, printed materials, works of art) and intellectual implications (raw data, literary and philosophical context, earlier critical comment).

If these skills be lacking, the results are immediately 'infirmed.' Thus, the 'promising' researcher must be well-rounded and possess the linguistic competence requisite to the problems at hand; furthermore, he must apply

himself without any assurance of significant results from his mental and physical exhaustion.

It is virtually impossible in the light of these demands to ask of prospective students sufficient *prior* experience of knowledge of given art-historical context; nor is this entirely necessary because, rather like a consultant, one is called in to perform a specific task. Entrance into the seminar may be decided on various grounds, most likely on evidence of proven skills, intelligence (receptiveness), and proven constructive contribution in other academic context. These skills are then used within the self-contained unit that is the seminar and its activity.

The seminar student is expected to accomplish a *basic personal stance* with regard to his assigned area, and to profit from that of his peers. If only in one regard, he is to judge reasonably and be able to enter into scholarly discussion according to his capacities. The level of performance is part of the student's insertion into a larger professional process – not the mere acquisition of knowledge, but the acquiring of insights, and only then of particular intuitions. He should thereafter be able to join discussion wherever and whenever it is held on his area. In other words, he must retain his experience and that of others. *This is not so much a question of being right or wrong as having a motivated opinion or judgment, one that can be defended and argued.* These are the reasonable expectations of the seminar process.

It is presumed that the professor has control of the larger perspective and wishes to examine particular details or aspects that normally surpass individual possibilities. Prior goals have been established that are to be reached (at least documented) in some degree; or whatever degree is possible. Topics are defined within this restricted choice; whatever their limitations, they cumulatively provide a more complete picture as a result of their specificity. The study of unpublished archival materials and contemporary sources (gazettes and newspapers most especially) complements the usual, more structured art-historical sources and is usually as instructive to the novice as to the experienced researcher in full possession of his subject.

In flinging bodily the seminar into the research swamp, all that one can expect is that the student make *his* the particular problem assigned even as he learns the tricks of the trade. This method is the diametric opposite of 'listening to his master's voice' in lectures, since the seminar student is – or should be – challenged to response at every moment. This process is normally cool and grim; something needs to be done, so do it. Many people drop out or fall by the wayside, but one should never be *asked* to leave a seminar.

The seminar is accordingly the best instance of the ruthlessly demo-

cratic process of research *with all its qualitative variations*. While everyone may engage in it, the superior student manifests himself through his initiatives, while he learns from consultation and example. All knowledge is to some degree borrowed (even stolen) unless one makes it one's own. In this limited sense, the seminar is groundwork for the dissertation: one is perpetually challenging, and challenged.

The professor's duty is to 'create' questions requiring further exploration and then to continue on in all directions. Mutual exchange between him and his students arises through simple observations, through the dropping (and picking up) of certain 'facts,' and most often through a series of apparently contradictory statements that arouse curiosity. It is the investigation of highways and by-streets, paved and unpaved. Demonstrations are often made with the same material presented differently, pulling down today the intellectual structures that were erected last session.

Should the presentation that results carry authority and make sense, there must be a high degree of competence in *intellectual formatting* and apparent quality in *discernment, variety, and clarity of argument*. Since verbalization is the prime vehicle for the comprehension of the issues arising, the resulting written work must somehow 'fix' that comprehension. *Research is always having to do something before you can do what you want.* It is inevitably the filling in of something *missing* so that you can go on to other things. Unless the professor has a commitment to ongoing research and its incidental problems, there obviously is not an ice-cube's chance in Hell that his seminars will be of profit to anyone, himself included.

The force and texture of seminars may be watered down because of excessive numbers or weak participants. This is unfortunate when all are deemed to meet on even terms against the unknown, although the problems themselves may prove to make very different demands upon those who undertake them. The seminar cannot for this reason be entered into with a 'career calculus' based upon immediate returns only. Those who survive will find their way because of the very diversity of this training and of the art field. Moreover, good academic training received in the seminar prepares for all sorts of activities – even those in fields *alien* to the history of art – because of the mental gymnastic involved.

Topics set are normally not susceptible of thorough study, although they may be systematically pursued. Another approach to the seminar is the assigning of *exactly defined problems* whose literature, intermediate manipulations, and solutions can be known, but which must be discovered, experienced, and followed through to what are foregone conclusions. Both

methods have their respective advantages; the latter usually renews itself only through the annual intake of new students.

And yet, in some educational systems seminars can be organized on a continuing basis, only to profit from skills and familiarity acquired over several terms rather than annually starting up from 'an unknown quantity of X.' There must, however, be a topic so vast or one whose implications are so great that intellectual work can be orchestrated over years rather than simply to meet the end of term. This is rather more the European system, where each year's seminar participants range from raw recruits to seasoned soldiers; where those newly come upon the scene may benefit from students who have been around awhile and know the ropes. In some instances this type of seminar may even include colleagues, at which moment the work plan rather comes to resemble that of the Master Class in music – if the system but allows it and an open-ended commitment can be made to address the nature and communication of knowledge.

The exact opposite is likely to be the Propadeuticum or Pro-Seminar, best compared to the introductory course, when it exists, in any or all of Bibliography, Methodology, and Historiography. Usually restricted to a given area, however, in European terms it is essentially an orientation for further work, with at least one major source 'held in common' for intensive study by all. Work is often of a collaborative and increasingly of a collective nature, where there may be from twenty to somewhat over a hundred people working on a given topic; where, as a result, *it is neither intended nor possible to separate individual contributions from the mass*. In some instances this associative type of research continues, as with the publications of the Neue Gesellschaft für bildende Kunst, Berlin, and its exhibitions.

So much for the assumption that art-historical research cannot be carried on in collaboration. But with the influx of students everywhere came the defeat in part of the stated aims of the Pro-Seminar, which once was the sense of immediate contact with those who teach, as they teach you how to study within the field. Pro-Seminars become the equivalent of mass feeding so that office hours can be devoted to spoon feeding and intellectual handholding. The former is probably more efficient because the basics of research for those having no prior acquaintance with them can be effectively communicated at one time, and uniformly so, rather than by endlessly repeating the process in a personal manner. At least the relatively impersonal nature of the Pro-Seminar as it has become has the advantage of putting the student 'on and with his own' so as to encourage self-sufficiency. It eases the hard vocation of the Brothers of Perpetual Encouragement that professors have become in North America, dispensing confidence to those *nominally in or interested in* the field who have neither

the abiding intellectual interest nor the will and capacity to function on any regular basis.

The Pro-Seminar was essentially an attendance certificate showing that one had had access to the professor and to the field, not a marked exercise. It raises once more the philosophical problem – as yet unsatisfactorily resolved by departments everywhere – as to whether one should not be able to 'reserve judgment' on aspirants to the field rather than being compelled to make 'full and complete disclosure' at every stage upon information that is at once partial and incomplete. In its simplest academic formulation, how can qualitative and quantitative elimination best be effected for the general good?

Put another way, the North American system measures its progress through *layers* of students whom one may see once or twice and never again, and whom it is difficult, individually and as a class, to evaluate throughout their years of presence as they are always doing different things. The European system presumably has more *texture* through continued contact at many different levels and circumstances over an extended period. Both must confront real decisions as to whom to admit (and how) so that a succession may be had that is truly *able to form minds, able to keep the field from collapsing from within*.

To what degree, then, is it possible or desirable to design and mark assignments that follow semesters rather than the growth of thought, research patterns, and the acquiring of real skills? The danger, particularly in the smaller departments or among highly competitive professors, is that the marking process may turn, consciously or not, into a popularity contest, into a head-hunting process that justifies one's importance in the eyes of others. The more students, the better – and better off – one is. This attitude, once accepted, can lead to decisions of the moment which compromise the needs of the future. We are far from having a consensus about the nature and aims of art-historical teaching, since this requires heightened consciousness of the field as it is and could be, not less than as it ought to be. It does seem that the balance is tipping in favour of learning the precepts rather than thinking. The surest signs are the fear of doing one's own work.

Theses and Dissertations

By analyzing too minutely we often reduce our subject to atoms, of which the mind loses its hold.

Thomas Jefferson to Edward Everett, 24 February 1823

The dissertation is the final step in the three-tiered academic process beginning with course work and seminars. It is in itself a 'comprehensive examination' through the exploration of a topic involving a defined area of competence given form through art-historical craft. This effort is likely to be prolonged over many years and is further presumed to justify the time and expense involved.

The dissertation provides the first tangible answer as to why one is in the discipline, what one hopes to accomplish, and some indication of the level of distinction one may be expected to attain in future. It should, but in practice need not, have further significance. Intrinsic quality suffices.

Thesis and Dissertation are respectively often reserved for the MA/PHIL M and PH D degrees. In common parlance they are, with some reason, often used interchangeably for the simple reason that a dissertation should in the strict sense propound a *thesis*. In simplest terms a thesis is a form of *written discourse,* 'a proposition laid down or stated, especially as a theme to be discussed and proved, or to be maintained against attack (in Logic sometimes distinct from hypothesis, in Rhetoric from antithesis); a statement, assertion or tenet' (*OED*). As a formal statement 'in partial fulfilment of the requirements' for a university degree it is deemed to mark the transition from a student (or private) life into a scholarly career. Whether it does indeed demonstrate the aptitude and suitability of degree candidates for intellectual responsibility is the result of a curious *ménage à trois* between the student, his director, and the topic itself. The thesis's merit, indeed its distinction, is sanctioned by the standards of the individuals involved not less than of the academic institutions and/or department in which it is granted. It is the *intellectual by-product* of a research process dependent upon a very complex series of human relations. These range from candour to brutality, ideally mediated by the frankness of all concerned.

At its best, the dissertation allows 'going astray' as a fundamental process of the life of the mind since in any case intellectual pursuits can be structured only provisionally. At its worst, it becomes a determined effort against intelligence, resourcefulness, and talent through an imposed form and too great an application. There is doubtless some middle course that partakes of both these necessary evils.

As a general rule the majority of students are probably not *trained* enough, *educated* enough, or *competent enough in the languages and craft* of their intended profession to be able to cope with art-historical issues. (This is a shade more serious than simple stupidity or mere lack of flexibility in the prosecution of a dissertation topic.) There is no rule in practice for the choice of a topic in view of a dissertation because it is intimately connected with

- the exigencies of particular fields,
- the type of research involved, and
- the nature of the questions asked.

While the selection of a topic very much depends upon circumstances, it is even more dependent upon the *intellectual and emotional make-up* of the student, who, for example, might be disposed to avoid artistic literature, abstract reasoning, or the intricacies of connoisseurship – any one or a combination of which could have consequences of serious nature for his research. In point of fact, the latter two – abstract reasoning and connoisseurship – are most easily fled from by students; in marked contrast, anyone can search out and compile literature he neither comprehends nor analyses. To all but expert eyes, a student can manipulate such 'primary sources' with some semblance of mastery.

Thus, there can be no *a priori* privileging of one type of topic as opposed to another. This is why dissertations often change course, focus, or even name (title) as they advance. Within certain tolerances the topic *must* be appropriate to the type of mind, curiosity, and even the *present* working tools of the student. This structure illustrates the theoretical and often real differences between the European and Anglo-American education systems, all of which have for some years already been grossly overpopulated.

In the European system, the student is expected to define (i.e. to discover and refine) a topic on his own, then seek an appropriate and willing mentor. If he is convincing and capable, he may be accepted; otherwise he disappears from view. All other things being equal, however, the intended director may not wish to accept both topic and student en bloc; nor might he find the topic susceptible (or advisable) of development; in worst eventuality, he might not even think it worth his time. And he is under no obligation to accept anyone who presents himself. In the Anglo-American system, a professor often proposes topics or 'gives them away' with greater or lesser alacrity. This is a side-effect of formally constituted departments with an assigned sense of responsibility to the common weal, however unqualified it may be, and an obligation to make its societal contribution *visible* through the number of enrolments. Both models have merit; they naturally assume rather different levels of initiative and commitment from all parties.

The traditional European model is, however, much more likely than the Anglo-American one to give some sense of *being in a discipline* rather than having a continuance of some sort of class assignment. Regardless of the number of students who disappear en cours de route in both systems, those who do continue on – again, not necessarily to the end – react in very different ways. They either know, or come to realize and accept, their

inappropriateness to the field; or else, rather like the dog at the door, they presume, not incorrectly, that if they stick around long enough they will be 'let in' to a career, which they take for the field itself.

Rather than simply waiting at the door, it is better to scratch; and it is usually the thesis that gives weight and a measure of authority to the demand for entrance. In other words, the dissertation must be an 'accomplished' piece of work in which the very choice of topic in some way defines its very feasibility and significance. How then to choose a 'suitable' topic?

A topic must first be capable of some, even a considerable, degree of development. *If upon reasonable examination it seems unlikely to go – or lead – anywhere, if it can only go so far, say a long article, it should be abandoned forthwith.* Almost by definition a thesis cannot be a *catalogue raisonné*, although a catalogue of some sort may form part of its content or apparatus.

A proper topic is normally a direct reflection of one's degree of understanding of the field and the context of the problem addressed; this context should be sufficiently rich and textured to be 'significant,' that is, to *create and elucidate* problems and interrelations rather than excluding them from the start. *Description and compilation do not suffice.* One does not immediately establish narrow boundaries, and if one does, the research process will only expand them – perhaps to the point of carrying one away by the *excitement of discovery* and its corollary, a *loss of focus.* It is therefore necessary rather more to *gain* than *have* a sufficient knowledge and intuition to anticipate what potential is in a subject or how it might expand. Rather like a geometrical problem, one should see general borders, but many points of intersection.

The dissertation is a do-it-yourself conundrum that is a return to Original Conditions. It is a research strategy or plan of attack revisited and constantly revised. At the moment of choosing a topic one cannot 'write an outline,' only a series of statements, facts, or ideas (hypotheses); often, only a series of contradictory interpretations. It is useful at this early stage to work out for one's own reference a brief statement of
– *what* is to be accomplished;
– *where it stands* in respect of present knowledge; and
– *in which* institutions and places it must (or can) be done.
This statement permits rapid comprehension of modulations in research arising through specific findings; it should be consulted and modified on a regular basis so as to situate – and reorient – general ideas not less than the general thrust of your work.

Perhaps the easiest way to understand the importance of the Topic (and of the Dissertation as a literary genre) is to think of its component parts,

beginning, curiously enough, with the Conclusion. This by definition introduces *no new material*. Its framing is crucial because it is a judgment arrived at through the research process and by reason. It provides stark contrast to the Introduction wherein the problem is set *as it was known* when you began work. The Conclusion is the bottom piece of bread in a closed-face sandwich whose filling is the different chapters whereby you work out your method, discover (and incorporate) new facts and material – and where interpretations are made that lead on to your Summary of Accomplishments.

Your Conclusion, once reduced to *Dissertation Abstracts* form, is henceforth likely to be part of the introductory chapter of anyone else's dissertation. Although written first (or written only as a feasibility study for a topic), the First Chapter is nearly always the historiographical one; it outlines and situates approaches and work that have helped you to *define* a problem or topic.

Now it is a curious thing indeed to overhear students speaking among themselves of the evolution of their dissertations. Rarely does one hear *what* has been found or *where* it seems to be leading except in very limited context. Conversation seems restricted to purely technical points, as if there were no point in speaking of one's *real* work, only of its details. One learns of bibliographic and footnote notation (usually garbled), access to sources, difficulties in photographic acquisition, problems in typing or word processing to the required format. Often these issues are discussed as if they were *universal and invariable*, rather than in need of precise adaptation to individual circumstance. At the same time, the dissertation's content is usually defined in practical terms – the submission of outlines or chapters, criticism of them and any redrafting or modification, the resultant changes in proportion (length) and the necessity of providing additional arguments or examples found wanting in the reading.

Perhaps the students are right to discuss in this manner, since dissertations are usually so focused – and training so narrow – that conversation is virtually impossible. Perhaps they are right, as well, since no one not previously engaged in serious research, however limited, is likely to estimate realistically the *duration* of the research process, much less all that is involved in presenting a *formal* piece of writing. But these are virtually at the end of the process and represent only abstract considerations. What is maddening is the time involved in last-minute (split-second) *manipulations* such as the mounting and proper identification of photographs, establishing THE bibliography (which has been retained from all that was consulted), fabricating effective special apparatus such as Tables, Catalogues,

and all the other things that can be done only when one is *in full possession* of the material from which the thesis is derived and distilled.

As a result, it is far easier to acknowledge a good dissertation when one sees it than to define it in advance. It will possess the necessary formal virtues through its procedure and presentation. It will demonstrate fully the *ingenium* – the insight shown by contribution to the discipline in a notable degree of something not previously known or recognized. It is something that reveals and demonstrates the 'image' of the researcher rather than just what the Master has given. Not just documentary crumbs from the table of Knowledge or even the more succulent sauces and desserts born of intuition and long experience but needing investigation, proof.

Discernment and judgment are needed to go beyond what is known, to be able to argue indifferently with written or personal authority in a *convincing* way. The size of a dissertation is no real criterion of worth because it may be path breaking (even breathtaking) by its *grasp of the issues*. It may offer a new perspective, but one which results from the skilful montage of numerous references to a problem. It necessarily depends upon, yet deviates from, Authority to the point that a first-rate dissertation is one without which the art-historical picture would be very different, or not exist at all.

To reduce the dissertation to any more mechanical level is to mistake technique for an end. And this end is a *level of reflection*, a training in itself, however much it may be applied to a given topic, becoming somehow, in some measure, quantifiable.

Undertaking the dissertation brings with it a sense of isolation, even of psychological desolation once it dawns that there is only oneself and one's supervisor against the unknown. At least there was a sense of shared confidence or uneasiness in the earlier stages of postgraduate work, whether in courses or comprehensive examinations. Henceforth there is little or none because specialized research in even a broad and familiar area means the reduction or even the annihilation of one's familiar circle of interlocutors. Rather than programs and requirements come one's own choices in – and within – such literature as exists.

What should result from this process is a better ability to evaluate material, to comprehend research method that seemed vague or abstract when one was 'getting out' one paper after another from local resources. What should come from these years of real apprenticeship is a greater sense for the field, how one might eventually fit into that larger picture, perhaps whether one is suited to it at all. In a word, whether one has great promise, can make a reasonable dent, or must always remain on the periphery of things. All these result from personal traits and training whose character

and relative merits were as yet untested. For it is with research, particularly that undertaken when travelling, that one comes to know what sorts of things to expect and how they affect work. This amounts to a totally different approach to the ideas of learning, research, and writing.

It is at this point that linguistic considerations come to the fore. If you are not comfortable with the 'primary language(s)' required by your topic, the transition from *intermittent reading* to *intensive and spoken usage* will be uncomfortably abrupt. Like it or not, you are at the mercy of your predecessors by virtue of the literature you will – or may – be required to use. French is fine, Italian too, but what if your shaky German needs Dutch as well, or an important complement of classical languages?

Curiously enough, the prime difficulties come through what should otherwise be the high point of postgraduate study – travel and research abroad – where language becomes current and practically oriented; where your energy is spent asking directions, informing yourself about procedures, getting answers; where 'common ground' must be established with curators, administrators, and technicians. *All this occurs in a local or even a shared language rather than one's own!* It is neither fair nor reasonable to expect everyone to speak English; that they may is a sad commentary upon our own education system in regard to the major language groups. While the use of an acquired (third) language that neither individual knows well is at times the only possible solution, one always wonders what may have gone lost in simultaneous translation beyond an evident lack of nuance. And it might be remembered that some of the most embarrassing situations may arise when one chooses an 'incorrect' common language in which to address someone who has profound historical or personal scruples against its use.

A second level of difficulty often encountered is Travel Fatigue. This is not so much the (expected) fatigue arising from constant travel and intensive work as the anxiety of not knowing whether one can actually get to the material needed within the allotted time. One often feels – and may later discover – that important things were omitted when one was on the spot and that one must *go back, forget about it, or find alternatives* when these exist.

This feeling falls into the category of 'lingering doubts and real disappointments' of more or less immediate nature. It is knowing the clock is ticking away and that one can do only so much in given time in even the best of circumstances. As one recent PH D mused, 'it is writing out a list of things, places, and tasks, then cutting it in half.' This effort serves as an incentive to do sufficient prior work before departure so that one knows what *is* important to do and see. One may need to visit two places that are

across the street from each other, only to discover they are open only a few days – even the same days – of the week, at the same or staggered hours. Or that in a given city or region, 'I went to ... , but it was closed,' in which case an immediate decision must be made whether to stay over another day, or through the weekend within a tight schedule, or to go on.

Two conditions, then, apply to foreign research that are usually unbeknownst to the North American. First in line come the 'unexpected formalities' necessary to gain access to the research facilities or works themselves. Such formalities, unavoidable to nationals and foreigners alike, may result in the loss of the greater part of a working day; yet they must be anticipated and their necessity understood in the midst of tight scheduling and research imperatives. One rapidly learns to take precautions by verifying in the major reference books conditions of access, opening hours, and holidays – writing and even calling ahead rather than assuming the doors will fly open at your approach. A second factor, usually forgotten by North Americans who live in a secular even more than a Protestant society, is the religious calendar around which all social and public functions are built in Catholic countries. If in doubt, ask those who have been there on the long Ascension and Pentecost weekends or over unanticipated national holidays.

There is a third factor that comes into play: the distinctions to be made between major research centres and the smaller albeit necessary ones situated in widely separated cities and hamlets where one may experience institutional reserve upon the unheralded arrival of strangers, and startling differences between posted and actual hours of service. The Innocents Abroad who are researchers become particularly vulnerable to the vagaries of internal attitudes and problems, from sudden strikes to unannounced closures of indefinite duration. However important it is for you to gain access, this fact, if it is such, is much lower on the scale of immediate and continuing occupations local administrators see within much more extended time-frames than are available to you. Putting all these matters in perspective, it is impossible to protect oneself against every circumstantial inconvenience; but it is a matter of simple prudence to avoid descending unannounced during an Annual Closing.

When 'working up' the thesis or dissertation, lessons hard learned are more carefully learned and best remembered. The Director/Supervisor is then useful in direct proportion to his knowledge or the quality of his intuitions. In fact, the relationship between student and supervisor is likely to be as emotionally close as to one's spouse: there will be difficult moments, even frictions, but both must work towards a common goal from which both stand to learn something. As a student, you know your Director as

a person, but how well do you know him as a scholar? One of the most effective ways of finding out is to read his published works. If you do, you will have determined his sensibilities, his style, the sorts of things he goes after, his range as well. In a word, all you can or cannot do together. Most topics are defined with reference to well-stocked libraries and published documents; thereafter, one builds one's own reference shelf from generally available sources, inter-library loans, and the research effort, going further and further afield according to the needs. Inter-library loan must be approached on the assumption one will never see the item again, implying hard decisions about *why* one wants a title; these in turn parallel the 'weeding' process inherent in the course of research as one progressively 'cuts and clarifies.'

Everyone has from time to time been reduced to 'looking pitiful' in any or all of the preceding circumstances. Yet it is somehow part and parcel of the main academic goal of gaining confidence in one's abilities, of systematizing work as it proceeds rather than waiting until the last to order it all up. There is bound to be much initial sloppiness as one casts about. Later, one discovers that the source of a photocopied illustration was not written on the photocopy itself and that the literature must be gone through to locate it. Later, one realizes a 'running bibliography' should have been kept, with every item correctly notated and filed *as it came in*. Later, it is realized an argument or chapter was not blocked out properly, or that chapters were considered in relation to each other rather than as separate entities. All these and more are the normal frustrations because the requirements of a dissertation are so very different in scope from those of a mere paper.

It must be remembered that a 'first submitted chapter' is, whatever the changes effected, always the informational basis for a *first revised* and submitted chapter. Although the intent is to gain confidence and greater skill in research, the first critique is often profoundly demoralizing for all concerned. This fact is why it is near suicide to work with someone one does not know or has never had course work with – why this cautionary note applies to students and professors equally. If the system permits supervision without prior knowledge, at least take all the advice and information you can get so as to know the probabilities of undertaking work together. After all, *the first piece of writing submitted for evaluation usually results in the tightening up and reorienting not only of method but of the topic itself*. The experience can be shattering for students who have unreal or very abstract ideas about research and embark on topics whose scope and ramifications greatly exceed any previously experienced.

The switchover from written authority to one's own, from mere application of concepts and literature to their extrapolation in other contexts, is

part of an extended commitment to the more sensitive appreciation of academic purpose. If this does not occur within a reasonable time, the aspirant should be allowed or encouraged to fade away or disappear altogether.

Academic Alienation

> Vous avec reçu chez vous le rebut de la pédanterie, parce que, dans toutes les professions, ce qu'il y a de plus indigne de paraître est toujours ce qui se présente avec le plus d'impudence. Les véritables sages vivent entre eux retirés et tranquilles; il y a encore parmi nous des hommes et des livres dignes de votre attention.
>
> Voltaire, *Babouc, ou le Monde comme il va*

If art history is all that great, why are there so many unhappy people in it? What are the reasons for this state of affairs? Does it attract particularly unbalanced individuals or is there something about the field in itself that distinctly unsettles or eats away at everyone? Once again, appearances must belie realities. The mystique of intellectual work – of research into art – can only involve misplaced and unrealistic expectations from the moment one enters the fray.

The young scholar is led from simple observation to think that there are great rewards, recognition to be had, if not for the asking at least for the taking. He has only to look around to see the highly visible manifestations – exhibitions, monographs, consulting, lecturing – that indicate the substantiality of the field. There are regularly constituted Departments, Programs, and Institutes that by their very existence must indicate the health of the field, a demand for its services. If rewards and recognition, the first tangible and the second much less so, do not come or interminably tarry along the roads, if the long-awaited call to Munich or Harvard or the creation of a Chair never materializes, what then? Probably the discovery that for most people within the field, personal satisfaction is no longer sufficient. The question then arises as to whether one can really become absorbed in one's work without external marks of distinction if there is nothing over the horizon but more of the same.

There are inescapable historical forces behind this sad turn of events. Were one to have worked around the turn of the present century, large pieces of the art-historical puzzle remained to be discovered and fitted in. Today the pieces are getting smaller and smaller, to the point that more than one reviewer has mused, 'do we need the publication of more documents if they do not substantially change the view held in the past?' This

point is well taken, when the level of talent of researchers has not greatly increased and when more people are researching – putting out in different form – fewer topics. It has become difficult to put something out that changes our views or creates new ones, since the general level of activity has little basis in fact.

Perhaps this is why it is easy to find a wide and highly characterized range of walking personality disorders among academics. And why the number of alcoholics, which can be concealed, and suicides, which can't, has risen as greater numbers of people see the field melting out from under them when totalling up 'finished, unfinished, and never-finished business.' How can you tell a promising student or a distressed colleague his area of interest has been undone by Fashion: that his field doesn't exist for either the public or the powers that be, has no ready-made audience, perhaps no audience of any size; and that there is little or no chance of amelioration within his lifetime? *That the concentration of effort on 'accepted' topics has bred mediocrity into the field.* How many scholars do you know who say with equanimity that there is much real activity within their fields, and that they have been born fifty years too soon to profit from it? But this is the essence of historical research, and historians should realize it.

In these circumstances it is likely that 'drift' in accepted scholarly practice is a sign of the times and of the profession. Casually engaged in, further sanctioned by poor training and intellect, this drift goes against all that the cultivation of the mind implies: rigour, selectivity, a sense of direction. And then there is real interest and enjoyment in the material, the feeling of controlled excitement as one again sits down to work.

And yet, most of the certifiable disorders come once one is 'well into' a project, perhaps to the point that it would prove embarrassing or disastrous to turn back just as it is proving difficult to complete the work entered into. For this reason among others, it may well be that the general acceptance of the Monograph as the basis for tenure and promotion is misplaced. Most subjects do not really lend themselves to this treatment, while most minds cannot survive the strain of sustained research. A fine book is a mark of distinction, certainly. Since, however, it merely brings everything in the scholarly arsenal to bear upon a topic, a better idea of a mind and its workings may well be had from going through a scholar's articles. After all, he has used these to define *his* area in an impressionistic fashion and to that end will likely have used a greater variety of 'ways and means' than those authorized by monographic structure. Unfortunately, what seems to be happening is that the old-line periodicals are having some difficulty in keeping their periodicity; they struggle on in the face of myriads of papers that are merely 'generated' for meetings, colloquia,

and symposia. This highly significant form of Academic Alienation bears elaboration.

Now it is understandable that new periodicals are founded because one must be new, has different ideas, or caters to different standards, publics, or politics. Yet for all the library continuations devoted to journals new and old, for all the monies devoted to monographic production and acquisition, it seems that an increasing part of current scholarly production in the Humanities leads toward that graceful contradiction in terms, the 'oral paper.' These are in great part command-performance papers that represent a type of commissioned research having its own problems of quality control. If the contributions (more likely, offerings) are restricted on qualitative grounds, the conference itself is at risk; if these be the best in the running on the imposed theme, or merely what can be had, attendees may find it better to meet socially while the proceedings go on – and on, and on. Two or three days has become the minimum for scholarly respectability and the necessary comings and goings, while certain occasions run over a period of one or two weeks. Since the audience comes and goes according to personal convenience, one may wonder whether everyone can have benefited from what was presented. One knows what one has heard or heard about, or one awaits the *Acts*.

Conference themes are imposed and often highly circumstantial in nature. It is greatly to be feared that their existence reduces considerably, if only in theory, the number and type of 'spontaneously generated' writings that would be possible if everyone were left to find his own level. People can and do produce for meetings, seemingly not for themselves or for the periodical literature (a transcribed talk is not normally a real piece of scholarship). However, there is probably no essential difference between an attempt to get the Acts of a symposium together and the gathering in of contributions to a Festschrift that was intended from the first to appear in 'hard,' that is, in published form. Their basic problems are, in turn, the rough equivalent of thematic issues in the journals. It is only that the difficulties of the editorial process are proportionate to the number of participants and their dispersion throughout the civilized world. With one exception, that is: if publication of Acts is part and parcel of the conference package, one has only oneself to blame if one does not wind up in print.

In its most perverse phrasing, if almost anyone can 'get into' a foreign topic in a relatively satisfactory manner within severe time constraints, why can this not be done, and done regularly, for *regular* research and publication? What is done seems to be done only so that it can be voiced *in whatever form it is at present in*, but rarely represents finished work, much less work that is sufficiently advanced for serious presentation and discus-

sion. If it is published, it represents the termination of the commissioned research; and the delays may be such that everyone has forgotten what was said or is unsure whether it really was. It will naturally be objected that colloquia and symposia are greater in number and far less restrictive than periodicals. Certain it is, though, that they have been the academic growth industry of the last twenty years, but it is individuals who determine the level and quality of their contribution as well as the profound motivation for their presence. Reduced to the spoken word, which is more likely than not to be unstructured scholarly exchange, conferences of high quality can only be occasional rather than annual events. Because it proceeds independently of fashion, high-quality intellectual output is made without reference to this month's, much less this year's, meetings.

With the dissertation comes the first realization that research is an actual, daily matter. Then it dawns that much is to be done in the way of organization and procurement before one gets to any strictly defined intellectual effort. One discovers how to write four or five letters of inquiry a day, and how exhausting this is. Or is this because it has been approached in the wrong spirit, because this type of work was never expected? Then, as well, comes the realization that art historians work with fragmentary evidence that requires historical acumen and sophisticated powers of conceptualization. Many opt out at this moment; that is to say, they opt for the topic that can be worked on from what is at hand, or that cannot be sustained beyond an easily visible point.

Now it is often more difficult to work conveniently with too much documentation than in a dispersed manner with not enough. The simple comparisons/rapprochements one learned from the texts and in seminars no longer function as they should and may even be quite uninformative for all their factuality. The antiquarian's smug 'it is always nice to be able to confront the works with the drawings' leaves too much unsaid, too much that is not or cannot be interpreted. Much more sane is the seasoned archaeologist's view of any drawings or engravings of hitherto unrecorded classical monuments that might come to light: it remains to be seen what their worth is, as opposed to their mere existence.

When all is said and done, it is a sure sign of intellectual deficiency – not scholarly objectivity – when over a period of years there has been no sign of alteration of method and less sign of thought on what has been in circulation. The field none the less seems firmly rooted in this expectation, to the point that much dubious thought and historical method pass for brilliance. Still and all, it is a wonderment how one could avoid thinking about the implications, the rush of conflicting suggestions, the exhilarating *uncertainty* provoked by the documentation. The surest sign this has

not occurred is when the scholarly apparatus and organization of a publication is either mundane or, more likely, *simply does not work* even if one has had full control over its form and development. No amount of illustration, no amount of documentation said to be unknown or to have been misinterpreted, can replace *hard organizational structure and mature reflection*.

These two qualities have much in common, grow from each other, and meet again after periods of separation, even of estrangement. In theory they cover the continuous discourse that is presumed within classes and seminars, where the real problem is not the information itself but the quality of discoveries arising from efforts at proper formulation. In any form of dialogue there are moments of brilliance amidst much intellectual groping towards awareness, and from awareness on to its application. Whatever its tonalities and dissonances, the 'written diction' possible with published work can be given a uniform texture not possible in an oral delivery that cannot be seen and voiced at all stages of development. Many a seminar report or conference paper, once transcribed, is seen to be less than reasoned and altogether less convincing than it sounded when delivered.

In the end, one has the impression that more time and energy is spent preparing for conferences than for ongoing research and teaching. That conferences have become some sort of escape mechanism rather like the breathing holes for seals in the ice – concealing dangers, which, for all their currency, remain hidden from the unsuspecting. Such a system places conference organizers in a position of undue strain, and perhaps even of influence. While one may accept, however reluctantly, that the second, third, and sixth speeches do not really address the announced topic, the real question is whether the topic may really advance or consolidate scholarship, provide significant results. Like the vague and unconfirmed suspicion of danger confronting the seal, the conference goer confronts the faceless determination of what is to be researched. Delivery of the topic is the performance end of scholarship, presumably at a higher level than the class or seminar, within the context of a happening. What is disturbing is the suggestion that the nineteenth-century scholar, working in isolation and dependent upon his own resources, picking away day by day and year by year so as to be thoroughly grounded in all aspects of his interest, is passé. Everything is potentially a 'quick fix,' accessible to everyone by short cuts that are the result of modern organizational method. No wonder there is superficial interest within the field when the research presented is normally the result of research rather than formation.

The quick fix also affects the economics of publishing, which, although it is thought essential to the field, is a subject of satisfaction to no one. The concern is really how to 'settle out' pricing and production so that publica-

tions may be had by those who need them. The solutions proposed more through inattention than active concern have in general been polarized: a rarefied production or on-demand publication; a limited number of titles to be had *by subscription* or the establishment of co-operative, parallel, or academic presses to set off the traditional University ones.

These views serve to entrench superficial distinctions between 'prestige' and 'utilitarian' publication, rather than to reinforce the greater choice and quality that might be obtained if there were more diversification in research and more consideration about the production values really required in each instance. If choice and quality were the focus, it is not impossible that price structures could be more accurately determined so that art publications as a whole could become as varied as those in other fields. This possibility seems unlikely as things stand, for the question is still begged as to where and how craft is learned if you have never faced a set of proofs, have no idea of the different stages of the editorial process, and no real inkling where your own work stands in respect of what is being produced.

It is utter madness to engage in a long and involved piece of writing unless one has had a thorough apprenticeship in the 'minor genres' of the note, catalogue entry, and article. Here we come full circle, for no term or research paper, not even a thesis, really serves as more than a writing clinic for battered thoughts. *Like these and the conference paper, the thesis is something done for presentation, then dropped.* It is thought, most erroneously, to have been a sufficient effort in itself, when by its nature and circumstances it is only an introduction into the field of scholarship.

What then? I dare say that it is virtually impossible to organize the field despite all attempts to do so. Yet art history is becoming increasingly structured, in the restrictive sense of the word. Like any ornament, it is approached and understood superficially whether from within or without. Its historical basis is neither profoundly recognized nor admitted; but what should be a 'distancing factor' is usually the focal point of the worst critical excesses when historical method is patently misunderstood or consciously diverted from its real purpose. Not to worry, few people know what they are missing, or how they are being led down the garden path.

To conclude on an optimistic note, art history has become 'professionalized' in all its elements, each of which has its own preoccupations and exclusive standards to the point that it now takes greater insight to do what was formerly done as a matter of course. The eighteenth and nineteenth centuries were right: art history is best pursued as an avocation by those who have knowledge and love it. Better yet, it should not be *pursued* at all since it inevitably eludes the clinical practitioner.

Public Lectures

> Die Feder ist dem Denken was der Stock dem Gehn: aber der leichteste
> Gang ist ohne Stock, und das vollkommenste Denken geht ohne Feder
> vor sich.
> Schopenhauer

The public lecture is rooted in one's personality and outlook. Its craft must
be mastered before it can be made an art. It is essentially a *conversation* with
two interlocutors – the images on the screen and the audience – both of
whom are mute.

Its intent is to present things afresh, almost like thinking out loud. Al-
though structured, the public lecture requires great flexibility (which can
be acquired) and great presence (which some lecturers never have or ob-
tain). One works with the givens, of which the most deceptive is oneself *as
seen and heard by others*.

A speaker usually attracts his audience through his known, suspected,
or hoped-for reputation and through a topic that sounds interesting
enough to warrant the displacement. If the former be an unknown quan-
tity, then the *topic* is usually the predominant factor in deciding to attend.
One indulges one's curiosity to the extent of one's time, which *is* a luxury.

You may know your subject but be a poor lecturer, whether in the class-
room or on special occasions. If your voice has an unpleasant quality and
timbre (or cannot be heard), if you have insufficient theatrical presence to
'carry the house' physically and vocally, then forget about lecturing alto-
gether. Any such advantages you do possess must be cultivated through
good diction, personal radiance, and the *strict avoidance* of monotonous
delivery. Indeed, the lecture should have the same qualities as a good con-
versation – varied pace and emphasis – and the same qualities as a good
publication, namely a beginning, a development, and a solid conclusion.

Of these, the *entrée en matière* is the most important. Whatever your man-
ner of conclusion, your first remarks should not only set the stage for what
follows, they must be so interesting as to catch – and then to hold – the
attention of your audience.

The public lecture ('public' in the ways discussed below) is a matter of
knowing and judging an audience determined purely by time, place, and
circumstance. (An afternoon lecture is very different from an evening one
in every way.) In even the best of circumstances, the lecturer must, while
he is talking, come to know the time required by the audience to *react and
identify*. As he visually co-ordinates with his subject, so must he be able to
see (and address) *what the audience is seeing*.

Knowledge of the prospective audience and facilities is necessary for successful lecturing. This principle is neglected only at one's imminent risks and perils. There are some six essential concepts to retain in this matter:

1 know your material (you may *have* to improvise);
2 know what you wish to accomplish (*why* are you there?);
3 determine what approach you wish to take towards your material (personal, even subjective; but *not* to the point of idiosyncrasy);
4 have some realistic idea of what is expected of you, and what your particular audience can be expected to understand (Cicero's *prudentia* in rhetorical matters);
5 plan your lecture with some understanding of possible and probable *spans of attention/concentration* (rather different things, these) as well as their regularity or intensity;
6 know what you can take for granted in details such as quotations (it does matter if the audience is fluently bilingual or merely unilingual) and choose your language accordingly.

In all these things, your chosen 'conversation' will assume rather different proportions – and ensuing problems – if it is twenty, forty-five, or sixty minutes long. Since your slides must be put in a prior, fixed order, you will have to 'keep things alive' through your own reactions, inflections of voice, even asides.

Remember above all that the spoken and written word have the same issues, but different presentations. *Spoken and written 'footnotes' function very differently; so do formal punctuation and punctuation achieved by breath control or intonation.* Even sentence structure is crucial for success. While one may follow with some ease a complex musical line, it takes considerable mastery to deliver (and receive) a long sentence with many qualifying clauses. The problem is to reduce to a certain core (what to convey) so as to challenge perceptions while clarifying them. At the end there may be additional discussion or formal questions, but these are inevitably scattered and specific; they must be preceded by a coherent general statement into which they may be inserted or from which they arise.

Oral presentations, presuming as they do a listening audience, are none the less very different from written ones. It is impossible to 'leaf back and forth,' to read at one's own speed, or to engage in other such indulgences. There is give and take as one is led and follows, or perhaps anticipates, the exposition. The speaker must be ready to alter, however imperceptibly, his approach according to the perceived interest and response of his voluntarily captive audience. He must be on the alert, familiar with all the basic issues (and his own ideas) so as to effect seamless transitions, rapid generalizations, and whatever becomes necessary. The 'pregnant pause,'

which invites expectation at a crucial moment, is also a necessary device.

Rarely is mastery of *technical matters* so necessary as in the public lecture in art history, whether it occurs at the classroom level of surveys and seminars, or in the formal, outside lecture. These matters are terribly objective in nature, as opposed to a general understanding of the likely audience, but they must be looked to.

One should have an idea of the shape of the hall, its size, and thus the distance from the screen (maxima and minima), the type and size of screen surface(s) and thus of the projected image. It is rather disconcerting to have overlapping images or projections that disappear off the top and bottom of the screen; proper adjustment must be made so that the audience remains blissfully unaware of these preparations and can simply enjoy what is put before them.

Acoustics is a major concern, for if they are uneven or muddy, and one has a soft voice, some means of amplification will prove necessary. If the hall is well and *permanently* set up, it is likely that the space will be dark, not dim. One should be able to see the slides without interference from light seepage from windows or lectern, an important matter whether one uses a solid or a light-pointer, or none at all. There must be sufficient contrast so that both colour and black-and-white slides appear in *full relief*. Remember that everyone will be looking at the screen, not at you.

Most of the irritating and distracting things that happen in public lectures are avoidable, and it is difficult to say whether the speaker or the audience is likely to be more disturbed by them. Nothing so disrupts and destroys a lecture as pauses that break the concentration – when, as a result, people whisper, sigh, or converse, or when there is stony silence bordering on anger. The competent lecturer takes nothing for granted if he is to protect himself and his audience from these contretemps.

Simply assume that anyone outside the art historical field may want illustrated lectures, but that they will have no conception of what is necessary for their proper conduct. Even people within the field are far from blameless in this regard. It is surprising how often one discovers that replacement bulbs for projectors are not available, that only one projector is available rather than the two you presumed would be present, or that two projectors are set up, but one is of the carriage type and the other a carousel. Make these tractations part of your initial correspondence. Send timely reminders and, above all, verify projection facilities and meet your projectionist once there. If all this seems rather fastidious – and it is – remember that your lecture may change drastically in conception if you set it up for double projection and discover at the last moment that such is not possible.

The invited lecturer must, for an illustrated talk, assure communica-

tion with the slides (projectionist) and the projected image(s) in order to work with them. The physical and mental manipulations are entirely different if one has remote controls (buzzer or, horror of horrors, voice signals, thumps, and the like) or self-controls for projection. Familiarize yourself with them well in advance (for self-controls, have them taped down if they are not permanently installed) and, if possible, practice them before anyone arrives. Your hosts should be more than willing to assist you because this is as much in their interest as yours.

The maintenance of *regular visual reference* with your audience through slides varies with the documentation. As an art of space, Architecture must be 'projected' into two dimensions so as to duplicate one's normal experience of the structure while facilitating comparison between parts. One will, for instance, place all ground plans to the right if the elevation appears on the left. For churches, one will 'enter' the structure from the bottom of the screen and progress to the top; in so doing, one respects the traditional orientation of churches by having entered from the west and gone on to the sanctuary at the eastern end.

This approach, most obviously, is fundamentally different from showing a painting and its details, or disserting on a cultural theme and introducing opportunely different types of works of art as they are called for. The last is for identification purposes (identification of the object and with the topic) while the former is for analytic and synthetic purposes. Some may find that it is better to construct a visual argument and then write a coherent lecture around it, rather than simply illustrating points; the former course is likely to have visual economy, and thus to make its points more forcefully.

The public lecture may in an extended sense be said to have four different levels of application:
1 classroom (repetitive and progressive);
2 seminar (selective and intensive);
3 professional and learned societies (highly focused on career and reputation);
4 the true public lecture (people *unknown to you* although they may well know you).

In all cases, the lecturer *mediates* between the image and the audience. So it is that the public lecture, strictly speaking, excludes the student and professional communities and represents the broad and even vaguely defined base that lies outside the field or one's personal concerns. This community is to some degree unpredictable in its composition and fidelity; it exists on a higher or lower level in itself and a more general level than one usually deals with.

While statistically it would seem to be on the rise, the public lecture is

probably on the decline. Its wisdom and integrity might be questioned now that it has become an instrument of institutional politics, which asks acknowledgment of its activities while publicizing them.

This inflationary tendency, when compared with the number of lectures or lecture series in earlier years, is laudable to the extent that universities and museums are involved in fundamental research and require some vehicle for manifesting it. As a result, the availability of lectures has virtually resulted in their becoming non-events rather than a rare occasion to be looked forward to. The ability and desire to attend may, as a further result, be a simple matter of timetable.

When organized into large conferences, symposia, or colloquia extending over several days, public lectures come under suspicion. They are seen for what they are – exercises in institutional activity of the public-service kind, or a very impersonal and democratic means of professional development.

Unlike speakers at other public lectures, art historians and their audiences spend most of their time in the dark. Time was when one feared public disorder in rooms only *partially* darkened to facilitate the projection of lantern-slides, although the same fears did not pertain when going to the legitimate theatre. That time is past. The cinema habit has settled social etiquette for viewing, but with it has come heightened expectations natural enough when one pays for entertainment. There is rarely paid entrance to public lectures. The visuals must somehow be worth it and may even compensate to some degree for deficient content.

It is surprising, even shocking, how lecturers can travel hundreds of miles to project slides of poor quality, poorly mounted, slides not even under glass so that they constantly go out of focus; how, as well, slides can be in no particular (or apparent) order, even out of order, or appear upside down and backwards. (The latter trick may be a 'grabber' for undergraduate lectures, but it rapidly wears thin and cannot be sanctioned for public consumption.) These deficiencies are disconcerting enough at professional meetings, inexcusable for the general public. They fundamentally undermine a discipline where arguments are made and broken on the basis of what one sees.

Everyone has at one time or another had to 'compare' black-and-white and colour slides, but what should one think of the latter when they are so deteriorated as to have gone red, blue, or green, or to have faded into nothingness? What of good colour slides taken against coloured backgrounds that fundamentally alter colour perception by inadvertent juxtaposition? And what of copy photography that inevitably seems to result from books published at the end of the Second World War?

Too many individuals accept unquestioningly the image put before

them. They will say that a thin white fillet between the image and blackness only accentuates the perception that one is seeing a reproduction, not an original. No one in his right mind could, however, maintain that one is actually viewing an original on the screen; unless, of course, 'original' refers to the quality of the slide. The philosophical question that results is whether one should have some transition between the image and its surround or whether the one should melt imperceptibly into the other. I personally favour the fillet, which provides some rest for the eyes as well as denoting the margins. But this type of problem must be resolved according to one's conscience, and facilities. Such things do affect perceptions of the field, however, and one should be aware of them. It is more than embarrassing to see better 'slide shows' from an amateur photographer's vacation than from within the university and museum sector with its professional aspirations.

The omnipresence of television means that viewers have become accustomed to fairly rapid pacing and visual transition. As a result, part of the experienced lecturer's task is to determine the 'assimilation and absorption capacities' of the audience, whether intellectually or visually. This is *technical logistics* – the delivery of the desired slide or slides at a given moment.

The results can be very different depending upon whether carriage or carousel projectors are used: the former can be fouled up manually and the latter mechanically. The first is perhaps to be preferred as it is most easily rectified; the second is subject to the *thickness of slide and its label*. When details or comparisons require double projection, one should calculate the risk not less than the effect of simple, gross, or merely unexpected technical error.

There are roughly four ways of presenting a public lecture with slides:
1 building the lecture *on the slide sequence* itself;
2 using *paired* slides, leaving the public to 'fill in' between the polarities implicit in double projection;
3 *interspersing* slides throughout the lecture as significant points are made, with the conjunction of word and image truly 'illustrating' the intended concepts; or
4 delivering a lecture *without* benefit of slides, then following the exposition with rapidly commented slides, thereby *reserving and concentrating attention on the respective intellectual and visual sectors* by thoroughly preparing the audience.

Whichever the model adopted, it is suggested that one 'rehearse one's lines' as any actor would. The mechanics of projection mean a certain delay in delivery and in response that goes further than voice quality, pro-

jection, and knowing how to ad-lib. A cluster of slides rapidly succeeding each other will be understood differently from a slide left on for a while; rather like the conductor of a ballet orchestra, your voice must adjust to the physics since they cannot adjust to you without certain risk. This simply means that one is not free to use one's voice as one might were it unaccompanied by visuals.

This caveat should be remembered as its lack of observance is clear evidence of discourtesy and lack of professionalism on the part of the speaker. After a while, one pities the situation of defenceless auditors who may never summon up the courage to walk out, as they should, in the face of a totally unrehearsed presentation. If they did, there might be tighter standards within the field as a whole, particularly for those who essay to reduce their latest book to lecture form.

One might understand that speakers 'wear thin' in the course of the normal hour's engagement. But it is surprising that one could have nothing to say in twenty minutes' time. In any event, the best evidence of success as a lecturer will be to note whether everyone is looking raptly at the screen and never at yourself. Although not intended as entertainment in the strict sense, a scholarly lecture has to create some sense of unfolding drama if it is to make any impact at all. More time should be devoted to its care and feeding rather than considering it something that can be 'creditably' thrown together at a moment's notice.

The Student's Emergency Kit for Notation

Footnotes serve three essential purposes: (1) factual reference, that is, source of information; (2) footnote discussion proceeding from factual reference; and (3) the excursus or digression that exists parenthetically and requires no initial reference, often containing information impossible to integrate into the exposition:

[1]A. Syncope, *The Futility of It All* (Toronto: Department of Fine Art, 1980), p. 147 (or pp. 147–59).

[2]L. Thimblebrain, 'I Thought I Had It Right the First Time,' *Journal of Inessential Iconography*, XLIV (March 1949), p. 71, affirms that no one had ever told him his notation was in greater part incorrect because his instructors had corrected only matters of detail, and these rather inconsistently.

Whether an article or a book, first reference must always be complete. After that time, it may be replaced by shorter notational forms; their choice and usage is governed by relative position to the original reference and hierarchical order. These are most usually:

- ibid. (*ibidem*, in the same place)
- op. cit. (*opere citato*, in the work cited)
- some form of shorter reference
- loc. cit. (*loco citato*, in the place cited; in the passage last referred to).

Loc. cit. replaces ibid. or op. cit. when recurrent reference is made to the exact page or passage previously cited within a work cited earlier on. Ibid. and op. cit. refer once again to a work, but not to the specific pages or volumes given in first reference. The sequence of appearance of given authors is impossible to determine in scholarly work, but the reader must not have to thumb through page after page to find any first (complete) notation; the agony of doing so has led to the substitution of short title for op. cit., which avoids the problems of misuse by author and frustration of the reader. Short-title reference is in any case required when you cite from several works by the same author. Remember that ibid. is followed by whatever new information (volume, section, paragraph, or simple pagination) is necessary. An ideal sequence of these forms might be:

[1]A. Syncope, *The Futility of It All* (Toronto: Department of Fine Art, 1980), pp. 147–59.

[2]L. Thimblebrain, 'I Thought I Had It Right the First Time,' *Journal of Inessential Iconography*, XLIV (March 1949), p. 71.

[3]Syncope, op. cit., p. 165.

[4]P. Stumblebum, *Reflections on the State of Art History in Canada* (Destruction Bay: Polar Microfiche Ltd, 1967), II, pp. 347–64.

[5]Ibid., I, pp. 434–7.

[6]Loc. cit.

[7]Cf. Thimblebrain, op. cit., pp. 179–80. Remember that cf. (*confer*, compare) does not mean 'see' in referring to a source.

'Abbreviated Reference' in Archaeology and Art History

The purpose of abbreviated reference is said to be threefold:
- to avoid confusion in either internal or comparative reference, i.e. to one or many footnotes;
- to provide normalized reference, thereby promoting rapid and sure comprehension;
- to permit more references in less space, therefore at less cost.

These ideals have in reality rather different and often conflicting origins: a long editorial experience or scholarly tradition on the one hand and, on the other, the purely economic considerations resulting from the typographical composition process. They may be the result of general agree-

ment or else a series of quite arbitrary decisions, in either case intended to gain time in writing as much as reading by the use of familiar abbreviations. These become the, so to speak, 'least common denominators' applicable to references most used with the field – *serials*. (To put this in some perspective, the Robarts Library, University of Toronto, possesses somewhat over 250 art-historical and 100 archaeological journals in all languages; were one to multiply these by a factor of two or three, one gains some idea of the quantity of literature employed with some regularity in these disciplines.)

Such abbreviations may be conditioned – even imposed – by different journals or linguistic groupings, most notably in English, French, and German. They often correspond to the 'house-style' of a periodical more than to any conservative, much less elegant, usage. In sum, they are *conventions adopted for the sake of convenience*! For example, the ever-rising costs of typesetting make it expensive just to insert full or half stops (periods and commas), to employ *italics* for journal titles, or to set volume numbers in Roman rather than Arabic. It is accordingly even more expensive to normalize inconsistent references or to modify their character and positioning. Inelegant or artificial simplicity is said to minimize if not altogether to avoid these dilemmas.

Of course, initial responsibility for comprehensible notation rests with the author and not with any editor or designer. This is even more true for essays and term papers remaining in typescript and which must be judged 'as is.' In these latter cases, there are at least three possible choices, largely conditioned by the *amount and complexity of recurrent reference*:
- a complete and entirely classic (passe-partout) notation;
- use of abbreviations favoured by professional journals;
- some shortened reference (author and date at very least) supposing either a full citation at their first appearance or else a full bibliography that identifies them.

It might be noted that the second solution requires considerable effort in the application and is normally not employed except among established scholars for actual publication. The third solution assumes an understanding with your instructor. In all cases, the intent is a *consistency* of notation and the ability *fully* to identify the source in question, whatever its nature!

Reference and Notation

Nihil admodum memorabile factum esset.
Livy, *Historiarum*, XXV, 32

Research and publication in the history of art are either object-oriented or involve a problem, theme, or context into which works of art may enter. The first approach usually involves *like* objects – the same classes of decorative or applied arts, the same types of artefacts, similar iconography, style, or the like – while the second becomes ever more varied the more widely one casts one's net. The relevant literature may therefore have little to do with the art literature as such.

For topics with an abundant although not invariably useful literature, hundreds of potential references must be *identified* and *located*. Then follows the ordering of material for one's own intellectual work rather than retention of the more general systems of librarians and archivists for *finding* it in the first place. As a result of what can be assembled from all the pertinent sources, new informational structuring and clarification are required.

Notation, in contrast, is a way of ordering one's material and findings for the use of others. It allows the placement of visual and written material through forms and conventions that may be rapidly comprehended while indicating relative importance. Notation may include parenthetical asides that can be skipped over by the mind's eye, but even this is only part of a rather sophisticated process that aims at the same type of simplicity found in a list. It reduces to essentials; it clarifies these by punctuation in much the same way diagramming a sentence clarifies thought.

While most people trouble themselves over the basics – reference to monographs, journals, and official documents – the greatest problems in art-historical reference concern, in the first instance, reference to the works of art themselves. (Architectural notation is particulary maddening when compared with other forms of artistic expression.) Such reference may be direct or only indirect, as with mention of *provenance* or allusion to *reproductions in books* or to *photographic sources*. As a general rule, however, writers often have difficulty in noting literature not already in printed form (archival materials, illuminated manuscripts). While conventions already exist for mention of *non-print* materials – or can be worked out through simple application – it is surprising how little attention has been paid to modes of reference to a class of literature that everyone uses: the exhibition catalogue.

The exhibition catalogue as a literary genre is a crash course in the outline of art history, its personalities, and monuments. Its text assumes a high factual density and extrapolations therefrom, with each element – descriptive, bio-bibliographical, technical, critical – a research problem in itself. The catalogue attempts to bring all these elements together in com-

pact form through some particular focus achieved by various criteria of selection.

Beyond this, the exhibition catalogue is characterized by:

1 *how many* works are catalogued and *to what level*;
2 the *amount of work previously done*, whether within or without the organizing institution;
3 the degree to which the catalogue is *independent of* or *correlated with* literature (whose, what level, and how far?);
4 the *thoughtful restriction of goals* (what can be accomplished well in a given time with available technical and organizational resources and personnel).

The feasibility of the concept and ability to co-ordinate at all levels is shown in all these things, although the result may be different depending upon whether there is rigorous selection or a casually anthological approach to the work of one artist, period, or tendency. *The best way of understanding different levels of notation is to examine how a given work of art has been catalogued throughout the years.*

This context (which is also the level at which the work may be loaned) is the best way of discerning levels of scholarly treatment: some items may only be catalogued by resident or invited experts and were likely acquired because of historical and aesthetic qualities lending themselves to intensive cataloguing.

Once a catalogue physically exists, it may be cited in footnotes or form part of a bibliography. There are, as a result, two different notational requirements:

– intermittent or occasional reference to something that must be *identifiable* as a catalogue;
– identification of a *class of literature* within bibliographies that in full or abbreviated form may be used and cited within other catalogues.

The problem is then twofold: *how to identify a title as an exhibition catalogue, and how best to refer to it*. Now a catalogue having one or several authors is most analogous to the monograph. But the catalogues of permanent collections and *catalogues raisonnés* can – and should – be referred to as the reference books they are; they can be found through the corporate author (institution) and/or the author, if credit is given.

Such is not usually the case with temporary exhibition catalogues. One may know that such-and-such authored a catalogue *at the time it appears*, but with time, few catalogues are associated with their authors, so it is the institution that becomes the natural identifier, i.e. city and corporate body. This will more likely be the case when the catalogue is the result of the type of collaboration where even an *et al.* is meaningless for retrieval by

the author. For this reason libraries and bibliographies tend not to retain more than the classic 'three-to-five' authors in their tracings; even then, they are unable to distinguish between the nature or quantity of entries attributable to given authors. (Insofar as the curriculum vitae is concerned, an academic does not list individual entries in auction or exhibition catalogues, only those *catalogues* in which he has had a substantial role or actually authored.)

Thus it is that the two easiest ways of current reference to exhibition catalogues are
– by the use of an *abbreviation* (exh. cat.) which makes clear the nature of the literature cited; or
– by giving the *running dates* (opening and closing) of an exhibition, which dates no book ever has.

Within the catalogues themselves, most individual entries use abbreviated forms of reference that are keyed to a section of the bibliography. Within entries, references may be interspersed with other literature, but it is usually better to separate them out, e.g. by provenance, exhibitions, and references.

When turning to the bibliographical listings themselves, one finds two general types of ordering if the exhibition literature occupies a separate section rather than being subsumed into the bibliography as a whole:
– *chronological* (followed by city, institution, and title)
– *alphabetical by city* (followed by an entry similar to that for the monograph, with or without mention of running dates)

The second of these, organization by city, automatically employs a *chronological ordering* that is quite unproblematic. In contrast, the establishing of a purely chronological sequence necessarily intermixes 'origins and venues' and will likely be organized *alphabetically by corporate body* unless there is some reason (and possibility) of determining relative chronology within a given year of issue; because not all catalogues have authors, this type of information will be included within the body of institutional listings.

Of course, a convenient assemblage of specialized art literature might appear under the bibliography as a section devoted to Collections and Exhibitions.[1] This format has the distinct advantage of isolating permanent and temporary catalogues from articles and monographs and is likely to be of most use in treating larger themes. In 'art literature intensive' publications, however, exhibition catalogues will more easily be severed from the permanent collection catalogues upon which they depend because the latter can easily be listed under monographs.

The rationale for this approach is usually within the context of art that has long been discussed and catalogued. In fact, it is possible to exclude

altogether permanent catalogues from a bibliography on the grounds that 'catalogues of public museums and galleries have not generally been included, since, where a connection with a particular gallery is indicated, it is assumed that the reader will refer to the catalogue if he wishes.'[2] The clear implication here is that a catalogue *exists and is accessible*; moreover, that the *most recent* catalogue will likely be used, thereby making reference to all the preceding ones. While this may to some degree be presumed of specialists, it is exceedingly presumptuous for the more general reader. It assumes the form of yet another of the 'pass-ons' in notation requiring the reader to do work *already done* but not retained in the publication.

Whether one would wish to take issue with this procedure or not might be considered through the examination of references within both temporary and permanent catalogues. Most pre-First World War catalogues consist almost entirely of reference to *other permanent collection catalogues* or to *monographs*. Since the Second World War, the balance has shifted to the point that the majority of references made are from *journals* and *museum bulletins*.[3] This shift in orientation indicates more clearly than any other the course of research and publication in or with respect to art institutions – and the necessity of maintaining periodical subscriptions within libraries.

Of course, it must be remembered that catalogue bibliographies are only *presumed* to be complete; in reality, they may simply represent institutional holdings, not the bibliography that exists or is pertinent. The user of exhibition literature must realize this lest a catalogue bibliography discourage further research because of its implied focus. While a catalogue bibliography can be a major contribution to knowledge, the role of the catalogue itself is in its discussion of ideas and authenticity. Users would do well not to forget this. No one is ever obliged to come to the same conclusions as the literature he uses.

Reference to circulating ('itinerant') exhibitions is complicated, at least in theory, by indecision as to *which* corporate body the catalogue should be attributed. Because few catalogues bear an author's name, the surest approach is using the name of the organizing (corporate) body. If the exhibition is shared, use the *first venue*, that is, the name of the institution at which the exhibition opened. (This information is normally given on the title-page or its verso and available to all.) This procedure is justified on two accounts: (1) major exhibitions will not likely go beyond two or three venues at most; and (2) exhibitions of lesser prestige, circulated more widely because of some educational mandate, will have been created for this purpose and are easily attributable to a corporate body.

One of the few notational problems peculiar to the circulating exhibition is the likelihood – sometimes the certitude – that the contents of the exhibi-

tion will be somewhat different than the catalogue content. This problem may be remedied through printed supplements when, for example, additional items are drawn from local collections. When, however, there is a *unitary* catalogue – the result of concentrated effort and collaboration – the art works that drop in and out are usually indicated by symbols or more likely by asterisks corresponding to the particular venues; these may even indicate works that were requested, perhaps even catalogued, but which did not at the last moment *come*.[4]

Despite a minimum lead-time of two years for an exhibition of medium complexity, these difficulties seem inherent in the mechanisms of the loan exhibition. *Fortunately, since all exhibition catalogues proceed on a unitary basis, last-minute adjustment is always possible.* This may take the form of a symbol or asterisk. It may also assume the form of a stock phrase – NOT IN EXHIBITION / NOT SHOWN – for a fully catalogued entry deemed essential for general comprehension of the exhibition. At worst, one may retain a numbering system with several 'ghosts' that have no corresponding entry, sometimes even no mention of the work that 'got lost' in the process.[5]

In those cases, fewer in number, where an exhibition catalogue was produced in different languages, should one consider the *first venue and language* as the 'original' edition? This is a moot question because it depends upon the contributors and institutional ententes that may determine where an exhibition *opens*, regardless of who has *produced* it. Like a shared edition of a monograph, the 'first and/or authoritative' text may not necessarily be the first to appear, only the text most easily produced.

Reduced to simplest terms, the question is whether an exhibition catalogue in 'another language' is an unaltered translation or whether the catalogue itself has been rethought and reproduced, i.e. reconsidered in content as well as scholarly apparatus and design. There is no easy answer to this dilemma.

One naturally gives the preference to the catalogue that is *available and in one's normal language group* unless word of mouth has it that there are substantive differences between versions or substantial problems with one. (Excluded from this discussion is the bi- or multilingual catalogue where the reader may instantly verify the translations if he desires. It will also be remarked that all references and apparatus will be parallel in such publications, which may not be the case with separately produced or reconstituted catalogues.)

In the absence of specific knowledge, one will use the catalogue at hand. When title-page information indicates there could be 'differences,' one will go to the specialized art-historical institutes and libraries that are likely to have assembled what seem to be 'duplicate' catalogues in different language

groups. The problems attendant upon translation suggest this step should be taken when the stakes are high; otherwise, no one probably cares or has taken the trouble to compare. What is asserted stands.

In making reference, one requires specific notation. Both are functions of the material treated, not something that can be anticipated in sufficient detail for instructions in a manual.

Notwithstanding this, the issues underlying notation may be considered and their essentials and refinements characterized. They are here treated within the context of exhibition-catalogue entries where their problems are most evident. Once the issues and principles are understood, the notation may be applied to articles, monographs, and other forms of art-historical writing with some ease.

As often happens with notational problems, these principles constitute a series of options from which the researcher chooses – or innovates – in light of his present circumstances. They appear here under general headings likely to be thought of by most writers.

DESCRIBING THE WORK OF ART

This is methodical and systematically executed material description. It is also a way of interpreting the work of art by carrying a necessary task beyond the immediate needs of registration. This Janus-faced quality combining general and comparative description and research inhibits work as much as simple terminology – or insufficient experience in cataloguing simple and complex works of art of all kinds.

Few publications are generally available on the subject, although many museums and research institutes have extensive 'in-house' rules for the inventorying and cataloguing of art. *These rules may reflect long tradition or have evolved idiosyncratically to serve the needs of a particular research project.* Caught between these two poles, the apprentice usually relies on fact sheets and the experience of elder colleagues. Otherwise he is left to his own devices.

The French have, as usual, shown the way through the publishing of a sub-series of their *Inventaire général des monuments et richesses artistiques de la France* (Paris: Imprimerie Nationale, 1971–). This series is best traced through the corporate body or series title because the author's names are subsumed into the general listing of advisers and collaborators:

Baudry, Marie-Thérèse. *Principes d'analyse scientifique.* SCULPTURE. *Méthode et vocabulaire* (1978)

Peyrouse de Montclos, Jean-Marie. *Principes d'analyse scientifique. ARCHITECTURE. Méthode et vocabulaire* (1971). 2 vols

Viallet, Nicole. *Principes d'analyse scientifique. TAPISSERIE. Méthode et vocabulaire* (1971)

Even if one has no real hold on French terminology, it is impossible not to learn something from these volumes, eventually to be completed by OBJETS, VITRAIL, MOBILIER, and PEINTURE ET DESSIN.

FULL BIBLIOGRAPHICAL REFERENCE

Provision of full bibliographical data is, from an editorial and scholarly point of view, the most classic and necessary of procedures. When consistently applied, the student will learn it, not otherwise.

Full bibliographical notation provides complete information to anyone not fortunate enough to reside in a research centre or to have to hand the 'usual' reference tools. Whether it appears in monographs, catalogues, or articles, full reference is indispensable to the reader requesting a title or inter-library loan. It is also a form of scholarly courtesy.

The newer and excessively abbreviated notations now gaining currency are unquestionably destined for studies relying upon modern and secondary literature and are quite *inappropriate* for historical studies. In a misguided attempt to find a least common denominator, they tend to blur necessary distinctions. *In so doing, they divorce the researcher from the actuality of historical documentation.* That is their purpose, to be applicable by the unthinking majority who know and care not that barriers are being set up between the historian and his materials.

Despite simplified 'recommended' forms, the most conservative notation also corresponds to the traditional distinctions. Among its particularities is an insistence upon full publication data (Place: publisher, date). Even the punctuation has its profound reasons since the colon after Place also *characterizes* it – New York: (i.e.) publisher, date. All this gives credit to the publisher in the same way as does retention of the author's name. Whether for the Early Modern period or our own day, it is a reminder of who is responsible for our literature.

Conservative usage also maintains, in the case of 'volumation' of articles, roman rather than arabic numerals. Granted, the former are not just something you learn, they must be reconstructed in an additive way rather than being instantly recognized. But their retention maintains fluency in deciphering the dates of traditional texts. They can be looked up, upon occasion, in the back of a dictionary, but the scholar should commit them to memory.

It is, moreover, useful to distinguish between roman and arabic in periodical 'volumation' because some journals have only individual numbers, not volumes (the *Revue de l'art* is not alone in this usage). As a result, instead of the number being a subdivision of a volume, it stands alone, with a given number of numbers comprising a year. By reserving roman for volumes and arabic for individual issues, there can be no question of confusion.[6]

Periodicals are deemed to have been published at the stated date *of issue*. Occasionally one may have reason to determine the actual date at which a number appeared, in which case the information usually follows within square brackets, [published June 1975] in the case of an issue dated sometime in 1973. Dates may often be established from date-stamps in periodical reading-rooms that give date of receipt for processing, however much they disfigure the cover.

The real problem of reference to periodicals (weeklies, monthlies, semi-annuals, or quarterlies) is that they are identified by *numbers, months, or seasons*. While one's index cards are likely done from the individual issues (or, always subject to verification, from periodical indexes), these issues are not usually presumed: few people – and virtually no institutions – collect only individual issues of periodicals, since this belies their function as publications appearing at stated intervals. This means that the specific descriptors (numbers, months, or seasons), although still physically present, 'disappear' when the volume is bound. Distinctions in notation are made these days depending upon whether there is continuous pagination throughout the volume or whether each number is separately paginated.[7] How this is handled remains largely a matter of personal preference.

ARCHITECTURAL REFERENCE

Architectural reference seems difficult for anyone not regularly engaged in architectural history and cognizant of its descriptive needs. Mention of movable works of art in public collections can be effected by a simple parenthetical mention of place and collection (Paris, Louvre). Not so with architecture.

The advantage of architectural reference is that it is entirely based upon historical fact. Its problems lie more in nuancing these facts when, for example,
- the plans of a building may precede by some time its execution;
- the building program itself may have proceeded by stages rather than continuously;
- the plans may be by an individual or a firm; the first may die unexpectedly while the second may undergo various mutations (partnerships, incorporation, reconstitution under a variant name);

– the structure may have been pulled down;

– the structure may be known (or known in a given place) only from discussions in monographs or, more likely, in the periodical literature.[8]

The decision to be made is whether to place the emphasis upon the *city, monument, and architect* in that order, or upon the *architect, monument, and city.*[9]

Moreover, nineteenth- and twentieth-century civil and ecclesiastical architecture often requires mention of the street address (or corner) if it is to be *located* within the present urban sprawl. This is, of course, a problem scarcely envisaged by architects of earlier years, but it is always a current one for students and historians. For this reason it is best to secure a good guidebook in advance in order to orient oneself in a city or region; after all, that is the purpose of such literature, and a long tradition has resulted in sophisticated and well-produced guidebooks.

Such precise reference, however, is neither made nor necessary for Mediaeval, Renaissance, or Baroque monuments because they occupy the Centrum and usually dominate it. Nor is this done for *palazzi* and early churches even though they may have been assigned street addresses in recent years.

It should also be noted that architectural reference does not respect the convention (*Chicago Manual* 7.148) that titles of paintings, drawings, statues, and other works of art be italicized while 'traditional or descriptive' titles are given in roman. *A building is not italicized as are movable works of art because its name functions as a proper noun.*[10] In any event, the sheer volume of architectural work done over the last two centuries and its matter-of-fact circumstances (commissions, competitions, collaborative work) require a different notational approach than that used in the other arts.

The most important decision made by any writer is the amount of historical (descriptive) information included in his photographic legends. He must determine the *acceptable minimum*, particularly when further detail may only be the result of long and involved research and will somehow have to be articulated *into* the necessary minimum. This choice depends upon whether he treats one architect or architectural firm at a time, or instead draws in many examples around a theme or problem.

Proper captioning should not become an end in itself or be carried to the point of absorbing all creative energy. Provided its facts are correct, a photographic legend provides a historical précis of edifices or structures; it can never serve comparative purposes any more than it can stand for or replace proper textual analysis. As an example of how far the process might go as a result of a curious and unusually problematic building program, we might consider a particularly 'complete' caption on the above-mentioned models:

J.W. Root (d. 1891) for Burnham & Root, revised by Charles B. Atwood. Reliance Building (1889–90) 1891 & 1894. SW corner of State & Washington, Chicago

Many would find it essential, at least a courtesy, to include in their captions the *denomination*, if a church, or the *common or accepted name* of civil architecture as necessary qualifiers:

London: All Saints (Ang.), Margaret Street (1849–50) 1850–9, William Butterfield

Toronto, Ontario: Municipal Buildings ('Old' City Hall), 60 Queen St W (1885–7) 1889–1901, E.J. Lennox

Whatever the perspective in which one works, the aim of architectural captions is, as any other form of notation, clarity and rapidity of reference combined with fundamentally correct information. Variations on the complex models (buildings never named or identifiable only by region) are, therefore, all the easier because of lesser precision and/or information to begin with. The solutions will come from the monuments themselves, and from their study.

ILLUMINATED MANUSCRIPTS

Appearances to the contrary, manuscript reference proceeds by analogy to the informational needs of other art forms. It is simply that these references normally arise from the careful examination of the manuscript itself and from comparison; apart from the colophon, where it exists, the information necessary for reference is not 'set out' for one the way it is on the title-page of a book.

Manuscript notation is essentially descriptive in nature, completed by analogies. When literature is cited, much depends upon the degree of detail one wishes to enter into, for there will certainly be mention of prior 'in-house' literature, and then of 'outside' studies.

For descriptive purposes, however, a summary catalogue of manuscripts – incidentally providing elements for 'running reference' – includes
1 the type or name of the manuscript and its author
2 its date
3 its origin (geographic region, scriptorium)
4 provenance (present collection and call number, often completed by concordances)
5 the *size* of the manuscript (a useful indicator of the type of illustration one might expect to find beyond that given supra, 1)
Refinements upon this scheme centre broadly on a more detailed 'codi-

cological study' and the degree one wishes to go into the contents. This process is obviously a very different thing for separate leaves or entire manuscripts or classes of manuscripts. A similar distinction is had in exhibition and collection catalogues, much less independent studies that determine their own frames of reference.

If proper description and notation has been done, the most important thing for any manuscript catalogue will be its indexes, gathering together the 'usual categories' of information that are ultimately of interest in the study of illuminated manuscripts per se. This is to say that what has been collected or selected ordinarily presents a chronological sequence or some stylistic and iconographic development for all its variety.

These categories are generally agreed upon and most logically determined. Following the model of a succinct (illustrated summary) catalogue, they include
- dated or datable manuscripts
- index of texts and authors
- index of illuminators and scribes (distinguished one from the other)
- index of persons, mainly owners
- index of coats of arms
- index of mottoes
- index of places[11]

The study of illumination is long and arduous, highly informed by period and place as well as the emerging (identifiable) personalities who can, in time, be studied like any other artist. The problem is in distinguishing the *essential preliminary cataloguing effort* from *intensive cataloguing and study* arising from works whose period and character facilitate it.

Much of mediaeval art, if reduced to manuscript study, is singularly intractable to aesthetic norms as we understand them after 1400. It is studied on the basis of motif and its transmutation in different families of surviving evidence, with scholarly attention being focused on working back to a presumed authoritative model. The difference lies in what one has to work with and how it can be treated.[12]

As with other reference and notation, the student of manuscripts does well to begin with the standard permanent catalogues issued by institutions with outstanding collections and a long and stable tradition of scholarly publishing.

PRINTS AND DRAWINGS

The study of drawings often begins with old inscriptions on them or their mounts. Beyond such historical conjecture, analogues and technique com-

bine with provenance, if there be any, to lay the bases for more careful study. Beyond description and notational problems, the results of long study often are summarized by a number of positive identifications and a 'beyond those drawings currently in dispute, scholarly opinion has it that ...'

Whatever the mystique attached to their study, the cataloguing of drawings often begins (and ends) with enlargements on the purely historical and visual data; alternatively, commentaries situate biographically the work, drawing analogies and comparisons (the first being formally structured, the second merely of a suggestive nature and open to question) by way of explanation.

What is the level of detail one must go to in order to characterize and understand a drawing? This greatly depends upon whether the work is known *only* through catalogues, whether it has been catalogued *and* exhibited, or whether it is *just entering* critical discussion – often after being acquired because of prior discussion and literature.

In discussing a drawing one will consider paintings resulting from studies, given the many changes involved in working out a composition as opposed to its eventual realization; engravings drawn from the pictures are considered in descending order of importance. As has been remarked, 'The student of drawings has one important advantage over the student of paintings: there is a reasonable chance that the object he is looking at is very nearly the same as that which left the hands of the artist ... [so] we can often feel, when face to face with a drawing, that we are looking at what the artist really made, not at what happens to have survived of the original.'[13]

One proceeds outward in such studies from secure identifications into more questionable ones, thereafter into other references and allusions that, because of their uncertain number, become rather like a Bibliography – bringing together at one time and place items that cannot be physically assembled, only alluded to. The best form of study may be in an exhibition where the works have been selected and become truly didactic, but this experience can only be 'unrecorded opinion' unless committed to paper. *Transfer to written form must include the most coherent statement both of historical record and of living expert opinion.*

All this must be completed by historical reconstitution, a step often let go by authorities who were interested only in whether something was by an artist or from another's hand. Since drawings are an essential step in reconstituting the genesis of paintings, structures, or monumental decorations, sometimes of sculpture, they assume the form of

- fragmentary (or multiple) studies,
- presentation drawings, or
- notebooks,

not to mention drawings specifically intended for engraving, or the 'autonomous' drawings existing in their own right.

Thus it is that different levels of drawing notation concern not so much basic information as characterization and discussion. A drawing must be in circulation for some time before it can really be studied in more than a very essential way. Traditionally, identifications (attributions) have been made through the study of painting. Although the literature is still widely scattered and likely to remain so, the rise of illustrated catalogues of both painting and drawing has made easier the process of ascertaining the purpose of drawings in general.

While most Old Master drawings are fairly straightforward in their technique, the vogue for mixed media in the nineteenth and twentieth centuries may pose problems for the neophyte. *If in a position to do so, he should visit reputed and well-catalogued collections, comparing the written technical descriptions with what he sees, fixing the information in his mind's eye for future reference.* Subject is of no importance here, only the medium.

For earlier periods and collections, there is always a potential for changing attributions. In all likelihood even a securely reattributed drawing may retain its old attribution for simplicity's sake, the new (or proposed) identification being noted internally. Registers of concordance are often the only way of tracing changing attributions when one imagines the chaos resulting from constant and unsettling shifts required in cases of actual 'transfer of title and author.'[14] This is naturally a rather different type of concordance than that used to trace the same object through different catalogues; its importance is, however, greater by far than exhibition history.

Notational problems with drawings exist in direct proportion first to size, and then to the complexity of the work. Problems are simpler in architectural drawings because of their clarity of notation and since they are not really intended as artistic statements. Further complicated by an often impersonal style through their rendering by agencies and through executants, architectural, as opposed to other drawings, require 'un nouveau code de lecture; le déchiffrement du plan, de la coupe ou du profil d'un édifice s'effectue grâce à l'analyse, mais aussi à l'imagination, car le spectateur doit recomposer mentalement ces détails par rapport à l'ensemble du bâtiment.'[15]

Titling is the most awkward problem inherent in drawing study as one more often than not deals with iconographical fragments. Unless the historical record is

clear or the subject readily identifiable, titles are necessarily generic. Often they must be reduced to summary descriptions consisting of the number of figures and (perhaps) their particularities, and whether they are shown with a 'decor.' This is an art in itself. *One gives the most concrete (analytic) titles possible since one has only what one sees to go on – and may never have more.*

The surest identifications come from developed studies within the religious, mythological, or historical repertory – a clear incentive to learn to recognize the normal iconographies, attributes, and symbols despite stylistic differences. One might, for instance, establish a descending line of iconographical certitude (not precision) in titling a number of sheets:
– The Circumcision / The Continence of Scipio
– Five studies of a figure of Fortitude
– Young woman before a window / in a landscape
– Two nude men struggling [action determinable]
– Woman in profile to the left, her right arm raised [action indeterminate]
– Study of the legs of a seated figure
– A right leg
Drawings rarely 'carry' their titles with them, yet their frequentation induces a mental set that cannot fail to be useful to the art historian. *His aim is to render virtually every significant feature, not just to get the identification across.* While certain descriptive indicators may better find their place in the technical description along with condition, paraphs, and collector's marks, they are necessary in achieving a balance between abundance and scarcity of detail. If the historian can describe with precision and emphasis a simple study, he will be able to reduce all descriptors to their essentials elsewhere.

There is little difference in approaching the description of prints and drawings when emphasis is laid on technique. Yet one studies a drawing for what it *leads* to, a print for what it *is* – more properly, what it is *from*, since it may be derivative or reflect trends in painting. Drawing is a manual and engraving essentially a mechanical process that leaves its traces in some way.

Unlike the drawing – which is presumed unique, but may be one of many versions by the artist, his school, and students throughout history – the print is essentially a replicative/multiplicative process producing each time an original. Until the advent of the lithographic crayon, it tended to ignore the particularities of its models to substitute its own grammar and syntax.[16] In the words of old sales catalogues and repertories, this means that a print has 'differences' requiring attention and identification even if it is but one of a class of objects that are presumed identical.

Rather than underscoring the 'intentionality' of the work, as one would a drawing, the print historian traces processes through their progressive degeneration, as when a wood-block splinters away or a copper-engraving or etching loses its detail, or is restruck or reprinted at some later date on 'different' paper or with different kinds and qualities of ink. *The problem here is to establish the different 'generations' of an image without, however, necessarily knowing the intentions or particulars of reissue.* While one might accept a drawing for what it is if other considerations are right, the quality of preservation of a print more directly affects its desirability and market value unless it seems unique or unknown to scholarship.

Unlike drawings, where one measures the sheet (I prefer the imaginary line drawn at very centre from bottom to top and side to side),[17] prints are measurable because of a defined (bounded) composition similar to that in painting, or by borders. If undefined, when the composition floats in space, the composition can be measured to its outermost limits (fastidious and of questionable value) or, more sensibly, by the plate mark – the stone mark for lithography – which imprints the paper in varying degrees through pressure. The plate mark can be more or less apparent depending upon the paper, or whether the print has been washed or the border more or less cut away.

PHOTOGRAPHIC SOURCES AND REPRODUCTIONS

This section really concerns photographic legends or references in all their variety of purpose. They are usually of two types, for *identification* and for *characterization*, with the first the norm and the second the more useful by far, if well done. They imply reference *from* the text and can in certain instances *refer back* to the text from the photographs employed.

In the inability to illustrate everything – and everyone must face this circumstance at one time or another – authors cite reproductions in other articles, books, and catalogues. Although used indifferently, there is a moral as much as a technical nuance between the use of *illus.* and *repr.* in citation. The latter better indicates a further distancing from the original through replicative processes, while the former more usually harks back to illustration created for a literary or scientific text rather than that which is merely assembled to 'illustrate' given points. As Fowler would lament, few authors make such distinctions now and are unlikely to in future. In any case, *these problems refer to illustration not actually given, but only alluded to.*

When, however, reference is made to something included in one's own work, there will be either a *Fig.* or a *Pl.* reference, the first concerning an entity many of which may figure on a plate. The plate is normally one page

among many in a section reserved for illustration, while figures are usually integrated throughout the length of the textual exposition.

In certain books and catalogues, the two occur together: the figures then form part of a given plate, which becomes a *means of organizing material for rapid reference and for comparison*. In such cases the plate number serves as a *rapid finding guide*, hence its positioning at top left or right. This format is particularly useful when dealing with many small illustrations such as manuscript initials, numismatics, sigillography, and the like.

Traditionally, figure references are in arabic and plate references in roman, indicating the subordination of the former to the latter. Figure references can further be divided by appending letters of the alphabet, as Fig. 11a, a system that is most appropriate for a completely illustrated repertory.

Occasionally, figure or plate numbers will be dispensed with – most notably in exhibition catalogues – and only the number itself appears. Whether in chronological sequence or not (and the tendency is to use this system for *selectively illustrated* works), it provides a form of cross-referencing back to the entry. This system may be further refined by giving a page number in parentheses (p. 67). Such cross-referencing is employed by journals (the *Journal of the Warburg and Courtauld Institutes* is one), when plates are grouped and contain illustrative material referring to several articles or, more likely, notes. The rarity of this form of reference in no way reduces its utility.

No manual, even one intended as such, could possibly give examples of every variation of circumstance requiring special notation in art history and archaeology. Not only is this detail unthinkable, the reader would spend more time poring over the index than in addressing his material. The purpose of this volume is to encourage people to face problems of notation coldly and logically so that they come to solutions dependent upon and inherent in the material they treat. There are no notational problems that cannot be solved by a little time and thought; the problems come – and remain – only when haste 'infirms' common sense.

Photographic legends are constructed around the relative importance of information for one's present purposes. While there is no absolute model, there are usually three considerations that determine the possibilities of models likely to be used:

– the artist and one of his works (by far the most usual instance, hence the easiest notation);
– a type of art object (its creator and possibly its date and origin being secondary to the object itself);

– an artefact for which only the most generic of descriptors/denominations is possible.

This decision made, one has only to follow out a logical sequence of historical and factual information, then repeat the model in a uniform manner throughout. As always, the question is the *amount of detail* to be entered into.

It is customary at the end of a photographic legend to mention the collection or source from which the photograph or transparency was obtained. *These may or may not be identical, in which case the collection precedes the photographer or firm.* Unless otherwise stated, it is presumed that photographs come from the museum in which the collection/object is housed. When this model is not used, acknowledgment may be given as a group (referring back to individual figure numbers) under a heading such as Acknowledgments or Photographic Sources.

The easiest way to 'gain control' over photographic legends is never to leave them until the last moment. (It is surprising how much time and effort is required to get them right.) They should be as concise and thought through as any argument, but in brief, just as they should convey a defined purpose.

Properly done, captions enhance comprehension; indifferently done, they are obstacles to knowledge, wasted opportunities, worth little or nothing. Rather like footnotes, they reveal the quality of the accompanying exposition to be first-rate, mediocre, or little better and probably rather worse than a text that is necessarily more complex than a photographic legend. The scholar reveals himself in such details as much as or more than do a draughtsman's mannerisms.

In articles, such reference must be complete as there is no possibility of recapitulation elsewhere. For books and catalogues there is usually some sort of parallel listing whose information may vary, often considerably, from that of the legends themselves.

Consider, for example, an *identifying* legend of some complexity and then a *characterizing* legend of great elegance. Each is preceded by its general listing:

295. Jan van Eyck ('Hand G'): The Finding of the True Cross. *Les Tres-Belles Heures de Notre Dame*, Milan Part (now Turin, Museo Civico), fol. 118. Copyright ACL Bruxelles.
Plate 160. 295. Jan Van Eyck, Finding of the True Cross; Turin, Museo Civico, *Tres-Belles Heures.*[18]

One notices that the name of the composition, usually italicized, is subor-

dinate to its manuscript, which is therefore italicized at the expense of the composition.

67 J.B. Bunning: The Coal Exchange, London, 1746–9 133
67 J.B. Bunning: The Coal Exchange. This was another way of looking at that controversial new material – iron. If indeed architecture was 'ornamented building' then iron, too, like stone, must have ornament. A dubious theory, but superbly done. (Now demolished.)[19]

Reference from the text uses only the figure number within square brackets [67] and in the case of the listing, also gives the page number on which the illustration may be found. These, by the way, are *separated from immediate textual reference*; that is, they may appear several pages before or behind any mention of them in the text. Such descriptive legends exist in isolation from the text but in proximity to the illustration, forming thumb-nail character studies that the reader is to accept as exemplars.

THE BIBLIOGRAPHY AND ITS INTELLECTUAL USES

Bibliography is first a matter of topicality, then of utility, finally of historical importance. Although taken for granted, it should be questioned as to its structure and purpose since these condition the form in which it is ultimately cast, as well as its possible intellectual fallout.[20]

It is only natural that one tends to judge literature by what was available during one's formative years, realizing neither its novelty nor its enduring nature. Afterwards, however, comes a 'settling out' process wherein bibliography has to be discovered and experienced anew because it is so far removed collectively from what is currently being produced.

Nor can bibliography be 'done' to anticipate need beyond the merest and most immediate essentials; its evaluation, however, is a continuing process that is neither more nor less than *what one brings* to the study of literature as a result of maturation. Whatever its intrinsic values, one's opinion of the literature, whether familiar or newly discovered, depends upon the *spirit* in which it is approached – often, the *regularity and randomness* with which it has been consulted over the years.

Bibliography and Historiography are very much alike, then, 'taking little bits out of a great many books which no one has ever read and putting them together into one book which no one will read.'[21] *They steer the discussion and channel the perceptions through the understanding of sources and of the secondary literature.*

Too exclusive a concern with contemporary documentation can mean

just as great a loss of critical focus as ignorance of the sources and their nature: 'It was not Chardin who was named as the leader or the hope of the apparently declining French school in mid century. It was not his death but Carle van Loo's which seemed a national disaster.'[22] *Indeed, the distancing implied in historiographical research leading to the constitution of a bibliography is crucial in determining how one might approach a problem.* Obviously, chronological study of the literature gives what was said about (or added) in respect of existing knowledge. This order may at times be difficult to evaluate where the bibliography has grown in an exponential manner.

The Bibliography appended to a book or catalogue is a guarantor of the seriousness with which study has been undertaken and presented.[23] Research culminating in an appended bibliography must be 'complete' although necessarily informed by a judicious look at the literature itself. A bibliography addressing art in its cultural context is very different and in some ways easier to establish than one that must determine the 'lower limit of importance' for a historical artist of consequence. For earlier periods a chronologically based bibliography 'has the advantage that the reader can see at a glance the ebb and flow of interest in Poussin. It has the disadvantage that, if one knows the author of a book but not the date of its publication, it cannot be traced immediately in the bibliography, but this defect is remedied by the alphabetical index of authors appended to the bibliography.'[24] For thematic studies one may prefer a Condensed/Select Bibliography that 'does not include titles referred to only once, except for books and articles of special interest directly related to the subject of this book.'[25] Clearly, much depends upon what is included beyond bibliography directly implicated in the topic.

In many cases, however, the argument may be adduced from so many *indirect* sources that it becomes desirable to mention the source only as a footnote in apposition to the text. It is therefore 'lost' to general scholarship, which it doubtless could never serve since it is applicable *only to the place and point used*. As well, much can be said against having a formally constituted bibliography at all. It may well distract from the topic itself, while its absence at least forces one to read the book rather than skim the bibliography. (However, a bibliography gives some idea of who is active in the field and in what way.)

Another problem occurring mainly in the older literature is how much of the title to retain in bibliographical citation. This is usually a title/subtitle question. Yet it must be admitted that the fine eighteenth- and nineteenth-century descriptive titles often shed real light on what their pages contain, or specify an intent one might not otherwise suspect in abbreviated form only. For example:

Hilaire Pader, *La peinture parlante Dediée a Messieurs les peintres de l'Académie Royale de Peinture* (1667)

André Félibien, *L'Idée du peintre parfait Pour servir de regle aux jugements que l'on doit porter sur les ouvrages de peinture* (Londres: David Mortier, 1707)

These are the kinds of titles that may easily be abbreviated for purposes of conversation and citation *provided one knows the rest*. The 'rest' is, however, not as subordinate as a subtitle is supposed to be. Because they are sources, one would tend to give them a full citation inasmuch as they would not be current or familiar to most readers, while specialists might well have forgotten the nuancing of the title and might be prompted to reconsider something they use in one way only by simple force of habit.

In dealing with a more modern compendium presenting much the same problems of 'current vs complete citation,' only the regular user comes to know the historical influence that one volume or title may have exercised on others. Such a common reference as Robert-Dumesnil's *Peintre-graveur français* actually has a full title:

A.-P.-F. Robert-Dumesnil, *Le peintre-graveur français, ou catalogue raisonné des estampes gravées par les peintres et les dessinateurs de l'Ecole française; ouvrage faisant suite au Peintre-graveur de M. Bartsch* (Paris: 1835–71)

Even then, its eleventh volume was done by Georges Duplessis and may appear only under his name – the continuator of a continuator of Adam Bartsch. But this is a peculiarity inherent in print catalogues.

Bibliography that has been seriously meditated and assembled is much more than just 'volumes consulted and/or used,' it is a means of drawing attention to *types of literature* and their *relative utility or historiographic importance*. Nor is it just 'what exists' on a topic; otherwise it would soon overwhelm the topic itself and form a specialized (and presumably non-selective) bibliography. This has been done for Leonardo and Michelangelo; one still awaits Goya and Picasso.

If the title of a work is truly informative, it is worth a full citation in a bibliography. *Series merit full citation as well*. This is generally true for art literature where a series/collection name means a uniform format and purpose, whatever minor adjustments may have taken place along the way. Still, there are many 'collections' that are so loosely constituted as to be virtually meaningless, in which case they distinguish different levels of publishing activity, and thus of publishers.

Citations also acknowledge once again the patronage exercised by publishers in defining the different eras of scholarship. To know that the

great illustrated books came from Skira, Abrams, and Rizzoli not less than Phaidon defines both the editors' intent and the readers' expectations. To appreciate what Seemann or Schroll has produced over the years is an education in itself.[26] And to know that something is a Pelican History, is from the Klassiker der Kunst (once the 'last resort' if one wished to know what something looked like) or the Univers des Formes, tells us in great measure why we think as we do on certain questions. Yet few are those who are aware that Wildenstein's *Lancret* (Paris: Les Beaux-Arts, 1924) inaugurated the modern art monograph that reigns unquestioned – and scarcely equalled – in informed publishing circles.[27]

In all these cases, while a bibliography is usually seen as informative, it may also be 'directive' through its classification by *themes* as much as or more than by the usual distinctions between *types of materials* such as sources, monographs, and articles (*Chicago Manual* 15.83). By 'directive' I do not mean the Annotated Bibliography 'intended to direct the reader to other works for further reading and study' as defined in the *Chicago Manual* (12th ed., 16.2), but something intended primarily for undergraduate use and therefore 'prescriptive.'

Bibliographies in the Pelican Histories with their usual divisions by medium and then by nature – Painting, Sculpture, Architecture, and within them Sources, General Studies, Individual Studies – correspond to this prescriptive nature ('reliability'); yet, because of this prior selection, students may presume the titles cited have only one purpose because they are identified with a particular question. *This practice may be justified if one is to 'condense and label' a period handily.* One has little choice but to indicate its major preoccupations, personalities, and themes; but this is very different from the Selective Bibliography with which it may easily be confused.

Such bibliographies, once established, naturally lead lives of their own. Nowhere is this more evident than in re-editions and revisions of published work where an author is *in theory* obliged to take account of work accomplished by everyone since his original publication. Here theory and practice diverge yet once more, for why should an updated bibliography be any *less* selective than the bibliography originally employed?

Moreover, a truly updated bibliography may become so cumbersome as to be virtually unusable, becoming an exercise that defeats the aims of the work. It is sometimes easier to update footnotes (at least they focus upon the argument) than to engage in extensive rewriting. Mere revision of bibliography, however, may become an abdication of authorial responsibility: 'Here it is, for what it's worth!' In certain cases the originality and force of the original publication must be retained lest it become another book altogether, dependent upon erudition alone.

For this reason the Introduction most often reveals what has been done and why the author has accepted or rejected titles others see as essential if seen superficially or in isolation. *The 'reissued author' must then evaluate his work through time, an opportunity clearly not given to most scholarly publications.* As illustration we might take John Rewald's seminal *The History of Impressionism* (New York: Museum of Modern Art, 1946; rev. 1955, 1961, and 1973). This book will be seen to differ appreciably from the companion *Post-Impressionism from Van Gogh to Gauguin* (New York: Museum of Modern Art, 1956; 2nd ed., 1962), which remains nearly identical save for the bibliography.

The former is a masterly study in the art of subdivision and extension of chapters and the revision of illustration. Things once summarily treated are now multiplied and have come into their own while preserving the armature – in this case a readable narrative to which illustration is keyed without the usual figure numbers. 'As far as possible, the illustrations are arranged chronologically and in close connection with the narrative,'[28] while the only textual references to illustrations are by page numbers within square brackets [p. 30] when the work cited appears in another chapter; otherwise the illustration *follows the text* and gives in effect a *developmental history*.

Developmental histories of art are but rarely successful with anything other than Movements and Artists within Movements; only occasionally with the study of techniques or genres. *Whichever is chosen, the density of bibliography and illustration varies appreciably with the period chosen.* Perhaps this is why many researchers, unmindful of how difficult it really is to determine what is *worth* working on, prefer to work in the more recent periods. Unfortunately, embarrassment of choice always requires more discernment and intellectual fibre than initially seems the case.

This distinction is methodologically important. Easily focused and historically respectful writing is possible only *within context* and when applied to a *restricted and unvarying repertory of artists*, often taken from the short-lived, formally constituted Groups. Rewald's texts, for example, were written with the help of *direct or near-direct* testimony not available for earlier periods whilst his illustration had more to be 'recuperated' from prior dispersions than 'established' from only a few scattered manuscript or printed references.[29] *Each of these methods has its place and value in the history of art.*

Much, then, depends on the ease with which one can reconstitute the essential artistic repertory and contemporary critical issues rather than having to adduce them from the works themselves. Closely illustrated writ-

ing works well for artists' biography, but the same process may, however unconsciously, become arbitrary when dealing with themes.

Sure it is that the ability of the art historian to know and to identify the 'key monuments' and personalities remains dependent upon the quality of documentary interest of the times. This has very different implications for Movements such as Die Brücke, Munich or Vienna Sezession, or Worpswede as opposed to the 'currents' (Orphism, Purism as commentaries on Cubism or the whole Neo-Impressionist generation), which *succeed or counter* each other at a dizzying pace. Then, too, there are the varieties of 'stylistic incorporation' present in late nineteenth-century and early twentieth-century art that, while labelled, are rarely stylistically or intellectually coherent once they have passed their 'historic phase.' Expressionism and most particularly Realism and Surrealism[30] are representative of this latter category.

While so much of the history of art is in theory devoted to Firsts, this search may also be a useful historiographical exercise situating types of literature – the first bibliography, first autobiography, first monographic catalogue. However, this problem is in truth one dealing with *extensive and intensive reference* made possible through the documentation of artists and artistic phenomena.

In this view, it is rather more important to know when a type of literature *came into general usage* so that one can have reasonable expectation of finding something – biographical dictionaries and lexica, dealer and sales catalogues, journal literature, newspaper reviews, and exhibition catalogues – on one's topic. And when to understand at least in outline their essential transformations over the years.

In classifying the types of literature current since the nineteenth century and possible rationales for their inclusion and organization, one can do no better than to give in extenso Rewald's prefatory statement to his own bibliography, scarcely altered with the possible exception of the exhibition literature since its appearance in 1946:

This bibliography is meant as a *guide*. While most scholarly and more or less complete bibliographies devote equal space to the important and the unimportant, the good and the bad, an attempt has been made here to limit the list to the principal publications and at the same time to indicate to the reader what to expect from them.

The section devoted to studies on impressionism in general is arranged chronologically so that the reader may follow in the accompanying comments the development of the appreciation of impressionism as well as the progress of research.

The sections concerning individual artists (Bazille, Caillebotte, Cassatt, Cezanne, Degas, Guillaumin, Manet, Monet, Morisot, Pissarro, Renoir, and Sisley) are, for greater convenience, subdivided as follows: *Oeuvre Catalogues; The Artist's Own Writings; Witness Accounts; Biographies; Studies of Style; Reproductions;* and in some instances *Exhibition Catalogues*. Within each of these subdivisions the material is arranged chronologically. Since some publications must be listed under more than one heading, all items are numbered and the numbers repeated wherever this seems called for.

The comments deal mostly with the reliability of the various publications, special emphasis being put on firsthand material. Bibliographies, indexes, choice of illustrations, and the quality of reproductions, etc., are noted.

Of articles published in periodicals, only those are mentioned which contain important contributions, new documents, etc. Among books, however, even those which seem comparatively unimportant are listed if they have reached a large public or enjoy an undeserved reputation.

Since no attempt at completeness has been made, not all the publications consulted or quoted by the author are given in the bibliography. The reader will find ample references to further publications in the notes following each chapter.[31]

The emphasis placed on reproductions may seem surprising until one realizes that literature is consulted for rather different reasons: ideas and perceptions, erudition in the strict sense, and illustration. *The reissuance of certain titles has occasionally altered their nature in a fundamental manner*. In some cases a revised or appended illustration has served in much the same way as bibliography appended to simple essays or a revised and enlarged edition has carried both bibliography and illustration with it.

Consider, for example, the transformation of four of Berenson's essays printed from 1894 to 1907 through their printing with over 400 reproductions in 1952. While, so to speak, 'furnishing the eye (and perhaps the mind) through illustration' was – and remains – a mixed blessing, one can today scarcely conceive its revolutionary impact upon publication in our century; and thus of *informing study and perception*. As Berenson remarked:

Unhappily pictures cannot as yet be printed (so to speak) exactly as they are painted, in the way a writer's manuscript can be, without losing the quality of the original. The reproduction of a picture is still a makeshift, and may remain so for a long time, even if accurate and satisfactory colour reproductions should become available. The size of a composition has a certain effect on its quality, and colour clings to what is behind it. Thus a colour will, of course, not be the same on wood as on slate or marble or copper, and will

vary from textile to textile on which it is applied, as for instance rough or ordinary canvas or fine linen.

On the whole therefore (despite the childish hanker today for colour reproductions, no matter how crude) the black and white, made from a photo that preserves tones and values, gives the most satisfactory image of the original.[32]

Whatever the intellectual and practical decisions inherent in the use of Bibliography, its helpmate Footnote Bibliography, and Illustration, much of their perceived utility is conveyed through notational clarity. If one has little or no idea of what to do in one's own language group, then transposition and interpolation from foreign languages is bound to be more difficult to author and reader alike. *Such problems reduce to differing conventions of alphabetization, capitalization, and normalization of elements, first in themselves, and then through typographical conventions.* These may differ considerably depending upon whether one employs conservative or progressive usage; and while initially as floating and immaterial as the clouds, such conventions usually have substance within given language groups. *All are governed by logical sequence.* If comprehended in one's own language, these systemic principles can be applied within a reasonable amount of time to other languages as well.

In respect of traditions governing translations of descriptive terms into English (*Chicago Manual* 16.73, 17.22, and 16.38), a peculiarly Canadian problem is the bilingual catalogue or publication. Since the two official languages are clearly understood, the second language of a title need not appear within square brackets as a translation. To clearly designate the work as bilingual, both titles should be given in the order of their appearance separated by a solidus, whether French/English or English/French. (Bilingual catalogues, if conscientiously established, should never be disdained by anyone perfecting a second language because it is possible to learn as one reads into a topic.)

Another problem lies with manuscript sources that have (or have not) been extensively printed. Or perhaps one should say it is a dual problem, that of the *critical edition* on the one hand, and the *intelligent publication, transmission, and retrieval of archival documents* on the other. In the first, one is to place faith in a study or volume that was created to serve in place of the original. For the second, one may easily be misled because something may be *published at least in part* in an unexpected place or *cited in unanticipated context*.

Both approaches to documentation have their problems as well. The older critical editions may be faulty or haphazardly established, or may not take account of alternate readings or problems inherent in the sources

that today would be deemed essential but yesterday were felt to be mere details in respect of the body of knowledge being published. Moreover, it is virtually impossible to publish whole archives except in abridged form,[33] while documents may at least be grouped and published around specific issues.

In all events, the most recent publication is likely to provide a reliable starting-point since one cannot be expected to know out of hand the existence and location of the originals; the scholar goes back to these to verify and complete what is relevant to his current preoccupations, perhaps learning something as well from the form that the document assumes. *In any case, both manuscript and printed references must be given lest the unsuspecting reader be tempted to redo work already done.* The amount of verification necessary for this highly dispersed class of literature is quite unconscionable; hence the insistence, the pressing pleas, of the holders that they be provided with copies (or notice) of major work resulting so that it may benefit others.

From time to time, a bibliography and exhibition literature may be 'used in conjunction with [i.e. to complete]' a previously published bibliography. In which case rubrics such as Some Notes on Other Sources may give an idea of where and what research material remains to be exploited, while Suggestions for General Reading 'selected according to their usefulness and accessibility to the non-specialist reader' perform a general educative function.[34] This approach doubtless works better for national schools and subjects where there is already a literature of some extent and substance; it gives, however, real service in extracting from the more inaccessible sources and languages what can be of immediate use to the public at large.

There is yet another class of literature whose inclusion in a bibliography belies its significance: the studies useful in every way because they are the 'first' treatments of a topic in any extended way, or the first in many years.[35] *It follows that these are the most difficult to evaluate given their speculative nature whose labour-intensive research must then be retraced and extended by those wishing to penetrate the subject.* Their topics are often so 'classic' as to shock the reader into indifference, when he tends to equate the *importance* of an artistic period or problem with the *probability* of its prior treatment in the literature. Such works are normally the outcome of the progress of knowledge through much scattered publication and exhibition activity, and of the increase in documentation encouraged or discovered as a result.

More could doubtless be said about the intellectual uses of the bibliography. What should by now be clear is that not all items in it are of equal value even if given equal prominence within their class of literature. *By dashing*

into a Bibliography without reading the conditions upon which it is based, one must end up with an unfocused listing of sources.[36] The same is true of a text read without benefit of its Preface or Introduction.

A bibliography worth its salt has been crafted to serve as a means of understanding specific ends. *If one regards as unimportant what does not serve immediate ends, one suspends judgment upon the entirety of the evidence in the search for specific information.* Such gross simplifications are unconsciously imparted to the reader and set up a level of expectation that does disservice both to the author and to himself.

It is, in the end, just as impossible to overstate the importance of a finely honed Introduction to a piece of art-historical writing as of the prefatory statements to each section of its apparatus, including the bibliography. *Works never reissued or revised stand for their period.* They are, given their restricted press runs, the historiographic equivalents of bibliophilic rarities that must be examined for what they are as much as what they say.

When revised by the author, often after he has turned his back upon the field or problem for other things, he must reconsider the different *emphases and interpretations* in the topic as it now appears. The results are usually worth the trouble when, for example, an author writing in 1980 can say, 'by far the most gratifying part of what has necessarily been a difficult and tendentious labour of revision has been the discovery of how many pictures which in 1963 were only known to me from documentary sources have subsequently come to light.'[37] Clearly, the passage of but a generation invites fundamental reconsideration of the very bases of the history of art.

5 Cataloguing Theory

On Cataloguing and Some Unrelated Matters

> Le critique est le proxénète qui pousse les oeuvres vierges dans les
> lupanars de l'historicité expéditive.
> Robert Lebel, *L'Envers de la peinture*

To catalogue is a historical act. Whatever the disparities of sentiment or
interest leading to its realization, the art catalogue remains a historical cu-
riosity: uniquely situated by circumstance, often referred to, and scarcely
if ever rewritten, it becomes a document of art and history. This chapter
but imperfectly attempts to situate and characterize one of the most fun-
damental of art-historical acts – the classification of objects by criteria per-
tinent to them, involving known and unknown elements in varying pro-
portion, and likely proceeding from the most factual information into the
realm of interpretation.[1]

Appearances to the contrary, a catalogue concerns more the *particularity*
of evidence than the evidence itself, as much the manner in which things
are set out as what is dealt with. It must then characterize descriptive and
historical data, correct errors of fact, and further general comprehension
of problems.[2] (By virtue of aphoristic formulation, this covers fully 85 per
cent of the cases, the remainder fending for themselves as they have in
every epoch.) A different philosophic orientation employs the catalogue
as a medium for the dissemination of personal ideas and of research either
too fragmentary or so insufficiently demonstrable as to be virtually un-
publishable in any other form. These two tendencies are to some degree
unitary and, in any event, are seen to mean quite different things, depend-
ing on the period at which written. This intellectual process then permits
quantifiable distinctions (rarity, condition) as well as myriad qualitative
considerations of the object repertoried. These reflect the knowledge of

the moment or, more properly speaking, document the ignorance of the day.

Objects are the focal point of any collecting or cataloguing effort. In the most literal acception of the word *Realia*,[3] these material realizations alone are transmissible from generation to generation, place to place. They come to be known quite removed from their original context. The authority, the very identity, of the object and its associations must be re-created by the writer once he has reconstituted basic information and analogues; this is done with both a percentage of improvement, because of historical distance, and a corresponding loss of grasp, given demonstrable changes in social organization. Exposition of the object concretely serves the intellectual abstraction that is catalogue organization – a catalyst effecting the sometimes dramatic convergence of the visible and recessive qualities allegedly resident in the work of art. This compelling process of induction is fated to be incomplete at any given moment. However, as 'second exhibition' of the object, the very permanence of the catalogue that records it leads to an unwelcome conclusion, being *identifiable* with the work of art rather than paralleling it.

If all art 'addresses itself to the mind by the intermediary of the senses and reposes on a material element,'[4] the existence of the 'exhibition/catalogue' is amply justified by the convergence of the unexpected – of realization of significance *in and behind* the object studied. Structure facilitates comprehension of absolute interdependence between iconography and formal appreciation. The result is similar to that advanced, in quite different circumstances, by Edgar Allan Poe's interlocutor in the *Murders in the Rue Morgue* – something always 'on the verge of comprehension without power to comprehend, as men, at times, find themselves upon the brink of remembrance, without being able, in the end, to remember.' The catalogue is for those in varying degrees *unfamiliar* with what is being shown. Its conclusions are richly textured with various levels and qualities of information perhaps combined with a sense of how these conclusions are reached.

Realia, however widely diffused, often exert an influence quite independent from their material existence. As agents, they may leave no trace in a process of selection that involves discernible historical criteria. Objects are *particular* in nature: were there no local conditioning, no qualification of the progress of virtually unimpeded movements or tendencies, the historian would have only generalities to discuss. These are as pervasive as fog drifting through a mountain forest, vague and formless in itself but inevitably – and be it said, *naturally* – conforming by its very insubstantiality to the minutest exigencies of the local topography. Whatever the 'conclu-

sions,' we are left in expectation of a greater certitude that may not now or ever be proved any more than it may be disproved; what remains is a matter of attainment, not anticipation. By determining insofar as possible the circumstances of creation and re-creation – of *comprehended value* in the visual arts – we establish information of a more worthwhile sort. This is often inapplicable information, existing as a state of pure knowledge for the viewer, reader, or cataloguer. Its very *dis*interestedness enables us to comprehend what was done with what was at hand; how, in turn, recreation is experienced and transformed according to different levels of capacity and experience. All this is a positive, dare one say a necessary, act of *historical description*. Judgment is founded upon some optical experience, whether direct or, as with illustration, by default.

In earlier days, when taste was surer, reproductive engraving (eventually supplanted by lithography and, in turn, by photography)[5] became the major complement of a catalogue. (It has so remained, but is increasingly placed in proximity or direct apposition to the catalogue entry.) Taste *was* surer, since what was reproduced was part of the 'proper notion of things,' a system or systems of value that were considered unexceptionable despite – or because of – mere fluctuations in taste. Catalogues of the early eighteenth century acknowledged models capable of forming taste and young painters – examples that would cultivate a general taste for the arts.[6] Reproductive illustration came to lose its value because of increasing separation from its declared social function – the *preservation by multiplication* of an object of intrinsic interest or value. (The contemporary analogy is doubtless the stereophonic recording or tape deck: whereas recordings up to the early 1960s consecrate acknowledged values and performers, one has since witnessed the recording of music so as to gain entrance to the establishment to which one aspires. Attainment is, at an intellectual level, less stressed than *development*.) The relativism of a definition of art is, then, a dangerous tool in the hands of the naïve and the ahistorical. It has led to the extension of the word 'art' to a point inconceivable in the past, verging on the meaningless and further exacerbated by the confusion natural to a technological society, of the techniques and mechanics of an art form with the growth and perfection of the art itself.[7] Some consistent pattern has none the less been maintained: collections are determined by historical considerations admitting of personal idiosyncrasies or else represent contemporary or particular interests not as yet admitted to the canon.

A successful catalogue is by definition what becomes the subject and serves its internal design. As its problem is the transmission through some form of notation of that which will never have been experienced directly by

an increasingly greater portion of society, the choice of one typeface or format over another may prove immaterial. Now a reader or museum goer may often be able to determine, relatively unaided, the internal logic of what confronts him. Design or configuration is, I believe, somehow manifest; or becomes so, provided the criteria and selection are sufficiently compelling. Selection is also necessary for the catalogue where abbreviated notation seems superficial inasmuch as general truth abolishes all but significant detail. In contrary instances, the mere *accumulation* of history destroys any sense of historic moments (or their passage) that may be discernible in the selection and presentation of objects: the result is neither descriptive nor is it, precisely, extended cataloguing.

A reunion of artworks leads, perhaps, in the public mind to a fundamental misconception: all objects may be said to illustrate general themes or concerns; thus would general concerns (inevitably the expression of highly particular ones) find their particular illustration in the catalogue content. All this is more true of catalogues of the 'systematic' kind dear to the nineteenth century as opposed to the 'methodical' ones of earlier periods that serve as iconologies. More delicately phrased, these latter served as collections of imagery reflecting encyclopaedic concerns – of human knowledge itself, quite irrespective of artist.[8] Largely as a result of these distinct forms of ordering documentation, a naïve assumption follows that the mere existence, the very bulk, of materials on a subject may be equated with its historical significance. In truth, the diametric opposite holds: whatever the vitality of institutions, documentation coming from the periphery of recognized activity usually indicates intellectual ferment. It must further be admitted that documentation of any kind may be strikingly *un*informative, illustrating nothing of material worth to later comprehension beyond an image that exists and which derives from a specific context *become* historical! Historical knowledge is its own and sufficient reward because of the inimitable *contrasts* it proffers. Its universality is the result of curiosity and of query: personal initiative is extended into time, although usually without *consistent* thought of the future and almost invariably for some more immediate need.

The phenomenon of the historical catalogue (i.e. one having some historical rationale) is a recent one. Whether as inventories for the description or transfer of collections,[9] or as handlists or guides to the exhibition of works of living artists, catalogues were for the recognition of works in *immediate proximity* to the viewer. Only with time were such 'catalogues of historic record' employed as the basis for a summary history of the artist(s) involved or to collect the activities of an institution. Perhaps at that moment the lack of specific information (beyond artist, title, dimensions, and, oc-

casionally, format) was perceived as such. The mere fact of exposing was equated with historic actuality, the catalogue doubtless serving for little more than purposes of identification and resultant appreciation. Such efforts could be 'definitive' because they dealt with recognized quantities while the modern critical catalogue may, at best, be 'authoritative' because it deals with more than the purest of *material descriptions*.

Moreover, cataloguers of the late eighteenth century exercised their hand upon collections in like and in number never seen again.[10] The objects repertoried were generally the reference albums of practising artists; then as now they are evidence as to what surrounded an artist, but we should not expect evidence of manifest or uniform quality in their selection. Since the objects were repertoried more often by category than severally, they demonstrate the functional inseparability of collecting and cataloguing in some definitive (i.e. published) cultural document. Only when archival material began to be regularly employed to provide the 'dessous de l'histoire' was their importance as a source of specific information threatened, or more properly, modified. The examination of individual items rather than the catalogue as a whole became paramount.

Such efforts may represent the *first* literature upon the objects figuring therein. A provenance or history was begun that could be cited in future catalogues – and was, given the importance of the collections. The foundations were established for critical literature by virtue of *earlier authority*.[11] Few are the objects having a long or illustrious history. They have passed through hands that felt no compulsion to have usable or public record of their possessions. This circumstance poses exceptional problems when an object of great quality or curiosity emerges from limbo and demands entrance into the historical continuum. Then and then only may the full effects of the gradual divorcement of cataloguing from cultural function be felt and the quickening toward a specialized and, again may it be said, a very abstract and demanding discipline. In whatever form it assumes, the catalogue remains a work of initiation and reference to the researcher as much as to his indispensable complement, the educated general reader and private collector.

It is all too easy to forget just how recent is much of our scientific apparatus and the relatively few to whom it is owed but for whom it served as an instrument of personal attainment, even of agreeable occupation, rather than a relentless professional tool. Who today would collect 2,069 ephemera on the history of the arts of the late eighteenth and nineteenth centuries and excuse his references with a modest 'Cet ouvrage n'étant destiné que pour mon utilité particulière, je prie les personnes entre les mains desquelles il

pourrait tomber de n'être pas étonnées de n'y pas trouver l'ordre qu'on aurait pu lui donner.'[12] Whether other orders were possible or more to be desired, and to what usage this collection was put, remain unsaid.

The intensely *personal* nature of such endeavour, highly informed by social condition, may not casually be dismissed. The 'shared and signed' catalogue is a modern anomaly in that a certain disparity of approach and conception of catalogue notices is the result of *organizational* research. Such a catalogue is a conscious scientific monument, but it is no longer a cultural achievement. It is revealing of the interests and specialization of its contributors and assumes a language as varied as their number. *Linguistic expression is no longer a key to cohesive period mentality*: the structure of the catalogue, however varied, responds to the norms of a relatively depersonalized mechanism. In differing ways, the experience requisite for cataloguing exhibitions of current as much as historical art must be gained by indirect means. The 'catalogue/exhibition' is then as much a means of initiation as a work of reference. In the latter case only, a sense of false precision is encouraged when the subjects touched upon have relations of traditionally uncertain nature. As La Bruyère recognized, 'La curiosité n'est pas un goût pour ce qui est bon ou ce qui est beau, mais pour ce qui est rare, unique, pour ce qu'on a et ce que les autres n'ont point' (*De la Mode*, ii). It is exceedingly doubtful that collections today are thought the normal inspiration for large-scale artistic realizations when an object is valued for what it is, not for what it *means* in terms of historical and social description.

The agent of such types of transformation is of the utmost importance for any period in which the reinsertion of objects into their presumed context involves adduced literature. In such instances, research is comparable to societal mores – no longer a matter of experience, but of learning. There is always a danger of inadvertently forcing an argument to bridge the gap *between* an object and history. The representative function of the catalogue is the more difficult given its shortened notation; it may be the instrument of gathering together of relatively undigested or fragmentary observations. Whether the first cataloguing surpasses provincial interests or standards, or must be sustained by literature arising from it, remains an open question.

As an ultimate aid to *pure research*, the 'historical catalogue' documents and instructs posterity – quite beyond the level of applied research that becomes its spiritual reduction – as to the preoccupations of a bygone day. One should accordingly never fail to ask whether 'more is being made' than is justified by placement in a larger context. Nor should one fail to recall that commentaries reflect knowledge of particular individuals or in-

stitutions, the differences between them and general culture being farther apart than ever before. Economy of effort for maximum effect may raise consciousness more than concomitant familiarity with what is exhibited: the catalogue/exhibition could now assume and advance in great measure the role of the monograph to which it is the indispensable foundation and complement. The sheer quantity of catalogues produced in the last decade is sufficient witness to this phenomenon, their generally portative format and (often) coloured illustrations rapidly occupying for the educated reader the position once held by the coffee-table book of post-war years.

It would be difficult indeed to predicate motives for the creation of catalogues. A few words of caution are in order. This manner of publication – as opposed to the monograph and periodical – contains inherent contradictions and not a few real dangers. It may all too readily become an apparatus unquestioningly ransacked for information and analogies. All disciplines are more or less parasitic, if not incestuous, but rarely is a study so endangered by the rarefication implicit in the *catalogue raisonné* as the history of art. This process is rather like throwing a pebble into still waters, save that the concentric circles fall inward rather than extending themselves indefinitely, if sometimes imperceptibly, into uncharted depths.

Excessive reliance on authority may dictate certain works being exhibited because their commentaries are at hand,[13] effectively crowding out works of as high quality that are not so favoured. The virtue of this vice is that a given object becomes part of a circuit and thus increasingly familiar to the public; one may still say that the highest attainments are usually those that form in some way public awareness rather than responding to it. In either case, the endearing characteristics of the catalogue include a unitary presentation (i.e. by catalogue number) requiring only a limited attention span. This permits, on an ideal level, maximum attention to the work exhibited while reaching an extremely *current* level of information scarcely obtainable by other means. This currency is one of time and of accessibility; it is, however, in some measure dependent upon foreknowledge or the inherent attractiveness of objects. While it at least initially proceeds from superficially perceived truth, the purpose of an exhibition may not often be apparent even to its organizers until it is 'given to view' as a reality and not as a *conception* of reality. Such ambivalence is virtually impossible in the case of a 'catalogue/exhibition' founded on secure *documentary* basis: the objects themselves repertory affinities and dissimilarities permitting the most elementary observations to retain some universal validity; a cultural statement of historical nature results that is generally

comprehensible, although criteria for the selection of documentation must be unexceptionable if the concepts arising from it are to correspond to a historical truth.

We owe the early tradition and vocabulary of cataloguing to the French, especially to the lettered amateur. Foremost among these is Pierre-Jean Mariette, whose explicated allegory by Cochin and Choffard served as frontispiece to his sale of 1775 (fig. 1). Its legend reads: 'L'Histoire, le Génie du Dessin, le Dieu du Goût et l'Etude, rassemblés au pied du Buste de Mr. Mariette.'[14] Basan père had dressed the Mariette catalogue, which remains an enduring monument to them both. The frontispiece to his own sale of An VII, also by Choffard (fig. 2), bears witness to a rapid change in orientation in reading: 'Le Dieu du Commerce, et le Génie de l'activité déterminent le goût de l'artiste pour les avantages du commerce, ils lui facilitent les correspondances de son art chez l'Etranger.'[15] If such personal impulses can be said to become general instincts, the communication and commerce of works of art in the highest sense necessarily imply considerations of both qualitative and quantitative nature; these mirror a change in *epoch* far surpassing that of any particular *generation*.[16] The illustration of works of art in catalogues can only work in opposition to the celebrity of the authors who catalogued them.

The essential question must be to what extent illustration serves study rather than the process of *recognition or identification*, which is its first and most elementary level of application.[17] This query is that of the eighteenth century as well: formal statements abound to the effect that the principal object of a reunion of engravings was the study of painters (fig. 3). By extension, this point is particularly appropriate for the present catalogue and requires a certain development.

Reproduction of *oeuvre* has in recent times been developed to a high state by photographic means. It would present an absolute (i.e. scientific) rendering that gives evidence lacking in distinction or distortion – an equation all the more natural as it is illogically presumptive.[18] A photographic image is in its way more artificial than was engraving in that the conditions of manutention are entirely arbitrary, the perfection of mechanical processes resulting in something surreal even in the hands of the best practitioners, since sufficient of itself. Individual particularities in *rendering* painting are virtually annihilated, while earlier epochs presumed certain areas of agreement despite 'differences' in engraving as a medium of translation.[19] Such *diversion of attention* is quite impossible with printed or handwritten commentaries alone. It may be said that the advent of photographic reproduction has replaced proper descriptive notices so that the texts that

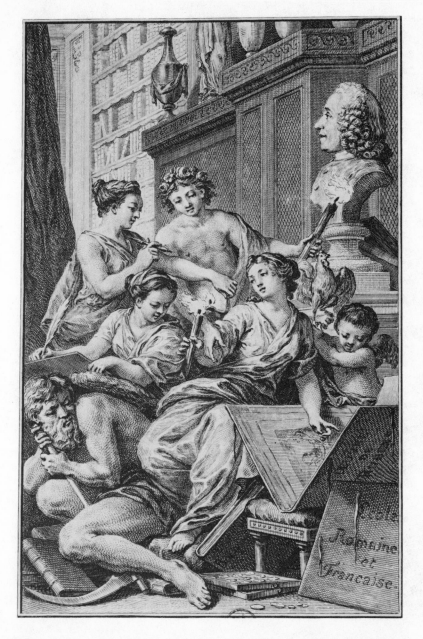

Figure 1 P.P. Choffard after C.N. Cochin fils, *Allegory to Pierre-Jean Mariette*
(IV/IV). Frontispiece to his sale, 1775. BN Est. Rés. Ef 18a (69 C 40100)

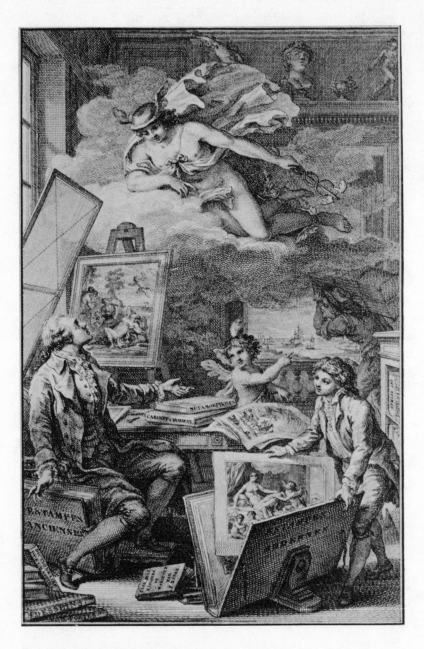

Figure 2 P.P. Choffard, *Allegory to P.F. Basan*. Frontispiece to his sale. An VII (1798). BN Est. Yd 2158 (75 B 69634)

PREMIERE SUITE
DE DOUZE ESTAMPES,
Gravées fous la Direction du Sr. LE BRUN, Peintre,

D'après différens Tableaux capitaux des plus célèbres Peintres des Écoles Flamande & Hollandoife, lefquels Tableaux ont été, ou font encore en fa poffeffion.

L'IDÉE de cette Collection eft de former un volume *petit in-folio*, mais dont on ne peut point encore fixer le nombre, & de faire connoître aux Amateurs, le gout & la maniere de chaque Auteur.

Ce premier Cahier contient ce qui fuit :

Un Payfage très-pittorefque, *de Lingelbach.*
Un Sujet d'animaux, *de P. Potter.*
Un Payfage avec figures, *de J. Steen.*
Un intérieur de Chambre hollandoife, *de Terburg.*
Une Préfentation au Temple, *de Rembrandt.*
Un Cavalier à la Porte d'une Auberge, *de Metzu.*
Deux Payfages avec figures & animaux, *de Berghem.*
Un autre avec Baraque, &c. *de Wouvermans.*
Un ―― avec Cavaliers, *de Wynants.*
Un ―― avec figures & animaux, de *Cuyp.*
Une Bataille, *de Vander Meulen.*

La feconde Livraifon auffi de douze Piéces, fe fera dans l'efpace de fix mois environ.

SE VEND A PARIS,
Chez BASAN & POIGNANT, Marchands de Tableaux & d'Eftampes, rue & Hôtel Serpente.

M. DCC. LXXVII.

Figure 3 *Premier Suite de douze estampes gravées sous la Direction du Sr. Lebrun, Peintre* (Paris, 1777). BN Est. Ad 63 (76 C 77326)

accompany illustration reveal levels of distinction as much of their author as of the works discussed.

When great private collectors of the seventeenth and eighteenth centuries opened their doors to selected visitors, when they published albums of their holdings (often by subscription and destined to remain incomplete), scholarship ceased to depend upon individuals for its prime impetus. The recent nature of this phenomenon is as little acknowledged as its results are undeniable: a local point of reference could no longer be taken as sufficient or, indeed, as constant. *Systematic and universal comparison was adopted as fundamental method*. This change was as much one of kind as degree. Heinecken developed a nomenclature[20] from the Dresden collections that is still intellectually valid, save that the 'complete' or representative collection moves from a dynastic to a continuing public function, strengthened always by purchase from individual collections. The number of authorities available in written form continued to be rather strictly delimited, in marked contrast to the number of works available for viewing or in the commerce.[21] These contributions came to general usage: while Mariette personally refused indiscriminate access to his own notes (continually added to, corrected, and commented) taken from the works themselves, the Vienna MS eventually formed the (significantly unacknowledged) basis for the henceforth indispensable *Peintre-Graveur* of Bartsch (1803–21), in 21 vols.[22]

For collections of unexceptionable importance – the early ones – it is imperative to appreciate the 'historic rationale of error' as we perceive it. Witness the Jabach collection sold to Louis XIV in 1671, foundation of the Cabinet des Dessins, Louvre.[23] To preserve its significance, one would have to publish in extenso and non varietur the acquisition inventory with its proper illustration – whatever the current state of attribution for individual drawings. This approach admittedly would result in 'catalogues that replace exhibitions,' exhibitions that, given their physical extent, would be impracticable as well as generally unpalatable. In such a way the hopes and illusions, the inconsistencies and imperfections, of an epoch could be preserved as its *accomplishments*, becoming indispensable and curious references of 'a certain historical exactitude.' These and other aspects must be restored to their proper context: Jacques Le Blon attempted to replicate the colour of pictures as well as motif and composition in his *L'Art d'imprimer les tableaux* of 1740,[24] while the innovation of engraving 'in the crayon manner' is its parallel for drawings.[25]

Such tentatives and successes in the eighteenth century to perfect the means of reproduction are sufficient testimony to informed opinion about and interest in the painters' *oeuvre gravé* – whether of the epoch or from

succeeding epochs. The inherent difference between the *interpreting* document tolerated, indeed encouraged, in earlier periods and the 'neutralized' (and neutralizing) photographic document was given new meaning in the early part of our century. The seeming incapacity of our own time to know or to discuss anything without benefit of illustration is but an extension of the photographic frame of mind. Reproduction in whatever form *is* the corresponding object, an object come to be known exclusively in absentia and entailing that elusive sense of repossession, of some precognition of and consonance with the period of its creation. Such 'communion by simulachrum' is, for the ever-changing public, a familiarity that in reality isolates and consecrates objects of whatever quality. Reaction to it may be as varied as that in the presence of the original. It is scarcely able to be as intense, and it in no way replaces the original in spiritual terms.

There are just and proper limits to what may be said about any work of art. The catalogue by its existence represents accomplishment that is trivialized by indiscriminate extension to all levels and every subject – with all things being indifferently and massively transmuted into 'historical documentation,' since this process requires neither effort nor thought. The decisions having been made by those undertaking the documentation (or its ordering), general participation becomes relatively more quiescent, not merely interiorized. The result is a tacit invitation to indirect experience. This would be less the case for spontaneous, even for the acculturated reactions of witnesses to an event.

With the Universal Exhibition of 1855, Baudelaire too well foresaw the pitfalls of naïve faith in progress, of perfection indefinitely and effortlessly extended into time, of a misplaced scientific impulse and a developed sense of relativism. His perceptions may be softened and nuanced in remarking that, for any epoch and for any previous epoch, 'plus un esprit préscientifique est inculte, plus grand est le problème qu'il choisit.'[26] Timeless individual perfectioning is not essentially preoccupied with questions of technique and detail at the expense of study. The arts and their dependencies have grace only in their infancy.

Half-a-Dozen Heresies Mainly Regarding Collections, Exhibitions, and Catalogues

I would first like to express my gratitude to the Executive of OAAG and particularly to Robert Swain for their invitation to speak in the context of the present workshop on collections, exhibitions, and catalogues. Those of you who already know me know also how delighted I am to deliver myself

of some irritating and even provocative remarks on the subject, and how much this is in keeping with my character.

In any case, we would not be assembled here unless we all sensed that things are not quite as they should be, a malaise reflected in a ground swell of recent literature whose implications we are today attempting to talk out. As a result, we can only begin to define, to isolate areas of concern and enunciate some ideas for testing against tomorrow's realities – some of which are already with us.

In selecting a title for this morning's discussion – and the number of heresies given is only an approximate one – you should keep in mind one fact that has guided me in treating this extremely complex topic. In briefest terms, it is that one must consider as an organic whole a number of things usually viewed as separable entities, inasmuch as these have, in the long view, intimate and often surprising relationships. These may be examined pragmatically as isolated issues; without their insertion into some larger historical perspective, however, our conclusions may prove quite worthless.

In this, I am mindful that the OAAG constituency comprises some seventy-nine members whose differing dates of foundation necessarily define the level of their individual problems. Thus it is that, from the forty-four Full Members,
- only two Ontario collections were established prior to 1900;
- four only being founded between 1900 and 1922;
- even as two collections were founded in the early 1940s and three in the mid 1950s;
- while sixteen were created between 1960 and 1969 (six in 1967 alone);
- and seventeen between 1970 and 1979 (nine in the period 1974–6).[27]

Of these, most are said to have contemporary collections while others are of a historical nature. As a result, I find it difficult to establish some consistent middle ground for discussing concerns when your membership runs from the National Gallery itself to the mandate exercised by the 'public library and art gallery' or even a 'national exhibition centre.'

In the remarks that follow I am naturally speaking as an 'outsider,' as one who is *not* aware of the internal problems of each institution. I, as must the

The oral nature of this address, delivered at the General Meeting of the Ontario Association of Art Galleries, McMaster University, Hamilton, 30 October 1980, has been respected in both content and emphasis. Upon its publication in article form (*RACAR* VIII [1981], pp. 137–52), an illustration of early date was added, while information giving rise to the text – which can still be read independent of them – was inserted as notes.

general public, form opinions and even judgments from tangible things – that is, from what can be known of individual and collective activity through what you produce. In this I am perhaps uniquely qualified to give a general picture since I come wearing three hats (which is perhaps better than having two faces), as

- someone who has created catalogues within and without Canada and who must use them, whose students use them within the university;
- someone who, as director of a special library devoted to catalogues, collects and classifies them, whatever their age or place of origin;
- someone who edits what I believe is the only journal of serious historical writing in the arts published in Canada – RACAR (*Revue d'art canadienne / Canadian Art Review*).

Now catalogues and other 'publications accompanying an exhibition' are notoriously difficult to evaluate without having them actually to hand. But I contend that we may examine in essentials the Canadian scene by assembling both an 'intensive' and a 'progressive' catalogue collection for your examination. Accordingly, you see before you as much of the catalogue production for the calendar year 1979 as could be brought together for this purpose by the McMaster and Hamilton art galleries. You also see virtually the entire production of the Agnes Etherington Art Centre during its near quarter-century of activity. Between these, we have models to examine *recent* trends everywhere as well as *developmental* trends within a given institution.

Why this particular emphasis? Because the catalogue is the residual product of an exhibition. We might then question the nature of the exhibition as a type of activity. According to the OED, it is 'to expose or show for amusement or instruction, or in a competition.' Such a definition, however comprehensive, says nothing terribly essential about the exhibition's function, which is, as they say, the name of the game. I much prefer the comments of a Swedish visitor to the Paris Salon of 1699: 'Although there is much that is indifferent, this spectacle [fig. 4] can only be grand, magnificent and useful for the spectator since one here sees, *together* in a single glance, things that ordinarily one only sees *separately*' [italics mine].[28] No lexicographer could provide a more basic definition than this of the exhibition's function – the *reunion* of art objects – a function *equally* applicable to the loan exhibition and to collections development from public monies to be held in public trust.

Curiously enough, until Michael Bell's thoughtful essay ('Canadian Galleries and Their Catalogues,' *Queen's Quarterly*, LXXXVI [Summer 1979], 254–63), there was little or no literature attempting to characterize this complex effort of production, publicity, and distribution. As an editor, I

Figure 4 Nicolas I Langlois, *The Salon of 1699*, detail from *L'Almanach Pour L'An de Grâce* M.D.C.C. (906 x 567 mm). First exhibition in the Louvre's Grande Galerie, showing temporary dividing wall at one end with dais, estrade, and throne, with a tapestry background for sculptures while the pictures are hung in registers, even in the window embrasures. BN Est. Qb 1 1699 (57 C 12848)

am pleased that his information came from *RACAR*'s initial survey of 'The Year's Exhibitions 1977' published in 1978. This repertory was the first of its kind and particularly serves smaller institutions whose publications could not otherwise be known for lack of opportunity and means. This listing has one important restriction: it voluntarily excludes all exhibitions simply *received* for circulation throughout the country and records only the *creative* effort that, to all intents and purposes, represents museum and gallery activity. It is therefore immaterial how many institutions profit from a given exhibition created by or for Canadians. What is at stake is the amount, the variety, and the level of activity involved

To put this production in perspective, we must first consider how institutions and individuals regard catalogues. As might be surmised, their needs are very different even if these can be in some way 'satisfied' by the same or related publications. In simplest terms, let us look at catalogues not from the point of view of those *producing* them, but of those who *acquire* them. (The designer necessarily plays an intermediary role in that he must work with what he is given!)

I recently asked a librarian of my acquaintance what she would do if a prospective donor confronted her with a possible gift of 10,000 exhibition catalogues, to which she replied that she would not faint but that she would surely scream. Her reaction did not significantly vary when the total was reduced to 5,000, 2,500, and so on until some critical point was reached, upon which she brightened up and said that she would *box* them. This, be it noted, is the essential problem of small formats in publication: they may measure as little as $\frac{1}{4}$ to $\frac{1}{2}$ inches thick, but this *physical* fact has nothing to do with their content or documentary worth. Most libraries treat catalogues as books (monographs), which they are not in any strict sense. Catalogues are for the most part paperbound, and so remain for a variety of reasons. Briefly, the catalogue is an *ephemera*, the bane of cataloguers and shelf-readers. Its fate is to be unbound, difficultly catalogued, and easily lost or misplaced. It has no high public *visibility* or image and, irony of ironies, requires, as any book, one catalogue card per item even though an unconscionable amount of work still results in a very small linear footage on the shelves. (To give you some idea of scale, my special library has some 15,000 temporary exhibition and permanent collection catalogues occupying some 550 linear feet; but we collect *only* catalogues and have created a system to permit their retrieval and consultation with the least effort, which is impossible for most other libraries.)

Now Canadian permanent collection catalogues, when they indeed exist,

Figure 5 Benjamin Zix, *Illumination of the Laocoon before the Napoleonic Court*, c. 1810–11. Drawing, 260 x 390 mm. An early example of a gallery or museum *nocturne*. Louvre, Cabinet des Dessins, Inv. 33406

fare no better than those of temporary exhibitions. For our purposes, however, I would like to introduce a terminological distinction borrowed from the French, where there is a difference between the 'permanent exhibition' and the 'permanent collection' – the first being what *remains on exhibit* from holdings (fig. 5), while the latter may largely be in the reserves. In either event, there remains an intent to exhibit whose practical application is, as often as not, predicated upon available wall space. Works of art are deemed suitable for 'viewing in given circumstances,' and they are selectively memorialized through publications.

However, the principal motivation of an exhibition is, after all, *not* the generation of documentation for future historians, even though this task is often retroactively assigned. It is rather to record some *momentary* interest that may or may not stand up in the light of history, and it is this interest that results in an exhibition. A good exhibition may demand a catalogue lest viewers go away unsatisfied, without what is in effect a memento; there are surely as many exhibitions whose main if not unique contribution (fig. 6) will have been to have put works *on view*.

We all know one solution to the catalogue dilemma, which is to mail out a bifold invitation that may include a hanging list.[29] However, these have no sense – and a low survival rate – once they have served their purpose as they cannot easily be dealt with. In practice, these become vertical-file material in art libraries: they are inserted, along with clippings, into artists' files when a one-man show is concerned. For group or thematic shows, they must be placed in some subject file and become untraceable by institutional origin. This seems rather important in view of the need for adequate institutional history, and I can provide ready proof of this.

Some years ago I commissioned for RACAR a listing of all exhibitions, with or without catalogue, of the Art Gallery of Toronto from 1906 to 1966, at which time a new name and a new phase of activity began.[30] Although there was little manifest enthusiasm at the administrative level for this project – at least until it was completed and accepted at the editorial level – it has since prompted queries from the Museum of Fine Arts in Boston in view of considering its own exhibition record. Now this list can be of real use only for the three oldest Canadian collections – the AGO, the National Gallery, and Montreal – but what was our surprise to discover, through adequate internal archives, the dates and themes of numerous unsuspected shows that fill gaps in our knowledge of what was seen in Toronto when exhibitions were presumably less frequent than they are now. (Of 802 shows, 408 were *without* catalogue.) Save for the obvious periods of the thirties and some of the war years, there is no real pattern in the distribution.

Figure 6 Paul Helleu, *Watteau Drawings*, c. 1900. Drypoint, 298 x 403 mm. The exhibition-goer as lone wolf rather than a social animal. BN Est. Ef 431 (87 C 130408)

My point is this: all exhibitions are *unique in moment*, but *serial* when seen in a longer time span. The programming of museum and gallery activities must concern itself with more than immediate issues. By this I mean that collections must have a sufficient sense of being and of history to decide what they wish to be remembered for – and what, as a result, they might be doing. The coming austerity may result in a more positive, a more thought-ful, approach to *activity*, which is, I stress, not merely *animation*. Should one be producing less but of better quality? Might one consider a wider *variety* of publication formats? Perhaps the present *definition* of art exhibitions is restrictive or, worse yet, misleading? Surely a balance must be struck between permanent collection building and the loan exhibition.

As concerns this last point, I submit that it is one of the more essential ones before us. Some *equilibrium* in public programs is expected by all, but this is not come by easily or regularly. One should not see only what is famil-iar, neither should one see only that for which one is quite unprepared. Should one not be cataloguing one's own works rather than the works of others? This is only a logical posit. Even the permanent collection may be 'rediscovered' through regroupment or selection for given purposes. It *is* constantly re-evaluated by varying the comparison group, and this is done – objectively done – through the loan or receipt of objects to and from other collections.

This is, moreover, a defensible philosophy for collections of any order and magnitude. The temporary exhibition is the discovery, the apprecia-tion, of *other* sensibilities. It is also likely to be more truly 'encyclopaedic' than any permanent collections (save those of world class) since it con-stantly shifts focus. From this I conclude that the nature of temporary ex-hibitions, their very subjects, must be *rethought* so as to take advantage of as yet untapped possibilities.

How then might we characterize *levels* of exhibition? Analogies with li-braries may be of some help in understanding different roles, which fall into roughly three interrelated categories:
- exhibitions originating research and themes (their equivalent being the research library);
- exhibitions disseminating these topics at other levels in order to arouse general interest (the special library);
- exhibitions responding to a public interest that has *become general*, which may be compared to the public library.

It should be noted that these 'levels of intent and performance' have nothing to do with national, provincial, municipal, or university affilia-tions as such. Such boundaries are, at least beyond an initial point of refer-

ence, misguided and arbitrary. If a vacuum is perceived, anyone is entitled to fill it according to his competence and means. But it is precisely here that preconceived ideas about exhibition concepts raise their ugly heads and restrict creative freedom. Conventional wisdom requires a classic name or subject for an exhibition concept. These are, by their maddening repetitiousness, the virtual death of the intellect. A corollary, that the duty of public galleries is to deal with contemporary art and artists, must also be brought into question. (After all, *their* names or subjects are by definition not classic!) These two roles are thus in real contradiction and we should clearly set out what is *involved in* rather than what *is said* about them.

There is a curious anomaly in all this: both historical and very contemporary exhibitions are *equally* foreign to the viewer's experience and require equal attention by creators and viewers; that is to say, 'on both sides of the catalogue.' The exhibitions mosaic has many levels, with one category directed toward the solo or group shows or the retrospective – even though the time authorizing a retrospective may seem indecently short to the historian, in which case it is called a five-year 'perspective.' One should know that many artists and students favour the one-man-show format, feeling as they do that a single painting or whatever does not sufficiently inform one of the artist's development, much less his approach to problems, to process. In this context the contemporary exhibition has a 'protohistorical' intent despite itself: a probe revealing an artist's state of mind and his technical means. At the same time, contemporary *experience* is assimilated so slowly – whatever its real or perceived worth – that it may be upsetting unless viewed with some detachment, through some filter. Perhaps for that reason many exhibition goers feel more secure when confronted with things no longer current.

What a pity, then, that Canadian exhibitions are as a rule too exclusively focused on the present, or even on the present from a certain area. As Bernard Berenson once wrote, 'the attempt of communities, big and little, to retain their own art creations, good and bad, great and small, for no better reason than that they were done by fellow countrymen or fellow townsmen long ago, is as narrowing, as self-immuring, as the rest of nationalism.'[31] In the light of older Italian art, he went on to suggest that it would have been better to have regularly 'exported' the finer artworks from point of origin so that all could benefit from them. This explicitly acknowledges the *comparative function* that the exhibition serves, for in due course the permanent collection becomes a historically based rather than a contemporary one – unless, of course, one sells off one's acquisitions each decade to finance those of the next.

One is therefore moved to wonder whether collections having a very re-

stricted appeal are not building on too narrow a basis for growth, much less survival. Galleries having small (or no significant) collections would accordingly run a higher risk in providing display space for the collections of others – of 'walls for other people's wallpaper.'[32] Were we to use the homely simile of the business office, these institutions might, through excessive reliance upon loan exhibitions, be likened to an office that purchased only expendable supplies rather than equipment that remains. Such activity is arguably incompatible with the role of a public trust in consuming time and monies but leaving no particular trace that justifies that activity.

You have by now sensed that I am leading up to something. I am. The exhibition as a phenomenon really begins only around 1760,[33] and was generally dependent upon professional associations or academies of the order of the Ontario Society of Artists or the Royal Canadian Academy. Rather like these, their success depended upon the enthusiasm and energies of members. What is more, such exhibitions did not invariably have catalogues. Indeed, throughout history, there have been more exhibitions that simply existed in some *available* space than exhibitions that left some verifiable record. How so? Because they were of short duration (one week to a month). No one really expected them to occur regularly, as we now do since 1945 or, more exactly, since around 1960. Outside the academies, exhibitions were highly circumstanced: artists exposed in their studios (fig. 7),[34] a group of artists exhibited in rented rooms or art fairs, or even in the equivalent of the commercial or parallel galleries of their day. These were all *events* because few in number, and they were to my knowledge almost invariably held at *one location* only. Public collections exhibited their holdings on a regular basis. Museums and galleries were built for specific collections (fig. 8) or in anticipation of a collection that could only grow with time. As a result they escaped the current tendency to relegate the permanent collection to less favoured (usually summer) moments in a full loan-exhibition schedule that, in turn, necessarily requires the *dismounting* of the permanent collection so that loans may be displayed in its place.

To anyone who lived through the Second World War – even through that brief and troubled period between the two Great Wars – the rise of exhibitions on some regular basis was the result of a critical and inescapable moment whose causes, one hopes, will not soon be repeated. Europe was then a great depot of *masterworks* often made homeless as a result of bombardments. Since they could 'be seen' again, since they were well known and catalogued, their circulation and/or reinstallation became a necessity well into the 1950s. Prior to the reorganization and

Figure 7 Abraham Bosse, *A Visit to the Sculptor's Studio*, 1642. Etching, 353 ×
325 mm. One notes a full repertory of speculative and commissioned sculp-
ture in wax, clay, and stone, including religious and mythological subjects,
architectural pieces, and coats-of-arms, statuettes, and their enlargements or
reductions. BN Est. Ed 30 (51 C 6941)

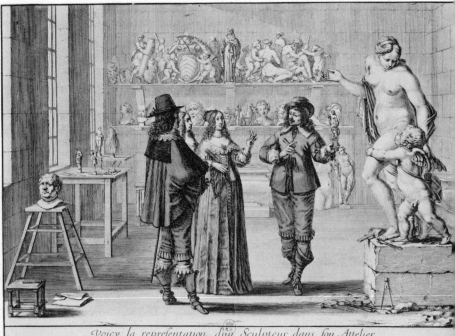

Figure 8 Christian G. Mechel and Philipp Gottfried Pintz, *Façade and Elevation of the Electoral Gallery at Düsseldorf*, 1776. View showing situation of pictures in a permanent installation, the smaller items having been mounted on the window shutters. BN Est. Ac 6 in -4° (76 C 78221)

rebuilding of museums and galleries, the itinerant exhibition was, as it should be, sufficient unto itself, not an intended money-maker for participating institutions or a cultural loss-leader for countries or political blocks. Whatever the then-existing diplomatic imperatives for reconstruction, the exhibition had not yet become a phenomenon risking the very existence of works of art in the guise of cultural identity as defined by artistic patrimony. There had not as yet been the proliferation of exhibition spaces, which must be kept filled and somehow functioning – presumably on the basis of someone else's activity. These transformations brought with them another change – the old 'guides to the exhibition' (handlists) became catalogues. With their development over the last two decades, the exhibition and its publications have become 'battered ornaments' whose lineage is to be found in the Vanity Press. Thereby hangs another tale.

An exhibition's catalogue is probably a narrowing rather than a liberalizing force, since it tries to *fix* the mirage that is the exhibition. It has become a symbol of cultural vitality and has taken on national production characteristics and often national preoccupations. It becomes a historical document of sorts, perhaps a historical statement, although the exhibition's public changes constantly – perhaps every five years – and could theoretically see the same exhibition at stated intervals with renewed pleasure and profit.

What, then, is the *regularity* with which institutions can originate or co-originate worthwhile, even first-rate exhibitions and catalogues? Here one might take issue with Michael Bell's otherwise excellent description of the excitement resulting from this activity within an institution. Such publications represent the largest unrefereed publishing effort in the world! They are *in-house* efforts with a presumably guaranteed purchase. We know also that they represent a major effort in personnel, in costing, production, and distribution. Given the prestige of catalogue production (which may sometimes be equated with cost), the *image* of the catalogue has doubtless become more important than its *usage*. It serves (and serves as) the *image of the institution*!

These are hard words but they are not uncharitable. It is understandable that institutions find it necessary to appeal to the vanity of their boards of trustees by producing something remarkable. It is however equally – and often painfully – obvious that catalogue writers and designers have but rarely put themselves in the position of anyone having to *use* them. Had they done so, at least the worst production aberrations could have been avoided, most notably:

- the indiscriminate use of coated paper (adding weight, thickness, and cost overruns);
- curious stylistic revivals in catalogue design that are but rarely more than cute or anachronistic;
- novelty formats (too long, too wide, with covers of inflatable plastic or forged steel, or yet of different grades of sandpaper riveted together);
- title-pages or catalogue spines lacking sufficient identification (name of institution, running dates, or even the year of exhibition);[35]
- poor production values of more- or less-subtle nature (poor editing or indifferent paper, casual proof-reading, insufficient margins and gluing, lack of pagination, and, most especially, poor layout).

This litany has nothing to do with *content*, unless all defects may be said to arise from insufficient lead time in conception and gestation. When, however, world production is surveyed, one begins to realize that catalogues are, on the whole, among the most poorly and most chaotically produced publications extant, unbindable and often unusable. One might think that the surest way to evaluate production would be to examine it materially. Yet this is not as decisive a method as might be thought, for no reference can be made to *historical developments* in the catalogue genre. And this, in turn, is only appreciable once we correct a basic misunderstanding as to the *nature* of the catalogue. It is not the accumulation of references or information alone; it is giving that information *tangible and intellectual form* within each entry and within the catalogue as a whole. This is done by placing the object in its context and interpreting it, so we must give a schematic history of catalogue evolution in order to know what a given catalogue or exhibition meant *for its time*.

The earliest exhibitions simply reunited artworks, numbering them so that they could be keyed to a simple handlist (fig. 9) giving author, subject, and perhaps some additional information. Descriptive details (dimensions, medium) were later added and, need I say, there were no illustrations. This method of handling art exhibitions continued through the 1930s in Paris, when there were first and second editions (*not* printings) and even 'provisional' and 'definitive' catalogue editions.[36]

This is possible only when the apparatus is simple; it permitted for nearly two hundred years the *last-minute addition* (or supplement) of artworks to the show. Once this format was abandoned (numbering by entry has been retained as numbered labels corresponding to the catalogue, which you know has nothing whatsoever to do with hanging order), once more extensive historical or critical notices were adopted, another problem resulted. That is that each object displayed necessarily had *unequal interest* and, as a result, unequal *possibilities for discussion*. Add to this any

Figure 9 Jean Dambrun, *August* or the *Salon du Louvre*, from the *Étrennes galantes des promenades et amusements de Paris et de ses Environs* (Paris: Boulanger, 1781). Engraving, 73 x 43 mm. The *livret* or handlist is shown available for purchase on the table at the entrance to the biennial exhibition, although admission was free. Exhibition critiques of all sorts were hawked outside the premises and were, as well, available from specialized booksellers. BN Est. Ef 71 (75 A 30799)

expectation of illustration (a frontispiece, plates at the back of the volume or as a plate volume) and you complicate design and production problems, often immeasurably. The move towards illustration *integrated within the text* has since 1945 or so simply compounded these problems. This has undoubtedly led to somewhat sterile distinctions between 'scholarly' and 'popular' catalogues. For my part I find this distinction difficult to comprehend beyond inquiring whether catalogues are meant to be regarded or consulted.

In most cases, neither criterion is wholly satisfied. However, emphasis on illustration has resulted in a more general criterion. One views the catalogue as much as or more than the exhibition itself! This becomes an important costing factor, particularly when it involves colour reproduction; but it is no less negligible when only black-and-white illustration is involved. I, for one, am not fully convinced that the public really is *mobile*, as has been held, unless the exhibition is held within some metropolitan or touristic circuit. One 'goes' to an exhibition, which means one thing in a small town and something else in a city. Once within the exhibition, it is usual to purchase a catalogue that may ornament one's bookshelves. If European precedent is any indication, an accumulation of catalogues is boxed up in cellars or attics and, at death, is put out to paper or inherited; in between, they may be disposed of at garage sales or recirculated as gifts. The point of this digression is that catalogue acquisition is rather more conditioned by *immediate availability* and can thus represent no reasoned or consistent acquisition. Many would add that a catalogue's cover represents some 90 per cent of potential attraction and that it should be thought of as indicating content even when the text lacks colour, or even illustration. A colder reasoning would simply say that a good cover and design are some indication of the *quality of production*. Still and all, appearances may be deceiving. Personal catalogue purchase, because of its erratic nature and limited quantity, escapes all the headaches of libraries, which are forced to obtain the national or foreign catalogue production sight unseen and regardless of quality.

We may then say without much fear of contradiction that, just as the choice of colour over black-and-white defines relative values, the appearance and the amount of catalogue illustration reveals different epochs. Colour is now viewed as a means of instilling interest, but it is not cost-efficient. Anyone who has taught appreciates the difficulty in double-screen projection of the mixing of black-and-white and colour slides – the first is too discreet and the second too distracting to be *seen equivalently*. What happens when one has a catalogue and 'has seen' the exhibition, or when one knows the catalogue only? In both cases, reproduction is some-

how equated with the original, even though we *know* that it cannot be the original in scale or texture. Colour adds another *dimension*, but does not of itself affect the strength or weakness of compositions whose essential configurations are better seen in the wide range of black and white tonalities. Even if the colour is *all wrong*, it commands attention because it is *there*. It might be remembered that the insistence on colour has gone hand in hand with colour-field painting, posters, and the like which originally encouraged its rise. Yet I suggest this is but a minor aspect of the real problem of illustration, which regards the collections from whence it comes.

It is scarcely realized that documentary photography is an art in itself: in black and white, for the cost of making high-quality colour transparencies for an entire collection is manifestly prohibitive as well as unnecessary. Yet photographs necessary for inventory and collections management are often generated only in respect of actual *demand*.[37] Any practising scholar usually measures the worth of the subject he is investigating in direct proportion to the number of new negatives taken, most usually at his expense. Yet it is instructive to note certain trends of the last decade as regards illustration. First came the small illustrations used as *visual footnotes* to catalogue prefaces and essays. Now grouped colour plates repeating black and white figures scattered throughout the text are upon us. Our concern might focus on the degree to which the mere availability of reproductive processes causes the needless proliferation of illustration as a more purely commercial vehicle, just as it may reduce the amount of new illustration because familiar negatives already exist. Unless compelling answers are forthcoming, I am tempted to say that this has already occurred – in much the same way that most periodical editors find it necessary to reduce by one-third illustration assembled by an author that serves no discernible purpose. As George Kubler has pointed out: 'When change is wanted, the public itself require(s) only improvement or extensions upon the actual product. Public demand recognizes only what exists, unlike the inventors and artists whose minds turn more upon future possibilities.'[38] We may transfer this idea to catalogues and exhibitions as 'the seriation of the known,' that is, of repeating in ever more complex manners formulae that once proved their worth. I submit with no particular humility that this expectation must change if the exhibition as an institutional phenomenon is to escape collapse by its own inertia.

How, then, are we to bridge the gap between object and spectator so as to give the public the presumed insights and knowledge of those who organized the exhibition? Again we may look to History for some ideas that have been forgotten in the press of things. In so doing, as Edgar Wind once

remarked in a footnote, one is left with the uncomfortable feeling that exhibitions are now set up so as to yield on scrutiny the 'desired' sense much as do tightly framed literary passages.[39] Yet none of this takes into account the amount of time that anyone *other* than a professional spends within an exhibition. It is my contention that many Canadian exhibitions are too tightly focused and repetitive to serve the general educated public; that for lack of means of comparison, visual literacy is actually declining. Nor am I alone in the uneasy sentiment that the public has perhaps been underestimated and overmanipulated. An exhibition is after all a social event (fig. 4) and the subject of mutual conversation. Yet one may well ask whether *yet another* one-man show chronicling an individual's exhaustion of all possibilities of thematic or format development serves this end. If the show is called 'didactic' then selection and interpretation are presumed to be impeccable, and the very order in which objects are perceived must be determined. Perhaps the aggressive and highly selective display of artworks reduces the artistic experience to something too structured, too direct, too simplistic, and, above all, too pretentious.

When looking at the full range of exhibition formats once current, we remark three basic types, the first of which was the simple *assemblage* of a number of objects having some roughly defined linkage. In a word, an interesting variety more resembling an album than a *catalogue raisonné*! Following this train of thought, one might cast a glance at two standard types of nineteenth-century exhibitions – the 'retrospective' and the many showings of 'masterpieces or treasures.'

The first of these, the 'amateur's retrospective,' has come down to us as the local or regional collectors' exhibition. At once a testimony of interest in the arts and a means of exchanging information, of forming opinions as to attribution, date, and quality, it recalls eighteenth-century tradition where the proper identification of a work of art was a major cultural service. (It still is.) As to the second, it doubtless stems from the great Manchester Exhibition of 1857 – with its six fat catalogues and 3,342 works of art of truly encyclopaedic range – a bench-mark in exhibition history not soon to be repeated. From it we have derived the idea of *exceptional quality* in the objects shown; hence the innumerable 'treasures' volumes, luxuriously produced albums drawn from permanent collections, albums depending upon the beauty of illustration. Yet 'treasures' surely means 'unique or outstanding in their place and time,' and this criterion should receive wider extension than it has. By definition, treasures are rather heterogeneous in nature, even if presuming some level of compatibility. It remains to find these objects and identify these levels.

Somewhere along the way, the 'treasures' concept was changed into the thematic or historical exhibition, both rather difficult to pull off adequately. Each of these terms defines a particular focus – the 'thematic' one being more general while the 'historical' one presumes some defined point of view about the past. One of the earliest of these is the Classicism show of 1846, featuring David and Ingres and reviewed by Baudelaire. All this is in marked difference to the type of historical show which, in the eighteenth century, simply exhibited objects under their owner's name, as *curiosities*.

In turn, we are led to the observation that the catalogue is no longer a fixed image of an exhibition that was created for a certain environment *and no other*. With the advent of the shared or itinerant exhibition (recalling that the International Exhibitions Foundation and many smaller institutions as well now create exhibitions *only* for circulation) the mounting of objects in spaces *not intended for them* results in abrupt changes in context and scale. Unexpected aspects may be revealed, so one must impress upon galleries and museums the necessity of proper installation shots as documents of institutional history and taste. These may complement or even supplant catalogues, but they do form part of a sufficient concern with internal archives that must everywhere prevail.

In sum, when an exhibition circulates, it is all the more important to have a good catalogue since the perception of the objects changes constantly. And *what*, you may add, *is* a good catalogue? *Whatever* it is, its real test is an ability to stand on its own over a period of time, to triumph over limitations inherent in its subject, or to surpass its author's deficiencies. A fine catalogue would still be remembered were its subject eventually to lead to a monograph or more extensive treatment, while its production values might, depending upon the case, be sufficient to interest the foreign market.

As to the public's 'experience' with catalogues, it may be said that the average Swede or Belgian, just as any Canadian, knows primarily *his own country's production*, and this perhaps only fractionally. No illusions are possible here: only the art professional or the scholar is concerned with continental or international production. This has necessarily different implications for Europe, given the smaller geographical area and, need one say, because of the multiple languages at one's disposal. But it is curious to note that Europe has more loan exhibitions 'from abroad' than Canada, so the question remains open as to whether one can and should rely upon only national resources. If, however, the answer is *primarily* to depend upon national artistic patrimony – in its widest sense – I dare say that a serious effort in collections building and propaganda is in order. This in turn

requires new dedication and new types of training and thinking within the art community. As previously mentioned, the small format has a place apart, an ambiguous role in publishing everywhere. But this format may range from the very modest to the rather complex. You are surely aware that, as of this funding year, the National Museums of Canada will have as condition that its assisted publications be *bilingual*. Because of the lack of sensitive translators, the results are sure to be horrendous, yet this is at base simply another variable in catalogue design peculiar to Belgium, Canada, and, perhaps, the Netherlands and Switzerland. Be it said, however, that these countries often produce multiple catalogues, or catalogues in the dominant language, and the public (particularly the foreign public) be damned. If only bilingualism were more intelligently approached: somehow the invariant reprinting of cited literature headed by *Bibliographie* while the letterpress has already appeared under *Bibliography* seems unjustified by any reasoning. What bilingualism may accomplish, which should not be forgotten, is the titling of objects in some conscious and regular fashion in the two main language groups so as to avoid casual or incorrect reference.

No, the surest way to good publications is to know *why* you are producing them and to determine their *level* of publication withal. Some of these are bound to be virtual throwaways, but they need not be unattractive. A hierarchy of involvement is implicit in this as in all publishing ventures. One must decide what is negotiable; in a word, what *could* be sacrificed and what *is* absolutely essential to preserve. The 'little publications' are like the various articles of an encyclopaedia – not just subjects arranged alphabetically, but showing some order and progression in human knowledge. Only *regular* catalogue production becomes second nature and avoids the pitfalls of the occasional publication. As to historical record, the rise and perfection of photomechanical means can only diversify and facilitate catalogue production. When properly set up, an electric typewriter can produce fine-quality publications once one takes into account the wide variety of paper and elements. For certain efforts, standard typewriter paper could be used for creating sheets destined for three-ring binders, thus facilitating preservation, consultation, and updating at modest cost.

For more sophisticated publications – those printed in some way – I dare say that the continuing problem is poor layout, where design does not advance understanding or pleasure but hinders it. Curiously enough, some exhibition catalogues more resemble dealer's catalogues or steamship menus than anything else. Designers' subtleties may be appreciated in some degree without, however, being able to define their qualities, and

we further know that *design* is itself subject to *fashion*: the catalogues of the 1920s and 1930s have a 'look' about them, just as do those of the 50s, 60s, and 70s, and as will those of the 80s. But it is to be hoped that there will be some discernible qualitative progression in the coming decade. (After all, if one were stopped dead by a poorly produced catalogue, the genre would have disappeared long ago.) There is an old saying that you can't tell a book by its cover. True enough. But a catalogue cover should tell you immediately whether to go farther because of a cover illustration – or title – that intrigues or repulses you. (In this context it is more important to have some strong feelings than any indifferent ones.) A cover illustration may be present for aesthetic or historical reasons, but its absence sets up no expectations; and this point might be considered in respect of art documentation, which is usually thought to be the result of *massive* illustration. I believe this is, once again, a 'future possibility syndrome' of those making a catalogue rather than looking back on it, as purchasers surely will. Within any historical or contemporary show, there is surely one work that is of the highest significance and quality. Perhaps it should appear on the cover, even be reproduced in colour (budget permitting), while the rest should depend upon a meditated text.

It thus appears – and this is crucial to our considerations today – that the catalogue must exist on many levels of sophistication. I particularly say this in the face of those curators and directors who look down their noses at the $200 or $500, the $1,000 or even the $5,000 exhibition. The state of health of a discipline is like that of a chain of being, as good as its weakest link. Without *feeder literature* making 'specific but limited' contributions, one can never progress into more complex spheres. I will go further: anyone who dismisses the good small exhibition may be sincere, but he is a fool. It is the level of *conception and execution* that makes the difference, not just the means.

The catalogue has its ultimate effect in the concentration of attention upon artistic patrimony as a whole. Upon publication it generates interest and stimulates 'finds' for years to come, enriching thereby the amount of artistic documentation available to all. In its consultation, one has a series of familiar patterns or configurations that might otherwise have to be seen within a limited time and, perhaps, crowded viewing conditions within the exhibition itself. Matter for comparison with as yet unknown or unidentified objects is provided. Yet there is no valid reason why one should not forgo in great measure the 'fine art' exhibition and catalogue for that of the 'cultural' exhibition incorporating art objects[40] which is now common in Europe. Within perhaps a generation or so, one would have

enough to work with at a scholarly level. Briefly said, the catalogue assures free and repeated access to an exhibition. Both the passage of time as well as the quite unpredictable intervals of time between consultations result in greater understanding since the catalogue is consulted *at leisure* and *at will*. There is no dearth of regional subjects that could regenerate local history and for which the catalogue is the least common denominator. I dare say that such effort is indispensable for an understanding of history and culture as exemplified by art.

A number of indispensable qualifiers must follow such a glowing call to arms: the exhibition concept must revolve around or converge toward artistic documentation. The catalogue must be well produced, which means well edited. Few of the public at large realize, and few professionals care to admit, that the exhibition is a *restrictive format*. In its purest form it deals with what is *on exhibition* and is therefore current; by extension, it becomes a publication to accompany an exhibition and often results in a book issued long after the show closes.

This brings us to another curious contradiction: a catalogue is issued for the exhibition even as it is supposed to record its 'results'! It therefore *anticipates* the fact. This perception led Georges Wildenstein to suggest in 1957 that the catalogue 'resulting' from an exhibition would most justify the expense of the whole enterprise were it issued after the exhibition closed and once all reasonable critical comment was in.[41] (This comment is only valid for a certain type of exhibition, to be sure.) Yet, as an editor, I am distressed by the lack of proper and serious critical attention given Canadian exhibitions once the journalists have suggested that the public flock to see them. If the art community were larger and less inbred, did it not suffer from professional shortfall as a result of rapid expansion between 1967 and 1977, I believe that catalogues might improve as a result of informed public comment. Whatever the time and energy expended in their creation, catalogue production remains a 'cottage industry' whose artisans have very different ideas of their craft. Otherwise put, they may not know it well if at all.

I hasten to add that a Guest Curator from the University is *not* the answer. On the whole, such a person writes as poorly as anyone else, and who among the permanent staff of a museum or gallery has not had to recast at critical moments the first (and perhaps only) catalogue of someone just finishing studies – for whom the splendidly edited result will provide rather misleading but impressive credentials for future employ? An exhibition catalogue is a very special brand of literature and, in general, most writers struggle so heroically with *content* that *form and expression* suffer.

262 / Cataloguing Theory

By this I mean that they seem incapable of taking an existing catalogue in hand and examining it to see whether its lessons are appropriate to affairs at hand.

Faced with this situation, I instituted a decade ago an exercise on catalogue evaluation within a seminar on bibliography, methodology, and historiography – since I observed that students at the fourth-year and even the MA level used this literature uncritically for reference purposes. They may be right in one thing: the catalogue *presents itself* as the most current, the most authorized statement on the subject once one excepts journal articles. (This may, but need not, be so.) As a result, students have been required to examine five catalogues – three in foreign language – in each of two topical groupings:
– an artist or group of artists;
– a theme or technique [stained glass, art conservation, the Bronze Age].
One of these assignments is given as a 10–15 minute oral presentation, and both critiques are written up in 5–7 pages with all apparatus, for submission. Grades are based upon material description of the catalogue and presentation of content, specific contribution to knowledge, as well as a guess as to the likely *historical position* of the catalogues discussed. Come seminar, the catalogues are fingered by all, much as we are doing today, to facilitate examination and comparison. I can assure you that comments are matter-of-fact and usually devastating. I can also assure you that catalogue literature is never again taken for granted.

There is admittedly one flaw in this exercise: it cannot be done without possessing many catalogues of all dates and from all over the world so that foreign-language capacity is incidentally brought to bear on a subject. There is one lacuna as well: students criticize without actually experiencing the *gestation* of a catalogue. This difficulty will be remedied in 1981/2 when a complementary seminar will be introduced, this time dealing with the development of exhibition concepts and supervised writing of entries, prefaces, and apparatus. I shudder to think of the preparation required, but I see no other solution to the problem than sensitizing people to the problematical aspects of catalogues – and *only then* to have them participate in catalogue writing. Time will tell. But grounding in research methods has to begin somewhere, sometime.

Certain catalogues are demonstrably successful, sought after. Others are eminently forgettable, while still others manifest the best intentions through deficient technique. What is important to the public who have seen an exhibition is that the catalogue not have a different spirit or direction; what is also important, if pressed, is that they confess that they are

buying fewer catalogues these days 'because of the expense.' One would like to be able to effect an *anatomy* of the more successful catalogues. In the end, one realizes that these have a peculiar aura that pervades – and sells. In sum, much depends upon what the public has come to know (and to expect) of an institution's catalogues *as a whole*, not necessarily of any *given* catalogue. Some exhibition organizers have adopted a recognizable *house style*; their publications are identifiable at ten paces and, whatever the subject, line up nicely on library shelves. Those of the Grand-Palais, Paris, and of the Cologne Museums come to mind, even though the latter are as unpleasant as the former are agreeable. In the battle for institutional image, one may lose individual battles yet gain the war by producing regularly, almost industrially. Other houses prefer to *number* their catalogues.[42] This assigns them a defined order of appearance and permits librarians to notice gaps in holdings not otherwise apparent. Some catalogues even give a listing of all prior catalogues, available or not, on the inside back cover, although this is practicable only for a restricted or specialized production. But such cases are decidedly in the minority, perhaps for the reason that both the public and the producing institutions consider the *catalogue of the moment* rather than catalogues past and future. Perhaps the best advice is to say that, lacking sufficient comparison, one must simply address the material and hope for the best.

In theory, this latter solution permits a variety of decisions giving variety to a gallery's catalogues, sometimes to the point of anarchy. In practice, it often results in a certain blandness or, worse yet, wild variations that have but little to do with their appropriateness to a given subject. But the day of recognition for the catalogue has doubtless arrived with the creation of the Alfred H. Barr, Jr Award for Museum Scholarship, founded this year by the College Art Association of America for the 'museum catalogue published during the penultimate year that is judged to have made the most exemplary contribution to knowledge.' Catalogues of public or private collections – or exhibitions – are also eligible. With them might come the Renaissance of the 'little publication.' And all its problems.

I should here like to insert a heartfelt plea for accessible handlists or summary illustrated catalogues of your permanent collections. The National Inventory Program (NIP) is *not* the answer:[43] $3,723,000 later, it has been discovered that information tendered by some 150 institutions over nine years is both unreliable and incompatible, as if 'Fine and Decorative Arts, History, Ethnology, Ornithology, and Archaeological Sites and Specimens' *ever* had anything to common. It also seems that this information is not for public access and that the 45 terminals of the NIP are intended as a means of collections management, that is, as *internal* records. It is safe to say that

the NIP might never have been considered a panacea had widespread and adequate permanent collections check-lists existed. Most of these since the nineteenth century were, by the way, written and printed by *private initiative* anyhow, which is rather depressing unless you happen to think, as I do, that this might be the normal state of affairs.[44] It follows that the NIP is a 'locations' device, provided you *know* what you want and someone has *described* it correctly. Like all software it presumes that information – in this case works of art – is somehow quantifiable and that adequate descriptive and, perhaps, scholarly research has already been done. What software may prevent is the putting together by anyone of disparate pieces of information to form something infinitely more complex and worthwhile. In this light, permanent collections and temporary exhibitions seem to converge towards a single purpose. And I am led to wonder aloud whether museum and gallery holdings are as well known *to each other*, to scholars, and to the public as might be thought.

Many older collections are worse catalogued (fig. 10) than those of more recent origin, and with more justification.[45] As a rule, temporary exhibitions are generated from gifts or bequests that have entered the collection on the pretext of commemorating a curator's activity or a benefactor's taste.[46] Still other collections have adopted another method, with varying results. There is something inherently touching about mounting a show containing a very minor work (even by a major artist) surrounded by better works from other collections, just as there is something basically honest in working with what one has and putting it in larger perspective through loans. In this light, perhaps the nature (and regularity) of institutional co-operation might be examined.

Precedents for this type of arrangement have existed for well over a decade, 'this' being to get the permanent collections on the exhibition circuit. One such understanding is to send part of Collection X to Collection Y, only to receive an exhibition in kind. This is important for two reasons:
– it permits everyone to see what the collections are and what their level is; and
– it stimulates restoration and cataloguing that are long overdue.
Concerted action among compatible collections should stimulate wider public interest while, as a result of a published catalogue, these collections could begin to exist to scholar and public alike. Why not form a consortium arrangement that might originate exhibitions based on works within a province or between provinces? To cite only one striking example, no less than eleven collections in the French provinces recently put on a show of eighty-five seventeenth–eighteenth-century French paintings.[47] Its catalogue has full-colour illustration and an agreeable text for around $20,

Figure 10 Benjamin Zix, *Dominique-Vivant Denon, Head of the Louvre, cataloguing Art Objects including Conquests from the Napoleonic Wars, 1811.* Drawing, 380 x 330 mm. An ideal view in its first version of three, prior to modification of details, notably the enlargement of the elephant and obelisk, and of chiaroscuro. Louvre, Cabinet des Dessins, Inv. 33404

followed by a black and white repertory and catalogue of artworks of that area of interest (even minor ones) represented in all eleven collections.

Naturally such older foundations have more in common (and more to draw upon) than most of their Canadian counterparts. But one must propagandize the permanent collections, drawing attention to the museums and galleries of Ontario and other provinces rather than to individual works from given collections. A catalogue of this type has greater potential for wide geographical appeal even as it spreads costs throughout many collections. It provides impetus for good and regular collecting and it might redress the present program imbalance favouring contemporary artists. If only one show of quality could be mounted every two or three years, the results one or two decades hence could be immeasurable. Of course, we are speaking of the setting up of mechanisms to favour a sure and almost inevitable progression over a period of time. It is understood that vast funding on a crisis basis is undesirable and would surely misfire; but there must be a sustained effort toward cataloguing and publicizing the permanent collections in many ways.

We might recapitulate as follows: institutional purchase (libraries, museums) represents relatively assured catalogue sales, while public interest may not always be assured. To acquire a catalogue means hearing about it, by word of mouth or by something in print, and *Quill and Quire* does not repertory anything having less than seventy-five pages! Some catalogue jobbers exist, usually adding up to 40 per cent for a service that consists largely of buying and distributing in bulk. (OAAG might itself take on some co-ordinating role in this line.) Yet all this seems a confession of inadequacy or lack of vitality on the part of acquisition librarians.

To fill this gap and reduce correspondence for individual transactions, Museum Exchange was instituted years ago and is rapidly degenerating as galleries discover that they are not getting equivalent exchange for their own production and are effectively subsidizing other institutions. Reliance upon this system has led to further impoverishment of funding for curatorial libraries. Should the system fail altogether, even significantly degenerate beyond present levels, it will have consequences far beyond the need for healthier budgets. Some of these are already apparent. One may receive multiple copies of catalogues from circulating exhibitions; permanent catalogues are not usually exchanged. This latter problem is entirely justifiable: permanent catalogues are large and expensive, so the deployment of personnel and funds over a period of time should be acknowledged and adequately recompensed. As a whole, Canadian production is of inferior quality to the English, German, and the French. But we must also acknowledge that we see the result of different traditions in funding cat-

alogue production over the years, that is to say, of experience, personnel, and organization. I for one would like to think that the strengthening of major art reference centres might result in better catalogues because of better research and familiarity with what has been produced. Two recent Ontario collection catalogues were immeasurably strengthened by research at the AGO and elsewhere, particularly by use of Canadian artists' reference files. One might accordingly query extensive reliance upon interviews and material description and insert some heavier research commitment in Canadian catalogues.

In any event the Museum Exchange program becomes rather problematical unless one knows what is *done* with the material received. Is it regularly kept for retrieval in reference or curatorial collections, thrown into closets, or distributed among personnel and friends? This seemingly impertinent question, for which precise answers could be forthcoming, leads to the whole issue of catalogue production in relation to the different museums and galleries. Is any *use* being made of them; can scholarly literature be *generated* from them, particularly in recently founded galleries? The realities must be faced: even over several decades it is unlikely that new libraries based on exhibition literature alone can render much service to themselves. One must build on established strength, with a continuity in tradition that can be extended into the future. Ontario is fortunate to have two major centres for art research, Ottawa and Toronto, the others, according to a National Library survey of 1978, being Montreal and Vancouver.[48] All these have, as well, the necessary general libraries to back up art research. Predominant strength is not simply domination but the recognition of the value of concentration in resources. I would recommend that curators everywhere discover the full range of documentation that exists on subjects of interest rather than contenting themselves with what is merely at hand.

In all this we must recall that the public is not and cannot be fascinated by *erudition*. Whether a catalogue entry has three or fifty-three references, or whether the catalogue itself has an extensive bibliography, is perhaps of no real use to them, although it is essential to the scholar.[49] No one wishes, moreover, to put out *multiple* catalogues where *one* would do, although the tabloid format (*Petit Journal*) at modest cost has enjoyed success since it costs little, is relatively portable, and can be pitched once its immediate interest has passed. But all catalogue producers should realize that their publications are of great potential interest to all and determine minimum production standards for *defined* purposes. (One of the most successful catalogues ever done – in 1929 – became a book that has since been reprinted

but whose text was the first proper descriptive labels for engravings.[50])
But I here speak as a connoisseur of catalogues, not as one examining the
gallery sales balance at the end of an exhibition. Otherwise put, your pub-
lic is more than a stone's throw away from your gallery, provided you wish
it thus.

None of us can predict exactly what will be retained by historical se-
lection in either permanent collection or exhibition activity. One thing
is sure: without catalogues, it will be impossible to *evaluate* that activ-
ity. So I submit that, if you have permanent collections, then the public
is owed a handlist at very least, perhaps more. (For that reason, a third
pile of catalogues is here exhibited, corresponding to Ontario only.) I dare
say that the roles of museums, public galleries, and the dealers – even
unto the non-profit or 'parallel' galleries – must also be re-examined to
see whether their assumed roles are indeed proper ones. In short, noth-
ing can ever match individual initiative (fig. 11) in seeking one's own
salvation.

I am also mindful of the fact that institutions exercising public man-
dates often have difficulty in advancing solutions to even the most press-
ing problems. After all, they are in common parlance thought to 'respond'
to public demand; yet to assume this passive role is exceedingly dangerous
for their collective and individual conscience and, doubtless, for their sur-
vival as art professionals. I should like to assure you that RACAR is willing
to put before the public the necessity of permanent catalogues, but that its
task would be made easier were OAAG and other professional associations
to manifest their concern in the form of resolutions to this effect. Whatever
the difference in vocabulary or avenue of approach, art professionals form
a community that should upon occasion act as one. Not upon impulse or
inspiration, for to originate is carefully, patiently, and understandingly to
combine.

In conclusion, I should like to feel part of a privileged generation – the
one that came to grips with basic custodial obligations and established a
firm foundation for its successors to work, and to work better. I can think
of no finer guide than the words of Hans Tietze in 1944:

To my way of thinking, research is not an autonomous realm within which
any problem, that of an artist of secondary interest included, can be allowed
to assume disproportionate importance. Such an attitude ... belongs to the
stage, now left behind, of economic abundance, and demands revision. In the
field of art history, as in others, a more planned economy seems unavoidable.
Each individual study should fit into a general pattern not drawn, to be sure,
by a 'leader' or by any other appointed or self-appointed agency, but estab-

Figure 11 Michel-Honoré Bounieu, *The Arts Bereft: Allegory on the Distressed Circumstances of the Musée Central des Arts (Louvre)*, inaugurated 23 Thermidor An II / 10 August 1793 and opened to the public 8 November following. Mezzotint, 505 x 373 mm. BN Est. Dc 19 (78 C 85916)

lished by a conscientious and responsible examination of the needs existing in the field of studies in question.[51]

Are we really sure to have made substantial progress towards this goal in the intervening thirty-five years? Come the year 2000, I dare say we would all like to look back to this workshop and know that something of worth began here because of a free exchange of different viewpoints regarding problems in common.

Describing a Work of Art

> ... quelque prompte que fût son imagination, elle ne devançait jamais son jugement.
> Mlle de Scudéry, *Le Grand Cyrus*

Proper descriptive style is the result of being able to 'collect one's thoughts,' the search for the most concise and telling formulation, the right verb. It is knowing when to say 'the forest edge' and not 'the edge of the forest.' It is compression for force, articulation for progression, and the maintenance of cadence, broken by the unexpected adjective or punctuation, for emphasis. Above all, it is *chastened* language.

Nowhere is this sense – innate to some, born of experience to all – more necessary than in describing a work of art, or contrasting several. Let us take as example a short passage from Panofsky's description of Bronzino's *'Exposure of Luxury'* in the National Gallery, London:

This description was of course made from memory because the picture had gone to France (whence the use of the past tense instead of the present). Vasari's statement is thus neither complete nor absolutely correct. He omits the figure of Time, again characterized by his wings and hourglass, he covers many details with the summary expression 'and other passions of love,' and finally he lists more figures than actually appear, for he speaks of Jest and Pleasure as well as of other Cupids. Never the less Vasari's description is quite good as far as it goes, and even his assertion that Pleasure and Jest were seen 'on one side' while Deceit and Jealousy were placed 'on the other,' unjustified though it is as a description of the compositional structure, can be defended when interpreted as relating to a contrast in meaning. Iconographically the picture does show the pleasure of love 'on the one hand' and its dangers and tortures 'on the other,' in such a way, however, that the pleasures are revealed as futile and fallacious advantages, whereas the dangers and tor-

tures are shown to be great and real evils. [*Studies in Iconology* (New York: Oxford University Press, 1939), p. 87]

Not a word is wasted. All the phrases fit; nothing is awry in the shifting context of historical and critical data, which are masterfully, seamlessly interwoven. Most readers would doubtless retain the quotation marks 'on one side' and 'on the other hand' as signs of emphasis by their evident parallel construction. Few will remark that the last pair *taken as a pair* describe a subtle compositional and iconographical relationship.

Few writers may hope to attain such economy of expression, such density. Rather like Rimbaud's 'la lampe de la famille rougissait l'une après l'autre les chambres voisines,' description must aim at concretizing, at the *fixing and objectivation* of impressions and data in some logical sequence. Better a granitic style with all its ruggedness than a wooden one, much less a style that is an indifferent jumbling together of stock phrases or currently fashionable terminology. *If you are impervious to style, at least be clear.*

Proper descriptions of works of art function rather like 'retaining walls' that keep in all that is essential while keeping out naïve or trivial impressions. A high level of phrasing is not usually something that comes in the heat of writing, or from writing against a deadline. More often one 'comes upon' the proper tone or sequence of thoughts when something is on one's mind and the mind is let loose to wander over a period of time. The more volatile thoughts can never be reconstructed in their essentials as easily thereafter, while they can be elaborated considerably if caught on the run.

One should, in reading about a work of art, never have the impression that only the proper nouns change while the terms of description are entirely interchangeable. The work is unique even within its genre or period, and must so appear. No work is a simple digest of what is known about a period or what one knows of other works by the artist. *Description in its highest sense tells one more than what one sees; it informs the reader how it is seen, and why.* The term is here restricted to incidental description rather than the catalogue entry that might have been supposed from the 'misleading' title of this section. The normal connotations of words must be combated lest their more fundamental sense be lost forever.

The 'afterthought' comes as the crowning achievement of thought as it is revealed through style; but it usually does not come unless or until the process is already engaged. As concerns description, it is more akin to 'polishing' one's sentence when a qualifier or minor rephrasing flashes through the mind – often somewhat later but without expected relation to what has been said or written. This 'brainstorming' process works like the lightning to which it has just been compared: a series of staccato and

272 / Cataloguing Theory

often quite unrelated comments or revisions to things past; mental proof-reading without benefit of text.

At this juncture, one finds the inability to discipline one's descriptions usually takes three levels:

1 the inadvertent use of filler, repeat phrases, passive constructions, or the first words that come to mind (*unconscious*; often revealing current or personal speech patterns);
2 indecision about the level of detail to be introduced at a given moment (*conscious*; usually cleared up once one has something to work with);
3 the time and effort required to revise the written work as a whole, balancing each part within a larger sequence (*manual*; must exist in combination with the will to persist on to the end).

While these factors are highly individual in nature (some people must do drafts, then correcting, others can compose at the typewriter, while still others are oriented to the word processor), they are all functions of thought, and thus of style. *The aim of description is a series of provisional conclusions or observations that, taken cumulatively, lead on to the general conclusion.* Any number of sentences could have served as conclusion to this section. This one does: you should have sensed its coming.

The *Catalogue Raisonné*

> La critique souvent n'est pas une science; c'est un métier, où il faut plus de santé que d'esprit, plus de travail que de capacité, plus d'habitude que de génie. Si elle vient d'un homme qui ait moins de discernement que de lecture, et qu'elle s'exerce sur de certains chapitres, elle corrompt et les lecteurs et l'écrivain.
>
> La Bruyère, *Des ouvrages de l'esprit*

This is no ordinary catalogue. It results from an abiding interest in an artist and the honest estimate of his art-historical stature. These, taken together, must demonstrably justify the inordinate effort and expense required for its creation. If these initial criteria be respected, its publication is thereafter of enormous help to anyone by its concentration 'in one place' of the reference corpus of an artist's entire work.

The *catalogue raisonné* is just that – reasoned – and serves three purposes:
– the establishment by critical means of an artistic oeuvre;
– enabling others to find what you could not;
– providing, through selection and discussion, elements likely to be of use to others working in the same general area and more than likely facing much the same problems.

The very definition of the *catalogue raisonné* addresses the dangerous but stimulating game of Attribution, which presumes a sure intuitive sense and rationale for making attributions. These may depend upon style or documentation, usually both. The *catalogue raisonné* requires a full explanation of method[52] just as it requires one to be honest about one's doubts and certainties. It is normally a piece of mature work undertaken individually so as to 'maintain control,' although in a larger sense it is also a collaborative or even a collective endeavour through its pursuance of scholarly contacts and the science of a particular generation or epoch.

Properly pursued, the *catalogue raisonné* eschews but cannot altogether avoid the temptations of commercial interests that feed into and on it. Its creation is dependent not so much upon difficulties inherent in the *size* of the oeuvre in question, but upon the *travel* required to locate and (repeatedly) compare a scattered oeuvre and to gain – in some cases, to win – *access* to private and even public collections.

The first of these difficulties is to some degree alleviated by the 'ready' availability of photographs and through insertions (scholarly queries) in the expected journals. Direct knowledge of the 'works arising' is supposed, but is not invariably the case. (Actually, once his reputation is established through the appearance of his *catalogue raisonné* or as a result of a steady stream of studies and articles on specific points, an author is often *sought out* for his expert opinion by the naïve, the hopeful, and the crassly interested.)

The second difficulty may involve a veritable spectrum of personal and institutional relations, research on and contacts with collateral relatives, cast-off mistresses, and other *ayants droit*, and the relative availability within one's own lifetime of certain types of documentation, whether in the public domain or not. Moreover, some artistic personalities may be deemed sufficiently within a national or institutional interest so as to give rise to a type of 'protectionism' regarding availability to other scholars and curators. While this may lead to wide discussion in specific instances (these things are hard to conceal but may flourish because of their very notoriety), such practices are rather less reprehensible if the Protector is actually *working* on the material rather than hatching it like the Phoenix.

It may be seen from this that the *catalogue raisonné* requires a certain type of practitioner for whom The Hunt is both the attraction and the satisfaction. While concentrating attention upon his subject, the very density of information required supposes the accomplished exercise of the most disparate types of research methodology. Some would say, not without reason, that the *catalogue raisonné* is Art History *en grand* in its balanced attention to each relevant component – stylistic aspects, iconographic analysis,

portrait identification, and all the sticky or rusted 'nuts and bolts' of prove-
nance and exhibition history whose elucidation is never easy. For this rea-
son, many people all too capable of doing the research for such catalogues
are temperamentally unsuited to putting them together coherently.

The *catalogue raisonné* accordingly follows no fashionable trends since its
raison d'être and the time required for its completion virtually preclude
any real profit from simple modishness. When one adds to this equation
the horrendous economic factors inherent in its publication and the great
personal discipline required to get it to the compositor (and to correct it), it
is surprising that this scholarly mainstay has not gone the way of all flesh.

The genre qua genre has doubtless been preserved *because* of its archaic
nature and the essentiality of its information, but it is becoming increas-
ingly rare. It is, after all, somewhat easier to put out exhibition catalogues
and coffee-table books because of their quite *unsystematic* nature. What has
happened is that the term Critical Catalogue has come into vogue, further
clouding the issue. Here the term Critical is a redundancy, an anglicism, or,
more likely, it is simply not realized that a critical catalogue may be selec-
tive while the *catalogue raisonné* is necessarily critical but just as necessar-
ily aims at completeness. (The worst presumption is that *any* catalogue is
critical and complete, which is simply not true despite its currency.) Were
these misapprehensions generally overcome, it is quite possible that Crit-
ical Catalogue could become the official English translation of the French
catalogue raisonné. Until then, the term and its cognates – catalogue, corpus,
Werkverzeichnis – continue to assume as many meanings as the catalogue
itself assumes forms.

Presentation of the *catalogue raisonné* is entirely dependent upon the date
of issue of the publication in conjunction with the level of funding and pro-
duction that characterize the work as a physical object. Even the quality of
paper informs the quality of reproduction fully as much as the reproduc-
tive process chosen. *It is best with a complete illustration in a format sufficient
to permit the works to be judged rather than simply identified*. This or any lesser
ambition is further costed through the length and complexity of the entries
and apparatus.

The whole question of scholarly apparatus must not only be faced, it
must be mastered, particularly when there is a question of Addenda/Sup-
plements. (For the exceptionally well-documented artist it may even be
possible to leave space for 'lost' or 'homeless' works.) But the most real
underlying concern is whether a *catalogue raisonné* can – or should – be put
into a single volume, whether as text and plates together, or as a text with
matching plate volume.

The 'unitary' approach is likely to be the least satisfactory for historical

artists. *Addenda* and *corrigenda*, if they appear at all, are likely to be printed only in the periodical literature unless they are sufficient to justify a substantial supplementary volume – which may by its very existence constitute an embarrassment. In contrast, the 'multiple volumes' approach has the distinct advantage that each succeeding volume permits a recapitulation of what has emerged since publication of all preceding volumes; the oeuvre is therefore considered within a single publication, albeit in several tomes and at specified intervals. The corresponding disadvantage of this mode of publication is that rising costs over the years may force abandonment of the project or considerable diminution in production standards unless the first volume proves a best-seller. Also, this latter method supposes a more sophisticated approach to the apparatus of a chronological ('development') catalogue obviously difficult of execution except through long familiarity with the research process and the artist being catalogued. After all, one must *begin publication* with the difficult and obscure origins of artists who were fortunate enough to emerge from the pack and became recognized, even recognizable to the point of setting other artists out on more or less honest careers as copyists, popularizers, or forgers.[53]

In the decision of apparatus and critical approach to entries it is wise to consult many *catalogues raisonnés* to see what most nearly approaches the problems occasioned by one's chosen artist. One must also examine reviews, *catalogues in hand*, to gain some further idea as to their perceived merits and failings in the eyes of other experts in the field. At this point it does not really matter that you know (or hope to know) the most about the subject; the issue is how well and succinctly it can be got across and how well your apparatus serves other, usually less-specialized readers. The order of rubrics may be varied[54] and more complex models proposed.[55] None of these may be useful in themselves, but their example provides insights that may result in an appropriate model for your own work.

The *catalogue raisonné* done as other than the *Liber Veritatis* of the artist himself is, not without reason, often considered as that part of Art History that serves as the 'research, development and validation bureaux of the art market,' particularly as concerns more modern painting, where 'dealers as either authors or publishers, or both, have a monopoly of all the most important and expensive artists – and at times even possess their archives.'[56] However, the 'critical difference' within this critical mass is that a fine *catalogue raisonné*, resplendent in its scholarly probity, necessarily *unsettles* even as it clarifies. A commercially oriented one resembles the sales list it likely is, and is further revealed in its effortless resolution of likely and even apparent difficulties.

In the evaluation of such works, one must take into account the likeli-

hood of ever being able to verify and weigh assertions not less than documentation for oneself. The *catalogue raisonné* may not restore to us all that an artist, were he also restored to us, would choose to accept as his work; for all its faults in human judgment and documentary *lacunae*, it is probably the next best thing. Even if redone, it remains a monument to scholarship and to the art that inspired it. It is always the point of departure for further work since its contents are, as has been charmingly put, 'hostages to Time.'

6 Cataloguing Practice

Catalogues: The Search for Form

> Since a superficial formal criticism never fathoms the depths of a work
> of art, it is one of the most dangerous agents in fomenting prejudice on
> a large scale. A work of art is good, not because it has structural features
> in common with others. It is good only on its own merits.
> Ulrich Middeldorf

The more complex a work of art or monument is, the more a descriptive act
is required. This act, which is an integral part of perception, begins with an
interested and concerned encounter, whether *in petto* for one's own benefit
or with the stated intention to 'work on something.' It is Taking Note –
a process of analysis and assessment that can pass through verbalization
and even into print. Even were it never put to use, it remains a type of
verification.

Description makes the work of art (and ideas concerning it) physically
present so that the image 'speaks out' rather than mumbling disconso-
lately. While it may seem 'reductive,' it is really a basic constituent of
the art work, a necessary one so that it becomes impossible to accept and
work on one's presumptions and prejudices. *It is the difference between being
physically present before an art work and mistaking one's own presence for that
of the work of art*. It is the difference between gazing on something as an
intellectual tourist and seeing things as part of a conscious creative act.

The work of art has things to say, but one must question it, listen to it
as well. If one Takes Note, the object may simply catch one's attention.
If, however, we work on an object about which we would otherwise care
little, we are obliged to involve ourselves against our wishes and often
against all reason. *This difference in concern is also the difference between art
appreciation and art history*. It is here applied to the cataloguing process,
which also must search for and create formal statements.

Description has a very fundamental function in any historical discussion. Yet it must be differentiated, perhaps even defined because it is now close to extinction. Possible exceptions to this rule are the *catalogue raisonné* and questions of connoisseurship that require objectivization of seemingly intangible observations if the attributions are to carry authority. Wölfflin and his successors being dead and buried, it is increasingly necessary to reconstitute the Art of Description.

Description is part of a preparatory process; it is not normally an end in itself because of the great effort and concentration required, and because of the inability of using pure description. It is necessary to convey in a few sentences the essentials rather than flowing along indistinctly for pages and pages. Good description is an art in itself and has a long literary tradition (*ekphrasis*) whose purpose is in the main to convey

– formal composition,
– iconographical concerns, and
– colour,

as opposed to mere technical (material) details that are a lesser part of the cataloguing process.

The Rise of Illustration has led to the Decline of Description to the point that about the only place one discovers the vestiges of description is in the better guidebooks and national monument inventories.

A further problem is the confusion, natural enough, between description *as taking note* and description *as the conveyance of visual and historical impressions in an orderly fashion*. Rather than trying to resurrect the work through maddening detail, good description *stands in place* of illustration – even were it available – so that one can visualize essentials. A fine guidebook can be used quite apart from as well as in the presence of the monument. It fixes the *characteristics and locations* with the greatest economy of words and precision; it presumes that one can see and recognize essentials from the indications given.

The core of the art-historical disciplines is the 'reading' of images, not of texts; but it is all too easy to think one is succeeding in this, doing it well, when one is not. Now the teacher brings people to the monument and sets the stage for a conversation in which he may play no part. This role is diametrically opposed to that of Education Departments in art galleries and museums that, by personal appearances before the work of art, foster only second-hand experience; they tell people what they are supposed to be seeing rather than helping them experience it directly. In this they have the easier role, for the University has to contend with two characterized reactions before the art work or its surrogates. Since its programs are neither entertainments nor casual excursions, one finds that:

1 students interest themselves in *facts and dates* (the bio-bibliographical approach once one adds readings); they then 'learn slides' rather than learning the monuments, rather like television commercials that gain their audience impact from their easy concepts and precise vagueness;
2 students are clueless, in a state of consternation, know that they are helpless before the monument because they have developed no historical context, no rules for developing a critical sense of sight.

The first approach is too specific and the second too random. Hence the concern for seminars once the survey courses are over and done with: these are *working situations* in which visual literacy can be challenged while historical skills are being developed. What seminars demand is a sense of motivation and some potential for visual literacy (not, by the way, necessarily a result of prior experience or training).

Motivation has two orientations. The first is bibliographical, which trusts what has been written before what one sees. The second is perceptual, but naïve. It is like the fly-trap hanging from the ceiling of the cottage: what touches sticks without any pattern; it is the infantile reaction of students in the lower schools, without order and discernment, but very aware of what is there. Both are physical rather than mental levels of perceptiveness, since nothing instils or asks for judgment. The one is passive, the other indiscriminately active. Both show what awaits the cataloguer as well.

Description is approached from various angles in the cataloguing process. Techniques of description represent a moment of truth through what catches the attention and what results from research. One fashions a catalogue entry – *materially*, through description of height and width, from top to bottom, left to right or foreground to background; *sequentially*, from factual description through provenance, literature, and exhibition history, and any commentary arising from these.

Sifting the evidence and finding the 'right place to start' (by no means uniform) leads to the computing of norms, standardization, and the creation of systems. Any catalogue entry is like a sentence or a sequence of sentences in a paragraph. A beginning and an end are supposed. The problem is to find the beginning.

Drafting a catalogue entry is like systematic reading that one reduces to essentials. Vigilance in response is required lest one fall into complacency and commonplaces. In the writing, one should have had sufficient leisure to *contemplate* what one is saying rather than trying to pick the intellectual bones of the victim, that is, the work of art. As in other forms of research, some initial choice is necessary as to where time is spent and what is likely to be formative rather than informative. In the writing or reading

of good catalogues one should have a sense of freshness and naturalness that suggests that the work has been enjoyable.

Once in possession of at least the obvious information, the cataloguer is advised and encouraged to look for the most appropriate terms to convey his observations. This requires ponderation. What word gives the best idea of form, colour, composition, even perception? Continuing the analogy of the properly constructed sentence, one must avoid gratuitous adjectives and adverbs. *These and other 'qualifiers' become simple filler, where a nice word or phrase replaces a missing thought.* This fault is usually more obvious within the concision of a catalogue entry than in other literary forms.

How does one acquire – or develop – a sense for the appropriate use of vocabulary in art history? First, one must enquire whether speech and writing habits have been established to the point that it is virtually impossible to change them. *Whatever the response, the danger is more likely to be in the current ('professional') jargon*, which is a self-made means of strangling freedom of mind and expression far more dangerous than any authoritarian' decrees.

In its use one has lost touch not only with all the richness and variety of traditional usage, of history, but with the living language itself. Yet jargon is excused, is said to be a shorthand (more likely a short circuit), an abbreviated notation that saves time because it is universal. This assertion is unproved and untenable. The proof is when it mixes indiscriminately various levels of communication through language (the street, courtroom, temple, and academy), restricting in the process not only the choice but the usage of vocabulary and syntax. *Art history needs good, sophisticated language to survive its own pretensions.* Language is our most important and sacred possession and ally. It is also the most abused and uncared for. It should be tended, shepherded along, not simply received.

Given limited space, the cataloguer should give himself lots of time for description. Through concentration, practice and many false starts, the right terms and even the right point of departure will be found. Description becomes easier with time and a knowledge of the routines – and there are moments of routine. To be avoided is *overapplication of routine* through which one is carried away so that cataloguing becomes a self-serving – and self-perpetuating – exercise.

Description as cataloguing is a craft to be learned. It is a mixture of frenetic activity and fastidious routine balanced out for each entry and over the catalogue as a whole. The tradition was established in the eighteenth century by the Basans, Gersaints, Huquiers, Joullains, and Rémys who are remembered in ways that do them historical injustice. Their work was

intended for momentary usage, not written as the reference books they clearly became and whose merits were early recognized:

La description analytique et méthodique des tableaux, faite avec la clarté et la précision requises, n'est pas une chose aussi facile, ni aussi indifférente, qu'on pourroit la croire, à n'en juger que par les catalogues ordinaires, qu'on publie communément pour les ventes des collections après le décès des possesseurs. La différence saillante qui se trouve, pour la rédaction, entre le commun de ces catalogues et ceux, qui ont été rédigés successivement à Paris par des connoisseurs instruits depuis une cinquantaine d'années, et qui sont si recherchés par les curieux, prouve déjà évidemment le contraire.[1]

Restricted' to paintings, prints, sculpture, *objets d'art et de curiosité* and all the cultural appurtenances of the day, early standards of cataloguing arose in the auction sale. These standards no longer apply with the rise of art literature and its interpenetration of genres. However, clear distinctions were already drawn between *levels* of cataloguing. This situation will *never* change with the years.

Beyond following good models, one should try in cataloguing to recollect what one did years ago; even then, memory fails and one must start from scratch today as one did yesterday. The result may be better, worse, or roughly the same, depending upon the quality of one's written and mental notes. *Cataloguing is only comprehensible in the long term: it cannot be well done in a complete vacuum by creating an entry from odds and ends, or from nothing at all*. A good cataloguer is someone who has thought and written much, not someone who does nothing but accumulate detail *and* catalogue it.

A word of warning. Cataloguing is one thing provided one has *full control* of the process down to and including the establishment of files (private research). It is quite another if one works from *inherited* materials, as Janson did with Lányi's notes for his Donatello monograph; given free rein in their use, he doubtless received clear indications of intent and at least partially formed but scrupulously established dossiers. It is the assorted *institutional* files that are likely to be treacherous to anyone given access to them.

Established over generations by anyone who happened to be available, institutional files must be viewed, reviewed, and systematized by competent hands. Much of what they hold will be perfectly useless, although they may occasionally establish an important link without quite knowing it. Scholars will find such dossiers of use only when the institutions themselves conscientiously and intelligently document all works as they come into the collection.

If only in its choice and amount of illustration, virtually any art-historical writing includes elements of cataloguing that are not formally designated as such. *It is their narrowness or, conversely, their breadth of focus that gives form to the argument*. Suppose it were possible to pull together all the illustration one needed, and even to publish it; would such illustration make – or carry – an argument?

The answer is clearly no. *Historical facts fail to convey the qualities of art just as reproduction fails to distinguish particularities of quality*. The question is whether one may learn more from a few works superbly commented or from a multitude that flit past the eyes and mind.

This is the age-old problem of the museum visitor or cultural tourist who is faced with the assimilation of too many different things within a short space of time, but whose memory is not up to it.[2] The rise of art books and catalogues is thought to have solved this problem through the provision of a type of artificial memory. But has it?

The answer, if there is one, depends greatly upon the context in which works of art are presented:

1 *An art history* is highly selective, dealing with the great currents, personalities, and monuments that can be seen and generally accepted; it is based on consensus relieved by a few personal idiosyncrasies or preferences.

2 *A monographic study* normally resembles an illustrated biography unless it is thematically oriented or accompanied by a catalogue; its illustration may be split between that concerning the artist and his times, and reproduction of the works themselves.

3 *A catalogue raisonné* presumes, in the words of Charles Yriarte, that 'la meilleure biographie d'un artiste c'est le catalogue de ses oeuvres.'[3]

4 *A permanent-collection catalogue* works with what it has, drawing to it other works of art; it has rather limited intellectual and creative freedom, compensated somewhat by its clarity of purpose (let's find all we can about our ...).

5 *An exhibition catalogue* necessarily concentrates everything that may be grouped around or applied to a single work of art; multiplied by the number of entries, it normally illustrates only the work catalogued while simply making reference to others.

6 *The article or note* has by far the greatest freedom – and risks – since its intent is precisely to escape the restrictions of the text, the monographic, and the catalogue formats; it juxtaposes quite unexpected things according to its purpose.

One must, therefore, distinguish a catalogue created for its own sake from catalogues that accompany in some way a piece of writing. *The one*

exists as the subject of research while the other is an adjunct that documents and supports the writing that precedes it. The first is likely to be complex (and illustrated) while the latter may be reduced to a simple list that merely informs readers of material rather than discussing it.

Whatever it may represent in its own right, a catalogue is (or should be) a *step forward* from all that went before, or a step *in a different direction* because of its approach to the subject. Recapitulation and repetition are always involved, so 'proof of scholarship' is to do this with the greatest possible clarity and economy in scholarly apparatus.

The reasons for undertaking a catalogue today are, perhaps, four in number, since one should

1 *replace* a catalogue long out of print and unavailable;
2 *revise* outdated, poor, or incomplete catalogues;
3 *correct and augment* existing catalogues (usually in one's files and through footnote asides until the *corrigenda* and *addenda* are both sufficient and substantial enough to justify putting out a 'new' work on the subject);
4 *create* catalogues on subjects never before treated or treated only incidentally.

Actually, there is a fifth and somewhat less avowable instance where one may

5 *preface* a catalogue in facsimile reprint and pocket the royalties incumbent upon one's name and serious work.

Depending upon whether one wishes to undertake a more inclusive historical context for works of art or to confine one's efforts to known and surviving works, certain options remain open to the researcher. As with other forms of art-historical writing, one

- may *treat* only works at hand (as with a private or public collection);
- may *consider* an oeuvre consisting of works recorded, but lost or destroyed, as well as those that survive;[4]
- may *establish* what once existed, as the reconstitution of old collections often dispersed through sale or sack;
- may *repertory*, aiming for a corpus from which all may work in greater detail and sophistication;
- *must study* any and all of the preceding in order to do intensive interpretation of a single work of art.[5]

Many an argument today is thought to stand or fall on the type and degree of relationship between text and image. Most readers do not question this 'adjusted reality' that is illustration. Although natural enough to the public, illustration somehow transforms over a time the perceptions of those within the field, most of whom have only 'seen illustrated' works of art that authors have, we trust, actually seen in order to write about them.

Why is this a matter of concern? Because, whether in black-and-white or in colour, no reproduction can actually give the work of art, while certain modern works relying on very fine and necessarily transitory optical effects are actually unable to be photographed as they are perceived. This observation is even more true when one deals with configuration rather than subject: who among us can really understand Abstract Expressionism *en noir et blanc*? The surrogate quality of illustration must always be reinforced by a text, but of what kind?

The surrogate quality of reproductions, for these only represent the work of art, may be defined in terms of what is a *reasonable expectation* of illustration and its accompanying text. Obviously neither can exist alone; nor can they, taken separately or together, be pushed or forced beyond certain limits that a good art historian recognizes. The problem is whether a longer text can sustain the reader's attention or becomes a hindrance and whether it informs, and is informed by, the work of art and its illustration.

As will be seen, this latter consideration is primary to the Illustrated Summary (General) Catalogue and implicit in the catalogue of a loan exhibition. We are brought back full circle to the purpose of cataloguing, which is to bring together information and illustration in some meaningful and permanent form that could otherwise never have any historical resonance.

In some cases illustration enables us to understand how earlier art historians worked before the advent of photography and reproductions.[6] At a slightly later date, the picture postcard assumed a scholarly importance scarcely imaginable today.[7] Such *aids* to private research and documentation were once received 'as they were issued' with the greatest of expectations and delight.[8] Useful to scholars of any age but particularly in their declining years, photographs represented a means of fixing and situating discussion as much as for identification, filing, and cross-reference.

Photography was – and remains – useful in establishing discourse or writing. *It 'introduced' originals to those who had never seen them, while for the professionals it decomposed and particularized monuments previously seen or known only in a general sense.* It recorded Romanesque capitals, Gothic stained glass, and *Schnitzaltare* that were too inaccessible, distant, or complex to delineate by other means, just as it permitted the whole-scale documentation of decorative and minor arts otherwise too many and too tedious of execution.

As a result, one should know or try to establish the *date* at which a photograph was taken since, whatever the reasons for its taking, it becomes a valuable bit of historical information. Moreover, it is probably not too much to say that our acceptance of methodologically situating details in a general view lies somewhere within the history of photography once the

principle is transferred to lantern-slides. Such demonstrations are not usually transferrable to publications without effort and imagination; simple economics and a certain insensitiveness of format and page layout usually quite undo the comparative intent of tightly woven expositions.[9]

Unfortunately, the sense of intellectual anticipation and control felt by Burckhardt has perhaps soured with the proliferation of 'mechanized after-images' that have formed the principal means of artistic dissemination since the turn of the century.[10] In compensation, the rise of technical laboratories and studies means that one no longer has to be content with a picture of the *surface* of a work of art.

One may now obtain under certain conditions X-ray and infrared photographs liable to shed light on individual points. The same is true with the 'in restoration' photographs showing a work of art in ruinous or deteriorated condition and therefore unexhibitable to the public. While such photographs may be stamped 'Exemplaire strictement réservé à la Documentation. Reproduction rigoureusement interdite' they are better than nothing. They are, if not available, at least consultable, to qualified researchers. Their reproduction, as a matter of right, is a different matter altogether; in certain conditions, rather than publish 'in restoration' photographs, the institution may choose to restore a work that has suffered only benign neglect.

In any event, most larger collections routinely establish photographic dossiers of all new acquisitions as they come in (indeed, as a condition of acquisition) and will necessarily establish them for works already accessioned as they are restored. The rise of Principal Acquisition / Promised Gifts publications and exhibitions can only accelerate photographic inventory so necessary to progress within the field, while expressions of interest from the outside hasten what should be done anyway. The history of art is the result of many chance collaborations, the timely intervention, and the specific query, the combined effects of which may preserve works of art from total destruction and even lead to public exhibition regardless of current taste. One never knows what chain of events will succeed the 'letter bomb' that is a request for photographs or information. This is all the more reason to send them.

Historical facts fail to convey the qualities of art just as reproduction fails to distinguish particularities of quality; Berenson commented on this dilemma some sixty years after his original work on Lotto, largely as a result of the great Lotto exhibition of 1953:

Some readers may ask: why this attempt to describe a picture, now that good illustrations reproduce it so well? No doubt, but the reader is too apt to take

in a reproduction at a glance, to extract from it a minimum of its quality –
and that confined to the treatment of the subject only – and to pass on to the
next. A description may serve to make the reader look more in detail now
that photographic reproduction permits it. I only wish I had the leisure and
allowed myself the space to describe more minutely, and to draw greater at-
tention to, the quality of each painting for its purely artistic as well as for its
illustrative content.[11]

Berenson's view is rooted in an understanding too often forgotten by writ-
ers: the strength of a catalogue entry (or any other text for that matter) is in
its point of view, not in the synthesis of others' opinions and all literature
up to that point. Texts accompanying reproductions must 'illustrate' the
work of art in purely artistic terms and in such a way that it becomes indi-
vidual, no matter how much general information is included. *The quality
of information is more important when there is less of it than can be included, not
when there is simply less of it to be had.*

A case in point is the Illustrated Summary Catalogue, which attempts
to present, usually in a single volume, the entire permanent collection for
general reference. It is intended to be used by anyone and gives only essen-
tial information supplemented by a reproduction of each and every work.
It tries to present rapidly and without complicated apparatus the collection
itself.

The success of such an endeavour is a question of design and of pro-
duction values that result in a catalogue whose cost represents a mini-
mal, or else a very major (and likely institutional) investment, since the
publication is more or less portable, paperbound, or in hard covers. Such
catalogues meet two requirements:

The visitor who does not happen to be a professional art historian may feel
the need of a means of quick reference when walking round the gallery ...

Secondly, the inclusion of photographs of every picture is intended to pro-
vide a quick means of identifying a reference to a given picture away from
the National Gallery.

In either case those who require a basis for prolonged and serious study
will need the separate volumes of the detailed catalogue, and the volumes of
reproductions on a larger scale.[12]

This means, in some instances, that the General Catalogue is a concise
version or abridgment of extant scholarly catalogues; in others, it becomes
the means to making more detailed catalogues once the collection's con-
tents become known.

The ease with which the Illustrated Summary (General) Catalogue can be issued exists in direct proportion to the number of art works involved, their range (period, media), and any incidental or fundamental problems of identification or attribution. One counts oneself fortunate to be able to rely upon the explanation of the *subject* (biblical, mythological, literary, or historical), the *sitter*, or some salient, that is to say *visible* detail (inscriptions, particularly in foreign or dead languages that are often identical to all public intents and purposes).

Such texts function in lieu of extended (explanatory) labels such as might be provided for loan exhibitions. Since these are given in book form and concern the permanent collection, their universality of application is assured only through their *remaining* summary. Many catalogues dispense entirely with 'explanations' and give only physical and historical information. So much depends upon the nature of the collection that the governing rule of General Catalogues is: the barest of factual information is both eternal and incontrovertible. Explanations will take care of themselves in other contexts.

One may well ask why institutions produce Illustrated Summary Catalogues in view of all these variables. Simply because they remain the most economical and efficient manner of making things known. This goes farther than giving the repertory, for illustration in this context provides the means of

- preliminary stylistic identification (so *that's* what a ... looks like)
- provisional estimates of quality (that's *so* much better than *our* ...)
- more precise knowledge of range (I didn't know ... did *that* sort of thing)
- recognizing rare iconographies or unusual treatments of commonplace ones (I've *never* seen a ... like that; what *is* he doing with it?)
- drawing attention to more contemporary artists (we might keep an eye on ... ; he seems worth looking into)
- constituting a repertory of historical artists (who's that? He's not in any of the usual books of reference)

While the last of the above-mentioned categories may be established from an unillustrated catalogue, its predecessors are initially entirely dependent upon reproductions. (When selective illustration must be made, one chooses the best or more representative from works by a single artist to stand for the whole; if all are given, they, like the catalogue entries, should appear in chronological order.)

All these purposes 'served by illustration' are as necessary for the combinative work of the professional as for the more limited needs of the public. Much depends upon how the reproductions are perceived, and that is a function of prior training and of purpose – that of authors and their

readers. This type of publication represents not only an artificial memory but also the artificial eye of the connoisseur or art historian: *it affects the 'good eye' that is merely physical, and the 'good inner eye' that is recognition and distinction as applied to art works.*

The Illustrated General (Complete) Catalogue is, still and all, a relatively recent phenomenon, not without its dangers for all its presumed benefits; it probably ceases to be 'summary' when it requires a dictionary stand for support, as do the Rijksmuseum and Uffizi catalogues of 1976 and 1979. But these are exceptions, for the reputation of a collection is not necessarily commensurate with the weight and dimensions of its catalogue. One might, however, query whether these are mere functions of the number and complexity of pieces repertoried, or the indirect results of design and production factors. They could, after all, be issued *without* illustrations. Since, however, the purpose of such catalogue-albums is to render accessible in one place the collection as a whole, they avoid distinguishing between works of art presented and those remaining in the reserves. *Once illustrated, they become, more surely than mere art books à la Malraux, true 'museums without walls.'*

Nothing is more deceptive as a genre than the Summary Catalogue, illustrated or not. It is as labour intensive as the 'scholarly catalogue' presumed to double it since the *preliminary work* is the same for both. It is just that the effort does not show. As Michel Laclotte once remarked: 'Aussi concis qu'en paraisse finalement le résultat, un travail tel que celui-ci suppose des efforts considérables tant pour la vérification systématique des données matérielles et historiques, supposées, souvent à tort, irréfutables, que pour des recherches de première main.'[13] One could have no better proof that the history of art proceeds from innumerable lists where art works are reduced to their bare physical and historical bones for examination. What seems at some question is the degree to which credit is desired (or can be given) for necessary work within the catalogue, since this investigation is basic to the understanding of the object.

Such credit is whole and unreserved if one *initials* a given entry within a collaborative publication; it is subsumed under a general preface in the case of an institutional publication *issued as such.* With catalogues by a single author there is usually no mistaking *who* is responsible for the entire content, whether technical or interpretive. Yet this responsibility has different implications depending on whether one deals with an exhibition catalogue or the fundamental data supplied by the permanent collection catalogue. In the former case we speak of an individual responsibility and in the second an institutional one represented by an individual or individuals.

This relative negation of self within an institution is a far cry from the curious phenomenon now surfacing with some free-lance or guest curators who are full of themselves. *These persons usually want the catalogue under their name, not that of the corporate body that has facilitated and published their work.* An 'added entry' is not enough, even though their names will in any case be found in the Author drawer of the public card catalogue. (Such aspirations are often frustrated through the provision of Library of Congress Cataloguing in Publication Data supplied on the verso of the title-page for mindless but efficient replication.) One suspects that the reasoning is that their work appears to be an independent brochure or plaquette, more visible than any article (although this presumes most institutions can handle the small formats) and somehow as worthy of attention as a monograph. What a difference between the exhibition catalogue, then, and the Louvre Catalogues, which may have authors but are entirely identifiable in their most recent reincarnations by purely generic descriptors.

Whatever the extent of their commentary, scholarly apparatus, or illustration, catalogues should be organized so that the *mode and intentionality* of their organization is clear. These are usually explained in a prefatory note but must be equally clear in essentials even when leafing through the publication. No misplaced concern with design must be permitted to frustrate the reader's desire to get at the information he desires as quickly and easily as possible. Catalogues are, as a result, organized along one of three systems, with

1 a by-the-numbers approach that presumes the keying of picture frames, display cases, and/or labels to the catalogue itself (usually appearing as a simple guide to the exhibition);
2 a chronological/developmental approach paralleled in both notices and illustrations (normally requiring an index and infinitely disconcerting for casual as opposed to scholarly usage);
3 the artists arranged *alphabetically* and illustrations arranged *chronologically* (presumes the use of running headings by artist at the top of each page, perhaps even cross-references to and from the plate/figure and its text).

While one may quibble about the appropriateness in given cases of one model over another, it must be remembered that the unitary nature of catalogues requires the *building of cross-references into the work as a whole*, where they co-ordinate for immediate purposes the text and its illustration. *No other form of scholarly writing works on such an assumption or requires such care if the work is to serve all who use it.*

The catalogue-as-reference-work is more easily understood with the collection than the exhibition catalogue. With this perception goes the ques-

tion of size and weight. One often wishes that the Nantes catalogue of 1913, created by Marcel Nicolle and still altogether remarkable, had left its impression on art institutions enamoured of coated papers and cumbersome formats. As Emile Dacier remarked in speaking of its scientific method,

Ce qui est vrai du fond ne l'est pas moins de la forme: tout a été minutieusement étudié, depuis le choix de caractères (un elzévir très net, malgré son très petit corps), jusqu'à celui du papier (un papier de riz très mince et très résistant) et du cartonnage en toile souple, en vue de faire de ce livre de plus de 700 pages, un ouvrage de bibliothèque, un instrument de travail le plus complet possible à l'intention des érudits, en même temps qu'un guide léger, maniable et bon marché à l'usage des visiteurs.[14]

This (unillustrated) and attractive format might still be used to advantage by collections with large and varied holdings. What remains to be explored in each case and country is the degree to which new printing and paper technologies – now reflected in the 13th edition (1982) of the *Chicago Manual* – are seen or felt to obviate other solutions.

Certainly word processing and computer typesetting have their advantages in the constant modification of order and last-minute insertions peculiar to the catalogue genre, whether in its creation or at the editing and production end. But it is in their ability technologically to *condition* material rapidly according to wish, thus giving an extraordinary variety of catalogue treatments to information possessed by a single art institution, that these processes should be looked to. Even the length of lines or the manner of their succession may be major factors in a catalogue's critical reception and utility.

This is only part of the larger problem, which remains open and highly subject to individual preference. Is it better first to issue an Unillustrated Summary Catalogue that permits everyone to work on an interim basis; that, into the bargain, becomes a *laboratory* for the more complex problems of illustrated catalogues of either summary or scholarly nature? After all, information itself becomes outdated or may be cast into better formats, while catalographic procedures (and habits) are subject to change, and profit from prior example. One learns from the errors of others as well as of oneself, although at different cost, and much can be derived from intellectual analysis of permanent collection catalogues produced from 1970 on – the period of major thrust of institutional publication in the history of art even if the plans for these works may date from earlier periods – or from vague and untested models.

Now it is easier by far to establish a plan for one's institutional catalogues than to divide up the history of art into something like the Pelican Histories. One simply examines the relative strengths and weaknesses of the collection *as it exists* and determines their distribution accordingly, keeping in mind the areas of greatest future strength in acquisition.

Some institutions go so far as to publish a chart of the plan of their scholarly catalogues (*Gegenstand vs Zeitraum*) that includes the relative chronology of such publications as have appeared or are under way.[15] This is possible when an exclusive model is followed throughout the course of publication, when it is issued only in paperbound format at an accessible price despite all the scholarship that has gone into its making, and when it is not meant to be a bibliophile's delight. This is a course open only to some levels of art institutions and is in any case a choice. Its opposite number is those collections that are willing and able to experiment with catalogue format. It is here that one notes the relative advantages of the summary catalogue (illustrated or not) over the unhurried and exhaustive scholarly model.

Now the summary catalogue of French painting issued by the Louvre in 1972 (supra, n. 13) not only incorporates information from previous 'modern' catalogues issued from 1958 to 1965, it served as a model for the illustrated summary catalogues that have since appeared of a portion of the French School (1974), the Flemish and Dutch Schools (1979), and Italy and Divers (1982) – the last of which announces an illustrated general catalogue of the French School that began the whole process.[16] The cataloguing effort was begun with the most consistent, most familiar, and most catalogued material (the 'National School' as one might expect) and worked outward. Yet, if each of these is presented as the 'exact continuateur' of the 1972 catalogue, there are still enough significant variations within the confines of the formula to demonstrate some rethinking of the model even as the pace of work quickened. It will be recalled that the illustration of summary catalogues aims at completeness rather than selectivity and that References are limited to the principal catalogues of the Louvre, usually at a minimum distance of some fifty years.

Thus it is that the French School of the seventeenth and eighteenth centuries has large illustrations with figure numbers (doubling the catalogue order) established by the surname of the artist, title, and inventory. The works themselves are placed in an ideal chronological order, and in an unusual but welcome deviation from practice, the plates precede the repertory itself. This catalogue follows the 1972 model in its information but uses shorter line lengths and typographical distinctions to facilitate scanning.

DIE WISSENSCHAFTLICHEN KATALOGE DES WALLRAF-RICHARTZ-MUSEUMS: 11 BÄNDE

GEGENSTAND	ZEITRAUM			
	bis 1550	1550—1800	19. Jh.	20. Jh.
Deutsche und niederländische Malerei	Altkölnische Malerei (in Vorbereitung)	Deutsche Malerei, erschienen 1973 als Band X	Gemälde des 19. Jahrhunderts, erschienen 1964 als Band I	Malerei des 20. Jahrhunderts, die älteren Generationen, erschienen 1974 als Band VII, die jüngeren Generationen, Band VIII, erscheint 1975
	Altdeutsche und altniederländische Malerei, erschienen 1969 als Band V	Niederländische Malerei, erschienen 1967 als Band III		
Malerei der romanischen Länder	Italienische, französische und spanische Gemälde, erschienen 1973 als Band VI			
Handzeichnungen	Ausgewählte Handzeichnungen, erschienen 1967 als Band IV			
Bildwerke				Bildwerke seit 1800, erschienen 1965 als Band II Ergänzungsband Bildwerke und Objekte, erschienen 1973 als Band IX

Eine Liste der Kataloge findet sich auf der Rückseite des Umschlags.

Figure 12 Schematic distribution of proposed collection catalogues, included in all scholarly collection catalogues of the Wallraf-Richartz-Museum, Cologne

The Flemish and Dutch volume cites foreign precedents in Europe and America (p. 8) as immediate motivation for the feeling that one could well fuse 'l'opération "catalogue" et l'opération "album photographique," éviter ainsi les aléas d'une double numérotation, et offrir à un public moderne friand d'"intégrales" et plus exigeant qu'autrefois des catalogues totalement illustrés et vraiment exhaustifs.' Illustration has thus been reduced to vignettes integrated within the text. These, about the size of large art stamps for collectors, are given by author and successive inventory number of an artist, as Gerard Dou, so that one has in one place – provided he has been correctly identified – the history of the Louvre's collecting of a given artist. Illustrations and their matching texts are organized in two columns, with cross-references to variances in the name of the artist.

As its immediate predecessor, only a page reference is possible with Italie et Divers as there is no catalogue numeration, the name of the artist and inventory number being the only retrieval unless one immediately recognizes the painting. Some attempt has been made to break away from the two-column layout and its rigidity, resulting in a somewhat confusing layout because horizontal division lines are no longer sufficient to maintain the grid. Since, however, it includes a supplement to the Flemish and Dutch catalogue (pp. 371–82), the catalogues are obviously intended to be placed together on the shelves.

Temporary (Loan) Exhibitions

The rise in the number of loan exhibitions has in recent years been rather phenomenal, their quality rather less. With them has come a number of problems that depend upon whether one is prompted, even minded, to do the work properly. Many catalogue entries are done by people who really do not know (or care) what they are doing. This, combined with the press of time, usually leads to *poor quality* – which is rather different than unevenness – in the entries and a superabundance of 'canned' or superficial statements.

Such is less likely to be the case when a single author *signs* the catalogue, as this normally indicates a research commitment of long standing. Curiously enough, there are very few *co-authored* catalogues; one has in their place catalogues with so many and so varied contributors that the editor becomes the author in all but name.

German terminology (*bearbeitet/herausgegeben von*) makes in theory a distinction between intellectual and purely editorial work; in reality, these

two tasks may be combined in the hands of a single person so as to impose real unity upon a diversity of parts. For catalogues, the former normally addresses the *arrangement of material so that it can be used*, presenting rather more facts or information for further purposes than highly conceptual matters. The latter deals with more factual preoccupations: the correctness of information, spelling, grammar and syntax, abbreviations, and such things as concern the internal economy of the work. Both are preparatory stages to formal editing processes necessary to publication.

Catalogue entries usually have a pronounced biographical, cultural, or documentary bent. *Beyond mere quality, much depends upon how rich the 'life of the work of art' has been before it entered public hands.* What were the terms of its creation, exhibition, and criticism; who were its owners and why? These factors are quite beyond individual control and form part of the forces – and accidents – of History that research tries to clarify.

When temporary-exhibition catalogues contribute little or nothing new and endlessly restate commonplaces at different levels for audiences of different sophistication, they are likely to be worth the money only for their pictures. They become a type of magazine concentrated upon art, an occasional publication rather than a monthly or quarterly. Far too many entries read like illustrated biography upon which are grafted the most elementary historical, stylistic, and descriptive elements – all of which betray low-level or inexperienced cataloguing efforts.

In the reading one should always enquire whether the entries seem to have been 'farmed out' or whether, even when assigned, they have been followed through and structured according to at least nominal models and themes. If only more cataloguers followed the example given in the first catalogue of recent times assigned to a curator from the provincial museums of France, where we read: 'Les notices du catalogue qui concernent les artistes et leurs oeuvres présentes à l'exposition, sont établies avec le souci de caractériser ceux-ci et celles-ci en fonction du sujet *France-Europe* plutôt que de fournir des renseignements élémentaires que l'on trouve facilement dans les dictionnaires.'[17]

Temporary-exhibition catalogues naturally differ in quality and kind, depending upon whether their entries come from the possessor institutions or are done by independent scholars. Moreover, *their quality will in large measure depend upon the evenness of quality of works selected and upon their adherence to a 'model entry' circulated to all contributors.* The first will determine what one has to work with and the level of the institution, while the second attempts to foresee at least immediate and common problems in catalogue notation and may have to be periodically revised. Any in-

stitution showing its own works can say what it will about them; in fact, it is likely that the information will have been sufficiently researched as to be the basis for the museum catalogue. However, such in-house cataloguing requires the greatest discipline lest one be uncritical (or biased) towards one's own objects. In such cases, 'keeping to the facts' is usually responsible only for sins of *omission*. For loan exhibitions drawn from all sides, the cataloguing effort is fraught with less apparent ethical considerations – even and especially when small concessions 'secure' a wished-for object.

One should be ever mindful that no exhibition can be completely and successfully realized in the face of rising insurance rates and often close calculations on the number of expected visitors upon which the show must be costed. Given a host of other variables – authorized movement of specific art works, timing of loan requests, institutional and diplomatic peccadilloes, the time necessary to receive, inspect, and set up the exhibition – it is not surprising that the time given over the catalogue production seems very minor indeed, almost an afterthought even if it is the one thing that fixes and commemorates a considerable collective effort.[18]

Only in an article or book may one range at will over all the material required for a 'thesis exhibition,' which is surely why more and more catalogues include comparative material and illustrations.[19] Given the unitary aspect of the classic catalogue – an illustration per work – one is effectively prevented from constructing arguments or theses beyond those that are implicit in the titling of the show. In essays and articles, in contrast, there are several, distinctly nuanced possibilities.

'The illustrations are not presented as art history; nor are they picture-book history. They are inseparable from the argument in the text, but do not so much illustrate the text as state the same argument in another medium. They use visual images as historical documents in their own right.'[20] Intended or not, the last sentence of this quotation aptly defines the role of illustration in exhibition catalogues not less than in the history of art itself. The work of art enters into historical study and, perhaps, History.

In many instances, illustration quite dispenses with *indifferent* explanatory texts as the knowledgeable reader's attention is arrested and he rushes to the particular of description and provenance that can be used – and well used – by everyone. This response is the ultimate lesson in humility for anyone writing exhibition catalogues. *The concepts the writer has evolved, the use(s) he intends, are sovereignly ignored by readers interested in the material for its own sake and for the ways they might employ it for their own use.* Facts concerning the work of art are the backbone of cataloguing effort;

in most instances they will be the only things of worth that the catalogue documents.

A word on catalogue introductions, which range from the sterile to the bombastic. These should be direct and readable, should give some idea *why* one has assembled the exhibition, and *what* has presumably been accomplished in its mounting. A properly written Introduction situates the problems, personalities, and approaches as would a good essay, with a thesis, exposition, and conclusion.

At the other end of the catalogue comes whatever scholarly apparatus is required by the subject. It is regrettable that most catalogues have nothing in the way of an index although the work itself may assume monographic proportions. Certainly the multiplicity and fragmentation of information inherent in the exhibition catalogue invite such a summary, and indexes may be the only way to gain control over essential information or to show influence through different media.[21] The 'cultural catalogue' that employs art is, curiously, more likely to be indexed than an 'art' catalogue.

Beyond the homage paid Committees and Lenders comes the one *complete and uniform research tool* of any exhibition catalogue, the Photographic Credits. These normally assume the form of a separate listing with cross-referencing by catalogue or plate number. In this form, the reader knows what photographs he can purchase, and from whom. Yet one too often discovers that sources are given for only a portion of the works illustrated and that it is maddeningly impossible through correspondence to locate a photograph shown but not acknowledged. Private collectors and the lesser collections usually must call in photographers because they lack their own facilities, so this matter must be looked to with more than the usual attention. Perhaps the better way would be to have the credit accompany each notice, but the economics of typesetting usually are against this solution. As in so many cases, one must recognize the problem.

Sooner or later one must face the fact that not even a corporate body, much less an individual, is likely to have a complete run of even the *current* catalogues. Early catalogues – those issued over the last fifty years or so – are in any case scarce because their press runs were limited to anticipated demand. They also tend to be fewer in number, since the loan exhibition had not received its present extension.

No one then envisioned the rapid development of art-historical studies based upon such ephemeral documentation; the very early catalogues concerning Symbolism, Surrealism, and Sezession are more collector's items than anything else. Many of the fine early 'catalogues of record' are wor-

thy of collection for their design as much as their content. But the *compe-tition* for them will normally be for the artists and monuments that have emerged from the Dust Mound of Art.

Some years ago it was rare to see exhibition catalogues listed with the antiquarian dealers; now they form staples or, at very least, filler in the ab-sence of a steady flow of monographic studies. It has always been difficult to assign values to exhibition catalogues except by *demand*, by which time it is often too late to secure them unless reprintings were anticipated from the start or facsimile reprintings have since become commercially feasible.[22]

Exhibition catalogues are desirable because they *seem* interesting or are *known* to be significant because often cited. More recent developments (the 'weighty' catalogue) make the choice somewhat easier in that their docu-mentary and intellectual pretenses are greater. *Yet most if not all work going into catalogues is lost, as are any corrections or revisions arising from them.* At present, one has to do a *précis* of a catalogue's contents in the absence of an index, while precious few blank pages are reserved these days for 'Notes' when costing particular catalogues.

Yet an analytical index is not entirely useful either. In the manifest im-possibility of gathering together scattered references to works of art in its pages, a single page of the catalogue might be reserved for a simple listing. This would work particularly well in the case of individual artists, whose works are listed by title and date and serve as a succinct Chronology that gives the biographical details. In larger catalogues this type of reduction is all the more necessary because of intervening commentary and apparatus, while it is common in dealer catalogues and catalogues of contemporary artists.

In its best format, such a listing should have the name of the institu-tion, catalogue, and running dates of the exhibition followed by the works. The whole page could then be photocopied and filed along with vertical file material for both individual and institutional use, whereas at present record is usually kept only of individual art works through notes.

Such a procedure would be of most use within the art institutions them-selves, facilitating the work of 'the next exhibition' by giving at a glance what was previously 'selected and seen' within a given context. For the Canadian scene, as doubtless for other national productions, it would per-mit a rapid and certainly a less bulky means of establishing the repertory of works already catalogued and pertinent to different areas of interest. It is also less costly in the long run for the service provided. But it is perhaps too simple and too effective to be widely adopted when one is struggling to get the catalogue together *from such lists.*

Permanent-Collection Catalogues

> Pedanterie ist ein Insektenauge, welches nur das nächste und
> kleinste unendlich vergrössert sieht, und nie viel, geschweige ein Ganzes
> übersehen kann.
> Wilhelm Waiblinger, *Tagebuch*

While sharing the same general assumptions and procedures as the temporary-exhibition catalogue, the permanent-collection catalogue differs from it in a number of important respects. It is the work of generations who, consciously or not, participate in the writing of an official and authoritative statement by which the Collection stands; that is, it treats only works of art in its own possession.

This statement becomes a reference book defining the institution and its holdings, not something that is purchased because of a merely topical interest. Stemming from many levels of incipient research, its findings lead to further research and refinement of observation; while it may *in part* be challenged through interpretations and articles on individual pieces, *as a whole it stands until revised*.

The permanent-collection catalogue defines the Collection and its many subcollections not less than the level at which they have been assembled. In its writing the problem is to escape an understandable microscopic focus upon a series of individual objects so as to place them in their appropriate historical context. The catalogue must be something more than the sum of its parts, it must re-present the collection as a more meaningful context for further activity. Indeed, its pages reveal changing concepts of quality, curatorial competence, and opportunity as much as changes in any living organism. Its publication is an obligation inherent in a public trust and normally assumes three different formats: 'Le type parfait de ce genre de travail est le catalogue raisonné, ouvrage à différencier formellement du guide ou de la description à l'usage des visiteurs.'[23]

The 'collection catalogue' should be as complete and unbiased a publication as possible if the ultimate interests of the institution are to be served. No decisions concerning attribution made by an internal committee alone will stand up 'from the outside' if they are manifestly self-serving, naïve, or wishful. Cataloguing effort is, then, a fundamental test of institutional integrity evidenced through its acquisition and research policies: the scope of the collection and its quality are perceptible at a glance through illustration and through the nature of commentary and documentation in the entries.

The singular advantage of a permanent collection is that the works are

always at hand. Whether on the walls or in the Reserves, *immediate reference* is possible while external criticism – with all the investigation and consultation it implies – is elaborated over the years. Reference is made to all levels of artistic literature, more especially the temporary exhibition catalogues that provide platforms for intensive discussion of particular works much as articles do for particular problems.

Sophisticated cataloguing effort, however, can only be built on years of opinion and information that 'settle down' into more defined patterns. This is true even for 'controversial' works that have been acquired far in advance of public, even of scholarly, interest and knowledge. Fine acquisitions stimulate research precisely because they can be explained only to a certain point and no further. How fine they *really* are is confirmed or denied by succeeding generations, but it is safe to say that any *category of objects* is likely to be studied only if some of its *better* representatives have previously entered museums and art galleries.

Among the many curious paradoxes characterizing the art world is the realization that art institutions, which are splendid acquisitors (and organizers of loan exhibitions), may for a time be somewhat less than dynamic in publishing their own collections; they may, as a result, depend upon visiting rather than resident curators to undertake this essential work and assume its responsibility thereafter.[24] This may as much indicate the state of knowledge in particular areas as a bill of health for the institution concerned. In any event, no one in his right mind would assert that all that can be known about an art object is known at the moment of its acquisition: *an acquisition provides the pretext for further investigation from the moment it satisfies the requirements for entry into a collection.* No one can say where additional information may come from, so it is necessary to undertake some form of publication, were it only the listing in greater or lesser detail of acquisitions forming part of the Annual Report. For institutions and administrative bodies of a certain *hauteur*, this may assume the form of a separate publication of occasional nature.[25] And most collections reserve the right of publishing detailed studies in their *Bulletins* which can form the basis for an entry in an eventual catalogue.

So it is that there is a fundamental difference between the first collection catalogue and the fifth or even the twenty-fifth. These represent different stages in the transformation of Registrar's/Curatorial files into public statements. Institutionally speaking, the collection catalogue presumes the renewal of generations each having different interests and competences. It is highly unlikely that the same person or *équipe* will have presided over all the collection catalogues; it were better that this did not happen, for there is a competitive factor in the selection of an author and the commitment of

resources presumed in this effort. Every catalogue may through its formal presentation and intrinsic quality serve as example for others in its field. Not even the greatest experts can write all the catalogues necessary in their field, but their (often contradictory) *opinions* form a necessary constituent of files that need to be completed and revised on a regular basis.

Generally speaking, a permanent catalogue may be arranged:
- by alphabetical order (artist's name);
- by period or chronological order of the works catalogued;
- by 'period' defined as the birth dates of the artists.

The first approach is everywhere appropriate as it answers the dual question: Who is represented / What is contained therein? The remaining approaches more likely correspond to rather extensive collections of first magnitude.[26]

The catalogue may be 'integrated' by making no distinctions between media (painting, sculpture, drawing, decorative arts) just as it may be divided according to these. It may be fully or only selectively illustrated, even unillustrated, but it must always be *fully indexed*. If it is several generations removed from the first collection catalogue, some form of Concordance may prove necessary. The collection may be treated as a whole or by subcollections; it may be of international or 'national' scope, however defined. It catalogues *what is there*.

There are few public collections consisting uniformly of masterpieces. However, their respective levels are recognized and acknowledged: there is a *qualité Louvre*, what one expects from the Cleveland and Metropolitan Museums, what one associates with the Hamburg Kunsthalle, and all that one would like to think of National Galleries everywhere. Some collections live in the past while others continually work towards the future. Not only do their names conjure up certain works and impressions, but these have in large measure been inculcated through their catalogues. The problem is with lesser institutions and the resources put at their disposal: in conditioning the type and level of acquisitions, one likewise determines the possibilities for their cataloguing.

There are basically two types of effort: 'extended' versus 'summary' cataloguing, the first of which concerns only what lends itself to *intensive and high-level* discussion so that the second becomes 'minimal' cataloguing. These categories only acknowledge inherent qualitative differences. One must respect whatever is in the collection, knowing that someone might be interested in it in future – a further incitation for prudence in acquisition policy. One 'does what one can' for the material without overstating the case; this is certain not as much as one *may wish* and is more likely much less than one *can do* for works and artists of more intrinsic interest.

Minimal cataloguing is reserved for materials of lesser individual interest, given their poor or indifferent quality or the fact that they are too dispersed among themselves. They accordingly form a body of only marginal interest or a necessary background for understanding works and personalities of greater importance.[27]

One of the more troublesome areas in the research of collections deals not with individual objects but with wholesale cataloguing effort undertaken outside the nominal authority of the institution. This activity most likely occurs with provincial and municipal collections and assumes the form of university theses. At its best it allows the author to consecrate a major and uninterrupted period of research and travel, although there is the corresponding danger that work will become so intensive as to lose sight of general issues likely to appear were the research done over an extended period of time. Yet it also has the potential for *undercutting* or even *transforming* the traditional responsibility of the curator to research his own collections. Or is it that the Curator has either an unrealistic view of what cataloguing entails or else has no scholarly ambitions that can be satisfied by basic custodial attention?

There are probably no general rules in answering this question, only specific cases and contexts. However, a generous attitude presumes that any work done is better than work left perennially undone. The 'difference' depends in any event upon the quality of the cataloguer and the problems occasioned by the collections, not the affiliation of the researcher. Most North American collections need never face the manifold copies and variants of famous works that grace numerous European collections created for historically different reasons. It is, however, equally true that 'more and very recent' works of art are bereft of basic biographical information, much less any literature of consequence permitting their insertion into even a tenuous historical context. Again, *one expects different levels of attainment when dealing with the first collection catalogue as opposed to the first catalogue in one, two, or five generations.*

Cataloguing must have a term. This means more than a printer's deadline or some commemorative date that must be observed. *It defines the place at which work stopped and from which further work begins.* This date is best set at the end of a calendar year although it may with equal reason be arbitrarily determined. It should always be the subject of a formal statement: it means that the documentation has been gathered and intellectual work has begun so as to make a coherent statement on the basis of available material.

A reminder on the distinction to be maintained between 'editions' and 'printings' of catalogues: the first presumes changes of a substantive na-

ture, while the second is simply a repeated press run. (It is always useful to include mention as to the press run of a permanent collection catalogue, whether or not each copy is numbered.) *What is surprising in view of their fundamental importance for the field is that there has been no concerted effort in facsimile reprints.* Many collection catalogues of the heroic period are such that they could be run off in a single volume for each institution; but only when there are *differences* or when 'catalographic' study *warrants* it. Others had in their day such high and persistent demand that they are really reprints with such minor revisions as result from the typesetting process and slight intercalations or additions. Rather than undertaking descriptive bibliography such as exists for historical and poetic texts where substantive questions arise, the art historian is concerned only with content, however wrong it may prove to be.

General counsel as to what might be placed in the Permanent Catalogue can only concern principles.[28] For specifics, words remain singularly mute and one must consult extant catalogues. *No one should create an ideal catalogue entry when one can consult real ones.* Only in this way can one take in and incorporate the lessons others have learned the hard way, by respecting the nature of their material.

If it addresses all the basic information of the temporary exhibition catalogue the Permanent Catalogue does so in an intellectually compact manner, since it is not issued against impossible deadlines. It is more meditated, it comes to grips with previous literature and theories on the works catalogued. Its form is likely to be more 'classic' because it serves as and must be used as a reference book.

More than any catalogue of a loan exhibition, the permanent-collection catalogue must address 'levels of quality' in similar classes of art objects held everywhere. As Kubler notes, the historical problem addressed is one wherein 'prime objects and replications denote principal inventions, and the entire system of replicas, reproductions, copies, reductions, transfers, and derivations, floating in the wake of an important work of art. The replica-mass resembles certain habits of popular speech, as when a phrase spoken upon the stage or in a film, and repeated in millions of utterances, becomes a part of the language of a generation and finally a dated cliché.'[29] This comprehensive view may be a painful, even an embarrassing process, but it is – or should be – an unavoidable obligation. Otherwise the works of art remain only artefacts that are collected, perhaps classified, and yet *laissés pour compte*. The most basic work has been effected, but has gone no further. Thus it is that the willingness and ability to confront the responsibility of comparison and examination of context – and to resolve it through the efforts of its own staff or outsiders – invariably defines the level of

the art institution. If not highly researched (or researchable for whatever reason), the Permanent Catalogue should at very least be an *accurate summary catalogue*. Its fundamental purpose is to 'publish' what is held in a collection.

While it is perhaps inevitable that many works of art have only been exhibited 'in house,' an ultimate test of collections policy is whether – and in what context – they have been exhibited and written on *elsewhere*. Even very provincial objects can be minor masterpieces, but these may not be recognized as such if no one puts them in a larger context. *They remain only isolated objects, not part of a continuum.*

Not all artworks are signed and dated, much less attributable to individuals. Many more can only be defined generically, by century, school, tendency, or type. In most cases, temporary-exhibition literature records the movement (and thus the 'life') of the object in its literal and figurative sense. It further serves as a warning against excessive exposure and in any case records where and how it was exhibited. The exhibition catalogue may well be the inadvertent laboratory analysis for works of art, as it forces researchers and cataloguers (who may *not* be identical insofar as their real functions go) to 'do something' in explaining the loans. The Permanent Catalogue, in utilizing and distilling prior literature, provides a thumb-nail sketch of the popularity of a work of art as well as an Early Warning System useful in determining conservation measures and further loans. This aspect was less of a problem when visitors came to see works of art on permanent display; it has since become a major preoccupation.

In whatever form or context, the act of cataloguing aims at describing works of art so that they become individually recognizable and identifiable in a historical and material way. This is to say that Description and Illustration are useful in case of theft, deterioration, or destruction of the work of art. While extreme, this rather unexpected definition of purpose shows that cataloguing may not be taken lightly. One never knows to what purpose one's information may be put when, for example, certain discussions of technique may be of especial use to forgers.

There have come to be a number of accepted components of the cataloguing process. Their order may vary within the entry, but their basic identifications – author, title, and date – provide shorthand reference to objects of all types and periods. These elements may be determined with varying accuracy and are derived from the work of art itself (internal evidence) as well as tangentially (adduced or external criticism). Their concerns may be listed and globally defined as follows:
– *Material description*: medium, dimensions, identifying marks such as possession stamps, inscriptions (signatures and dates), apposed elements

(labels on frames), and restoration history. These are the *most basic* descriptors. Every attempt should be made to employ precise and uniform terminology for most general comprehension.

– *Provenance*: possessors of the piece, given in chronological order from earliest mention, although one often begins with only the one or two most recent owners. Once completed by the Inventory/Accession Number for institutions where this is applicable, one can only complete this summary history by the discovery of prior owners.

– *Literature/references*: presumably of scholarly or informed public nature (reviews in newspapers and magazines) where art is discussed on its own merits rather than as a means of recording where it has been seen. May be merged with exhibitions.

– *Exhibitions*: a type of provenance concerning the accessibility of works of art, also given in chronological order, but whose texts may or may not be of scholarly nature.

– *Discussion*: the situation by internal and external evidence of the artist and his work in historical, aesthetic, and qualitative terms. Depending upon the sophistication of the catalogue and intent of research leading to it, the problem is one of common sense and balance. *Such entries are too often culled from dictionaries and accessible texts when they exist, failing which one is forced to do real research and original cataloguing.* The latter case most tests one's mettle and ingenuity.

– *Illustration*: a least common denominator presumably conferring immortality upon artworks, although it is more a question of the extent and size of reproductions and their articulation within the catalogue through a series of practical decisions than anything else.

The main thing is to assure that catalogue design sufficiently *separates and identifies* entries rather than running them together in a visually or intellectually confusing manner. Catalogue entries should be appreciable as such, should be visible and visibly separate. *Get a competent and sensitive designer lest well-ordered information lose its clarity through poor page layout.*

SOME INFORMATIONAL AND NOTATIONAL PROBLEMS

Although cataloguing seems to deal only with objectified and normalized information, nowhere is a fact less factual than in titles, dates, and dimensions. These can never be taken for granted and are often subject to revisions that range from the niggling and negligible to retitlings that fundamentally alter our perceptions about not only the artwork, but its creator as well.[30] One might, then, consider some problems attendant upon these three classes of information even if most cataloguers probably will never have to touch upon their thornier aspects over the years.

With the possible exception of prints, most works of art lack materially incorporated titles and must therefore *be assigned* names. *Historical titles* come down to us through the artist (contracts and correspondence with patrons and friends), by sales, collection, or exhibition catalogues, and in inventories of all types. *Modern titles* are usually from the artist or his dealer; they are confirmed or contradicted in internal records and catalogues done with or without the artist's collaboration. (Much depends upon his present reputation and his own care in titling and recording his works.) *All titles* are of varying reliability, depending upon the epoch at which they appear or the care with which they were thought out.

Titles are of several types, all with a *presumed iconographic basis* that contributes in some way to a level of certainty in identification. These, from the most certain to the most problematic, are usually distinguished by typographic means:

1 generally accepted titles are normally italicized (*underscored* in the typescript) as books would be;

2 attributed or controversial titles normally appear 'in quotes' to indicate their tentative nature. One may propose a name change by the use of 'cues' such as: here considered a ———, with the title underscored as any secure one would be.

Proposing a new title is a slow affair that depends on evidence unearthed by the research process. When one no longer knows where or how to contact the artist, one follows backwards any provenance, exhibitions, or criticism already known.

Retitling is almost as important an event as the reattribution of an artwork from one artist or school to another. It is more easily accepted when the results justify the time and effort. It may be quite some time before art institutions consent to modifications although they may be current or long accepted in scholarly circles. The work may for some time retain its traditional name, with the new one in brackets, appearing as an *alias*, or continually relegated to discussion under the appropriate catalogue entry. Then it is a question of whether the new findings are accepted and with what rapidity they are taken over into the scholarly literature.

From time to time a *catalogue raisonné* lends its force of authority to titling. Such cannot, of course, be the case for most artworks. They never lend themselves to this level of treatment, or can never be investigated as a corpus within a reasonable amount of time. *The 'research advantage' of the unitary system implicit in the catalogue is that one perceives individual problems and can address them directly.*

A related and little thought-of problem is that of titles in translation. This might be said to have become more problematic with the international

commerce. In reality, it is somewhat less of a problem when smaller institutions collect only national production while larger ones have sophisticated and multilingual staffs. None the less, translation is not so much a matter of linguistic sensitivity per se as its application to problems inherent in 'descriptive' and 'allusive' titles.

Titles since around 1900 seem to be more factual and less obviously misleading even though their 'iconographic component' is weakened. One cannot, for example, gain a fair idea of what

Aquarell mit Strich
Komposition 7

actually look like without benefit of illustration, perhaps even of colour reproduction, as would be required with

Yellow, Orange, Red on Orange

We are no better off with other tendencies and movements in analysing and translating

Caoutchouc
Objet désagréable à jeter
Le Roi et la Reine traversés par des Nus en vitesse

We seem to have some concrete indications of motif, style, or composition in such titles as

Tête cubiste
Torse
Philodendron vor rotem Grund

and will be baffled by *Untitled*, whether alone or in number.[31] Even compositions defined by their episode or protagonists present some of the same problems. For example, is it a *Sacrifice of Abraham* or a *Sacrifice of Isaac*? A brief identification of the characters may once have sufficed to situate the action or ethic for contemporaries, but this quite fails the modern viewer who was never raised on a diet of classical mythology and history.[32]

Regardless of epoch, then, titles and subjects of works of art often have little in common and less that is tangible. Even if they do, they cannot transmit – or transmit only with varying degrees of accuracy – how they appear to the viewer, not in the artist's intent. *Illustration's role is to affix an image to a choice of words – the title – so that the two are bonded.* A photograph in the curatorial files and a reproduction in a catalogue satisfy the same

purpose: identification and some suggestion of possible interpenetration of *title, meaning, and visual image.*

However much this may be denied or consciously subverted, as with Duchamp, Magritte, Pollock, or Rothko, these three levels are somehow indissociable in fact. *Titling is the restitution of the profound contemporary basis for discussion and criticism once it has become history.* In the case of applied and decorative arts, titling may be a terminological description based on usage or function.[33] It is no less a problem because it deals with *classes of objects* rather than something of inherent or presumed uniqueness.

A fundamental difference exists between works that are (signed and) dated and those for which only a range of dates or approximation thereof is possible. By analogy, it is one thing if one catalogues for the permanent collection a body of work by a single artist and another if one catalogues many works by many different artists.

In the first instance, it will be possible to familiarize oneself thoroughly with process and development, most likely resulting in the assignment of dates where they are missing, which might, moreover, result in the assigning of an order of precedence among several works from a given year or years when other evidence is lacking. In the second, one will have to research a wider range of art in order to do the most elementary cataloguing.

One proceeds naturally from what is most to what is least evident, that is, from the dated works. But some art is created, modified, or completed over a longer period of time, perhaps even revised after many years have passed. It is here that the use of conventional signs and abbreviations (provided they are generally understood for what they are) enters in.

– *fl.* (*floruit*/active): all one can discover is a year or years of activity; must be distinguished from Known, which means simply lived.
– *c.* (*circa*/about): precise to a certain point, but no further; may be used in dating art in the same way that biographical information is given when either the birth or death date is unknown while the other is secure.
– period designations: generally attributable (18th c.), but non-specific thereafter; may be assigned a specific range of implied dates through stylistic appellations, as when a Cubist work determines the *terminus post* or *ante quem.*
– dates separated by a hyphen (-) [sometimes an en dash –] or a solidus (/): the first indicates a consistent working period; the second, work that can be situated between the terminal dates.
– dates separated by (and) or (or): the first documents two different, known campaigns; the second, campaigns identifiable with one *or* the other date.

– date followed by (?): the traditional mode of indicating a date to the best of one's knowledge.

Some of these designations can be determined only through very specific research, and only then if the information required is accessible and organized. Others are likely to result more from a sense for the object and for period style and its possibilities, i.e. through direct study. In the absence of documentary information, the latter mode concerns attributions and influences inferred from wide experience with works of art. In like manner, such phrases as

– Attributed/Ascribed to
– After
– School of
– Manner of

are only so many ways of nuancing doubt in the most favourable light. The most telling examples are given in the keys to terminology in sales catalogues, where ingenuity is never lacking in way to suggest *Rubens* to the naïve and unwary.

Dimensions in our day are usually taken uniformly height before width. Like bibliographical data, the important thing is that they be taken – and given – as uniformly as possible. One may wish to use millimetres for drawings and prints and centimetres for paintings as inherently appropriate to manifest differences in scale, but one will not mix systems within a catalogue.

Distinctions must sometimes be made that indicate to the reader the accuracy that was possible to measure, or which is inherent in different types of objects. Sculpture, for example, comprises *three* dimensions: height before width before depth. Prints may be measured by the image (if bordered), by the composition (if the border is lacking), by the plate or stone mark (if an engraving or lithograph, and if preserved on the sheet).

Two-dimensional works of art of regular or irregular shape are usually measured by their *maximal* dimensions. Occasionally, special conditions obtain that make this measurement either impossible or undesirable, for circular objects can only be given a *diameter*. In other instances, dimensions may be followed by parentheses, i.e.

– (sight) – that which is visible, usually employed when the work cannot be unframed;
– (framed) – when the surround is deemed an integral part of the work, not an adjunct.

A further indication of *relative dimension* was once included in many older catalogues but has since passed into history. This comprised a general calculation based upon the size of the figure if a sculpture, and the

size of figures if a painting. It was usually indicated in supplementary abbreviations as:
- gr. nat. (grandeur nature)
- $\frac{1}{2}$, $\frac{1}{3}$, $\frac{1}{4}$ nat.

Such a calculation is applicable only to a certain type of historical painting and antedates the more widespread use of photographic illustration. However, it is still one of the best indicators of relative size when reading a catalogue and remains of greatest utility for the scholar who uses such information for his own purposes. Most readers, however, have great difficulty in determining scale from measurements alone beyond a general impression of verticality or horizontality.

Lest cataloguers become too dogmatic in their proclamations concerning uniform descriptive standards, whether national or international,[34] it is well to recall that earlier centuries often *reversed* the order of height and width for pictures and engravings, and with reason. This phenomenon is amply documented both in the Salon *livrets* and in eighteenth-century sales catalogues, with the measurements usually followed by '*en largeur ... en hauteur,*' although there are many cases where one is left to one's own devices in determining the orientation of a painting stated to be '*environ 4 pieds sur 5.*'

While with painting such a description might be attributable to the necessities of placement on walls, above doors, and between windows, there is a more natural and incontrovertible logic when it is applied to prints. *Once prints are removed from a portfolio it is impossible to hold them by top and bottom since arms do not function in that way.* Our present assumptions of measurement suppose matting, framing, and hanging on walls; once prints are back in their Solander boxes, they are never handled by top and bottom either, and one returns to the older, more comfortable ways.

Yet another way of 'measuring' prints (retained by Le Blanc) results from *uniform paper size.* This uniformity was an influence from the book trade, not only for illustrations but as the result of the constitution of bound reference albums that had to be stored vertically. For those familiar with this system, it is virtually infallible as the most rapid indication of format. It is not likely to mean much today when the average reader may perhaps have seen a proper folio volume in his lifetime but has little idea of the book trade and the difference between the quarto, octavo, and smaller formats that are all around him.

The taking of dimensions is always a function of what is possible, and then its refinement. Common sense is always functional. It helps to make the distinction between levels of description required for registration (internal) purposes and for publication.

VISITORS, GUIDES, AND INSTALLATION SHOTS

What is the role of art publications; what are art publications within the museum or gallery? Certainly not just a series of press releases for exhibitions and activities, nor yet just a 'printing job' to be done by a certain deadline. There is always a vast and generally invisible infrastructure of work and of the staff and time needed to do it. But to what purpose, to what end, the permanent catalogue?

Perhaps its most generous definition is 'a compendious register of the works of art existing in our public and private galleries, affording easy reference to names, dates, and subjects, with just so much of explanation, illustration, and criticism, as might stimulate the curiosity and direct the taste of the reader, without exactly assuming to gratify the first or dictate to the last.'[35] *In simplest terms, the art institution is caught between competition for the public's attention and public expectation.*

Provided one can know the latter, must it be satisfied blindly, consciously, or should that 'expectation' be considered in part unformed and steps taken to do something about it? In the former case, must one compete on unequal grounds or risk doing what is necessary and hope for the best? In either event, the art institution must decide whether to have one or many publications of its collection; in the latter case it must also decide whether and how they should 'complement' or 'duplicate' each other. *Even a specific audience is always a presumed one.* No one is forced to buy a collection catalogue, so in coming to grips with such a classic problem one must take account of changes in attitude between the nineteenth and twentieth centuries.

Mrs Jameson, to whom we owe the foregoing definition of a collection catalogue, greatly advances our understanding through her justification of the format for her catalogue, noting that it was 'printed and arranged so as not to fatigue the eye while the reader was standing or moving in varying lights,' that it was to be 'portable and pleasant in hand,' and that it further conformed to the practice of public collections in referring to artworks by number 'through the order they hang.' Not only do these incidental comments document viewer's habits, they reflect how things were presented to him.

In the first place, many galleries today are not only temperature and humidity controlled, they are light controlled; however many lux are permitted, they are constant, because artificially maintained. In addition, there are no longer really such things as permanent installations that are keyed into a guide that is both light and portable and can be had for a modest sum. (Labels, even those giving the inventory number, are not the same

thing at all.) *As a result there is a distinct bifurcation in experiencing and documenting the collection not at all dissimilar to that between a loan exhibition and its catalogue-of-the-moment.* We do well to consider the 'installation shot' taken within the galleries before returning to our central question of what might be called 'differentiated publications' within the collection.

If they know of them at all, most museum goers would recognize the installation shot as a means of identification of works of art when there is little or no catalogue illustration. *What has happened is that the works themselves are in all likelihood photographed, not how they are presented for viewing.*

None the less, this type of photography documents concepts of presentation and is an indication of professionalism on the part of the exhibiting institution. It is not without its risks in revealing for all to see how hangings were very carefully thought out, or not thought out at all. Beyond this immediate concern, the installation shot is an acknowledgment that hanging order is rarely that of the catalogue. It is only in the hanging of a loan exhibition that relations that were only apparent become clear (size, colour, iconography), so enough works should be shown so that the comparative groupings can be understood. (This is where the exhibition catalogue with its unitary illustration becomes, even with proportionally sized illustrations, a hindrance to understanding that can only be remedied by seeing the exhibition.) It is in this way that one tests whether the premise is false or whether the hanging confirms concepts enunciated in the catalogue essay.

Proceeding on, one discovers that the installation shot also serves as a type of 'corrective identification.' This says that if enough of individual works are shown, one may be aided in identifying a work
– known under another title,
– one which poses questions of dating,
– even whether the painting or drawing was reworked at another date, or
– whether it is another work altogether.
It is the modern equivalent of giving a verbal idea of the hanging order and decoration of the Louvre 'Salon' of 1725 'pour en conserver la mémoire, servir de note pour les morceaux qui auront été exposez publiquement, et pour donner au moins ce plaisir aux Curieux et aux gens de l'Art, qui n'ont pas été à portée de voir ce spectacle, aussi agréable et varié que scavant et précieux.'[36] It conforms to the basic idea of an exhibition, which is the bringing together of works of art.

And yet, this type of record is important, not tomorrow or the next day, but as pure record. When one looks back at what was *not* photographed over the years, one has a sense of loss, of regret for what could have been and what one would have known. (For this reason, even studio shots

and photographs of collector's walls and rooms are historically invaluable since they 'put it back together' as it was.) Anyone thereafter can see how exhibitions were structured. In this context, even a 20 per cent usage factor is doubtless a good institutional investment because the negatives sooner or later are used for research and study.

Photographs of permanent installations experienced on an everyday basis are even rarer than temporary ones, perhaps because they are taken quite for granted by those whose responsibility they are. They are still about the only documentation capable of duplicating the viewer's progress through the galleries, a progress once measured in a 'pleasant and portable' Guide that gave the works *in the order seen*.[37] Whenever there is an upheaval or a change in the aesthetics, philosophy, or politics of hanging, galleries are shifted about in part or in whole; in any case there is a *change in epoch* that can never be seen or observed again.

Today if a permanent hanging is photographed at all, it is likely to be when a new or refurbished gallery is opened. But this is rarely done in any systematic way, nor can it be considered part of the 'publicity stills' with their *staffage* of real or imagined visitors. The installation shot is part of the exhibition history of a museum or gallery and has nothing – or everything – to do with public viewing. The works are on display, not the public; their arrangement affects that public intimately. For this reason installation shots are taken in empty galleries so that works on temporary or permanent display are seen in their true context. Hanging height is inferred through evident relationships between floor and ceiling, while a thoroughly documented gallery would show walls in relation to one another so as to give roughly the impression of a walking tour. This is analogous to the taking of photographs in palaces or monumental decorative ensembles so that one can orient oneself.

Admittedly, this is not the easiest of art-historical documentation to generate: paintings, even sculpture, are more easily photographed than anything under glass or in display cases because of reflections. This technical dilemma becomes virtually insoluble for Installation Pieces if one has films or slides flickering away or, as can happen, illuminations from slides onto other surfaces. Here it becomes difficult and perhaps even impossible to interpret what is happening, since it is all so momentary or sequential. It is difficult to know where, perhaps whether, the part fits into the whole.

This is precisely what happens with the works of art in a permanent catalogue. The current expectation seems to be that one needs nothing in hand while wandering through the galleries; that one can take a tour (live or Acoustiguided) that is so highly selective that it comes, because of the press, to resemble the Stations of the Cross in a Holy Year; or that one can

always secure something to take home as a memento upon leaving. The concept of defined order and place of works of art, much less a hanging order keyed to a catalogue-guide, seems definitively abandoned, only to be replaced by an explanatory sheet or guide indicating the rooms devoted to different periods.

Unfortunately, the rise in collecting activity and the decreasing proportion of works that can (or should) be displayed have perhaps made this type of guide impracticable. Perhaps, as well, the public has become more sophisticated; unless we presume it will look only at what appeals to it in an immediate and visual manner. Whatever the cause – and one is the prominence of the temporary exhibition – an effect has been to weaken the impulse toward cataloguing permanent collections and to create publications that cannot or will not be used on the spot. In so doing one forgets that the dressing of permanent catalogues is a National Inventory without the name, one that Thoré correctly saw as a way of inspecting and verifying catalogues *through playing them off one against the other*.[38]

In the end, the publishing of collection catalogues goes to the heart of art history as it has become. Not that it is the easiest way for the art historian to understand what he is about as the progress is so fragmented, so fluctuating between the general and particular, now working from the known to the unknown, now studying the unfamiliar object to place it in more familiar context. This process corresponds rather well to the distinction established during the course of the eighteenth century between *connoissance intellectuelle* and *connoissance matérielle*, the first being the result of natural intelligence completed by study, the second being entirely dependent upon long comparison of a great number of works by different masters.[39] The difference between these two branches of the same art lies in whether the work is judged good in itself or merely considered good because of the name attached to it, a name that, if wrongly assigned or tendentious, sweeps away the entire sand-castle of critical commentary.[40] The work changeth not, the artist may.

Much of the blame attached to buying an artwork on the basis of old attributions may be assigned to the average collection catalogue of earlier periods, more particularly the sales catalogues whose *descriptions ampoulées*, with the further adjunction of prices, were seen to have progressively transformed the field by corrupting not only purchasers but also the artists themselves.[41] Such temptations are possible in any era, but must be seen against the as yet unpainted canvas of published erudition. At least one formulation dating from the Ancien Régime assigns a certain type of connoisseur nearly all the elements associated with the modern art historian's work:

Figure 13 Methodical disposition of a gallery as illustrated in *Catalogue complet du Musée du Louvre, salle par salle, avec un répertoire complet donnant la place de chaque tableau* (Paris: Balitout, Questroy et Cie, 1882)

Mettrons-nous enfin au rang des connoisseurs celui qui possède à fond l'histoire de la peinture, qui sait le nom de tous les peintres anciens et nouveaux, le détail de leurs aventures, la liste de leurs tableaux, pour qui ils ont été faits, en quel païs, en quelle année, ce que l'on pensa d'abord, ce qu'on en a dit dans la suite, par combien de mains ils ont passé, les dommages qu'ils ont soufferts, les réparations qu'ils on reçues, les lieux où ils se retrouvent encore. Cette érudition n'est rien moins que méprisable. Elle est bonne à acquérir; et si elle devenoit bien profonde, elle répandroit un grand jour sur bien des obscurités.[42]

This art-historical model is still followed to the best of one's individual capacities and circumstances, although its execution requires the experience born of maturity. No matter how straightforward the informational tasks outlined by Laugier, their execution is necessarily fragmented throughout time. Much more effort is required to 'keep the thread going' against the dulling forces of Time and Memory, which is why there was by century's end a general realization that publications, good ones, were a means of general transmission and verification of accumulated knowledge. We always forget what any permanent catalogue represented for its time and how much more any differences in quality were apparent when there were fewer of them.

Models

> Mit dem Fachwerk des Buches möge man Nachsicht üben und erwägen, das dasselbe nicht rein auf theoretischem Werk angelegt werden konnte, sondern sich grösstenteils nach der zufällig vorhandenen Masse der wirklich vorhandenen Kunstwerke und Kunstaussagen richten musste. Ausserdem ist es nicht meine Schuld, das sich alles mit allem berührt und daher jede Einteilung streitig bleibt.
> Jakob Burckhardt, Entwurf zu einer Vorrede

Why a section devoted to Models? Because there are many ways of handling models for cataloguing, but only three for understanding them. The *least* effective of these is a discussion. Not only is the process vague and misleading since one cannot know what is being worked with, but it also cannot be followed easily. The *most* effective way would be to consult suggested works, but this is not always possible. A middle course has, therefore, been adopted in these pages by *reducing to tabular form* the apparatus of selected catalogues.

Full bibliographical reference is given for those wishing to follow up the models, and some passing commentary made on the reasoning behind the apparatus itself. Whatever its faults, this approach can be scanned and understood at a glance regardless of the specifics within the cataloguing rubrics *whose order can be a choice or a necessity; occasionally it is an emphasis.*

One normally sees catalogued historical works of some distinction whose entries are necessarily long and complex; in reality, the cataloguing process begins from nothing, to which everything (or nothing) is added. *Whatever the amount or quality of information, it must be fitted into the 'usual' rubrics and sometimes even into unexpected ones.* The models given have, because of their compact nature, the great advantage of close and immediate comparison so that the thoughtful reader can determine options concerning the material he is cataloguing. The listing of rubrics *given in different orders* is at least as informative as an annotated bibliography; perhaps more, since it explains material at sight only.

The number and type of cataloguing rubrics possible are functions of the works of art. It could not be otherwise when the same type of information may mean different things when placed in different context. For example, inclusion of photographic negative numbers (when they exist) is a service; yet mention of early photographs of works of art (Alinari, Andersen, and Braun most notably) gives testimony to scholarship, taste, and the historical organization of the discipline. While a reproduction today renders a service, it is likely to be far less significant than an Old Reproduction of a drawing or painting. Thus it is that the identical documentary concerns proceed on different levels according to their date.

Catalogue entries invariably begin with author, title, and physical description of the work dealt with; these may, however, combine or separate several levels of inference or information. Authors must, for example, decide whether a possession stamp is part of the object's *material description* or is more properly placed with the historical data concerning the *provenance* of works on paper; it does, after all, have a dual function, a dual existence. Most likely it will be put under the former category, while one may find reason or necessity for separating exhibition and scholarly literature, whose differences are more easily comprehended.

All the more reason to reduce the accompanying Models to simple rubrics to see how they function, can be separated or combined. Little control is possible over information going into the rubrics, while their form conditions the type and degree of access to the data they contain.

This section accordingly presents models for a wide variety of catalogues identified by type. No attempt has been made at rendering typographical distinctions or other design factors affecting the general dispo-

sition of catalogue entries; it is the *order* of rubrics that is paramount. Here and there it has seemed better to illustrate actual pages from catalogues so that the *cumulative effect* of catalogue apparatus can be appreciated.

Once an entry is prepared, the problem is to place or, if one will, to 'arrange' entries so that their integrity is preserved, is apparent. The choice of the number and width of columns and margins, the aeration within and between entries on a page unless these are separated by lines, the ready recognition of the catalogue number whether in conjunction with or in opposition to the Pl. or Fig. reference – none of these can be dealt with here for obvious reasons. Nor can the different typefaces and their relative size and combination. The reader should, however, be aware that all these things fundamentally affect the quality and utility of intellectual work within the catalogue he consults; and that these factors are determined by the sectionalization of information into rubrics, which means that the specificity of catalogue rubrics, and thus their number, may draw together – or fragment – the same information. Whatever the approach, it affects the scholarly apparatus and seemingly the 'amount' of information presented; certainly the amount of effort required by the reader to 'reconstitute' a given work of art and place it in its proper sequence.

Such a train of events is hardly perceptible in normal circumstance. However, it occasionally happens that two works appear on the same subject at much the same time and show just how the balance can be shifted according to whether one wishes to emphasize each individual work or The Work:

Authentic Paintings	Autograph Paintings
Authentic Unassociated Drawings	Studio Works
Lost Works	*Chiostro dello Scalzo*
Attributed Paintings	Lost Works
Untraceable Authentic Paintings	Drawings[44]
Attributed Drawings[43]	

In the reading it is impossible to say that the aims of the two authors, not less than their results, are identical. How fascinating it would be if, for major questions, it were possible for two scholars of note to work at much the same time but to different ends. In any event, the point is made that the most hidebound of cataloguing conventions are somehow elastic.

Much depends, as well, upon the way in which the choice of a model informs special apparatus and discussion. There is a difference between a Missing (Untraced) and a truly Lost Work, just as there is some question as to whether Lost Works should be isolated or chronologically inte-

grated. (One may always hope to find a canvas or panel painting, never a destroyed fresco cycle.) For artists working within a geographically delimited region it may prove desirable to adopt a *topographical* orientation for the catalogue; indeed, when an oeuvre is both monumental and circumstantial in nature and is sufficient to have been dispersed, cataloguing *by collection* has real advantages for future scholarly generations:

The Paintings and Preparatory Drawings
Untraced Paintings
Doubtful and Wrongly Attributed Paintings
Concordance with Landon 1803–05[45]

Surviving Pictures (Berlin-Washington)
Lost Pictures
Notes on Some Attributed Pictures[46]

Finally, most artists have some form of special apparatus or documentation applicable to them alone because of some accident of history. Depending upon its date and place of origin, it is of value in determining the amount and quality of oeuvre under study, or its intellectual organization:

The Cycles
Single Projects
Marginal Fields[47]

The cataloguing models that follow show how importance can be assigned simply through relative placement of the *identical* rubrics or through the merging or separation of *closely related* types of information. In so doing they are perceived differently and scanned more or less easily.

Again, the subject-matter or period is here less pertinent than the succession of rubrics used in these or any other individual catalogue entries, and it goes without saying that mere reduction to rubric form gives no real insight into the length or complexity of each. Rubrics have been copied or derived from the languages of the catalogues cited, each of which has been chosen for its exemplary nature and presumed accessibility.

Selected catalogue models, analysed

00. Titel
 Beschreibung
 Bibliographie

Ausgestellt
Herkunft
Provenienz (Sammlung/Privatbesitz/Im Kunsthandel/Verbleib Un-
bekannt)

Hans Naef, *Die Bildniszeichnungen von J.-A.-D. Ingres* (Bern: Benteli Verlag,
1977–80), 5 vols. The text is on the left page, the illustration on the page
facing; longer texts continue on the verso of the illustration page.

00. Title (pl. 000)
 Description
 Dimensions
 Provenance (including marks)
 Old Reproduction (usually engravings)
 Literature
 Photograph
 Commentary

A.E. Popham, *Catalogue of the Drawings of Parmigianino* (New Haven/London:
Yale University Press for the Pierpont Morgan Library, 1971), 3 vols. The il-
lustrations gathered together in plate volumes, chronologically and by affinity
with known commissions or periods.

00. Autore
 Titolo
 Datazione
 Dati technici
 Cornice
 Ubicazioni
 Attribuzioni
 Esposizioni
 Bibliografia
 Inventario
 Foto
 Note

Gli Uffizi. Catalogo Generale. Florence: Centro Di (1979). The information tabu-
lated, four columns per page, each column surmounted by an illustration
(cf. fig. 16, p. 325).

 Historical/Stylistic Group
00. Figs. 000-000
 Collection, Inventory Nr.
 Description
 Dimensions

History and Publication History
Commentary and Analysis
G.M.A. Richter, *Kouroi. Archaic Greek Youths. A Study of the Development of the Kouros Type in Greek Sculpture* (London: Phaidon, 1970^3). Arrangement is typological, with multiple illustrations (grouped and identified briefly by collection or location) permitting cross-comparisons.

00. Artiste
 (Naissance et Mort)
 Titre
 Technique
 Dimensions
 Annotations
 Historique (marques, ventes, numéro d'inventaire)
 Bibliographie
 Expositions
 Etude critique
 Collection

Ecole de Fontainebleau (Grand Palais, Paris, 17 octobre 1972–15 janvier 1973). The rubrics applied to a wider than normal range of art.

00. Title
 Date
 Standard Print Literature Reference
 Dimensions
 Condition
 Provenance
 Inventory Nr.
 Text
 Notes

Jay A. Levenson, Konrad Oberhuber, and Jacquelyn L. Sheehan, *Early Italian Engravings from the National Gallery of Art* (Washington, DC: The Gallery, 1973). The illustrations integrated, arranged by Masters or Tendency.

00. Titolo, Inventario (Fig. 00)
 Descrizione
 Coll.
 Bibl.
 Foto
 Commentario

Beatrice Paolozzi Strozzi, *Luigi Sabatelli, 1772–1850. Disegni e incisioni* (*Gabinetto*

disegni e stampe degli Uffizi, L) (Florence: Leo S. Olschki, 1978). One of the most attractive and serviceable of presentations.

00. Titre
 Dimensions
 Description
 Provenance
 Commentaire
 Histoire et Bibliographie la concernant
 Expositions
 Bibliographie

Hommage à Claude Monet 1840–1926 (Grand Palais, Paris, 8 février–9 mai 1980). Typical of works for which documentation, however extensive, is by far overshadowed by commentary and public press.

00. Title/Album
 Identification and Dating
 Technical Information
 Exhibited
 Discussed

Richard Brettel and Christopher Lloyd, *A Catalogue of the Drawings by Camille Pissarro in the Ashmolean Museum, Oxford* (Oxford: Clarendon Press, 1980). Particularly useful for the 'decomposition and reconstitution' of sketchbooks and for problems arising from the application of such evidence to the oeuvre as a whole.

00. Titre
 Description
 Historique
 Bibliographie
 Oeuvres en rapport
 Texte

Marie-Claude Chaudonneret, *La peinture troubadour: Fleury Richard et Pierre Revoil* (Paris: Arthena, [1980]). The iconographical analogues, repertoried by both subject and author in chronological order, are possible only within a sophisticated and consistent historical apparatus such as the Paris Salon.

SOME PHOTOGRAPHICALLY REPRODUCED CATALOGUE PAGES

The following pages give a severely restricted sequence of catalogues chosen principally for the type and effect of their layout. Were this idea to

be followed through (which space and the economics of publishing forbid in the present pages), the result would be a complementary volume of plates having a dual focus: temporary-exhibition catalogues and the illustrated summary catalogues of permanent (public) collections. Their careful selection and ordering would permit students and scholars to scan existing models in view of their own needs in much the same manner as one consults books of wallpaper – a restricted substance in its own way not dissimilar to works of art.

306 (fig. 243)
Portrait of the Bookseller
Francois Babuti
Canvas, oval, 24 × 19 in / 60 × 48 cm

Coll:
Mrs Lyne Stephens, her sale, Christie's,
8–20 v. 1895, lot 374; Rodolphe Kann, his
sale, Paris, 1907, lot 148; Roussel, his
sale, Paris, Georges Petit, 25–28. III. 1912,
lot 11; D. David-Weill.

Exh:
Salon, 1759 (113); Salon, 1761 (97,
described as 'beau-père'); Paris, 'Le Siècle
de Louis XV' 1934 (174).

Lit:
Diderot, Salons, 1761, i, p. 134, fig. 55;
Abbé de la Porte, Observateur Litteraire, 1761
p. 81; Charles Normand, J. B. Greuze, no. d.,
p. 74; Goncourt, 1, p. and p.; W. Bode,
La Galerie des tableaux de M. Rodolphe
Kann, 1900, repr.; Martin, no. 1055; Emil
Michel, La Galerie de M. Rodolphe Kann,
G.B.A., 1901, 87, p. 594; W. Bode, preface to
Rodolphe Kann Sale, 1907; Martin, 1908,
no. 1055; H. Frantz, 'La Collection Roussel'
in L'Art decoratif, 20. iv.1912, p. 256, repr.
p. 259; Camille Striensky, G.B.A., 1913, 92,
p. 214; L'Illustration, 2. II. 1922 (repr. colour
on cover); L'art et l'Artiste, Feb., 1924, p. 171,
repr.; Henriot, 1916, pp. 171–173, repr.;
Châtelet and Thullier, French Painting – from
Le Nain to Fragonard, 1964. pp. 224–25,
repr. p. 222; Gunnar W. Lundberg, 'Le
graveur suédois Pierre-Gustave Floding à
Paris et sa correspondence', AAF, XVII, 1932,
p. 291 (letter of 23. xi. 1761).

Diderot described this famous portrait of
Greuze's father-in-law as follows:
*Il parait que notre ami Greuze a beaucoup
travaillé. On dit que le portrait de "M. Le
Dauphin" resemble beaucoup celui de
"Babute" mais que du peintre, est de toute
beauté. Et ces yeux évailles et larmoyants, et
cette chevelure grisâtre, et ces chairs et ces
détails de veillesse qui sont infinis au bas de
visage et autour de cou, Greuze les a tous
rendus et cependant sa peinture est large.*
He was not the only one to do so: The Abbé
de La Porte in Les tableaux exposés au Salon
de cette année (1761) spoke of it as 'un vrai
chef d'oeuvre et peut-être proposé comme
une utile leçon dans la manière de bien traiter
la tête. Ce n'est pas seulement par les
caricatures que gravent les années qu'il a
donné à ce portrait la force de l'effet et la
verité du caractère, mais c'est par des
passages, dans les teintes des carnations,
dérobes a la nature même avec cette finesse
qui lui est uniquement reservée (quoted by
Henriot, op. cit., p. 172).
It was drawn by Gabriel de Saint-Aubin in his
copy of the Livret of the Salon of 1761 (See
Dacier).

Lent by Monsieur Pierre David-Weill.

307 (fig. 21)
L'Empéreur Sevère reproche
Caracalle, son fils, d'avoir voulu
l'assassiner
Canvas, 48¾ × 63 in / 124 × 160 cm

Coll: Académie Royale de peinture.

Exh:
Salon, 1769; Cleveland, 196 (1 repr.).

Lit:
Diderot, Salon, 1769 (Oeuvres Completes
xi, p. 429), for extensive references, see
Cleveland Cat.; there are two modern studies
Edgar Munhall 'les dessins de Greuze pour
Septime Sévère', in L'eil, April, 1965;
J. Seznec, 'Diderot et L'Affaire Greuze' in
G B A, 1966, LXVII, pp. 338–56, fig. 1.

No. 000 was Greuze's Morceau de Reception
at the Académie Royale de peinture, 23. viii.
1769. Its submission was a complete disaster.
Dr Anita Brookner has summed up the
situation as follows:
'The records of the Académie are discreet on
this matter and give no account of the drama
that took place. According to Diderot, Greuze
was received by the Académie and then told,
*'Monsieur, l'Académie vous reçoit, mais c'est
comme peintre de genre; elle a eu égard à
vos anciennes productions qui sont
sxcellentes et elle a fermé les yeux sur
cell-ci, qui n'est digne ni d'elle ni de vous'.*
Greuze 'lost his head' and tried to point out
the excellence of his picture, then became
over-wrought and, leaving the picture in the
Salon, retired to his home where an even more
furious wife was awaiting him. Greuze was
by this time sufficiently unhinged to accuse
her of plotting with her lover Blondel
d'Azincourt for his downfall, but this conflicts
with Diderot's statement: *'Vous ai-je que
Greuze venait de recevoir le remboursement
du mépris qu'il avait eu jusqu'à present pour
ses confrères?... Sa femme en ronge les
poings de fureur'.*

Lent by the Musée du Louvre, Paris.

308 (fig. 232)
Girl with the Dead Bird
Canvas, oval, 20 × 18 in / 50·8 × 45·7 cm

Coll:
De la Livre de la Briche; General Ramsay;
Lady Murray of Henderlaw, who bequeathed
it to the Gallery, 1861.

Exh:
Salon, 1765 (1 ı 0).

Lit:
Diderot, Salons, 1765; Mercure, 1765,
p. 107; Année Litteraire, 1765, pp. 162–63;
Avant-Coureur, 1765, pp. 555–56; Journal
Encyclopédique, 1765, p. 29; Brookner, ii,
pp. 34, 35, 145–147.

Engr
Flipart.

Another version, but rectangular and differing
in design is in the Louvre. Mathon significantly
said that No. 308 was a masterpiece: the girl,
according to him, was about eleven or twelve
years, and 'l'âge où le besoin d'aimer fait
qu'on se livre au premier objet qui se
présente'. (Troisième Lettre, 1765, pp. 5–6.)
Diderot, who wrote at length about no. 308,
considered it as being perhaps the most
interesting picture in the Salon, declaring that

Gessner would make a *belle idylle* of the
subject. For him it provoked the adjective
délicieux.

Lent by the National Gallery of Scotland,
Edinburgh.

309 (fig. 233)
Portrait of Jean-George Wille
Canvas, 23¼ × 19¼ in / 59 × 48·9 cm
Signed and dated: J. B. Greuze 1763.

Coll:
No. 309, or a replica, in Chevalier de Sitvan's
coll, his sale, Paris, 19. iv. 1830, lot 79;
M. T. et L..., sale, Paris, 31. III. 1840, lot 56;
Delessert, his sale, 15. iii. 1869, lot 28; Anon.,
sale, 6. iv. 1845, lot 110.

Exh:
Salon, 1765 (118); Paris, Union centrale des
Beaux-Arts, 'Alsaciens-Lorrains', 1878 (126);
Berlin, 1910 (59); Paris, 1937 (166); R.A.,
1953–1954 (180); U.S.A. 'Treasures of Musée
Jacquemart-André, 1955 (38); Albi, 'Chefs
d'oeuvre de Musée Jacquemart-André', 1959,
(35); Paris, Bibliothèque Nationale,
'Diderot', 1963 (324).

Lit:
Diderot, Salons, ii, pp. 36, 37, 153, fig. 39;
Mathon de la Cour, Lettres a Monsieur, 1765;
Année Litteraire, 1765, which remarks
(p. 163) on 'Le pinceau hardie facile et plein
de fierte'; J. G. Wille, Mémoires et Journal, ed.
G. Duplessis, 1857, 1, pp. 238–42; Martin,
no. 1262, repr. op. p. 24; L. Hautecoeur,
Greuze 1913, p. 130.

Engr:
By Muller of Stuttgart, 1776.

A replica of same size signed and dated was
in the A. Polovtsoff sale, 4. xii. 1909, lot 137,
and is now in the Prat-Noilly Coll: Marseilles.
J. G. Wille, one of the most celebrated
engravers of his time, was born in Germany in
1715 and died in Paris in 1808. According to
Wille's memoirs, Greuze painted une
ébauche admirable on 18. ix. 1763; he
returned to sit for him on the 21 and 29 of the
same month (on the second occasion for the
costume) and again on the 1. xii. On the
4. xii the picture was finished. Wille took it to
his family on the 10. xii; when his son saw it
he ran towards it, crying, 'mais c'est mon papa,
mon papa!'
Diderot's comments when he saw no. 309 in
the Salon are well worth quoting: 'Très beau
portrait. C'est l'air brusque et dur de Wille;
c'est sa roide encolure; c'est son ceil petit,
ardent, effaré; ce son ses joues couperosées.
Comme cela est coiffé! Que le dessin est
beau! Que la touche est fiève! Quelles
vérités et variétés de tous et le velours de
tous et le velours et le jabot, et les
manchettes d'une exécution. Comme j'aurais
plaisir à voir ce portrait à côté d'une Rubens,
d'un Rembrandt ou d'un Van Dyck. J'aurais
plaisir à sentir ce qu'il y aurait à perdre ou à
gagner pour notre peintre'.

Lent by the Musée Jacquemart-André, Paris.

Figure 14 Three-column layout with mixed typeface, from *France in
the Eighteenth Century*. Royal Academy of Arts, London, Winter Exhibition
(6 January–3 March 1968), p. 80

INV. 1040

Le Passage du bac.
B. H.0,500 ; L.0,705.
S.b.d. : *Berchem f.*
(Hofstede de Groot IX 328).
Provient de la coll. du Stadhouder
à La Haye, 1795.
Villot II 21 - Cat. somm. 2317.

INV. 1042

**Pâtres gardant un troupeau
au bord de l'eau.**
B. H.0,51 ; L.0,62 (autrefois
H.0,410 ; L.0,565).
S.b.d. : *Berchem f.*
Sans doute mis en pendant au
XVIIIᵉ siècle avec un autre
Berchem acquis à la même vente
et aujourd'hui déposé au Mobilier
National (Inv. 1039).
(Hofstede de Groot IX 701).
Coll. de Louis XV : acquis en
1741.
Villot II 23 - Cat. somm. 2319.

INV. 1043

Bergère trayant une chèvre.
B. H.0,635 ; L.0,595.
S.b.m. : *Berchem.*
(Hofstede de Groot IX 197).
Acquis en 1817.
*Villot II 24 - Demonts 2320,
p. 157.*

INV. 1044

Muletière près d'un gué.
T. H.1,12 ; L.1,40.
S.b.m. sur le rocher : *Berchem f.*
(Hofstede de Groot IX 389).
Acquis en 1817.
Villot II 25 - Cat. somm. 2321.

INV. 1045

**Lavandière et animaux
au bord de l'eau.**
B. H.0,245 ; L.0,315.
S.b.m. sur une pierre : *Berchem.*
Au XVIIIᵉ siècle en pendant avec
le Bergen INV. 1035.
(Hofstede de Groot IX 291).
Saisie révolutionnaire de la coll.
du baron de Breteuil.
*Villot II 26 - Demonts 2322,
p. 133.*

INV. 1046

**Paysage avec Jacob, Rachel
et Léa.**
T. H.1,66 ; L.1,38.
S.D.b.g. vers le milieu sur la
grande pierre : *C. Berghem 164...*
(3 ?) et non 1664.
Figures de Jan-Baptist Weenix.
(Hofstede de Groot IX 59 :
1664).
Acquis en 1816.
*Villot II 27 (pas de remarque
sur les figures) - Cat. somm.
2323 (id.).*

BERCKHEYDE
Gerrit Adriaensz.
Haarlem, 1638 - id., 1698.

R.F. 2341

**Le Dam avec le nouvel Hôtel
de Ville à Amsterdam.**
B. H.0,405 ; L.0,565.
S.b.g. : *Gerret. Berck Heyde.*
Legs de Mme Jacques Chatry de
Lafosse, 1921.
Demonts s.n., p. 190.

BERGEN Dirck Van
Haarlem, vers 1640 - id., vers
1690

INV. 1035

Paysage au cheval blanc.
T. sur B. H.0,255 ; L.0,315.
S.b.m. : *D.V. Berghen.*
Au XVIIIᵉ siècle en pendant avec
le Berchem INV. 1045.
Saisie révolutionnaire de la coll.
du baron de Breteuil.
*Villot II 16 - Demonts 2326,
p. 134.*

BERNAERTS Nicasius
Anvers, 1620 - Paris, 1678.

INV. 1622

Deux petits chiens.
T. H.0,53 ; L.0,65.
Coll. de Louis XIV (Manufac-
ture des Gobelins) ?

Figure 15 Two-column layout with integrated illustration of a summary illus-
trated catalogue: *Catalogue sommaire illustré des peintures du Musée du Louvre, I:
Ecoles flamande et hollandaise* (Paris: Musées Nationaux, 1979), p. 24

	P1300	P1301	P1302	P1303
AUTORE	Raffaello Sanzio (Urbino 1483 - Roma 1520).	Raffaello Sanzio (Urbino 1483 - Roma 1520).	Raffaello Sanzio (Urbino 1483 - Roma 1520).	Raffaello Sanzio (Urbino 1483 - Roma 1520).
TITOLO	Visione di Ezechiele.	Madonna della Seggiola.	Madonna dell'Impannata.	Ritratto di Leone X coi card. Luigi de' Rossi e Giulio de' Medici.
DATAZIONE	1510 (Malvasia 1678, Filippini Raffaello, Sanzio (Urbino 1483 - 1925), 1513 (Passavant 1869, Venturi 1920), 1514 (Beck 1976), 1516 ca. (Ciaranfi 1966), 1517 (Crowe e Cavalcaselle 1891, Gamba 1952, Dussler 1909, Camesasca 1962).	1511-13 (Crowe e Cavalcaselle 1885), 1512 (Ciardi Dupré 1966), 1513 (Serra 1941), 1513-14 (Gamba 1920, Dussler 1966), 1514-15 (Venturi 1920, Ortolani 1942, Fishel 1948, Beck 1976) 1515 (Pope-Hennessy 1971), 1515-16 (Francini Ciaranfi 1955, Camesasca 1936), 1516 (J. Rusconi 1957).	1512-13 (De Vecchi 1966), 1513-14 (Müntz 1881 e la critica posteriore).	1518 (ragioni documentarie, Passavant e tutta la critica posteriore).
DATI TECNICI	Olio su tavola, 40,5x30.	Olio su tavola, tondo, 72,5x71,5.	Olio su tela, 160x126,5.	Olio su tavola, 155,5x119,5.
CORNICE	Legno intagliato e dorato. Terzo decennio sec. XIX.	In legno, riccamente intagliata e dorata, metà sec. XVIII.	In legno, riccamente intagliata e dorata, sec. XVII.	In legno intagliato e dorato, riccamente ornato, sec. XVII.
UBICAZIONI	Conte Vincenzo Hercolani, Bologna (dall'origine); Uffizi, Tribuna (1589, 1638); Pitti (1649); Parigi (1799-1815); Pitti (dal 1815).	Uffizi, Tribuna (1589, 1638, 1649, 1779); Pitti (fine sec. XVIII); Parigi (1799-1815); Pitti.	Bindo Altoviti, Roma (dall'origine); Palazzo Altoviti (prima del 1550); Palazzo Vecchio (1568); Uffizi, Tribuna (1589, 1638); Pitti (1713; 1723, 1761); Palais du Luxemburg, Parigi (1799-1815); Pitti.	Papa Leone X, Roma (dall'origine); Palazzo Medici Riccardi (1524-23); Palazzo Vecchio (1553, 1560); Uffizi, Tribuna (1589, 1638); Pitti, camera dell'alcova (1713, 1723, 1758); Palais du Luxemburg, Parigi (1797-1815); Pitti (1815); Uffizi (1952).
ATTRIBUZIONI	Raffaello (Vasari 1550 e 1568) Giulio Romano (Giornaletto A-GF). Esecuzione di Giulio Romano (Morelli 1886, Crowe e Cavalcaselle 1891). Raffaello (Dollmayr 1895). Bottega di Raffaello (Gronau 1932). R. e Giulio Romano (Berenson 1932). R. e Vincidor (Fischel 1948). R. e Giulio Romano (Camesasca 1956). Raffaello (Berti 1961, Micheletti 1962, Brizio 1963, Ciaranfi 1966). Bottega di Raffaello (Dussler 1966). Raffaello (Beck 1976).	Raffaello (Inventario del 1589 e tutta la critica posteriore).	Raffaello (Vasari 1550, 1568). Raffaello e parziale esecuzione di Giulio Romano (Gruyer 1869). Giulio Romano e Penni (Crowe e Cavalcaselle 1885). Penni (Dollmayr 1895, Venturi 1926, Fischel 1948, Dussler 1966). Esecuzione parzialmente di bottega (Gronau 1923, Gamba 1932, Berenson 1932, Ortolani 1942, Brizio 1963, Becherucci 1968, Pope-Hennessy 1971).	Raffaello (Vasari e tutta la critica posteriore). Esecuzione di Giulio Romano (Rosenberg-Gronau 1909 e Gamba 1932).
ESPOSIZIONI	—	Mostra d'arte italiana, Parigi 1930. Mostra d'arte italiana, New York 1939.	—	Mostra Medicea, Firenze 1939.
BIBLIOGRAFIA	J. Beck, Raphael, New York 1976. E. Camesasca, Raffaello. I quadri, Milano 1962, tav. 152. L. Dussler, Raphael, München 1966.	L. Becherucci, in Raffaello, I. Novara 1968. J. Pope-Hennessy, Raphael, New York 1971. J. Beck, Raphael, New York 1976. L. Dussler, Raphael, München 1966, n. 31.	J. Pope-Hennessy, Raphael, New York 1971. J. D. Passavant, Raphael, 1860, II, pp. 328-29. L. Dussler, Raphael, München 1966, n. 30.	J. Pope-Hennessy, Raphael, New York 1971. J. Beck, Raphael, New York 1976. A. M. Brizio, in F.U.A. 1965. L. Dussler, Raphael, München 1966, n. 46.
INVENTARIO	Palatina Galleria 174.	Galleria Palatina 151.	Galleria Palatina 94.	Galleria Palatina 40.
FOTO	53158.	53217, 154112 (e particolari).	53153, 56890.	47730, 142712 (e particolari).
NOTE	La data 1510 risale ad un pagamento — scoperto dal Malvasia — di otto ducati per questo quadretto. Il Vasari lo dice eseguito dopo la 'S. Cecilia' oggi nella Pinacoteca Nazionale di Bologna. Il Loewy (1896) lo ha messo in relazione con una stampa di M. A. Raimondi, raffigurante un Giove a sua volta desunto da un disegno di Raffaello. M.G.C.D.	Il dipinto è considerato generalmente del tempo della Stanza di Eliodoro e l'apice delle ricerche coloristiche e compositive del tema delle Madonne. Disegni relativi: due schizzi nel Museo Wicar a Lille; altri nella collezione von Hirsch a Basilea (Serra 1941, pp. 105-06). Una copia, in arazzo, nel Museo di Bordeaux. M.G.C.D.	Fu dipinta per Bindo Altoviti a Roma. Dopo la congiura del 1552 fu confiscata da Cosimo I e collocata in Palazzo Vecchio. Le radiografie hanno dimostrato che, sotto l'attuale, esiste una prima versione assai diversa (Sampaolesi, in Boll. d'Arte 1938, pp. 496-503). Esistono disegni autografi sia per la prima versione (Windsor Castle) sia per la seconda (Berlino, Kupferstichkabinett). M.G.C.D.	La data del dipinto si situa fra la seconda metà del 1517 (elevazione al cardinalato di Luigi de' Rossi) e l'agosto 1519 (morte del de' Rossi). L'ipotesi dell'esecuzione di Giulio Romano si basa su di un passo del Vasari (ed. Milanesi V, 41), cui peraltro restante la critica non ha giustamente prestato fede. M.G.C.D.

Figure 16 Four-column layout of a summary illustrated catalogue: *Gli Uffizi. Catalogo Generale* (Florence: Centro Di, 1979), p. 442

A 3106 Portrait of a young woman. *Portret van een jonge vrouw*

Canvas 73 × 59. Signed and dated *N. Maes 1665*
PROV Bequest of P A Gildemeester, Egmond aan den Hoef, 1930

A 701 Marten Meulenaer

Canvas 45 × 34. Signed and dated *Maes 1675*
PROV Bequest of Jonkheer J S H van de Poll, Amsterdam, 1880 * DRVK since 1959 (on loan to Stedelijk Museum Het Catharinagasthuis, Gouda)
LIT V de Stuers, Ned Kunstbode 2 (1880) p 244. Moes 1897-1905, vol 2, nr 5014. Hofstede de Groot 1907-28, vol 6 (1915) nr 213. G Kolleman, Ons Amsterdam 23 (1971) p 118 (portrait of Martinus Meulenaer, son of Maria Rev and Roelof Meulenaer, b 16 Nov 1651)

A 1662 Cornelis Evertsen (1642-1706). Vice admiral of Zeeland. *Luitenant-admiraal van Zeeland*

Canvas 148 × 124. Signed and dated *N. Maes 1680*
PROV Purchased from J C de Ruyter de Wildt, Vlissingen, 1895
LIT Hofstede de Groot 1907-28, vol 6 (1915) nr 164. Staring 1948, p 35

C 90 Six governors of the Amsterdam surgeons' guild, 1680-81. *Zes overlieden van het Chirurgijnsgilde te Amsterdam, 1680-81*

The sitters are Jan Coenerding, Pieter Muyser, Isaac Hartman, Gerrit Verhul, Allardus Cyprianus and Goverd Bidloo, seated on the chair in front of the table

Canvas 130.5 × 195.5
PROV On loan from the city of Amsterdam (A van der Hoop bequest), 1885-1975
LIT Tilanus 1865, p 36. J Six, Ned Spec, 1882, p 170. Moes 1897-1905, vol 1, nrs 659:1, 3233, 4244:1; vol 2, nrs 5236, 8386. Hofstede de Groot 1907-28, vol 6 (1915) nr 549. Bauch 1926, p 102, nr 21. Riegl 1931, p 241, fig 71. Martin 1935-36, vol 1, pp 173, 201, 203, fig 114. J Knoef, Jb Amstelodamum 42 (1948) p 15

A 1645 Willem Pottey (1666-94). Lawyer and treasurer-general of Vlissingen. *Advocaat en rekenmeester-generaal te Vlissingen*

Pendant to A 1646

Canvas 61 × 49. Signed *Maes*
PROV Purchased from J C de Ruyter de Wildt, Vlissingen, 1895 * DRVK since 1958
LIT Moes 1897-1905, vol 2, nr 6057. Hofstede de Groot 1907-28, vol 6 (1915) nr 234. A M Lubberhuizen-van Gelder, OH 62 (1947) p 146

A 1646 Catharina Pottey (1641-1718). Sister of Willem and Sara Pottey. *Zuster van Willem en Sara Pottey*

Pendant to A 1645
For a portrait of Sara Pottey, *see* Haringh, Daniel, A 1655

Canvas 61 × 49. Signed *Maes*
PROV Same as A 1645
LIT Moes 1897-1905, vol 2, nr 6056 (portrait of Sara Pottey). Hofstede de Groot 1907-28, vol 6 (1915) nr 233

A 1259 Belichje Hulft (1656-1714). Wife of Gerard Röver (1643-1711), Amsterdam merchant and shipowner. *Echtgenote van Gerard Röver, koopman en reder te Amsterdam*

Canvas 44.5 × 33.5. Signed *Maes*
PROV Presented by J S R van de Poll, Arnhem, 1885
LIT Hofstede de Groot 1907-28, vol 6 (1915) nr 195

attributed to **Nicolaes Maes**

A 3508 Portrait of a young man. *Portret van een jonge man*

Panel 36.5 × 31
PROV Purchased from C L H Crommelin, The Hague, 1947
LIT Hofstede de Groot 1907-28, vol 6 (1915) nr 371

school of **Nicolaes Maes**

Figure 17 Three-column layout of a summary illustrated catalogue: *All the paintings of the Rijksmuseum in Amsterdam. A completely illustrated catalogue* (Amsterdam: Rijksmuseum, 1976), p. 358

Notes

CHAPTER 1 RESEARCH

1 The dilemma of 'conservation/communication' peculiar to the field has been satirized in restricted context: 'Thus, even if he does not go so far as Anatole France's Monsieur Sarriette – who had devised a system of call numbers so complex that only a mathematical genius could master it and, when such a genius finally appeared, pretended that the volume had been misplaced rather than hand it over to the 'customer' – the 'Keeper' or 'Conservateur' tends to prefer a classical philologist who works on an edition of Optatianus Porfyrius, studying the same two inconspicuous manuscripts for seven years, to an art historian who will ask for any number of priceless illuminated books at the same time and nervously turn their pages for purposes of comparison; or, alternatively, will order all the available *Bibles Historiales* in rapid succession, each of their volumes weighing twenty pounds and containing one miniature with which he is through within five minutes' (E. Panofsky, 'Homage to Jean Porcher,' *Gazette des Beaux-Arts*, VI/LXII [juillet–août 1963], p. 11).

2 The novelty of this procedure may be had from reading Boyer's Approbation for the *Histoire de la Ste-Chapelle Royale du Palais, enrichie de planches; par M. Sauveur-Jérôme Morand, chanoine de ladite église, présentée à l'Assemblée-Nationale, par l'Auteur, le 1 Juillet 1790* (Paris: Clousier/Prault, 1790): 'Les Pièces Justificatives qui accompagnent cet Ouvrage, ne peuvent être que le fruit des plus pénibles recherches, et il seroit à désirer que les personnes à portée de consulter, comme l'Auteur, les dépôts de nos Chartres, daignassent, comme lui, en publier les Monumens les plus intéressans; je pense donc que son travail ne qu'être bien reçu du Public.'

3 Robert-Henri Bautier, 'Les Archives,' in *L'Histoire et ses méthodes*, ed. Charles Samaran (Paris: Gallimard, 1961), p. 1120.

4 Jean Favier, *Les Archives* (Paris: Presses Universitaires Françaises, 1965), p. 39.

5 Anton Springer, 'Kunstkenner und Kunsthistoriker. Ein Nachwort,' in *Bilder aus der neueren Kunstgeschichte*, zweite vermehrte und verbesserte Auflage (Bonn: Adolph Marcus, 1886), II, p. 397.

6 As in the exemplary study of Carl Justi, *Winckelmann in Deutschland. Mit Skizzen zur Kunst- und Gelehrtengeschichte des achtzehnten Jahrhunderts. Nach gedruckten and handschriftlichen Quellen dargestellt* (Leipzig: F.C.W. Vogel, 1866).

7 Moreover, as noted by Carl Bernhard Stark, *Systematik und Geschichte der Archäologie der Kunst* (Leipzig: Wilhelm Engelmann, 1880), p. 55: 'Es hat der Archäologie ausserordentlich geschadet, dass man jedweges tastbare Objekt aus dem Alterthum mit gleichem Kunstenthusiasmus empfing und sofort die ästhetische Werthschätzung mit dem historischen Interesse verwechselte. Eine Menge antiker Objekte sind wichstige Erkenntnissquellen, aber nicht Objekte der künstlerichen Werthschätzung.'

8 In the mass of the naïve collectors and well-intentioned speculators, the keeping of detailed records seems a far less venerable practice than might be thought, witness 'W.C.M. on the Frauds of Picture Dealers,' *Annals of the Fine Arts*, II (1818), pp. 210–14, as he laments an inheritance expertised at less than a fifth of its putative value: 'My father had kept no account of his respective purchases, and being very close in all his transactions, we could never ascertain the different prices he had paid, nor of whom each picture was bought: we were therefore obliged to submit to our loss without hope of remedy.'

9 As with Louis Courajod, *Histoire de l'enseignement des arts du dessin au XVIIIe siècle. L'Ecole royale des Elèves protégés, précédée d'une étude sur le caractère de l'enseignement de l'art français aux différentes époques de son histoire et suivie de documents sur l'École royale gratuite de dessin fondée par Bachelier* (Paris: J.-B. Dumoulin, 1874).

10 Cf. Françoise Arquié-Bruley, 'Les archives des commissaires-priseurs parisiens avant 1970,' *Revue de l'art*, no. 54 (1981), pp. 85–91, for closely reasoned views on the deceptive nature of sales records, lately become fashionable as the *surest* means of identification, dating, and provenance of art works.

11 E.H. Gombrich, *Ideas and Idols: Essays on Values in History and in Art* (Oxford: Phaidon, 1979), p. 57.

12 Cf. Johannes Dobai, *Die Kunstliteratur des Klassizismus und der Romantik in England, 1700–1840* (Bern: Benteli Verlag, 1974–77), 3 vols. As seen in the number of pages per volume, Dobai's base period of 1700–50 sees an increment of some 50 per cent in literary output from 1750 to 1790, but only 80 per cent from 1790 on. Such work is also revealing of a curious phenomenon in the field, where major works on 'national' subjects are often the work of foreigners.

13 Now supplemented by Betty Woelk Lincoln, *Index of Festschriften in Art History, 1960–1975* (New York: Garland Publishing, 1987), and by Dorothy Rounds (comp.), *Articles on Antiquity in Festschriften. An Index: The Ancient Near East, the Old Testament, Greece, Rome, Roman Law, Byzantium* (Cambridge: Harvard University Press, 1962).

14 For a convenient summary, see *The Art Press: Two Centuries of Art Magazines*, ed. Trevor Fawcett and Clive Phillpot (London: The Art Book Company, 1976). Remember that these essays are written by librarians and designers, not art historians, and that their quality is rather uneven.

15 *Bibliothèque Nationale. Département des Périodiques. Catalogue collectif des périodiques du début du XVIIIe siècle à 1939 conservés dans les Bibliothèques de Paris et dans les Bibliothèques universitaires des Départements* (Paris: Imprimerie Nationale, 1967–77), 2 vols.

16 *Bibliographie zur Architektur im 19. Jahrhundert. Die Aufsätze in den deutschsprachigen Architekturzeitschriften, 1789–1918*, ed. Stephan Waetzoldt (Nendeln: KTO Press, 1977), 8 vols.

17 *Art Journal*, XXXIX (Spring 1980), p. 165.

18 Louis Gottschalk, *Understanding History. A Primer of Historical Method* (New York: Alfred A. Knopf, 1958), p. 28.

19 Although not intended for historical writing and its problems, one always consults with profit William Strunk, Jr, and E.B. White's classic *The Elements of Style*, 3rd ed. (New York: Macmillan, 1979), particularly its ch. V, 'An Approach to Style.'

20 A welcome exception, remarkable for its philosophical density, is Jean Adhémar, 'Vingt-cinq ans à la *Gazette des Beaux-Arts*,' RACAR (*Revue d'art canadienne / Canadian Art Review*), X (1983), pp. 163–9.

CHAPTER 2 BIBLIOGRAPHY

1 For three quite different instances of loss or destruction of art, see B. Berenson, *Homeless Paintings of the Renaissance* (London: Thames and Hudson, *1969*); M. Bernhard, *Verlorene Werke der Malerei in Deutschland in der Zeit von 1939 bis 1945 zerstörte und verschollene Gemälde aus Museen und Galereien* (Munich: F.A. Ackermann, 1965); *An Illustrated Inventory of Famous Dismembered Works of Art: European Painting, with a Section on Dismembered Tombs in France* (Paris: UNESCO, 1974); L. Réau, *Histoire du vandalisme. Les monuments détruits de l'art français*, 2 vols (Paris: Hachette, 1959).

2 Cf. M.J. Friedländer, *On Art and Connoisseurship* (Boston: Beacon Press, *1960*), ch. xxxviii, 'On Art Literature,' pp. 273–9.

3 See Frits Lugt, *Répertoire des catalogues de ventes publiques intéressant l'art ou la curiosité* (The Hague: Martinus Nijhoff, 1938–64), 3 vols to date, covering the period 1600–1900; unlikely to be continued.

4 Among the more important of these are the (*Bau- und*) *Kunstdenkmäler* of the Germanies; *Danmarks Kirker; Die Kunstdenkmäler der Schweiz; Kyrkor* (Swedish); *De Nederlandsche Monumenten van Geschiedenis en Kunst;* the *Oesterreichische Kunsttopographie.*

5 P.O. Rave, *Kunstgeschichte in Festschriften. Allgemeine Bibliographie kunstwissenschaftlicher Abhandlungen in den bis 1960 erschienen Festschriften* (Berlin: Gebr. Mann, 1962)

6 As might have been anticipated, in the decade between the implementation of the first and second *Anglo-American Catalogue Rules* (Chicago: American Library Association, 1967^1, 1978^2), the Library of Congress system has been plunged into a chaos that is far from being resolved since LC itself seems unable to decide what it is trying to do and how this might systematically be done. No relief is in sight as concerns headings and order of filing for every library plugged into its services. Most affected are the definition of corporate authors (fully 40–50 per cent of most library holdings), personal authors (now given as they are *most commonly* known), and the listing of periodical titles, all of which set up parallel systems that double the work and confusion of users. However arbitrary library cataloguing procedures might be regarded in establishing rules of reference, one at least felt that they were the result of conscious research effort. It now seems that no one can be bothered to continue the tradition.

7 The solution envisaged in the nineteenth century of classification under the series number and fascicule, the spine of the book bearing as well the author and title (cf. the *Bibliothèque de l'Ecole des Hautes Etudes Philologiques et Historiques*) has regrettably not found general favour in North America.

8 Mary W. Chamberlin, *Guide to Art Reference Books* (Chicago: American Library Association, 1959), nos 2146, 2147, 2287.

9 Ibid., nos 2365, 2367.

10 Ibid., no. 2295.

11 Cf. the abbreviations for the international literature of art in the *Répertoire d'art et d'archéologie.*

12 This dilemma reduces in practice to a rule of thumb: the author's contribution in any type of writing must be not merely discernible, but recognizable.

13 For a lively exposé, see Ellsworth Mason, 'The Great Gas Bubble Prick't, or Computers Revealed – By a Gentleman of Quality,' *College and Research Libraries*, XXXII (May 1971), pp. 183–96. Although the introduction of automated information systems is said to proceed independently of other services, it is usually observable that acquisition, binding, and maintenance budgets are reduced by one-fourth to one-half thereafter.

CHAPTER 3 WRITING

1 W.H. Fowler's *A Dictionary of Modern English Usage*, 2nd ed. rev. (Oxford: Clarendon Press, 1965) has yet to be surpassed for sheer literacy and engrossing reading.

2 Cf. E. Panofsky, 'Epilogue: Three Decades of Art History in the United States. Impressions of a Transplanted European,' *Meaning in the Visual Arts* (Garden City: Doubleday, 1955), pp. 321–46.

3 E. Panofsky, *'Virgo & Victrix*: A Note on Dürer's *Nemesis,' Prints*, ed. Carl Zigrosser (New York: Harper, Row and Winston, 1962), p. 15.

4 Louis Gottschalk, *Understanding History. A Primer of Historical Method* (New York: Alfred A. Knopf, 1958), p. 49.

5 Ibid., p. 50n2.

6 Presumably this subservience will be resolved with the arrival of on-line data bases into which some poor soul will have to feed titles. This utopic vision of 'research-through-the-pushing-of-a-button' is not yet done for articles – the bread and butter of the trade – or for exhibition catalogues; it is not well done for monographs. Until the Millennium arrives one must continue to cultivate good work habits and seasoned *Sitzfleisch*.

7 Jacques Thuillier, 'Conseils pour la rédaction des mémoires de maîtrise et thèses de IIIe cycle en histoire de l'art moderne et contemporain,' *L'Information d'histoire de l'art*, XX (septembre–octobre 1975), p. 152.

8 Jacques Lavalleye, *Introduction à l'archéologie et à l'histoire de l'art*, 3e éd. (Gembloux: Duculot, 1972), p. 202.

9 Ibid., pp. 25–6.

10 Bibliographers and readers alike are normally forced to interpolate punctuation left out by designers or not retained by computers. To take one classic example of recent date, Svetlana Alpers's *The Art of Describing Dutch Painting in the Seventeenth Century* (Chicago: University of Chicago Press, 1983) seems one thing until a period or colon is introduced between the words Describing and Dutch, at which time it is revealed to be quite another. Problems arising from the tenuous distinction of title and subtitle are compounded when the putative title is in reality a catchy phrase in apposition to the real (informative) title that follows. This process can rarely be reversed; the distinctions often made only by typographical differences in character are but rarely transmitted by indifferent and inattentive copyists. Retrieval is then usually through the author's name unless one has perfect recall or is a specialist.

11 Lee Johnson, *The Paintings of Eugène Delacroix: A Critical Catalogue, 1816–1831* (Oxford: Oxford University Press, 1981), I, p. vii.

12 So Bernard Berenson in his diary for 24 May 1942: 'In that sense Jakob Burckhardt was a real pioneer. After him it is easy for any instructed

person to apply the same questions, to pose the same problems, to set up the same categories for any period of the past and with relatively moderate gifts reach satisfactory results. It is easy for these mediocrities to ignore their debts, and to be accepted as great scholars and interpreters' (*Rumor and Reflection* [New York: Simon and Schuster, 1952], p. 96).

13 Lavalleye, *Introduction à l'archéologie et à l'histoire de l'art*, p. 234.

14 Thuillier, 'Conseils pour la rédaction des mémoires de maîtrise et thèses de IIIe cycle en histoire de l'art moderne et contemporain,' p. 153.

15 Viz. John Pope-Hennessy, *Essays on Italian Sculpture* (London: Phaidon, 1968), p. vii: 'The distinction between the autodidact and the trained art-historian is more fundamental than it may appear. The indoctrinated art-historian is trained to teach. From a comparatively early stage he is expected to have a working knowledge of the literature of great artists and a grasp of the methods by which they were studied in the past, and his prospects of professional success are in the ratio of his academic achievement. The self-trained art-historian, on the other hand, forges his own weapons. Establishing a bridgehead in some subject, he develops outwards as taste and opportunity dictate.'

16 'Pages inédites du *Journal* de Berenson,' *Gazette des Beaux-Arts*, VI/LIV (janvier 1960), p. 8, entry for 30 June 1955.

17 Cf. Robert Marichal, 'La critique des textes,' in *L'Histoire et ses méthodes*, ed. Charles Samaran (Paris: Gallimard, 1961), p. 1250: 'Un historien scrupuleux ne doit donc se fier sans enquere préalable à aucune édition: les bibliographies specialisées lui donnent le plus souvent des indications sur leur valeur, mais il en est qui ne doivent leur bonne reputation qu'au fait qu'elles n'ont jamais été contrôlées.' The best examples of such problems are the early nineteenth-century compendia after earlier Italian theoreticians.

18 Helen Gardner, *Art through the Ages: An Introduction to Its History and Significance* (New York: Harcourt, Brace and Co., 1926); rev. edns, 1936, 1948, 1959, 1970, 1975, 1980.

19 Gottschalk, *Understanding History: A Primer of Historical Method*, 2nd ed. (1969), pp. 23–5.

CHAPTER 4 UNIVERSITY AND PUBLIC LIFE

1 Erwin Panofsky, *Early Netherlandish Painting: Its Origins and Character* (Cambridge: Harvard University Press, 1953), I, p. 533.

2 Anthony Blunt, *The Paintings of Nicolas Poussin: A Critical Catalogue* (London: Phaidon Press, 1966), p. 181.

3 Far too many catalogues, particularly French ones, have an apparent aversion to giving *full pagination* – sometimes *any pagination* at all – for articles. They are seconded in this by catalogues from inexperienced art institutions everywhere. Surely catalogues could, no less than any other form of literature, respect the *minimum norms* of bibliographical description rather than transferring this responsibility to readers everywhere. Their failure to do so may be some indication that the organizers do not see their efforts in any historical way. This 'side-issue' is similar to that posed by giving running dates as sure identifiers of exhibition catalogues – a *trade-off* between the costs of typographical composition and informational service. While the catalogue itself may not appear in time for the opening (or closing) of the exhibition, its running dates give a close historical chronology of the event, and thus of exhibitions everywhere. This chronology is impossible to obtain with any other form of art-historical literature. Far from being a passing concern or the expression of fastidious curiosity, this is historical information worth preserving. Few people will be able to establish this information or look it up on their own without catalogue in hand, so it is the duty of the art institutions and historians to include it in their basic notation.

4 Cf. *French Painting, 1774–1830: The Age of Revolution* (Detroit Institute of Arts, 5 March–4 May 1975), p. 307: 'One asterisk (*) means exhibited in Paris only; two (**) mean exhibited in Paris and Detroit only; three (***) mean exhibited in Detroit and New York only; four (****) mean not exhibited.' Originating at the Grand Palais, Paris (16 November 1974–3 February 1975), the catalogue was translated and recast with modifications before going on to Detroit and the Metropolitan Museum, New York (12 June–7 September 1975).

5 Cf. *The Eye of Jefferson* (National Gallery of Art, Washington, 5 June–6 September 1976), p. 166, nos 278–9.

6 Many recent developments in notation – the replacement of footnotes by endnotes, simplified or suppressed punctuation, and the shift from roman to arabic – are usually the results of expediency. It will be found that Turabian tends to be normalized in accordance with the *Chicago Manual*, which (12th ed. 15.115; cf. 13th ed. 16.10, 16.43, 16.103) puts forth one practical reason – unwieldiness – and one functional one ('Some otherwise literate people cannot count up to C the Roman way') for abandoning roman once journals have reached their hundredth volume. (The MLA *Handbook* seems never to have heard of roman for periodical 'volumation.') The point to be retained is that such conventions aim for – and obtain – a Least

Common Denominator which is presented *as* the norm, not as one of several options corresponding to some historical or other rationale.

7 The tendency is to suppress p. or pp. in the first instance (cf. *Chicago Manual* 12th ed. 15.118; cf. 13th ed. 16.105, 16.107, 16.113, Turabian 6:74, and MLA *Handbook* 34b and 43b for 'continuous pagination' models), and to insert it in the second (cf. Turabian 6:76 and MLA *Handbook* 34c and 43c for 'issues separately paginated or issues only numbered').

8 Illustration in Arnold Lewis, 'A European Profile of American Architecture,' *Journal of the Society of Architectural Historians*, XXXVIII (December 1978), pp. 265–82, is necessarily based upon periodicals, e.g. Fig. 1. Adler & Sullivan, Wainwright Building, St. Louis, 1890–1891 Covering the Skeleton (*L'Architecture*, VII, 13 October 1894, 335).

9 For suggested models, see the Notes for Contributors of the aforementioned journal.

10 This concerns running references within texts. The same structures in photographic captions *might well* have typographic distinctions, while in the cataloguing of architectural drawings, the name of the building *would be italicized* because it represents a work of art standing for the monument.

11 Otto Pächt and J.J.G. Alexander, *Illuminated Manuscripts in the Bodleian Library, Oxford* (Oxford: Clarendon Press, 1966–73), I, passim.

12 *Medieval and Renaissance Miniatures from the National Gallery of Art* (National Gallery of Art, Washington, 26 January–1 June 1975) can serve as model for the resolutely scholarly cataloguing of selected illuminations of artistic value.

13 A.F. Blunt, 'On the pleasures of looking at drawings,' in *Drawings by Michelangelo, Raphael and Leonardo and Their Contemporaries* (The Queen's Gallery, Buckingham Palace, 1972–3), pp. 9–10.

14 *Musée du Louvre. Cabinet des Dessins. Répertoire systématique des fonds, I: Dessins de la Collection Everard Jabach acquis en 1671 pour la collection royale* (Paris: Musées de France, 1978). One can gain some idea of the reliability of older scholarship by examining the proportion of autograph works, their attribution, and even their assignment by schools.

15 *Dessins d'architecture du XVe au XIXe siecle dans les collections du Musée du Louvre* (Cabinet des Dessins, Paris, 20 mars–5 juin 1972), p. 7

16 The best explanation of this peculiarity is found in William M. Ivins, Jr, *Prints and Visual Communication* (Cambridge: Harvard University Press, 1953; reprint Cambridge: MIT Press, 1969).

17 In rarer cases, mainly architectural drawings, draughtsmen often give

two solutions to their patrons: there may be two sheets with a smaller one serving as a flap to give an alternate; this should be measured in like manner.

18 Panofsky, *Early Netherlandish Painting: Its Origins and Character*, II, p. xvi, pl. 160.

19 Robert Furneaux Jordan, *Victorian Architecture* (Harmondsworth: Penguin Books, 1966), pp. 11, 133.

20 See Kate T. Steinitz, 'Early Art Bibliographies. Who compiled the first art bibliography?' *Burlington Magazine*, CXIV (December 1972), pp. 829–37. There is always a question of availability, not only of titles but of information leading to them, the problem being to keep abreast during times of social upheaval and in areas or fields wrongly considered as being somewhat removed from the mainstream, e.g. Giesela Krienke (comp.), *Bibliographie zu Kunst und Kunstgeschichte: Veröffentlichungen im Gebiet der Deutschen Demokratischen Republik, 1945–1953* (Leipzig: Verlag für Buch- und Bibliothekswesen, 1956), and Gudrun Gerlach and Rolf Hachmann, *Verzeichnis vor- und frühgeschichtlicher Bibliographien. Beiheft zum 50. Bericht der Römisch-Germanische Kommission 1969* (Berlin: Walter de Gruyter, 1971).

21 Louis Gottschalk, *Understanding History. A Primer of Historical Method* (New York: Alfred A. Knopf, 1958), p. 24.

22 Wend Graf Kalnein and Michael Levey, *Art and Architecture of the Eighteenth Century in France* (Harmondsworth: Penguin Books, 1972), p. 135.

23 So the *Chicago Manual*, 16.1: 'Most works with any pretensions to scholarship include a list of books and other references bearing on the subject of the work. In the humanities and some other fields, the list is usually titled Bibliography or, if it includes only works referred to in the text, Works Cited. In the natural sciences a list of cited works is usually headed References.'

24 Blunt, *The Paintings of Nicolas Poussin: A Critical Catalogue*, p. 182, cf. 232–45.

25 Panofsky, *Early Netherlandish Painting: Its Origins and Character*, I, p. 513.

26 See *Der '75 Jahre' – Almanach des Verlages Anton Schroll & Co in Wien, 1884–1959* (Vienna/Munich: A. Schroll & Co, 1959), Chronologisches Verzeichnis, pp. 197–229.

27 Cf. Georges Wildenstein, *Les livres sur l'histoire de l'art. Ce que doit être une collection de monographies consacrée à l'histoire de l'art français* (Paris: Jouve et Cie, 1925). Beyond detailed considerations on format, paper, and type of illustration was an insistence upon the amount of oeuvre reproduced when even photographic archives were in their infancy.

28 John Rewald, *The History of Impressionism* (New York: Museum of Modern Art, 1946; rev. 1955, 1961, 1973), p. 12.
29 For views on the repertory of artists 'known only by name' and their implications for the history of art in general, see 'George Isarlo et sa cartothèque,' *Gazette des Beaux-Arts*, VI/XCI (mai–juin 1978), pp. 213–16.
30 To appreciate what may charitably be termed the fluidity of definition and appurtenance to Surrealism as defined by its most conscious practitioner, one has only to compare the 1928 and 1965 editions *chez Gallimard* of André Breton's *Le Surréalisme et la peinture*.
31 Rewald, *The History of Impressionism*, 4th ed. (1973), p. 608.
32 Bernard Berenson, *Italian Painters of the Renaissance* (London: Phaidon, 1952), p. x.
33 See Marilyn Aronberg Lavin, *Seventeenth-Century Barberini Documents and Inventories of Art* (New York: New York University Press, 1975).
34 See Robert Branner, *Manuscript Painting in Paris during the Reign of Saint Louis: A Study of Styles* (Berkeley: University of California Press, 1977), pp. vii–viii.
35 Dennis Reid, *Alberta Rhythm: The Later Work of A.Y. Jackson* (Art Gallery of Ontario, Toronto, 15 May–27 June 1982), pp. 101–4. It might be noted that such specialized bibliographies increasingly tend to receive a separate credit line when done by someone other than the author.
36 These conditions are not always *in evidence* in the exhibition literature, witness the Global Reference made to a much earlier catalogue. Although dealing to all appearances with a work of art having only a limited literature, one may discover to one's dismay that one item represents many others. This is simply a means of giving the Great Bibliographical Co-ordinates and saving typesetting costs. This usage is more common than might be thought and a further incentive to follow up immediately any catalogue bibliography; the result may be an entirely new set of bibliographical leads.
37 Francis Haskell, *Patrons and Painters: A Study in the Relations between Italian Art and Society in the Age of the Baroque* (New Haven/London: Yale University Press, 1980), preface to the 2nd ed.

CHAPTER 5 CATALOGUING THEORY

1 Classification and cataloguing systems in their most efficacious form correspond to intellectual retrieval and its changing logical associations rather more than the descriptive process that is both their most elemen-

tary level and ultimate aim. Arbitrary or uniform approach can only condition most unfavourably research methodology, which ideally mirrors the historical conditions of artistic creativity.

2 Certain catalogues serve as pure documentation, whether individually or as a chronological sequence within the activity of particular auction houses or dealers, inasmuch as they represent materials whose history is summarily determined and whose future destination remains unknown. Such catalogues represent a highly sophisticated research apparatus; their occasional or circumstantial usage affords opportunity to verify references from existing literature or, alternatively, the investigation of subjects requiring the manipulation of as much raw documentation as possible.

3 Cf. The *Reallexikon zur deutschen Kunstgeschichte* (Stuttgart: 1937–) and the Systematische Sachkatalog of the Zentralinstitut für Kunstgeschichte, Munich.

4 After Léon Rosenthal, *La peinture romantique: Essai sur l'évolution de la peinture française de 1815 à 1820* (Paris: 1900), p. 155.

5 G. Duplessis, 'Du dépôt légal des estampes,' *Revue universelle des arts*, XIII (1861), p. 163: 'La photographie, production bâtarde qui ne tient à l'art que par les objets qu'elle représente et qui n'offre, en empruntant ses moyens à une science facile, que les résultats encore très imparfaits, d'après l'article 22 du décret du 17 février 1852, est soumise au dépôt légal, de même que les estampes, lithographies et autres oeuvres d'art.'

6 For general considerations based on earlier literature, see M. Huber, *Notices générales des graveurs divisées par nations et des peintures rangés par écoles, précédées de l'histoire de la gravure et de la peinture depuis l'origine de ces arts jusqu'à nos jours, et suivies d'un catalogue raisonné d'une collection choisie d'estampes* (Dresden/Leipzig: J.G.I. Breitkopf, 1787), pp. iii–xxviii. Among these are the instruction of youth and the support of the aged, the depiction of things absent and the recalling of things to mind effaced by memory, combined with the realization that 'tous ces effets sont généraux, et chacun en peut ressentir de particuliers, suivant l'étendue de son goût, de ses lumières et de son inclination.'

7 'La seule condition requise est qu'un art trouve son public, ce qui légitime aussitôt son existence et lui donne droit au soutien des grandes collections et des musées. Apparemment aucune limite esthétique ou morale n'est assignée à l'inspiration et aux thèmes. Une entière confiance aurait-elle été faite à l'anarchie puisque la règle de la libre concurrence économique est appliquée avec la neutralité la plus parfaite et sans réserve à tous les peintres?' (Robert Lebel, *L'Envers de la peinture* [Monaco: Editions du Rocher, 1964], p. 96).

8 For the most eminent and unique example of a continually elaborated catalogue, see J. Guibert, *Le Cabinet des Estampes de la Bibliothèque nationale: Histoire des collections suivie d'un guide du chercheur* (Paris: Maurice Le Garrec, 1926), pp. 33, 58–9, 72–3, 133–7. See also André Jammes, 'Louis XIV, sa Bibliothèque et le *Cabinet du Roi*,' *The Library*, s. 5, XX (March 1965), pp. 1–12.

9 See Emile Dacier, 'Les catalogues de ventes illustrés au XVIIIe siècle,' *Le Portique*, no. 3 (1946), pp. 103–20 (Bibliography, 116–20).

10 E.g. *Catalogue raisonné d'un choix précieux de dessins ... qui composoient le cabinet de feu Pierre-François Basan père, graveur et ancien marchand d'estampes*, par L.-F. Regnault, peintre et graveur (Paris: An VII), p. iv. n.***: 'Dans le nombre de catalogues qu'il a publiés, on distingue ceux du cabinet Bouchardon, Rumpré, Slodtz, Quarré-de-Quintin, Fabre, les Vanloo, Mariette ci-dessus nommé, Neyman, Latout d'Aigues, Marigny, Cochin et Aliamet.'

11 'Some of the best catalogues of modern art have perhaps unwittingly helped to shape the working habits of younger artists. Paintings brought forth in rows and classes look irresistibly like illustrations for the artist's future *catalogue raisonné*. Is it possible that, in the place of the patron, it is now the cataloguer who looks over the artist's shoulder? As is well known, the cataloguer's excusable love of order has occasionally obscured the art of the past by forcing its profuse growth into linear sequences. Today, linear sequences seem to dominate growth. The catalogue has become an aesthetic force' (E. Wind, *Art and Anarchy* [London: Faber and Faber, 1963], pp. 164–5, n129).

12 G. Duplessis, *Catalogue de la collection de pièces sur les beaux-arts imprimées et manuscrites recueillie par Pierre-Jean Mariette, Charles-Nicolas Cochin et M. Deloynes, auditeur des Comptes, et acquise récemment par le département des Estampes de la Bibliothèque nationale* (Paris: Alphonse Picard, 1881), p. 200.

13 Further, an object continually loaned cannot logically be expected to spawn radically new or different conclusions in its notice. Distinction between scholarly and exhibition literature should be rigorously enforced.

14 *Inventaire du fonds français: Graveurs du XVIIIe siècle*, IV (Paris: 1940), p. 429, cat. 281. Cf. J. Adhémar, 'L'Inventaire du fonds français du cabinet des Estampes,' *Bulletin des bibliothèques de France*, V (juin 1960), pp. 169–80. (For the present catalogue I was privileged to consult J. Lethève, *Memento pour la rédaction de l'Inventaire du fonds français après 1800* (1956) and elements of as yet unpublished catalogues.) The description of the four states of the frontispiece neglects only to mention differences in the titles on the portfolios: 1° Ecole de Bologne, OEUVRE DE RUBENS, Ecole Romaine;

2° the first two no longer on striated ground; 3° and 4° Ecole Romaine et Francaise.

15 *Inventaire du fonds français*, p. 463, cat. 436.

16 Catalogue Basan, p. iii: 'A son activité est dû l'agrandissement du commerce d'estampes; créateur des échanges avec les nations voisines, la communication des chef d'oeuvres dont elles se glorifient, devint son ouvrage; nous lui devons aussi l'usage moderne des épreuves avant la lettre.'

17 Theodore Michel Lejeune, *Guide théorique et pratique de l'amateur de tableaux: Etudes sur les imitateurs et les copistes des maîtres de toutes les écoles dont les oeuvres forment la base ordinaire des galeries* (Paris: 1864–5), 3 vols.

18 Ludwig Volkmann, *Grundfragen der Kunstbetrachtung* (Leipzig: Karl W. Hiersemann, 1925²), pp. 39–48 and figs. 1–2 for the same machine illustrated by two different reproductive processes.

19 The *Gazette des Beaux-Arts* for some years undertook abundantly illustrated repertories serving to illustrate the historic relations between painting and engraving founded upon sufficient pictorial knowledge. Notable among these: D. Wildenstein, 'Les oeuvres de Charles Le Brun d'après les graveurs de son temps,' VI/LXVI (juillet–août 1965), pp. 1–58; B. Dorival, 'Recherches sur les sujets sacrés et allégoriques gravés au XVIIe et au XVIIIe siècle d'après Philippe de Champaigne,' VI/LXIX (juillet–août 1972), pp. 5–60. Perhaps the best appreciable demonstration of this process was G. Wildenstein's 'Les graveurs de Poussin au XVIIe siècle,' VI/LXVI (juillet–décembre 1955), pp. 73–371, which facilitated M. Davies and A. Blunt, 'Some Corrections and Addenda to ...,' VI/LX (juillet–août 1962), pp. 205–22, published concurrently with the 'Catalogue des graveurs de Poussin par Andresen ... 1863,' pp. 138–202.

20 C.H. von Heinecken, *Idée génerale d'une collection complète d'estampes* (Leipzig/Vienna: J.P. Kraus, 1771), p. 9: 'J'avertis le lecteur, que je considere par le mot de *Gallerie* les Collections de Tableaux, que les Souverains ont recueillez et dont ils ont donné les estampes au public.

'Je nomme *Cabinets*, les collections faits par des grands seigneurs, qui ne sont pas Souverains, ou rassemblées par des Particuliers.

'Enfin, quand les tableaux, d'après lesquels on a publié des estampes, ne se trouvent pas réunis dans une même maison, et qu'ils sont repandus dans differens endroits: je donne à ces Volumes le nom de *Recueils*, sans avoir égard au titre, que les éditeurs leur ont donné.'

21 Duchesne aîné, *Voyage d'un iconophile: Revue des principaux cabinets d'estampes, bibliothèques et musées d'Allémagne, de Hollande et d'Angleterre* (Paris: Heideloff et Campé, 1834), resumes a decade of travels by the Conservateur of the Cabinet des Estampes. His visit to Senefelder, whom

he had known in Paris, is instructive: 'J'ai trouvé cet homme ingénieux dans un atelier de la plus modeste simplicité. Il demeure près de la porte de Sendlinger, et s'occupait alors d'un travail sur l'amélioration des crayons; il paraissait cependant ne pas vouloir le faire connaître encore. Un de ses amis, M. Stunz, m'apprit depuis que M. Sennefelder avait une imagination tellement active, que souvent, en cherchant une chose, il lui venait une autre pensée qui amenait un résultat avantageux dont il s'émerveillait, et il perdait de vue le motif qui d'abord lui avait fait commencer son travail. Alors il oubliait son premier projet, jusqu'à ce que le hasard le ramenât sur la voie' (pp. 23–4).

The *Vollständiges Lehrbuch der Steindruckerey* (Munich: 1818) was simultaneously translated into French and English in 1819, the first with rare supplements of twenty lithographs whose plates are rarely repeated from one edition to the other. These may be appreciated in *A Complete Course of Lithography*, ed. A. Hyatt Mayor (New York: Da Capo, 1968), while the French text alone is now available in facsimile (Paris: Librairie Legueltel / Librairie De Nobele, 1974).

22 I am led to think that the *initial* identity of the Vienna inventory of 1717–18 and the Bref Etat of 1735–6 for Paris (supra, n. 19) represents an embryonic rationale for the dressing of systematic collections of the first order. The number of adjunctions and the search for 'belles épreuves' are far in advance of the day and represent a differentiation between amateur and connoisseur contributing to universal pre-eminence. Cf. *P.-J. Mariette. Les Grands Peintres, I: Ecoles d'Italie. Notices biographiques et catalogues des oeuvres reproduites par la gravure, XVIe-XVIIIe siècle* (Paris: s.d.), pp. viii–ix. Eight of ten original volumes respect this principle.

23 Cf. Vicomte de Grouchy, 'Everhard Jabach, collectionneur parisien (1695),' *Mémoires de la Société de l'Histoire de Paris et de l'Ile-de-France*, XXI (1894), pp. 217–92. The 5,542 drawings are detailed in BN MS fr. 863 and a selection has recently been shown: *Deutsche und niederländische Zeichnungen aus der Sammlung Everhard Jabach im Musée du Louvre, Paris* (Cologne, Wallraf-Richartz-Museum, 11 April–1 June 1975), and *Musée du Louvre. Cabinet des Dessins. Collections, I: Dessins de la collection Everard Jabach acquis en 1671 pour la collection royale* (Paris: Musées de France, 1978).

24 Review of second edition in Fréron's *L'Année littéraire* (Amsterdam: 1768), V, pp. 236–41.

25 Cf. J. Herold, *Jean-Charles François, 1717–1769* (Paris: 1931). In a related vein, see Heinecken, *Idée générale*, pp. 76–9 on the Cabinet Crozat.

26 Gaston Bachelard, *La Psychanalyse du feu* (Paris: 1949), p. 125.

27 Statistics courtesy Ontario Association of Art Galleries, revised as of June 1981.

28 'Quoy qu'il y ait beaucoup de mauvais, ce spectacle ne laisse pas d'estre grand, magnifique et utille pour le spectateur, puisque l'on voit la, d'un coup d'oeuil ensemble, des choses qu'on ne peut voir d'ordinaire que séparèment ...,' (Daniel Cronström à Nicodème Tessin le jeune [8/18 septembre 1699], in *Les Relations artistiques entre la France et la Suède, 1693–1718*, eds R.-A. Weigert and C. Hernmarck [Stockholm: AB Agnellska Boktryckeriet, 1964], p. 242).

29 For some indications concerning this phenomenon and its evolution, see Henri Attia and Raymond Josué Seckel, 'Les cartons d'invitation aux vernissages, esquisse historique. Résultat d'une enquête pour l'École des Bibliothécaires' (*La Chronique des arts*, supplément à la *Gazette des Beaux-Arts*, no. 1260 [janvier 1974], pp. 1–3).

30 Karen McKenzie and Larry Pfaff, 'The Art Gallery of Ontario: Sixty Years of Exhibitions, 1906–1966,' *RACAR*, VII (1980), pp. 62–91.

31 Bernard Berenson, *Rumor and Reflection* (New York: Simon and Schuster, 1952), p. 170.

32 Once known, the collections may well prove to be susceptible of improvement, with the cataloguing effort and resulting publications having provided an inadvertent but perhaps necessary impetus to this end. It is, however, equally apparent that the quality of installations can and must improve within a much shorter time, finding some intermediate ground between the knowledge that the works must be set off to advantage and the impression that they are as often as not merely *placed* on the walls. Among the contributing factors are inadequate lighting systems, lack of attention to colour values, inappropriate framing and matting, and, in the case of works under glass, 'cross-room reflections' – the works themselves becoming invisible as a result of contradictory lighting and intriguing, albeit uninformative, views of the hindsides of other visitors.

33 For a fine survey and copious iconography, see Georg Friedrich Koch, *Die Kunstausstellung. Ihre Geschichte von den Anfängen bis zum Ausgang des 18. Jahrhunderts* (Berlin: Walter de Gruyter, 1967).

34 Some of these not only took place within the artist's studio on a more or less regular basis (which would probably be considered an invasion of privacy today), but also served as conscious manifestations against official exhibition policy, e.g. *Salon d'Horace Vernet. Analyse historique et pittoresque des quarante-cinq tableaux exposés chez lui en 1822* (Paris: Jouy & Jay, 1822).

35 Nowhere is this more apparent than in the anarchy governing placement of spine information in thicker catalogues, for conservative European binding tradition holds that information running from the bottom

up avoids constant shifting of feet and craning of necks. That there no longer seems to be any consistent practice at all, with as many examples having information running from the top down, may be an unconscious indication that catalogues are no longer intended to be massed together on shelves and should be individually or selectively displayed on flat surfaces that set off the front cover to advantage.

36 Notably the *Exposition Eugène Delacroix: Peintures, aquarelles, pastels, dessins, gravures, documents* (Louvre, Paris, juin–juillet 1930), consisting of an album of 114 pages, the provisional text having 342 pages and 894 numbers, and the definitive edition, 383 pages with 895 numbers. Both are graced with something rarely found in much larger temporary exhibition catalogues these days, that is to say, *indexes*!

37 Some *initial* organization of photographic services and archives must be presumed, whether within or without the collection itself. In the latter case this may involve approved photographers and/or the confiding of such tasks to purely commercial firms; in time, it concerns the *upgrading* of negatives that, whenever restoration is involved, necessarily proceeds quite apart from any external demand. A striking early example of the construction of a text around available photographs – in which even the reference numbers arising from photographic campaigns are cited – is V. Alinari, *Églises et couvents de Florence* (Florence: S. Landi, 1895).

38 George Kubler, *The Shape of Time: Remarks on the History of Things* (New Haven/London: Yale University Press, 1962), p. 85.

39 'The medium of diffusion tends to take precedence over the direct experience of the object, and more often than not the object itself is conceived with this purpose in mind' (Edgar Wind, *Art and Anarchy: The Reith Lectures 1960*, rev. and enlarged, including addenda, 1968 [New York: Vintage Books, 1969], p. 79, cf. 76–7). Beyond any normal falsification of expectations as regards colour and configuration, the art catalogue normally effects a complete abstraction of absolute and relative scale of the objects exhibited, the consequences of which may be examined in the *Von Bembo bis Guardi. Meisterwerke oberitalienischer Malerei aus der Pinacoteca di Brera in Mailand und aus einigen Privatsammlungen* (Staatliche Kunsthalle, Baden-Baden, 3 Juli–4 September 1975). The text volume has only installation shots revealing relative scale and the effect of groupings, while the album shows only the individual pictures.

40 Perhaps the most pertinent and closely reasoned observations on the conceptions underlying such 'permanent exhibitions' and their realization – most of whose lessons are transferable to similar material employed within the temporary exhibition of art-historical nature – are found in Jean-Pierre Babelon, 'Expositions et Musées d'Archives,' *La Gazette des*

Archives, n.s., no. 38 (7 décembre 1962), pp. 99–119. One might take special note of his comments (pp. 114–15) on the necessity of considering more closely the roles, complexity, and interrelations of catalogues, labels, and panels, and of inspiring 'du respect au public pour le catalogue et pour ce qu'il contient de travail et d'érudition.' This latter issue applies as much, if not more, to the Administrations of the institutions in which catalogues are produced.

41 Georges Wildenstein, 'À propos des catalogues d'exposition,' *La Chronique des arts*, supplément à la *Gazette des Beaux-Arts*, nos 1060–1061 (mai–juin 1957), p. 1.

42 Most notably the Guggenheim Museum, New York, and the Stedelijk in Amsterdam. The rise of interest in scholarly catalogues of drawings exhibitions can be precisely dated to 1951, at which time the Cabinet des Dessins (Louvre) and the Gabinetto Disegni e Stampe degli Uffizi began their series.

43 Once disencumbered of its prudent rhetorics, my facts are drawn from H.D. Hemphill's *Report to the Council of Associate Museum Directors on the National Inventory Program* (May 1980). Their formulation is mine alone, although it is but an echo of the more general dissatisfaction voiced at the level of participating institutions. [The NIP has since been reconstituted as the Canadian Heritage Information Network, or CHIN. Emphasis is still on specimens and archaeological or historical artefacts, while it is always interesting to learn that the computer input for the few art institutions affiliated with the system is done from existing collection catalogues – which do not exist.]

44 Cf. Denise Jalabert, 'Répertoire des catalogues des musées de province,' *Bulletin de la Société de l'Histoire de l'Art français* (1923), pp. 121–290. One should particularly distinguish differences between editions and reprintings of given catalogues, noting the date of the first and all succeeding catalogues in respect of that of the collection's foundation – all of which led Marquet de Vasselot to remark in his preface: 'Ces répertoires prouvent que, sans des initiatives privées, des ouvrages de référence très utiles, concernant des services publics et dont l'impression devrait être assurée par les Administrations intéressé es, ne seraient pas édités.'

45 Catalogues of permanent collections are of inevitably 'progressive' character. Once *minimum professional standards* have been attained, they are thereafter more questions of complexity and refinement of scientific apparatus and presentation – format, the number and choice of illustration, reattributions, augmentations, and the like. After a certain point it becomes much easier to determine what is appropriate to a given audience

and to generate ever-more sophisticated productions on the whole, so maintenance of *continuity* is paramount. Compare, for example, J.J. Marquet de Vasselot, *Répertoire des catalogues du Musée du Louvre, 1793–1917, suivi de la liste des directeurs et conservateurs du Musée* (Paris: Hachette, 1917), and his *Répertoire des catalogues du Musée du Louvre, 1793–1926*, 2e éd. rev. et aug. (Paris: Musées Nationaux, 1927).

46 At time of writing it may be said that the greater part of cataloguing of permanent collections in Canada has assumed the form, in descending order of importance, of temporary exhibition catalogue entries, of exhibitions generated upon receipt of considerable gifts or bequests, and, more rarely, of annual or periodic showings of 'New Acquisitions'; see Irene Beaupré, 'Bibliography of Canadian Permanent Exhibition Catalogues' (University of Toronto: Department of Fine Art, 1979). In this context one can only commend the Fondazione Giorgio Cini, Venice, for the inauguration in 1956 and 1957 of two parallel catalogue series printed by a *trade publisher*, the first devoted to exhibitions generated in large measure from collections, the second to the collections themselves. The former effort has since been extended to co-operative ventures between public institutions and dealers so as to assure a greater variety of venues for exhibitions.

47 *Trésors des Musées du Nord de la France, IV: La peinture française aux XVIIe et XVIIIe siècles* (Dunkerque/Valenciennes/Lille, 1980); see esp. pp. 13–19, the essay of J. Thuillier, 'Réflexions à propos d'une exposition. Pour une politique régionale.' A similar initiative, proceeding from works held in three institutions, resulted in a splendid yet portable monograph-as-exhibition catalogue: *Carle Vanloo, premier peintre du roi, 1705–1765* (Nice/Clermont-Ferrand/Nancy, 21 janvier–15 août 1977).

48 *Research Collections in Canadian Libraries, 6: Fine Arts Library Resources in Canada* (Ottawa: National Library, 1978), I, p. 35.

49 One successful attempt to do a 'combined' catalogue incorporating both general and very specific information, particularly as regards historiography and attribution, is the *Primitifs flamands anonymes. Maîtres aux noms d'emprunt des Pays-Bas méridionaux du XVe et du début du XVIe siècle. Catalogue avec supplément scientifique* (Groeningemuseum, Bruges, 14 juin–21 septembre 1969).

50 William M. Ivins, Jr, *Notes on Prints, Being the Text of Labels Prepared for a Special Exhibition of Prints from the Museum Collection* (New York: Metropolitan Museum, 1930); Reprint (New York: Da Capo, 1967).

51 Hans Tietze, review of Luitpold Dussler, *Sebastiano del Piombo*, in *Art Bulletin*, XXVI (June 1944), p. 129.

52 In some of the more famous cases of amputation of oeuvre, such ex-

planations are curiously absent from the catalogue and have had to be printed separately upon request; cf. Horst Gerson, 'Rembrandt. *Oratio pro domo,' Gazette des Beaux-Arts*, VI/LXXXVII (avril 1971), pp. 193–200.

53 For a stimulating discussion of the types of queries and methodologies inherent in this eminently traditional practice, see Alfred Moir, *Caravaggio and His Copyists* (New York: New York University Press, 1976), complemented in the entries by the evolution of critical controversy.

54 Daniel Ternois, 'Ingres et le catalogue Naef,' *Gazette des Beaux-Arts*, VI/CXV (février 1980), pp. 95–6.

55 John Rewald, 'Some Entries for a New *Catalogue Raisonné* of Cézanne's Paintings,' *Gazette des Beaux-Arts*, VI/LXXXVI (novembre 1975), pp. 157–68.

56 Paul Joannides, 'Delacroix raisonné,' *Art History*, V (September 1982), pp. 348–52.

CHAPTER 6 CATALOGUING PRACTICE

1 François-Xavier de Burtin, *Traité théorique et pratique des connoissances qui sont nécessaires à tout amateur de tableaux, et à tous ceux qui veulent apprendre à juger, apprécier et conserver les productions de la peinture suivi d'observations sur les collections publiques et particulières, et de la description des tableaux que possède en ce moment l'Auteur* (Brussels: Weissenbruch, 1808), I, p. 115.

2 Already observed by C-N Cochin fils, *Voyage d'Italie, ou recueil de notes sur les ouvrages de peinture et de sculpture, qu'on voit dans les principales villes d'Italie* (Paris: Jombert, 1758), I, pp. viii–ix: 'Lorsque des voyageurs sont obligés de voir en un même jour trois ou quatre palais qui contiennent une grande quantité de tableaux, il n'est pas possible qu'il n'échappe à leur attention des choses qui meritoient d'être observées. On s'attache aux ouvrages frappans, et leur excellence fait disparoître plusieurs morceaux qui toute autre part auroient attiré les regards. Il doit donc arriver que plus il sera trouvé de belles choses réunies, plus celles qui ne sont que simplement bonnes auront ete oubliées, et que les mêmes Maîtres, dont les ouvrages auront été négligés dans un lieu, seront loués dans un autre ou ils n'auront pas été éclipsés.'

3 Cited in Lee Johnson, *The Paintings of Eugène Delacroix: A Critical Catalogue, 1816–1831* (Oxford: Oxford University Press, 1981), I, p. v.

4 Marie-Claude Chaudonneret, *La Peinture troubadour: Fleury Richard et Pierre Révoil* (Paris: Arthena, 1980).

5 This is a matter of focus that may more often follow fashion than do the obvious, important things. See Lorenz Eitner, *Géricault's Raft of the Medusa* (London: Phaidon, 1972), preface, in following up a suggestion of Walter

Friedlaender through considering the sketches and studies: 'It was my hope that in doing this I should be able to deal with its historical situation, with its gradually unfolding form and its content in one continuous narrative, and thus arrive at an insight into its meaning through an effort of reconstruction, rather than analytical dissection. From the start, I was determined to limit myself to the genesis of the picture and to its immediate effect on contemporaries, and to leave for later consideration its influence on subsequent generations of painters.'

6 Lino Moretti, G.B. Cavalcaselle: Disegni da antichi maestri (Venice: Neri Pozza, 1973), one of the mostre of the Fondazione Giorgio Cini.

7 It seems for a while that Berenson and Arthur Kingsley Porter independently envisaged a monograph on Lorenzo Lotto. Until he discovered the duplication of effort and withdrew, the latter had begun to annotate the backs of art postcards. (I owe this reminiscence to Prof. G. Stephen Vickers who had it from Mrs Kingsley Porter.)

8 As Burckhardt to Geymüller, 8 January 1892: 'In der letzten Zeit habe ich aus Italien eine Masse von Photographien bezogen, hauptsächlich Malereien; ein Luxus, welcher meine alten Tage erheitert, und den ich mir auch noch weiter zu gönnen entschlossen bin. Für meine Erben macht ja das nichts aus, wenn ich ein paar 100 Lire weniger hinterlasse; dafür kann ich noch flott vor meinem Auditorium aufziehen. Man hat jetzt viele schöne Kircheninterieurs, u.a. S. Francesco in Rimini, dann römische Baroccokirchen, und last not least, aus Mailand das Innere von S. Eustorgio, von S. Fedele, S. Alessandro und S. Lorenzo! Von letzterem freilich nur die Hauptconcha mit der näheren Umgebung, aber es ist doch so viel. Hätte ich noch das Innere von S. Celso und sonst noch dieses und jenes, so wäre ich völlig zufrieden. – Von Trecorre unweit Bergamo habe ich die vollständigen Fresken einer ganzen Kapelle von Lorenzo Lotto' (Carl Neumann, Jakob Burckhardt: Briefwechsel mit Heinrich von Geymüller [Munich: Georg Müller and Eugen Rentsch, 1914], p. 125).

9 The problem lies not with 'flat works' such as paintings, engravings, and numismatics, but with sculpture, architecture, and the monumental decorative ensembles, the last two of which must have co-ordinated plans and illustrations (general views, details) showing how the rooms and structures are articulated and oriented. Frederick Hartt, Giulio Romano (New Haven: Yale University Press, 1958), II, is notoriously deficient in this regard, while Egon Verheyen, The Palazzo del Te in Mantua: Images of Love and Politics (Baltimore/London: Johns Hopkins Press, 1977), is infinitely more sensitive to issues of 'reconstruction and decomposition' than his predecessor. Perhaps the most exemplary use of contemporary images and modern diagrams – to the point that their sequence gives

the entire argument – is that in Sylvie Béguin, et al., *La galerie d'Ulysse à Fontainebleau* (Paris: Presses Universitaires de France, 1985), pp. 7–64, with its linear schemes for general issues, isometric projections for significant areas or questions, and photomontages for specific disposition, all of them *scaled*.

10 Edgar Wind, *Art and Anarchy. The Reith Lectures 1960*, rev. and enl. (London: Faber and Faber, 1963), p. 77.

11 Bernard Berenson, *Lorenzo Lotto. Complete Edition* (London: Phaidon, 1956), pp. xiii–xiv.

12 *The National Gallery [London]. Illustrated General Catalogue* (London: The Trustees, 1973), note.

13 *Musée National du Louvre. Catalogue des Peintures, I: Ecole Française* (Paris: Musées Nationaux, 1972), p. 7.

14 *Marcel Nicolle, 1871–1934. Notice biographique et bibliographie de ses oeuvres* (Paris: H. Barthélemey, 1936), p. 15.

15 Evelyn Weiss, *Gemälde des 20. Jahrhunderts. Die älteren Generationen bis 1915 im Wallraf-Richartz-Museum mit Teilen der Sammlung Ludwig und im Kunstgewerbemuseum* (Kataloge des Wallraf-Richartz-Museums, VII, 1974), p. 9, series in progress since 1964.

16 Pierre Rosenberg, Nicole Reynaud, and Isabelle Compin, *Musée du Louvre. Catalogue illustré des peintures. Ecole française, XVIIe et XVIIIe siècles* (Paris: Musées Nationaux, 1974), 2 vols; information as of 1 January 1973); Arnauld Brejon de Lavergnée, Jacques Foucart, and Nicole Reynaud, *Catalogue sommaire illustré des peintures du Musée du Louvre, I. Ecoles flamande et hollandaise* (Paris: Musées nationaux, 1979); Arnauld Brejon de Lavergnée et Dominique Thiébaut, *Catalogue sommaire illustré des peintures du Musée du Louvre, II. Italie, Espagne, Allemagne, Grande-Bretagne et divers* (Paris: Musées nationaux, 1981).

17 Boris Lossky, *L'Art français et l'Europe aux XVIIme et XVIIIme siècles* (Paris, Orangerie des Tuileries, juin–octobre 1958), introduction.

18 Lynn Barbeau and Robert F. Swain, 'Exhibition Policy and Programmes,' in Ontario Association of Art Galleries, *Art Gallery Handbook*, eds W. McAllister Johnson and Frances K. Smith (Toronto: OAAG, 1982), pp. 97–114.

19 Such catalogues often have substantial essays, e.g. *Luther und die Folgen für die Kunst*, herausgegeben von Werner Hofmann (Hamburger Kunsthalle, 11 November 1983–8 Januar 1984).

20 Frances A. Yates, *Astraea: The Imperial Theme in the Sixteenth Century* (London/Boston: Routledge and Kegan Paul, 1975), p. xii.

21 See notable examples in *L'Ecole de Fontainebleau* (Grand-Palais, Paris, 17 octobre 1972–15 janvier 1973), pp. 479–85 and 509–16.

22 Facsimile reprintings are usually undertaken by reputable reprint houses; such exceptions include the catalogues of the Museum of Modern Art, the Gabinetto Disegni e Stampe, and the earlier of the Venice Biennale.

23 Pierre Pradel, 'Les Musées,' in *L'Histoire et ses méthodes*, ed. Ch. Samaran (Paris: Gallimard, 1961), p. 1038.

24 Hugh Brigstocke, review of *European Paintings of the Sixteenth, Seventeenth Centuries at the Cleveland Museum of Art, Catalogue of Paintings: Part 3*, in *Burlington Magazine*, CXXVI (January 1984), 42–5.

25 *Musée du Louvre. Nouvelles acquisitions du Département des Peintures (1980–1982)* (Paris: Réunion des musées nationaux, 1983).

26 Katharine Baetjer, *European Paintings in the Metropolitan Museum of Art by Artists born in or before 1865: A Summary Catalogue* (New York: Metropolitan Museum, 1980), p. viii: 'The entries have been organized alphabetically by artist for easy reference, whereas the photographs are grouped chronologically by school, so that the reader can assess the scope or the strengths and weaknesses of the collection in any given area.'

27 Formula adopted by Harold Joachim and Suzanne Folds McCullagh, *Italian Drawings in the Art Institute of Chicago* (Chicago: University of Chicago Press, 1979). Its complementary volumes, published in 1979–80 in the Chicago Visual Library, have a microfiche illustration.

28 Pradel, 'Les Musées,' p. 1038.

29 George Kubler, *The Shape of Time: Remarks on the History of Things* (New Haven/London: Yale University Press, 1962), p. 39.

30 As the suggestion concerning *La toilette de la morte connu comme la Toilette de la mariée*, in *Gustave Courbet, 1819–1877* (Grand-Palais, Paris, 30 septembre 1977–2 janvier 1978), pp. 107–9, cat. 25.

31 In certain celebrated cases it may be necessary to put out an Index of Main and Alternative Titles to make some sense of things, e.g. Hans K. Roethel and Jean K. Benjamin, *Kandinsky. Catalogue raisonné of the Oil-Paintings* (Ithaca: Cornell University Press, 1982–4), II, pp. 1083–1104.

32 A. Pigler, *Barockthemen: Eine Auswahl von Verzeichnissen zur Ikonographie des 17. und 18. Jahrhunderts*, Zweite, erweiterte Auflage (Budapest: Akadémiai Kiado, 1974), 3 vols. Useful for ready reference since the most common literary sources are given.

33 Despite the evolutions and revolutions of terminology for objects of current use, it may be possible to resurrect 'original appellations' as did Tamara Préaud, by rendering to each object 'le nom qu'il portait à Vincennes dans les registres de vente qui sont la source à la fois la plus complete et la plus sûre, en précisant sa première date d'apparition' (*Porcelaines de Vincennes: Les Origines de Sèvres* [Grand-Palais, Paris, 14 octobre 1977–16 janvier 1978], p. 13).

34 Cf. Dorothy H. Dudley and Irma Bezold Wilkinson, *Museum Registration Methods*, 3rd ed. rev. (Washington: American Association of Museums, 1979). It is useful for the discussion of principles and in most cases would be similar to using Fredson Bowers's *Principles of Bibliographical Description* for something other than a critical edition.

35 Mrs Jameson, *A Handbook to the Public Galleries of Art in and near London, With Catalogues of the Pictures, accompanied by critical, historical and biographical notices, and copious indexes to facilitate reference* (London: John Murray, 1842), I, p. v.

36 *Mercure de France* (septembre 1725), II, p. 2254.

37 *Plan-Catalogue complet du Musée du Louvre, salle par salle, avec un répertoire complet donnant la place de chaque tableau* (Paris: Balitout, Questroy et Cie, 1882).

38 T. Thoré, 'Les Musées de province,' *Bulletin des arts: Guide des amateurs de tableaux, dessins, estampes, livres, manuscrits, autographes, médailles et antiquités*, IV (10 juillet 1845), pp. 7–9.

39 *Dictionnaire des arts de peinture, sculpture et gravure* (Paris: L.F. Prault, 1792), I, art. CONNOISSANCE, pp. 441–2.

40 This judgment applies to entire corpuses as well as discrete works, as when John Pope-Hennessy underwent a major critical conversion in his *Fra Angelico* (London: Phaidon, 1952^{1}, 1974^{2}) as a result of incidental restorations and an incontrovertible (documented) shift in Angelico's birth date from 1387 to 1400, in acknowledging: 'Vasari's Angelico was a contemporary of Masolino, Orlandi's was a contemporary of Masaccio. Angelico was thus moved bodily from one side to the other of the great stylistic chasm that runs through Tuscan Early Renaissance painting.'

41 *Dictionnaire des arts de peinture, sculpture et gravure*, I, art. CATALOGUES DE TABLEAUX, DESSINS, ESTAMPES, pp. 316–19.

42 Abbé Laugier, *Manière de bien juger des ouvrages de peinture* (Paris: C.-A. Jombert, 1771), p. 23.

43 Sydney J. Freedberg, *Andrea del Sarto* (Cambridge: Belknap Press, 1963), 2 vols.

44 John Shearman, *Andrea del Sarto* (Oxford: Clarendon Press, 1965), 2 vols.

45 Richard Spear, *Domenichino* (New Haven/London: Yale University Press, 1982), 2 vols.

46 Cecil Gould, *The Paintings of Correggio* (Ithaca: Cornell University Press, 1976).

47 Julius Held, *The Oil Sketches of Peter Paul Rubens: A Critical Catalogue* (Princeton: Princeton University Press, [1980]), 2 vols.

Index